DULWICH
PICTURE GALLERY

Complete Illustrated Catalogue

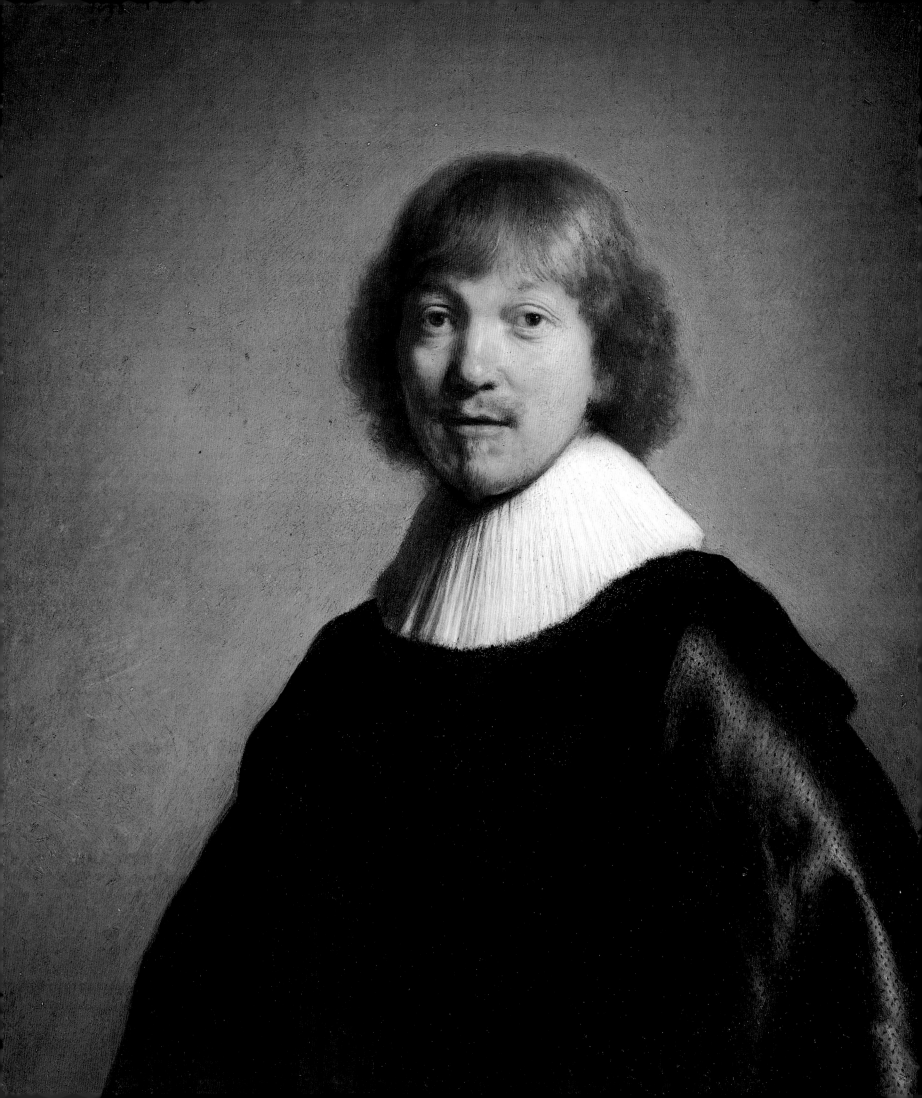

DULWICH PICTURE GALLERY

Complete Illustrated Catalogue

Richard Beresford

Published with the support of the Leopold Muller Estate

Unicorn Press

FRONTISPIECE Rembrandt *Jacob III de Gheyn*
DETAIL PAGE 6 Ludolf Bakhuizen *Boats in a Storm*
DETAIL PAGE 12 Meindert Hobbema *Wooded Landscape with Water-mill*

First published 1998 by Unicorn Press
21 Afghan Road, London SW11 2QD

ISBN 0 906290 18 X

A Catalogue record of this book is available from the British Library

Designed by Gillian Greenwood
Illustrations reproduced by John Rawlinson
Printed in China by Midas Printing Limited

CONTENTS

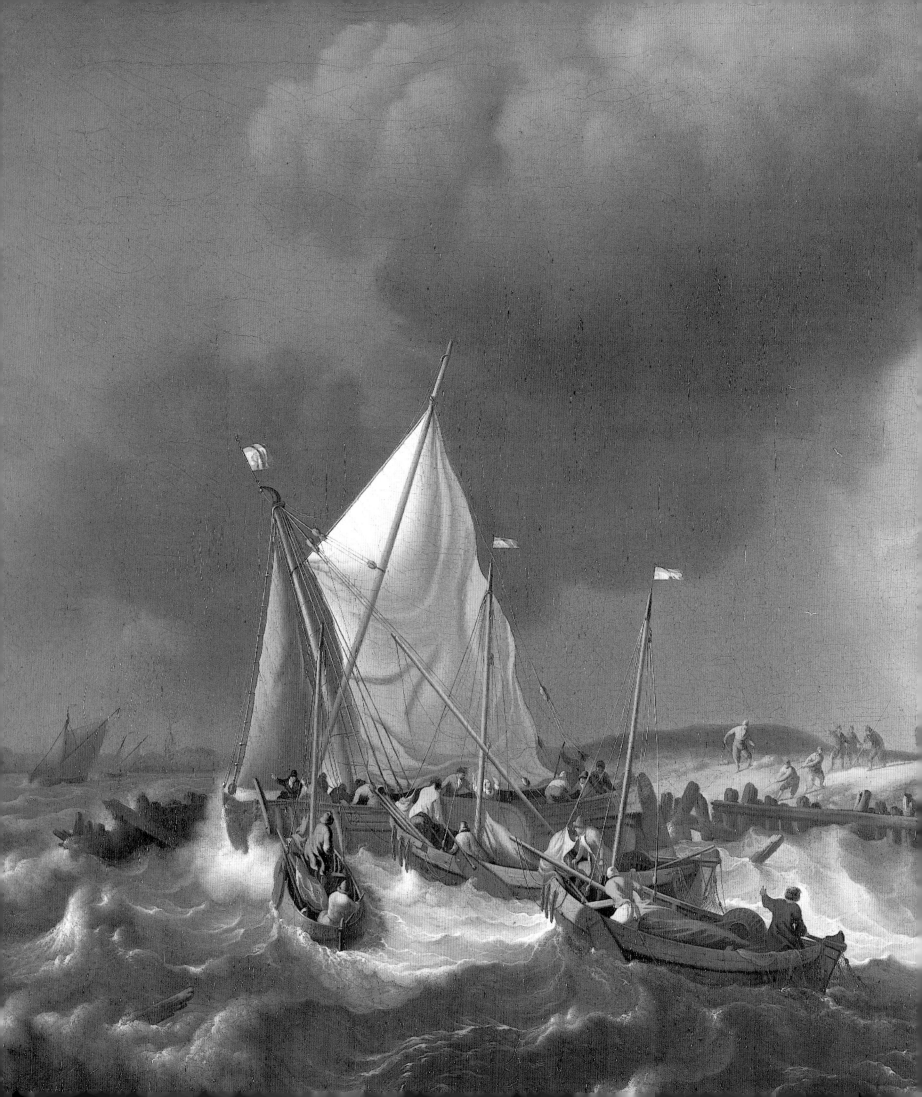

THE LEOPOLD MULLER ESTATE

Leopold Muller was born in 1902 on the Austro-Czech border and died in England in 1988. He came to England as a refugee just before the Second World War, but sadly his wife and two daughters were unable to follow him and became victims of the Nazi Holocaust. On his arrival in London, he opened a modest restaurant in the Edgware Road, and from this small beginning became a leading hotelier and restaurateur, acquiring many well-known establishments throughout the country. In 1960 he created the De Vere Hotel chain, which subsequently became a public company. De Vere rapidly expanded under Mr Muller's guidance and became the owner of, among others, the Grand Hotels in Brighton and Eastbourne, the internationally renowned Mirabelle Restaurant in London and the Connaught Rooms.

Shortly before his death in June 1988, Mr Muller disposed of his business interests. Although he had acquired considerable wealth, he was a very private person who shunned publicity, preferring the quiet life and never allowing his photograph to be published. Having no surviving relatives, he bequeathed his estate to be applied to charitable purposes in England in appreciation of the refuge that had been given to him by this country. It was his wish that the wealth he had created should revert to his adopted country to do good for others.

The trustees of the Leopold Muller Estate have supported numerous charitable causes in this country with a total of more than 200 donations. These have included projects devoted to the education of young children and to the assistance of museums and galleries associated with the National Heritage.

The trustees of the Leopold Muller Estate are delighted to support the publication programme of Dulwich Picture Gallery.

AUTHOR'S ACKNOWLEDGEMENTS

This catalogue owes its existence and much of its content to Giles Waterfield, who retired as Director of Dulwich Picture Gallery in 1996 and to whom I am indebted not only for his advice and encouragement, but also for a succession of exhibition catalogues published in the 1980s and 1990s which document many aspects of Dulwich Picture Gallery and its collections. These catalogues (listed with the abbreviations on p.13) remain a rich source of information on the collection, from which only summary details are included here.

I am indebted to my predecessors at Dulwich who worked on these catalogues, in particular Nicola Kalinsky and Ann Sumner, and to the many contributing authors.

Work on the present catalogue was begun by Gert Fischer, from whom I inherited a set of draft entries on the French, Italian and Spanish schools. I have also made use of the detailed conservation reports prepared by Patrick Lindsay as part of a general survey undertaken with the support of the J. Paul Getty Trust in 1989–90. I am much indebted to all my colleagues for their patience and support, in particular to the Gallery's Director Desmond Shawe-Taylor, its Archivist Helen Hardy, and its conservators Sophia Plender and Nicole Ryder. Sibylle Luig provided invaluable assistance with research and editing as well as preparing the index. A number of volunteers also made useful contributions and my thanks go to Britta Bode, Andreja Brulc, Sophie Chessum, Mayken Jonkman, Karen de Moor and Catherine Retford. In examining pictures, I have had to call persistently on the help of Stephen Atherton, Alan Campbell, Tom Proctor and Jo Awodeyi, whose help has been much appreciated.

I have attempted to revise attributions as far as possible to reflect current scholarly opinion and in this respect have had to rely heavily on the generosity of a wide range of scholars who have discussed pictures with me or provided opinions from photographs. Individual opinions have been recorded in the entries where appropriate. I am extremely grateful to the following for so generously sharing their expertise: Brian Allen, Ronnie Baer, Francesca Baldassari, Arnout Balis, Alexander Bell, Babette Bohn, Jean-Claude Boyer, Arnauld Brejon, Christopher Brown, Edwin Buijsen, Lorne Campbell, Alan Chong, Richard Cocke, Ronnie Cohen, Frederick J. Duparc, Judy Egerton, Elizabeth Einberg, Gabriele Finaldi, Ursula Fischer Pace, Susan Foister, Jeroem Giltay, Karen Hearn, Peter Hecht, Richard Herner, John Ingamells, Thomas Kren, Alistair Laing, Fabrizio Lemme, Christophe Leribault, Anna Lo Bianco, Sir Denis Mahon, David Mannings, Elizabeth McGrath, Fred Meijer, Ellen G. Miles, Dwight Millar, Oliver Millar, Evelyn Newby, Nicholas Penny, Stephen Pepper, Catherine Puglisi, Catherine Reynolds, Aileen Ribeiro, Malcolm Rogers, Pierre Rosenberg, Ashok Roy, Stella Rudolf, David Scrase, Nicolette Sluijter-Seiffert, Richard Spear, Katlijne Van der Stighelen, Ann Sutherland Harris, Marco Tanzi, Paul Taylor, Peter van Thiel, Duncan Thomson, Hans Vlieghe, Aidan Weston-Lewis, Humphrey Wine.

Although the current catalogue contains only summary entries, it is based on research intended to lead in due course to a full catalogue and much material has been assembled on file. This work would have been quite impossible without the unfailing support of the staff of the National Gallery Library, in particular Elspeth Hector. I am also much indebted to the staffs of the Biblioteca Herziana, the Courtauld Institute Library, the London Library, the Library of the Paul Mellon Centre, the National Art Library, the Warburg Institute Library and Photographic Library, the Wallace Collection library, and the Witt Library.

Richard Beresford, August 1997

DIRECTOR'S FOREWORD

Dulwich Picture Gallery is England's oldest public art gallery. It houses one of the best-loved collections of old master paintings in the country. The significance of the collection derives not only from the intrinsic quality of the paintings, but also from the historic nature of the bequests. The gifts of Edward Alleyn in 1619, William Cartwright in 1686, Francis Bourgeois in 1811, William Linley in 1835 and Charles Fairfax Murray in 1911 provide a series of invaluable case-studies of taste and collecting in these different periods.

Remarkably this is the first complete and fully illustrated catalogue of the entire Dulwich Picture Gallery holdings. So now at last scholars can see what these various collections actually contained. Peter Murray's catalogue of 1980 covers only exhibited paintings, with a check-list of the remainder. Such a partial catalogue provides its own insight into the history of taste, most graphically illustrated in the story of Guido Reni's *Saint Sebastian*. (DPG no. 268). In the nineteenth century this image hung at the end of the enfilade of Soane's five galleries as the climax of the collection, the 'high altarpiece' of the building. And yet its authenticity and Reni's reputation became less secure in the early years of this century, to such an extent that it was omitted from the main body of Peter Murray's catalogue. Recently Sir Denis Mahon has recognised the painting as an original and has most generously sponsored its conservation to prove the point. The painting will return to the Gallery in 1998 – not exactly to its old location, which is now an emergency exit, but certainly to pride of place within the seventeenth-century room. How many other relegated paintings will be promoted as a result of this catalogue?

A special debt of gratitude is owing to Dr Richard Beresford, who made such a huge contribution to the work of the Gallery during his brief time as Curator and yet who still found time for this time-consuming and invaluable project.

The meticulously scrupulous quality of Richard's research and the easy accessibility of his writing style will become rapidly familiar to all those who use this catalogue. In his work Richard has depended upon the wider community of scholars and museum curators, who are cited in full in the author's acknowledgement. The Gallery is indebted to all those who help us to understand our collection better by freely sharing their expertise.

We are also most grateful to Hugh Tempest-Radford for his enthusiastic participation in the production and distribution of this catalogue and to Patricia Williams of the National Gallery, an expert on museum publication, for her invaluable advice in this department.

Our final debt of gratitude is owing to the sponsor of this catalogue, without whom it would never have been possible. This book is the last of a series of educational projects supported by a magnificently generous donation from the Leopold Muller Estate. We are especially grateful to the Trustees of the Estate, and in particular to Mr Michael Garston who has taken such a lively interest in all our projects. This catalogue will provide the foundations for the educational work of the Gallery far into the future. With the other educational books and activities supported by the Estate, it provides a fitting tribute to the memory of a remarkable man. Finally we gratefully acknowledge the support of the Royal Historical Society who, acting as Trustees of the Robinson bequest, have made a most generous contribution to our production costs.

Desmond Shawe-Taylor

LIST OF SUBSCRIBERS

Domenico Acquarone
Giulio Alfonsi
James Allen's Girls' School
A. N. G. Annesley
Jane C. Avery
Revd R. A. Bagley
Daphne Bath
Hugh Belsey
Mrs Stella Benwell
Dr Richard Beresford
Bibliothek Museumsinsel, Berlin
Tony & Marjorie Bird
Lady Black
Ronald Branscombe
E. M. Bramwell
N. Brodie of Brodie
Xanthe Brooke
Mrs Susan Burton
Lady Butler
Evelyn Butterfield
Miss Edith Callam, MBE
David Giles Carter
Mrs Lesley Casey
C. A. Chapman
Muriel Chester
Mrs J. Clayton
J. J. Clarke
Mrs C. M. Cooper
Col and Mrs A. E. Cornick
J. K. Cramp
Ruth Crawford
Mrs Catherine G. Curran
Fondation Custodie
Mrs J. W. Davenport
Shihoko Davis
James F. Dicke II
Miss D. E. Dormer
Dordrechts Museum
I. F. L. Duncan
Stephen Dunk
Dr Ann Edwards
Mrs. C. Ehrenberg
Roger Fidgen
N. Fletcher
Brian D. Foord
Philip C. French
Yoshiko Fujioka

Mr and Mrs G. I. Fuller
Mrs B. I. Gilles
Michael Godbee
Mrs Jean Golt
Sir Nicholas Goodison
Peter and Charlotte Aileen Gooch
Dr Catherine Gordon
Jeremy M. B. Gotch
R. G. Gray
R. A. Griggs
J. R. S. Guinness
Philip H. R. Gwyn
Mrs. R. G. Halsey
Mrs K. Halstead
J. D. G. Hammer
Mrs J. M. Hamilton
Helen Grace Hardy
Moira V. Hartley
Dr John Hayes, CBE
Michael Helston
Barbara Hendrie
Herzog Anton Ulrich Museum
Alan Hobart, Pyms Gallery
Timothy Hornsby
The Hon Simon Howard
Mrs C. Hubbard
Bernard Hunter
John Ingamells
Lady Irvine
Mrs Jeffries
P. Joannides
Brian Jones
Paul Judge
Michael and Jennifer Justice
Daniel Katz
Laurence Kelly
Charlotte Kennedy
Mike and Alison Kermer
Michael Kerin
Kimbell Art Museum Library,
 Fort Worth
P. Kirwan
Richard Knight
David Koetser
Mason H. Lampton
Lampard Family
Mrs Patricia Landon

Landes Museum Joanneum, Graz
Isabel Laughland
Jeannette M. Leduc
Charles Leggatt
D. J. Lewis
Librairie du port SA, Saint Tropez
Shirley Lock
Olivia Logue
Los Angeles County Museum of Art
David and Masako Love
H. R. L. Lumley
Gerry McQuillan
Susie Macmillan
Mrs Anne Macrae
Sir Denis Mahon
Massimo Martino SA
Yuko Matzuzaki
Maxitruck
G. W. J. McMillan
James Methuen-Campbell
The Metropolitan Museum of Art,
 New York
Sir Oliver Millar
D. J. W. Milne
William Millinship
Anne Morris
Edward Morris
Belinda Murray
Museum of Fine Arts, Boston
National Portrait Gallery, London
National Galleries of Scotland
Charles Noble, LVO
Vita Noel
John Norton
A. D. Owen
D. G. Page
Mrs Anne Parker
Hamish Parker
Agnieszka Partridge
N. B. Penny
J. F. R. Pinnegar
Jules L. Plangere III
Elaine and Phillip Reader
Mrs. P. Reeve
A. M. Reeve
Frank E. Rehder
D. M. Richards

S. D. Riefe
John Ritblat
Mrs H. A. Rosser
W. D. Rothenberg
P. G. Sabin
Santa Barbara Museum of Art
Adrian Sassoon
J. M. Sassoon
Clive Saunders
Pam and Philip Schonberger
A. G. W. Scott
Nigel McNair Scott
Scottish National Portrait Gallery
The Revd Roy Screech
S. Segal
J. B. Senior
David Shapero
Desmond Shawe-Taylor
Shell International
Peter Silverman
K. W. Sissons
Mrs Merrill Spencer
Statens Museum for Kunst,
 Copenhagen
Mrs Jill D. Stern
Mark Studer
Chimiko Sunayama
John Taylor
Mrs Virginia Tuck
Mrs G. Turton
A. C. Twort
E. de Unger
Richard Verdi
Caroline Villers
M. Waddingham
The Wallace Collection
Graham Ward
D. L. Wells
Witt Library, Courtauld Institute
Malcolm Dean Williams
Eileen Wilson
Mr and Mrs Willis Walker
The Print Room, The Royal
 Library, Windsor

ABBREVIATIONS

ARA
Associate of the Royal Academy

Bartsch
J.A.B. von Bartsch, *Le peintre graveur*, 21 vols., Vienna, 1803–21; and *The Illustrated Bartsch*, ed. W.L. Strauss, New York, 1978

Collection for a King
Cat. exh. *Collection for a King: Old Master Paintings from the Dulwich Picture Gallery*, National Gallery of Art, Washington/Los Angeles County Museum of Art, 1985–6 (catalogue edited by G.A. Waterfield; contributions by C. Brown, P. Conisbee, D. Cordingly, J. Daniels, J. Fletcher, K. Garlick, I. Gaskell, M. Kitson, M. Levey, J. G. Links, D. Mahon, M. Rogers, J. Simon, L. Stainton, R. Verdi, G.A. Waterfield, C. White and C. Wright)

Conserving Old Masters
Cat. exh. *Conserving Old Masters*, Dulwich Picture Gallery, 1995 (cat. edited by R. Beresford and G.A. Waterfield; contributions by R. Beresford, D. Bomford, X. Brooke, A. Chong, M. Jaffé, H. Lank, A. Sumner, L. Till and G.A. Waterfield)

Courage and Cruelty
Cat. exh. *Courage and Cruelty, Le Brun's Horatius Cocles and The Massacre of the Innocents*, Paintings & their Context III, Dulwich Picture Gallery, 1990–1 (catalogue edited by N. Kalinsky; contributions by H. Glanville, J. Montagu, N. Kalinsky and R. Wrigley)

Death, Passion and Politics
Cat. exh. *Death, Passion and Politics*, Paintings & their Context V, Dulwich Picture Gallery, London, 1995–6 (catalogue edited by A. Sumner; contributions by P. Amos, C. Avery, M. Ashton, C. Bowden, E. Dekker, M. Foster, C. Gittings, O. Millar, D. Proctor, M. Rogers, A. Smith, B. Southgate, A. Sumner J. Thompson, L. Till, G.A. Waterfield and A. White)

Denning
See Inventories and Catalogues below

DNB
Dictionary of National Biography, Oxford, 1917–

Dutch Flower Painting
Cat. exh. *Dutch Flower Painting*, 1600–1750, Dulwich Picture Gallery, 1996 (catalogue by Paul Taylor)

Edward Alleyn
Cat. exh. *Edward Alleyn, Elizabethan Actor, Jacobean Gentleman*, Dulwich Picture Gallery, 1994–5 (catalogue edited by A. Reid and R. Maniura; contributions by S.P. Cerasano, S. Foister, and J.R. Piggott)

HdG
C. Hofstede de Groot, *A Catalogue raisonné of the Works of the Most Eminent Dutch Painters of the Seventeenth Century*, 10 vols. (vols. IX and X in German), London/Stuttgart/Paris, 1907–26

Kolekcja dla Króla
Cat. exh. *Kolekcja dla Króla*, Royal Castle, Warsaw, 1992 (catalogue edited by G.A. Waterfield; contributions by C. Brown, P.D. Cordingly, J. Daniels, J. Fletcher, I. Gaskell, N. Kalinsky, M. Kitson, M. Levey, J.G. Links, C. McCorquodale, J. Montagu, D.S. Pepper, M. Rogers, P. Rosenberg, L. Stainton, R. Verdi, C. White and C. Wright); the catalogue contains Polish

translations of catalogue entries from *Collection for a King* together with a few additional entries

Mr Cartwright's Pictures
Cat. exh. *Mr. Cartwright's Pictures*, Dulwich Picture Gallery, London, 1987–8 (catalogue contributors: G. Ashton, R. Jeffree, N. Kalinsky, P. Mitchell, L. Stainton, G.A. Waterfield)

Murray
See Inventories and Catalogues under 1980

A Nest of Nightingales
Cat. exh. *A Nest of Nightingales, Thomas Gainsborough: The Linley Sisters*, Paintings & their Context II, Dulwich Picture Gallery, London, 1988 (catalogue edited by N. Kalinsky and G.A. Waterfield; contributions by G. Beechey, M. Birley, K. Garlick, H. Glanville, J.P. Losty, N. Kalinsky, S. Wallington and G.A. Waterfield)

Nicolas Poussin, Venus and Mercury
Cat. exh. *Nicolas Poussin, Venus and Mercury*, Paintings & their Context I, Dulwich Picture Gallery, 1986–7 (catalogue by R. Verdi, K. Scott, and H. Glanville)

RA
Royal Academy, London/Royal Academician

Rembrandt's Girl at a Window,
Cat. exh. *Rembrandt's Girl at a Window*, Paintings & their Context IV, Dulwich Picture Gallery, 1993 (catalogue edited by K. Bomford, A. Sumner and G.A. Waterfield; contributions by M.R. Abbing, C. Brown, G. Cavalli-Björkman, P. Palley, S. Plender, M. Royalton-Kisch, A. Sumner, G.A. Waterfield, C. White and R. Willard)

Rich Summer of Art
G.A. Waterfield, *Rich Summer of Art: A Regency Picture Collection Seen Through Victorian Eyes*, Dulwich Picture Gallery, 1988

Richter
See Inventories and Catalogues under 1880

Soane and After
Cat. exh. *Soane and After, the Architecture of Dulwich Picture Gallery*, Dulwich Picture Gallery, 1987 (catalogue by Giles Waterfield)

Soane and Death
Cat. exh. *Soane and Death*, Dulwich Picture Gallery, 1996

Sumowski
W. Sumowski, *Gemälde der Rembrandt-Schüler*, 6 vols., Landau in der Pfalz, 1983

Thieme and Becker
U. Thieme and F. Becker, *Allgemeines Lexikon der bildenden Künstler*, 37 vols., Leipzig, 1907–50

Treasures of a Polish King
Cat. exh. *Treasures of a Polish King Stanislaus, Augustus as Patron and Collector*, Dulwich Picture Gallery, 1992 (catalogue edited by K. Bomford and G.A. Waterfield; contributions by A. Zamoyski, A. Rottermund, et al.)

INVENTORIES AND CATALOGUES

Cartwright inventory
Ms. of the Cartwright collection, inventory containing 239 items, the pages listing nos. 186–209 missing (Dulwich College Archive); transcription in *Mr Cartwright's Pictures*, pp.20–7

1802
N. Desenfans, *A Descriptive Catalogue (with remarks and anecdotes never before published in English) of some Pictures of the Different Schools purchased for His Majesty the Late King of Poland*, 2 vols., London, 1802

1804
List of Pictures to be Insured (Ms. Dulwich College Archive). Transcription in G. Warner, *Catalogue of Manuscripts and Muniments in Dulwich College*, 1881

1813
J. Britton, *A Brief Catalogue of Pictures Late the Property of Sir Francis Bourgeois, R.A. with the sizes and proportions of the Pictures* (Ms. Dulwich College Archive)

1816
R. Cockburn, *A Catalogue of the Dulwich Gallery*, London, n.d. (reprinted several times, on each occasion undated)

1824
*Catalogue of the collection of pictures bequeathed to Dulwich College by the late Sir Francis Bourgeois, c.*1824

1858
S.P. Denning, *A Catalogue of the Dulwich Gallery*, 1858 (Ms. Dulwich Picture Gallery Archive)

1876
J.C.L. Sparkes, *A Descriptive Catalogue of the Pictures in the Dulwich College Gallery with Biographical Notices of the Painters*, London, 1876

1880
J.P. Richter and J.C.L. Sparkes, *Catalogue of the Pictures in the Dulwich College Gallery with Biographical Notices of the Painters*, London, 1880 (entries on the British school by Sparkes and on foreign schools by Richter)

1890
J.C.L. Sparkes and A.J. Carver, *Catalogue of the Cartwright Collection and other Pictures and Portraits at Dulwich College*, London, 1890

1892
A Descriptive and Historical Catalogue of the Pictures in the Dulwich College Gallery, 3rd revised edition, 1892 (revised and renumbered edition of the 1880 catalogue incorporating entries on the College pictures taken from the Catalogue of 1890)

1905
Catalogue of the Pictures in the Gallery of Alleyn's College of God's Gift at Dulwich, 4th revised edition, 1905

1914
Catalogue of the Pictures in the Gallery of Alley's College of God's Gift at Dulwich, revised and completed by E. Cook, London, 1914

1926
Catalogue of the Pictures in the Gallery of Alleyn's College of God's Gift at Dulwich, revised by E. Cook and further revised and completed by the Governors, London, 1926

1953
A Brief Catalogue of the Pictures in Dulwich College Picture Gallery, London, 1953

1980
P. Murray, *Dulwich Picture Gallery, A Catalogue*, London, 1980 (a summary version published as *Dulwich Picture Gallery, A Handlist*, London, 1980)

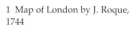

1 Map of London by J. Roque, 1744

DULWICH PICTURE GALLERY

While claiming to be the oldest public art gallery in England, Dulwich Picture Gallery is also one of the newest, having been established as an independent charitable trust only in 1994. Until that time the Gallery was part of Alleyn's College of God's Gift, a seventeenth-century charitable foundation, which numbers among its beneficiaries three schools at Dulwich: Dulwich College, Alleyn's School and James Allen's Girls School.

Edward Alleyn (1566–1626) began his career as an actor, and later became a successful entrepreneur of the Elizabethan theatre. His interests in the Rose and the Fortune Theatres (the latter the main rival to the Globe) and in the popular sport of bear-baiting, brought him sufficient wealth to acquire the Manor of Dulwich in 1605. He then set about righting the balance of his life and interested himself closely in the foundation of a college at Dulwich – the College of God's Gift – which, with its attached almshouses and chapel, survives next to the Gallery (though its exterior aspect is almost totally changed).[1]

The collection now at Dulwich began (somewhat inauspiciously) with Alleyn's bequest to the College, along with other furnishings, of a group of pictures.[2] Alleyn's diaries record several payments to painters for decorative work in his house and at the College, and he probably had dealings with painters in commissioning theatrical backdrops. In acquiring pictures he seems to have made use of the services of a 'Mr Gibkyn', from whom he acquired the set of Sibyls[3] and, very probably, the set of Kings and Queens of England[4] which remain in the collection (along with a set of Christ and the Apostles, which does not). Few other paintings can reasonably be associated with Alleyn's bequest: these include a set of portraits of Protestant Reformers,[5] and portraits of Alleyn himself and of a woman, thought to be his first wife Joan Woodward.[6]

The College seems to have maintained some connection with the theatre as it attracted in 1686 the bequest of a substantial collection of pictures assembled by the actor William Cartwright (1606–86).[7] The inventory of this collection, drawn up in a crabbed and semi-literate hand (apparently Cartwright's own), contained 239 items. Only about 80 of these are now identifiable at Dulwich. They comprise, nevertheless, an important survival, though of greater historical than aesthetic interest. Of some artistic note are groups of pictures by Lorenzo a Castro, Adam Colonia and John Greenhill, and individual works by Cornelis Bol, Isaac Fuller, Marcus Gheeraerts the younger, Jacob Huysmans and Robert Streeter. There is also a group of portraits of actors, most notably the only known contemporary likeness of Richard Burbage, who played leading roles in the first performances of a number of Shakespeare's plays.[8]

In the eighteenth century the pictures were assembled mainly in a picture gallery and adjoining room on the

2 The earliest surviving view of *Old Dulwich College*, 1776 (Jan Piggott)

3 *William Cartwright*, drawing by John Greenhill *c*.1660 (Jan Piggott)

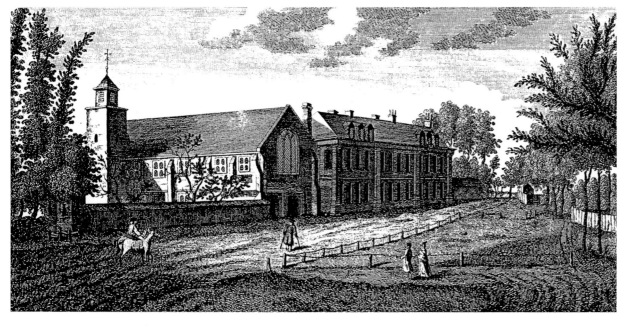

1 For Alleyn's career, see S.P. Cerasano, 'Edward Alleyn: 1566–1626', in *Edward Alleyn*, pp.11–31.
2 The pictures which it seems reasonable to assume formed part of Alleyn's bequest are listed in Appendix II.
3 British DPG537–545.
4 British DPG521–536.
5 See British DPG368.
6 British DPG443–4. For Alleyn's dealings with painters and collection, see S. Foister, 'Edward Alleyn's Collection of Paintings' in *Edward Alleyn, Elizabeth Actor, Jacobean Gentleman*, pp.33–61. The 33 pictures in the collection thought to come from Alleyn's bequest are listed in ibid., pp.76–7.
7 For Cartwright's biography, see N. Kalinsky and G.A. Waterfield in *Mr Cartwright's Pictures*, pp.5–11. This catalogue also includes a transcription of Cartwright's inventory and more detailed catalogue entries on the pictures than those included here. A few of the identifications with Cartwright's inventory have been changed in the Concordance on pp.318–20, following the discovery that the pictures almost invariably have on the back labels referring to the inventory, which must have been applied at a time before two pages from the inventory went missing.
8 British School DPG395.

4 George Dance, *Sir Francis Bourgeois*,
1798–1800, graphite and red chalk on paper
(Dulwich Picture Gallery Archive)

5 Paul Sandby, *Sir F. Bourgeois and
Mr Desenfans*, c.1805, watercolour on card
(Dulwich Picture Gallery Archive, formerly
DPG645)

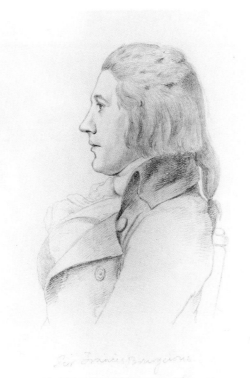

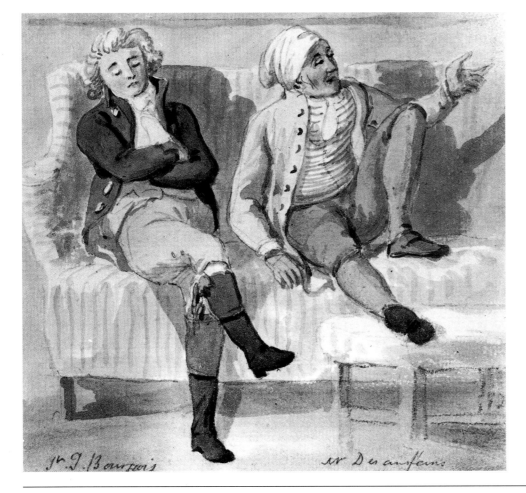

first floor of the wing of the Old College overlooking Gallery Road. Few works were added to the collection at that time, except for one or two portraits, principally of the Masters of the College, James Allen and his successor Joseph Allen.[9] (One of the College's more curious statutes required that the Master and Warden should both bear the name Alleyn or Allen at birth). The picture gallery attracted a few, generally rather disappointed, visitors. Horace Walpole saw 'a hundred mouldy portraits among apostles sibyls and kings of England'.

The status of the collection was transformed in 1811 when the College became the beneficiary of the Will of Sir Peter Francis (known as Sir Francis) Bourgeois, who bequeathed to it a collection of about 370 pictures, including many of great distinction.[10] Bourgeois had been the protégé and the heir of Noel Desenfans, a Frenchman who came to England as a language teacher but adopted the role of connoisseur-cum-picture dealer. In 1790 Desenfans came into contact with Michal Poniatowski, brother to Stanisław II Augustus, King of Poland, from whom he accepted the commission of acquiring suitable pictures for the Polish Royal collection.[11]

For five years Desenfans devoted himself to this charge, but his efforts were never to bear fruit in the manner intended. In 1795 Poland was partitioned and its enlightened monarch forced into abdication. The collection remained in Desenfans' hands. Attempts to persuade the Tsar of Russia to buy it were received coldly. A public auction of the pictures in 1802 found few purchasers. Desenfans even lobbied for the creation of a British national collection, offering to contribute lavishly to it, but the British Government was not to be drawn into such a new-fangled (and French-sounding) enterprise, at least for some years.

By 1803 Desenfans was resigned to remaining the owner of one of the most notable picture collections in London. Bourgeois was his enthusiastic partner and, at Desenfans's expense (and rather to his irritation), set about adding to the collection. This he did in more ways than one. Having trained as a painter (acquiring an inexplicable reputation in that profession),[12] he also applied himself to the task of restoring, enlarging and embellishing some of the pictures, even adding signatures.[13] The results were displayed in Desenfans's house in Charlotte Street, near Portland Place (now Hallam Street), where guests were entertained in a dining room hung with Poussins and retired to a library hung with Cuyps. The arrangement of the pictures is partially reflected in an inventory of the collection drawn up by John Britton in 1813.

In 1807 Bourgeois inherited from Desenfans both the collection and the problem of its destiny. His first instinct was to preserve the Charlotte Street house as a public gallery and a monument to Desenfans's achievements and ideals. It was evidently with this view in mind that he commissioned from his friend the architect Sir John Soane (1754–1837) a mausoleum to preserve his friend's remains in the midst of the collection. (Soane was to

create his own monument-museum, of course, in the house which survives in Lincoln's Inn Fields as Sir John Soane's Museum.) But Bourgeois's attempts to secure the freehold on the Charlotte Street house from the Duke of Portland met with an unsympathetic response and the idea had to be abandoned.

After briefly considering the possibility of leaving the collection to the British Museum, Bourgeois finally settled on Dulwich. The great actor John Philip Kemble, a friend of Desenfans and Bourgeois, is credited with suggesting this idea. In December 1810, after the riding accident that would lead some weeks later to his death, Bourgeois drew up his will. He left the collection in the hands of Desenfans's widow until her death, and it was then to pass to Dulwich College. In the event, Mrs Desenfans waived her life interest. Her desire was that her late friend's wishes should be put into effect as soon as possible. To this end she added a sum of £4,000 to the £2,000 provided in Bourgeois's will for the construction of a new gallery to house the pictures.

Bourgeois seems to have envisaged the collection being housed in the gallery which already existed in the

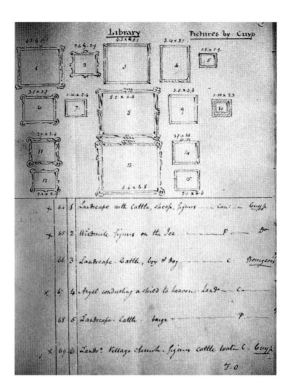

6 'Library, Pictures by Cuyp' from John Britton, *A Brief Catalogue of Pictures, Late the Property of Sir Francis Bourgeois, R.A.,* (London, MS, 1813)

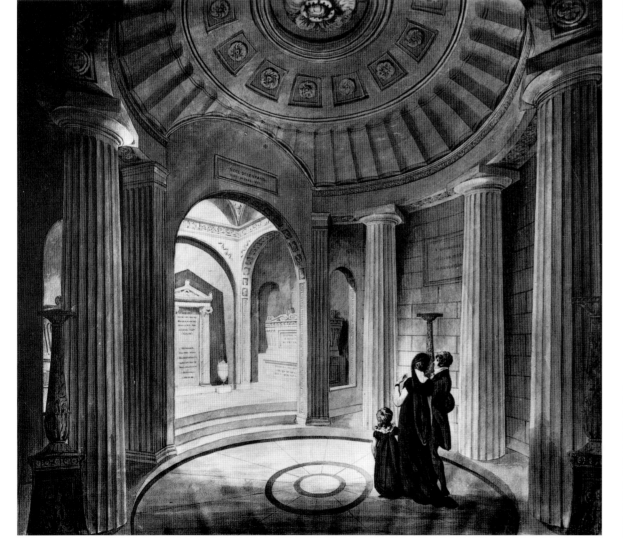

7 Sir John Soane, *Desenfans Mausoleum, 38 Charlotte Street, London,* 1807, pencil, pen and ink, and watercolour (Dulwich College Archives)

9 Of *James Allen* by Ellys and anonymous (British School DPG495–6); of *Joseph Allen* by Romney.
10 For Desenfans and Bourgeois and the formation of their collection, see the essay by G.A. Waterfield in *Collection for a King.*
11 For an account of Stanisław Augustus as a patron and collector, see *Treasures for a Polish King.*
12 On Bourgeois's career as a painter, see G. Waterfield. 'That White-faced Man: Sir Francis Bourgeois', *Turner Studies,* 1989, 9, pp.36–48.
13 See, for example, Borssum DPG133; Cuyp DPG60; Ruisdael DPG105; Teniers DPG76; Italian School (Bolognese) DPG2.

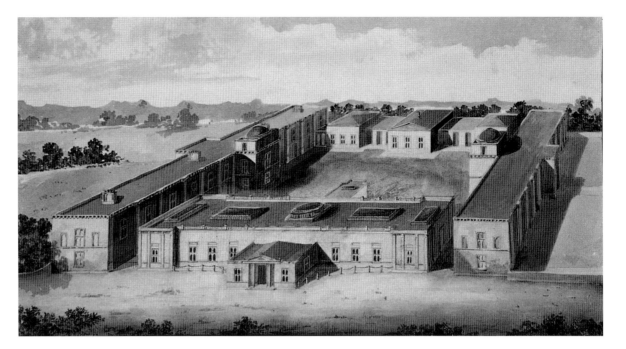

8 Sir John Soane, *Early design for the picture gallery, as part of a quadrangle*, 1811

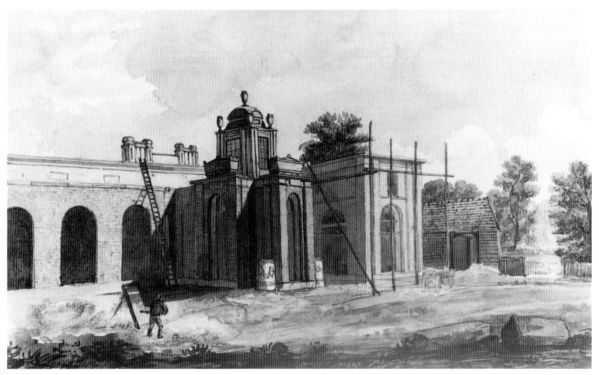

9 J.M. Gandy, *The gallery under construction,* c.1812–14 (Sir John Soane's Museum)

college buildings. On his death-bed he expressed the desire that the necessary improvements should be entrusted to Soane, who duly arrived to inspect the site on the day following Bourgeois's death. The old college buildings were, however, in a severely dilapidated condition and the idea of utilising the old gallery was immediately abandoned. Soane provided a number of ambitious proposals for new building work. Characteristically, his ideas were multiple, but they boiled down to the creation of a new quadrangle to the south of the College. These schemes proved too ambitious and in the end only the Gallery itself was built, though in origin it was conceived as one of the wings of a quadrangle.[14]

The unique character of Dulwich Picture Gallery was defined at this time. A regal collection became the property of a school and an architect of genius took responsibility for housing it. The building went through successive transformations in Soane's mind before it took its definitive shape. A constraint imposed by the College was the need to combine the gallery with a series of almshouses. The four rooms on the west side (overlooking Gallery Road) were originally built as almshouses. Soane himself appears to have added the idea of combining the gallery with a mausoleum. Bourgeois had merely indicated a desire to be buried in the College chapel. But Soane recreated something of the character of the

14 On the architecture of the Gallery and its subsequent alterations, see *Soane and After.*

Charlotte Street house, at least as Bourgeois had intended it: as a commemorative museum housing the remains of its founders.

The Gallery is an extraordinarily personal architectural creation, bearing almost no relation to traditional architectural practice as it might pertain either to a school or to an art gallery. Soane worked under considerable financial constraints and offered his own services without charge. For reasons partly of economy and partly personal taste, he abandoned the stuccoed porticos that would have been expected of such a building for a subtle and intricate articulation in raw brick, classical in spirit but not in detail. He devised a scheme of top-lighting which remains one of the Gallery's most admired features. And he placed at the heart of the building a mausoleum that illustrates as well as any of his surviving works the quirky individuality of his architecture, with its porphyry grandeur in *faux-marbre*, its '*lumière mystérieuse*' filtered through yellow glass, and its sepulchral acoustics.

Work on the building began in 1811 and the pictures were moved to Dulwich in 1814. Shortly afterwards Mrs Desenfans died, and in 1815 her body was laid to rest, beside those of her late husband and friend, in the new mausoleum.[15] From 1815, the collection was made available to Royal Academicians and students, but problems with the heating system delayed its opening to the public for a further two years.

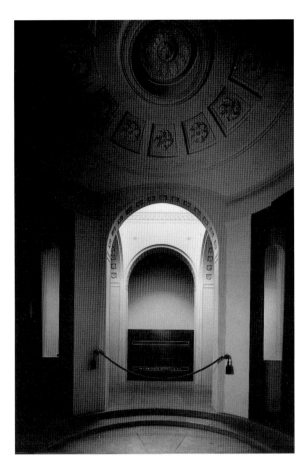

10 Interior of the Mausoleum (Dulwich Picture Gallery Archive)

11 J.M. Gandy, *Ideal view of Dulwich Picture Gallery*, 1823, watercolour on paper (Dulwich Picture Gallery G44)

15 For a detailed account of the mausoleum and its context within Soane's career, see *Soane and Death*.

Even after the National Gallery opened its doors in 1824, Dulwich remained for many years the most important collection of old masters readily accessible to the public. Naturally, many leading artists came to see the collection, including Constable, Etty, Frith, Holman Hunt, Samuel Palmer, David Roberts, and Turner. Another notable visitor later in the century was Vincent van Gogh. The Gallery also attracted distinguished literary visitors, amongst whom were Charles Dickens (whose Mr Pickwick also became a visitor to the Gallery on his retirement to Dulwich) and Robert Browning, who drew inspiration from the collection for some of his poetry.

The collection was also besieged by copyists. These had become so numerous by 1835 that the number of permissions granted had to be restricted to fifty and the number copying from a single picture to two. Students of the Royal Academy Schools also benefited from the arrangement by which up to six pictures could be borrowed by the Schools for the purpose of instruction.

These were selected by the Royal Academicians at the annual dinners to which, in accordance with Bourgeois's instructions, they were invited, so that they could report on the condition of the pictures. However, the Academicians' selection was not always to the students' taste. Some made the trip to Dulwich to copy Murillo rather than Poussin.

The curious visitor was offered little in the way of reading matter: only a simple list of titles and artists. This had been compiled by the Gallery's first keeper, Ralph Cockburn, in 1816. It would be sixty years before the first *Descriptive Catalogue* was produced. But the deficiency was amply met by the appearance of various guides to and descriptions of the collection, notably those of Benjamin Robert Haydon, William Hazlitt, Mrs Jameson and the German art historians J.D. Passavant and G.F. Waagen. The collection also provided many victims of vituperation for Ruskin's onslaught on established taste in his *Modern Painters*.

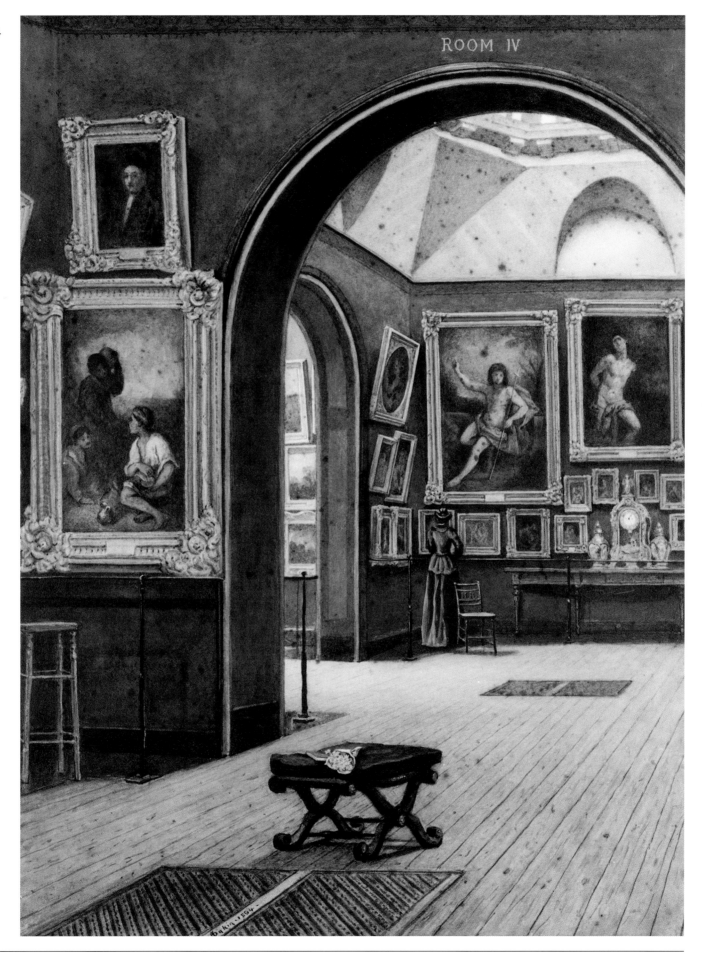

13 Joseph Dakin,
Interior of the Gallery, 1894,
watercolour on paper
(Dulwich Picture Gallery
Archive)

by Gainsborough, Archer James Oliver, James Lonsdale and Sir Thomas Lawrence.

A number of gifts and bequests enlarged, and to varying degrees enhanced, the collection during the nineteenth century. Gainsborough's portrait of *Mrs Moody* was given by one of the sitter's sons, Captain Thomas Moody, in 1831. The painter William Beechey gave the portrait of Bourgeois that he had painted on the back of a picture by Reynolds in 1836, thus adding two pictures to the collection, of which only one can be displayed (now the Reynolds). Few other gifts were of major significance, but mention might be made of works by Nuvolone and Bellucci, a portrait now attributed to Claude Lefebvre, and the portrait of *James VI and I* attributed to De Critz, given by H. Yates Thompson in 1898. Yates Thompson was to become Chairman of the Picture Gallery Committee in 1908 and would play a decisive role in the history of the Gallery in the first decades of the twentieth century.

The absence of British art in the Desenfans–Bourgeois collection, while not absolute, was sufficiently noticeable to stir patriotic disapproval. While the Linley bequest had done much to plug the gap, the gallery owes its important representation of British painting largely to the benefaction of Charles Fairfax Murray.[16] Murray was a minor Pre-Raphaelite painter who became an extremely able collector and dealer. He was a friend of Yates Thompson, who persuaded him to give a group of forty pictures to the Gallery in 1911,[17] followed by others in 1915 and 1917–18. The Gallery owes substantially to Fairfax Murray its remarkably representative sequence of seventeenth- and eighteenth-century British portraits.

A Gallery whose walls were already crowded when it opened was now under even greater pressure, and additional space had to be found. The years immediately preceding the First World War saw, under Yates Thompson's chairmanship, the first major expansion of Soane's building. In the 1880s the almshouses had already been annexed to Gallery use, partly to house the Cartwright pictures, which until then had remained at the College. But now an entirely new suite of rooms was envisaged to the east. These galleries, with the exception of that at the north-east corner, were completed by 1915. The last was not added until 1937. In consequence almost the whole of the east façade of Soane's original building is now obscured by twentieth-century extensions. It is intended that these should be remodelled in the near future to correspond more faithfully to Soane's original intention.

The Gallery fared poorly in the Second World War. While most of the pictures had been evacuated to Wales, the building was partially destroyed by a bomb, which narrowly missed the south-east corner, in 1944. The damage was severe, but the decision was swiftly taken that the Gallery should be rebuilt. And while the process was delayed by difficulties in acquiring the necessary funds and building licences, a renovated and now fully air-conditioned Gallery was reopened to the public by the Queen Mother in 1953.

14 Charles Fairfax Murray, *Self-portrait*, 1880–4, pencil (Fitzwilliam Museum, Cambridge)

From an early stage, the Gallery also began to attract donors. The most important of these was William Linley, whose musical family had been friends and patrons to Gainsborough. In 1822 the Gallery received on loan the magnificent double portrait by Gainsborough of *The Linley Sisters*. This must have had much to do with the fact that their Linley brother, Ozias, was a junior fellow and organist at Dulwich College. In 1835, partially in fulfilment of the wishes of Ozias, William bequeathed to Dulwich a distinguished series of nine family portraits

16 On the career of Charles Fairfax Murray, see R. Barrington, 'Copyist, connoisseur, collector. Charles Fairfax Murray (1849–1919)', *Apollo*, November 1994, CXL, pp.15–20.

17 Listed in Appendix II.

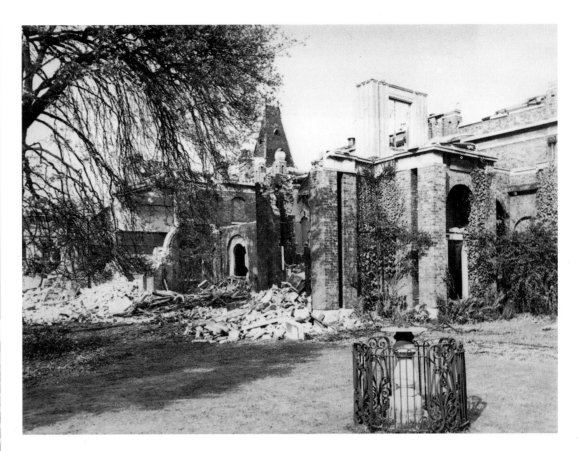

15 & 16 Dulwich Picture Gallery after July 1944
(Dulwich Picture Gallery Archive)

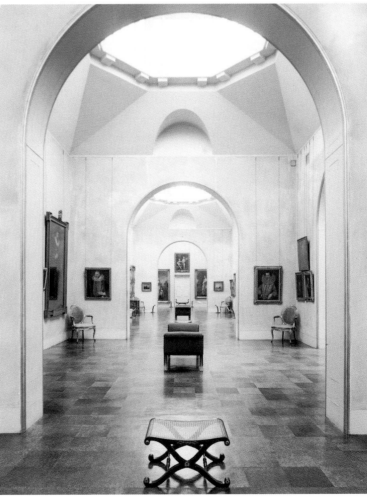

17 Interior of Dulwich
Picture Gallery, April
1953 (Dulwich Picture
Gallery Archive)

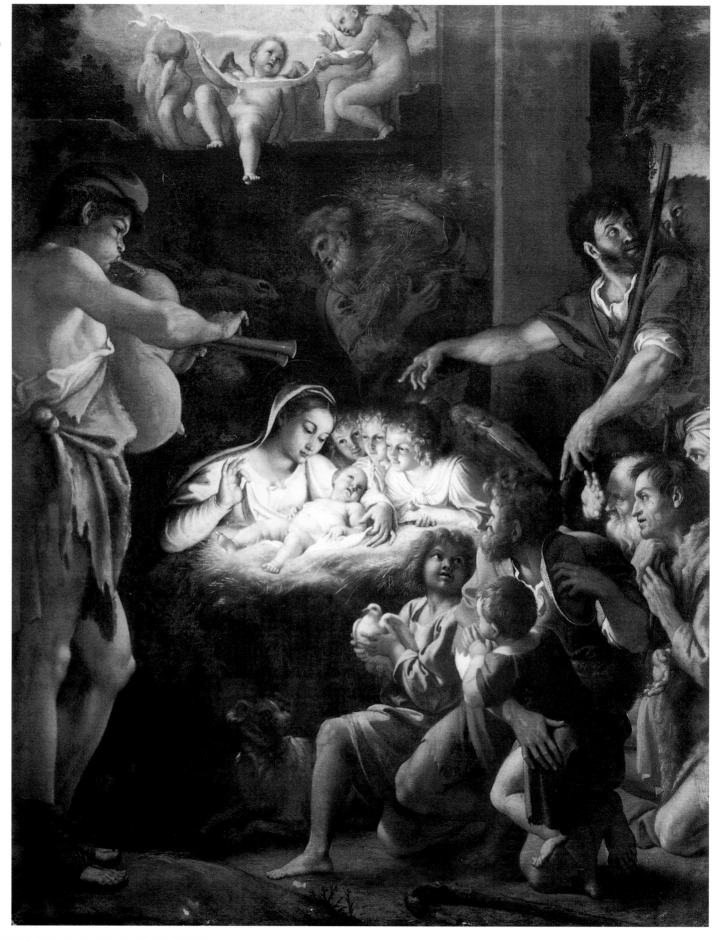

18 Domenichino,
*The Adoration of the
Shepherds* (National
Gallery of Scotland)

In accordance with the taste of the time, the Gallery was then entirely painted in grey distemper and the pictures on display – a fraction of the whole collection – were spaced out in a sparse, single-tier hang. Many of the pictures had been restored for the occasion by Dr Hell. The internal aspect of the galleries has since been changed by the introduction of artificial lighting in the 1970s and by redecoration and rehanging in 1980–1, which did much to recover the early-nineteenth century character of the Gallery. A complete renovation, however, is now long overdue and is planned in the near future.

Since the last War, the Gallery has suffered from the difficulties inherent in reconciling the increasingly stringent requirements of maintaining and providing access to the collection with the sums that a largely educational Foundation could consider providing for these purposes. The Gallery's funding problems reached a crisis in 1971, when the Governors decided to sell Domenichino's *Adoration of the Shepherds*, one of the most important pictures in Bourgeois's bequest. The picture now hangs in the National Gallery of Scotland, Edinburgh. Another crisis was reached in 1992 and the future of the Gallery was for a time in doubt, but was secured by the generosity of private benefactors.

The Gallery and its collections have since been ceded to a newly created independent charitable trust. The new Trustees, under the chairmanship of Lord Sainsbury of Preston Candover KG, have raised an endowment to ensure the Gallery's future. At the same time plans are well advanced to renovate Soane's building and to accommodate the services now expected of a public art gallery in a new annexe designed by the architect Rick Mather. There is every reason to hope that the Gallery will have been placed on a sound footing by the year 2000.

CATALOGUE

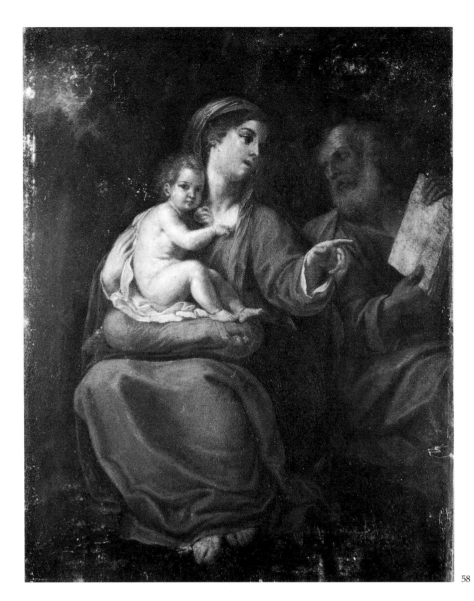

58

FRANCESCO ALBANI

Bologna 1578–1660 Bologna

Albani trained in Bologna with Denys Calvaert before entering the Carracci Academy *c.*1595 and studying there for four years with Lodovico Carracci (q.v.). In 1601 he moved to Rome, where he played a leading role in the studio of Annibale Carracci and also worked independently, before returning to Bologna in 1617. Apart from visits to Mantua in 1621–2 and to Rome in 1623–5, he remained based in Bologna. There he headed an active studio which produced quantities of small cabinet pictures, mostly depicting mythological subjects in idealised landscapes.

STUDIO OF ALBANI

58 Holy Family
Copper, 35.7 x 27.7 cm

DPG58 is a simplified version of an early work by Albani at Brocklesby Park of *c.*1609/10, of which a second version was formerly in the Orléans collection (engraved by Langlois). There are variants of the composition in the Museum of Fine Arts, Boston and at Tatton Park, Cheshire. From a photograph, Van Schaack judged DPG58 to be an autograph work of the mid-1640s, but it is catalogued by Puglisi as a workshop production.

Bourgeois bequest, 1811.

E. van Schaack, *Francesco Albani, 1578–1660*, diss., Columbia University, 1969, no.100; C.R. Puglisi, *Francesco Albani*, forthcoming, no.32.V.d.

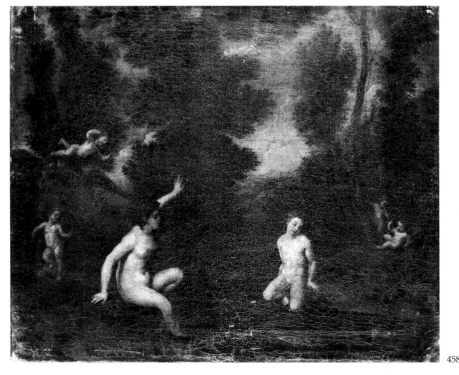

458

458 Salmacis and Hermaphroditus
Canvas, 60.6 x 74 cm

The story is from Ovid's *Metamorphoses* IV. Spying on Hermaphroditus as he bathes, the nymph Salmacis is consumed with passion; later she captures him in her embrace and their bodies become one – half-male, half-female. DPG458 is one of a number of studio variants based on an original by Albani in the Louvre and is especially close to an example in the Galleria Sabauda, Turin.

Bourgeois bequest, 1811.

Van Schaack, no.101 (as shop version); Puglisi, no.59.V.d (as workshop).

FOLLOWER OF ALBANI

259 Madonna
Canvas, 65.7 x 48.9 cm

DPG259 was inventoried in 1813 as Sacchi and is probably the 'fine female head by Carlo Maratti' admired by Hazlitt. The picture has been catalogued since 1880 as 'School of Albani'. C. Puglisi (correspondence on file, 1997) suggests that the style is closer to Maratti.

Bourgeois bequest, 1811.

CRISTOFANO ALLORI
Florence 1577–1621 Florence

AFTER ALLORI
267 Judith
Copper, 30.5 x 24.2 cm

The Jewish heroine Judith holds the head of the enemy Assyrian commander, Holofernes, whom she decapitated in his drunken sleep (Apocryphal Book of Judith XIII, 8). DPG267 is one of numerous copies after Allori's celebrated image, in which the head of Holofernes is reputedly a self-portrait and the figure of Judith a portrait of 'La Mazzafirra', for whom the artist developed an unreciprocated passion. The original was repeated in several versions, of which that in the Uffizi, Florence, seems to be the source for DPG267.

Bourgeois bequest, 1811.

HEINRICH VON ANGELI
Sopron 1840–1925 Vienna

AFTER ANGELI
550 Queen Victoria
Canvas, 121.9 x 99 cm

Lost. A half-length copy, according to the 1914 Dulwich catalogue, from the full-length by Angeli at Windsor.

Gift of subscribers, 1901.

JOSÉ ANTOLÍNEZ
Madrid 1635–1675 Madrid

Antolínez served his apprenticeship with Julián González de Benavides and then joined the studio of Francisco Rizi. He worked in Madrid, where he became a leading painter of religious subjects, especially the Immaculate Conception. He also painted portraits and occasional genre and mythological subjects.

69 The Crucifixion of Saint Peter
Dated, bottom right: *1660*
Canvas 110.5 x 83.8 cm

Saint Peter was crucified during the persecutions of Nero. He asked to be crucified head-down, being unworthy to suffer in the same manner as Christ. DPG69 is an early and relatively immature work.

Bourgeois bequest, 1811.

D. Angulo Iñiguez, *José Antolínez*, Madrid, 1957, pp.28, 41, pls.34–5.

259

267

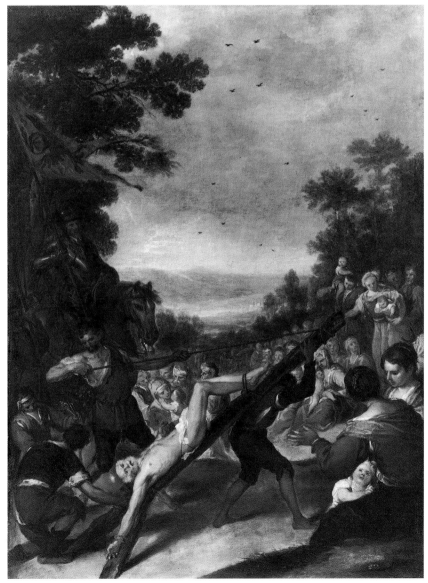

69

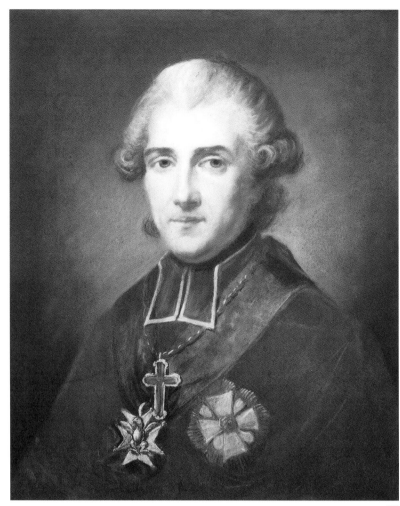

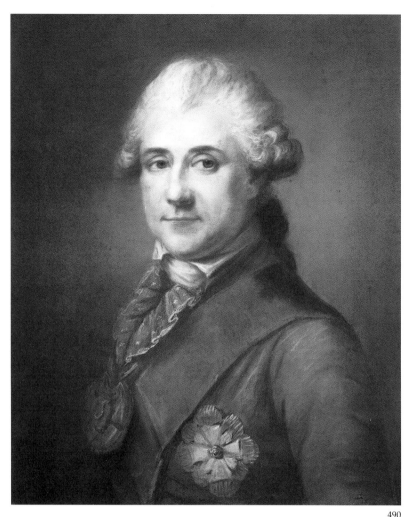

489

490

MOUSSA AYOUB

Active 1903–1938

A portrait and genre painter, Ayoub exhibited at the Royal Academy, 1906–34.

See After REYNOLDS DPG627

MARCELLO BACCIARELLI

Rome 1731–1818 Warsaw

AFTER BACCIARELLI

489 Michał Poniatowski, Prince Primate of Poland
　　Pastel on paper, mounted on canvas 60.9 x 50.6 cm

Michał Jerzy Poniatowski (1736–94): brother of Stanisłas Augustus of Poland (see DPG490 below); Bishop of Płock, 1773; Primate of Poland, 1784. On a visit to London in 1790 he met Noel Desenfans (see Northcote DPG28) whom he recommended for a commission to acquire pictures for the Polish Royal collection. DPG489 is doubtless a copy, perhaps like DPG490 below from an original by Bacciarelli. A comparable portrait by Bacciarelli (though it is not the source for DPG489) is in the National Museum, Warsaw.

Bourgeois bequest, 1811.

490 Stanisław II Augustus, King of Poland
　　Pastel on paper, mounted on canvas 60.9 x 50.8 cm

Stanisław Antoni Poniatowski (1732–98); elected Stanisław II Augustus, King of Poland, 1764; abdicated on the partition of Poland, 1795. An important part of the collection now at Dulwich was acquired by Noel Desenfans on his behalf, but remained undelivered at the time of his abdication. DPG490 is a half-length copy from Bacciarelli's three-quarter-length portrait in the National Museum, Kraków (R. Fournier-Sarlovèze, *Les peintres de Stanislas-Auguste II, Roi de Pologne*, Paris, 1907, pp.14–15, illus.).

Bourgeois bequest, 1811.

SISTO BADALOCCHIO

Parma 1585–after 1619 Parma or Rome?

Badalocchio probably studied at the Carracci Academy in Bologna before becoming a pupil of Agostino Carracci in Parma, 1600–2. He was then sent by the Duke of Parma to Rome to complete his training in the studio of Annibale Carracci, after whose death in 1609 he returned to Parma. He undertook a fresco commission in Reggio Emilia in 1613 and visited Rome in 1619, and possibly again shortly afterwards. He was otherwise active in Parma. Badalocchio's style was based on that of Annibale, modified by the influence of Correggio.

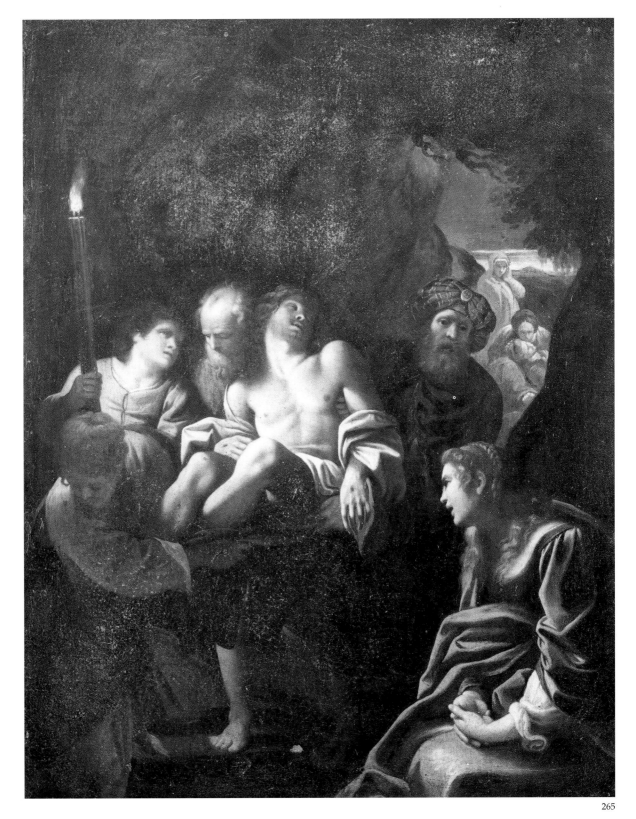

265

265 Christ carried to the Tomb
Canvas, 47.6 x 38.4 cm

The composition probably derives from a painting by Annibale Carracci commissioned in 1595 by a member of the Sampieri family of Bologna. The attribution to Badalocchio was proposed by Brugnoli and is accepted by Van Tuyll van Serooskerken, who suggests a date of *c*.1607. Several other versions are known, though their attribution remains problematic. A comparable composition is also known in a number of versions, of which one is in the National Gallery, London.

Bourgeois bequest, 1811.

M.V. Brugnoli, 'Note alla Mostra dei Carracci', *Bolletino d'Arte*, XLI, 1956, p.359; C. van Tuyll van Serooskerken, 'Badalocchio's "Entombment of Christ" from Reggio: a new document and some related paintings', *The Burlington Magazine*, CXXII, 1980, pp.182, 185 and n.34.

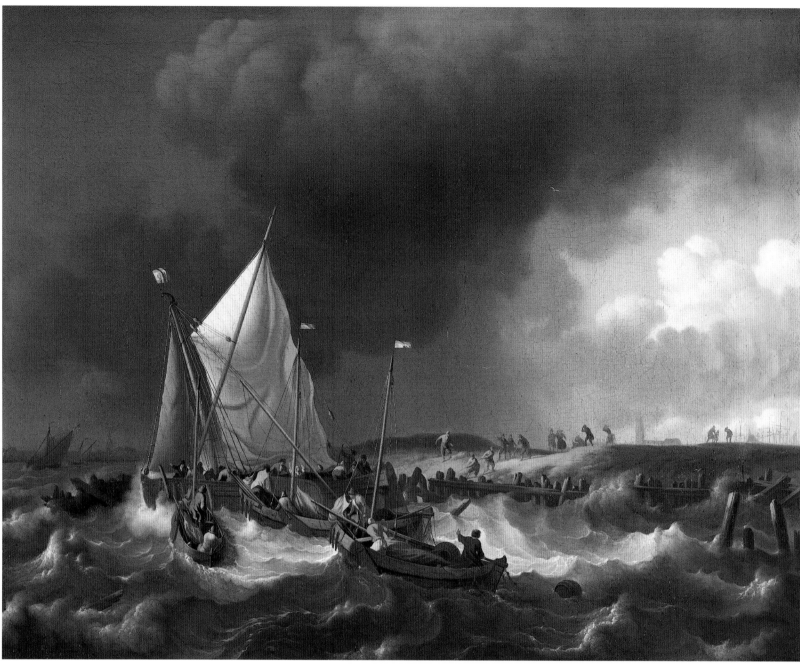

327

LUDOLF BAKHUIZEN

Emden? 1630/1–1708 Amsterdam

Bakhuizen first trained as a clerk in Emden before moving to Amsterdam, *c.*1650. He worked as a calligrapher and draughtsman, but also learned painting from Allart van Everdingen and Hendrik Dubbels. Bakhuizen was later influenced by Willem van de Velde the younger (q.v.), after whose departure for England in 1672 he became the leading marine painter in the Netherlands.

327 Boats in a Storm

Signed, on side of boat, lower left: *L.BAKHUZYN*
and dated on floating plank, bottom left: *1696*
Canvas, 63 x 79 cm

Bourgeois bequest, 1811.

HdG235; D. Cordingly in *Collection for a King*, no.1 and *Kolekcja dla Króla*, no.1.

409

289

FEDERICO BAROCCI

Urbino *c.*1532–1612 Urbino

AFTER BAROCCI

409 Holy Family
Oak panel, 57.2 x 43.8 cm

A crude copy (perhaps English) of Barocci's *Madonna del Gatto* in the National Gallery, London. The composition is reversed and therefore probably taken from the engraving by C. Cort of 1577.

Cartwright bequest, 1686.

N. Kalinsky in *Mr Cartwright's Pictures*, no. 43.

FRA BARTOLOMMEO

Florence 1472–1517 Florence

FOLLOWER OF FRA BARTOLOMMEO

289 Holy Family with Saint John
Poplar panel, 83 x 67.3 cm

Richter's attribution to Giuliano Bugiardini is rejected by Pagnotta, who regards DPG289 as a work of *c.*1515–20 by an artist from the school of Fra Bartolommeo, perhaps Fra Paolino.

Bourgeois bequest, 1811.

L. Pagnotta, *Giuliano Bugiardini*, Turin, 1987, no. 103.

386

398

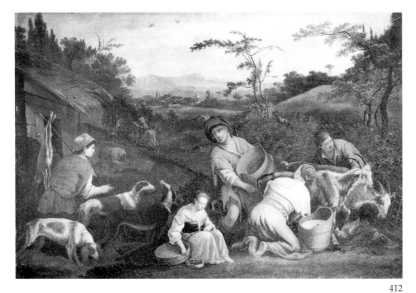

412

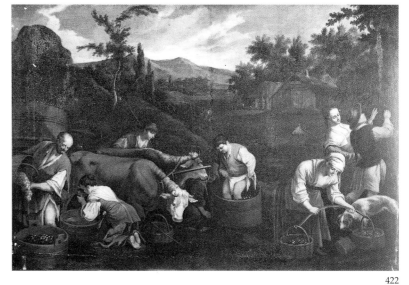

422

FRANCESCO BASSANO

Bassano 1549–1592 Bassano

AFTER BASSANO

386 Summer

Canvas, 98.7 x 147.7 cm

With DPG398, DPG412 and DPG422 below, one of a series which derives ultimately from a set of Seasons painted by Jacopo and Francesco Bassano in 1577. The originals of *Summer* and *Autumn* are in the Kunsthistorisches Museum, Vienna. *Spring* and *Winter* are lost, but known in replicas by Francesco, also in Vienna. The Dulwich copies are probably taken from one of the many series of replicas produced by Francesco and his studio, which omit the small biblical scenes in the backgrounds of the originals. Murray suggested that they might be the work of A. Colonia (q.v.), who is said to have made copies after Bassano, but they do not seem stylistically compatible with his work (cf. Colonia DPG371).

Cartwright bequest, 1686.

N. Kalinsky in *Mr Cartwright's Pictures*, no.61.

398 Winter

Canvas, 99.1 x 148.3 cm

See DPG386 above.

Cartwright bequest, 1686.

N. Kalinsky in *Mr Cartwright's Pictures*, no.63.

412 Spring

Canvas, 99 x 148.7 cm

See DPG386 above.

Cartwright bequest, 1686.

N. Kalinsky in *Mr Cartwright's Pictures*, no.60.

422 Autumn

Canvas, 99.1 x 148.6 cm

See DPG386 above.

Cartwright bequest, 1686.

N. Kalinsky in *Mr Cartwright's Pictures*, no.62.

THOMAS BEACH

Milton Abbas (Dorset) 1738–1806 Dorchester

Beach studied at the St Martin's Lane Academy and with Reynolds 1760–2 before settling in Bath, where he set himself up as a portrait painter. He exhibited at the Society of Artists 1772–83 (becoming vice-president 1782 and president 1783) and at the RA 1785–90 and 1797. Shortly after 1800 he seems to have given up painting, spending the remainder of his life in Dorchester.

591 Portrait of a Man

Signed and dated, bottom left: *T Beach / 1785*
Canvas, 76.5 x 63.5 cm

Fairfax Murray gift, 1911.

E.S. Beach, *Thomas Beach, a Dorset Portrait Painter*, London, 1934, no.97.

MARY BEALE

Barrow (Suffolk) 1633–1699 London

Mary Beale was probably first taught by her father, an amateur painter. In 1652 she married Charles Beale, with whom she lived at Walton until *c*.1654, when the couple moved to London. She possibly received tuition at this time from Richard Walker and by 1658 had acquired some reputation as a painter. After a period at Albrook (Hampshire), 1665–70, she established a busy portrait practice in Pall Mall. She was a friend of Lely (q.v.), whose then dominant style was the major influence on her work.

574 Portrait of a Young Man, possibly one of the Painter's Sons
Signed or inscribed, bottom left: *Mary Beale*
Canvas, 76.5 x 63.8 cm

The sitter was formerly incorrectly identified as the poet Abraham Cowley (1618–67) but may be the painter's elder son, Bartholomew Beale (1656–1709), who appears at the age of about ten in Beale's *Self-Portrait* in the National Portrait Gallery and has plausibly been recognised in other portraits by her (National Portrait Gallery, no.659; Althorp; Rugby School; see also Lely DPG563). Walsh and Jeffree suggest a date of *c*.1685.

Fairfax Murray gift, 1911.

E. Walsh and R. Jeffree, *The Excellent Mrs Mary Beale*, cat. exh. Geffrye Museum, London/ Towner Art Gallery, Eastbourne, 1975–6, p.69, no.21.

ATTRIBUTED TO BEALE

611 Portrait of a Physician
Canvas, 75.9 x 63.5 cm

Catalogued by Murray as Attributed to John Baptist Closterman, but the association with Closterman is rejected by O. Millar and M. Rogers (as 'not probable'). An attribution to Beale has been suggested independently by B. Allen, K. Hearn and T. Barber (oral communications, 1997). The sitter holds an anatomical drawing and this has suggested an identification with the physician-poet Sir Richard Blackmore (d.1729), to whom he bears some resemblance (cf. *John Closterman*, cat. exh. National Portrait Gallery, 1981, no.13).

Bequest of H. Margaret Spanton, 1934.

574

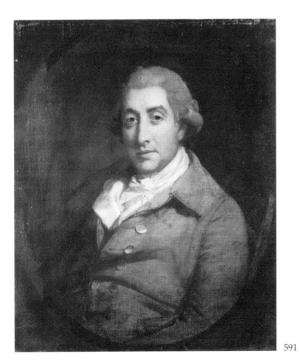

591

611

17

111

169

SIR WILLIAM BEECHEY

Burford 1753–1839 London

Beechey was a pupil of the RA Schools and is thought to
have received some training from Zoffany. Apart from
a period spent in Norwich (1782–7), he was based in
London. He exhibited at the RA 1776–1839 and in 1793
was elected ARA and appointed portrait painter to
Queen Charlotte. In 1798 Beechey became an RA and
received his knighthood. He was later principal portrait
painter to William IV. Besides portraits, he painted a
few landscapes and fancy pictures, a number of which
were exhibited at the British Institution in 1806–36.

17 Sir Peter Francis Bourgeois
Mahogany (?) panel, 74.9 x 62.2 cm

For the sitter, who was a friend of the artist, see
Bourgeois below; he is shown wearing the Polish
Order of Merit awarded to him by Stanisław Augustus
in 1791 (which is preserved at Dulwich). DPG17 was
painted, probably c.1810, on the back of a work by
Reynolds (see Reynolds DPG17A). Other versions by
Beechey are in the National Portrait Gallery and Sir
John Soane's Museum. It is not certain which versions
were those exhibited at the RA in 1813 and the Society
of British Artists in 1830. For copies, see Bourgeois
DPG465 and DPG466.

Gift of the artist, 1836.

W. Roberts, *Sir William Beechey*, London, 1907, pp.125–6.

111 John Philip Kemble
Canvas, 76.8 x 64.1 cm

John Philip Kemble (1757–1823): brother of Charles
Kemble (see Briggs DPG291) and Mrs Siddons (see
Reynolds DPG318); celebrated tragic actor; manager
at Covent Garden, 1803–17; friend of Desenfans and
Bourgeois; reputedly responsible for suggesting
Dulwich as a suitable home for the Bourgeois
collection. DPG111 was commissioned by Desenfans in
1798 or shortly before and was exhibited at the RA in
the following year. A version is in the Garrick Club.

Bourgeois bequest, 1811.

Roberts, pp.66–7.

169 Charles Small Pybus
Canvas, 77.7 x 64.8 cm

Charles Small Pybus (1766–1810): MP for Dover from
1790; Lord of the Admiralty 1791–7 and of the Treasury
1797–1803; more noted for his pomposity and ambition
than for any achievement. Beechey remarked on his
irritable temper and said that 'he was very vain of His
knowledge of pictures, but in reality knew nothing abt.
them' (*The Diary of Joseph Farington*, XI, New Haven
and London, 1983, p.3882). He was a friend and
business partner of Desenfans.

Bourgeois bequest, 1811.

Roberts, p.83n.

ANTONIO BELLUCCI

Venice 1654–1726 Pieve di Soligo

Bellucci is said to have studied drawing with a
nobleman, Domenico Difnico, in Dalmatia, but his style
was formed in Venice, where he was influenced by
Pietro Liberi, Andrea Celesti and Antonio Zanchi. In
1692 he undertook four altarpieces for Klosterneuburg
in Austria and for much of the next thirty years he
worked abroad: in Vienna, 1695–1700 and 1702;
at Düsseldorf, 1705–16; and in England, 1716–22.
His work for the Duke of Chandos at Canons Park
included the decoration of a chapel which has since
been moved to Great Witley church, Worcestershire.

46 Saint Sebastian tended by Irene
Canvas, 144.7 x 134.3 cm

Surviving his arrow wounds (see Reni DPG268), Saint
Sebastian is tended by Irene, widow of Saint Castulus,
who had come to bury him but found him still alive.
He is supported by an allegorical figure with a cross
and chalice, representing Faith. Magani proposes a
date of 1716/18. An earlier version of the same subject
by Bellucci is in the Hermitage, St Petersburg.

Gift of Rev. T.B. Murray, 1852.

F. Magani, *Antonio Bellucci, Catalogo Ragionato*, Rimini, 1995,
no.82.

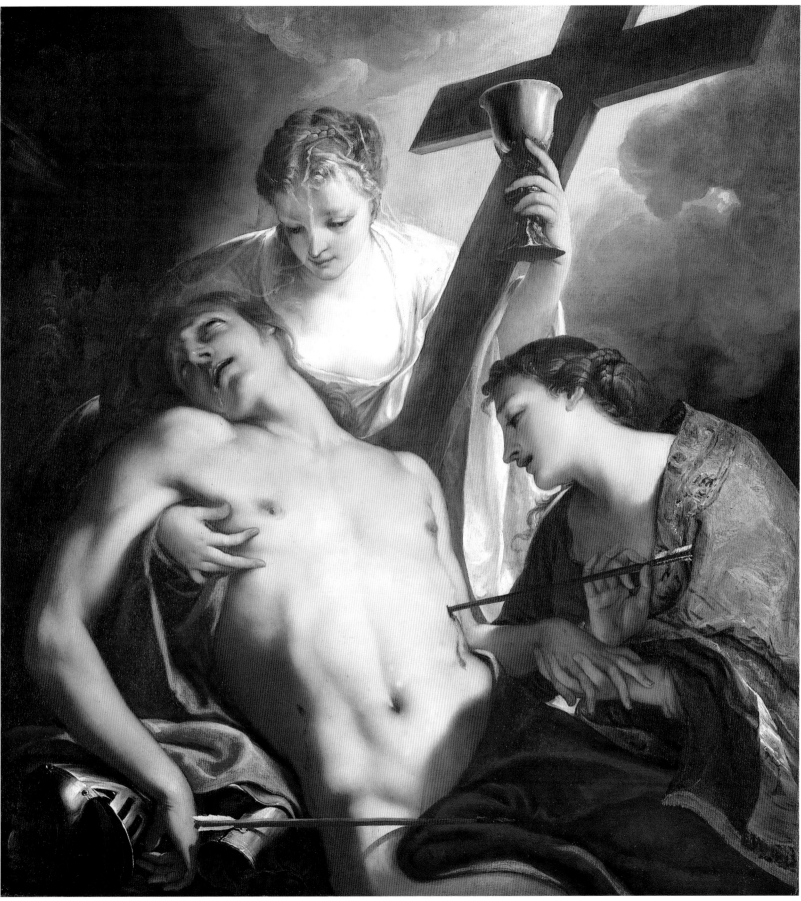

46

NICOLAES BERCHEM

Haarlem 1620–1683 Amsterdam

Berchem first trained with his father, the still-life painter Pieter Claesz., and thereafter, according to Houbraken, with Jan van Goyen, Claes Moeyaert, Pieter de Grebber, Jan Wils and Jan Baptist Weenix (though the last was his junior). He entered the Haarlem guild in 1642. He was travelling with Ruisdael (q.v.) near the German border c.1650, and probably made a trip to Italy c.1653. By 1656 he was back in Haarlem and by 1677 he had settled in Amsterdam. Berchem painted Mediterranean port scenes and some history and genre subjects, but is best known as a painter of Italianate landscapes. He also made a number of etchings.

88 A Farrier and Peasants

Signed, bottom right: *Berchem. F.*

Canvas, 67.3 x 81.3 cm, including a made-up strip of 1.2 cm at the left edge

Probably painted in the late 1650s or early 1660s.

Bourgeois bequest, 1811.

HdG174; E. Schaar, *Studien zu Nicolaes Berchem*, Cologne, 1958, p.85; R. Beresford in *Conserving Old Masters*, no.10.

122 A Road through a Wood

Signed, bottom right: *CBerrighem* (CB in monogram)

Canvas, 119.5 x 89.6 cm

The form of the signature indicates an early date – probably, as implied by Schaar, in the late 1640s.

Bourgeois bequest, 1811.

HdG345; Schaar, p.38 n.34.

122

157

196

157 Travelling Peasants *(Le Soir)*
 Signed, bottom left: *Berchem f*
 Oak panel, 34.4 x 45.6 cm

Probably painted in the mid- to late 1650s. See also DPG166 below.

Bourgeois bequest, 1811.

HdG380.

166 Roman Fountain with Cattle and Figures *(Le Midi)*
 Signed, bottom left: *Berchem.*
 Oak panel, 36.8 x 48.4 cm

Associated by Schaar with works datable *c.*1645/6. DPG157 and DPG166 have been paired at least since 1769, when both appeared in the Gaignat sale, Paris, but were clearly not painted as a pair since they differ in size and date.

Bourgeois bequest, 1811.

HdG192; Schaar, p.20.

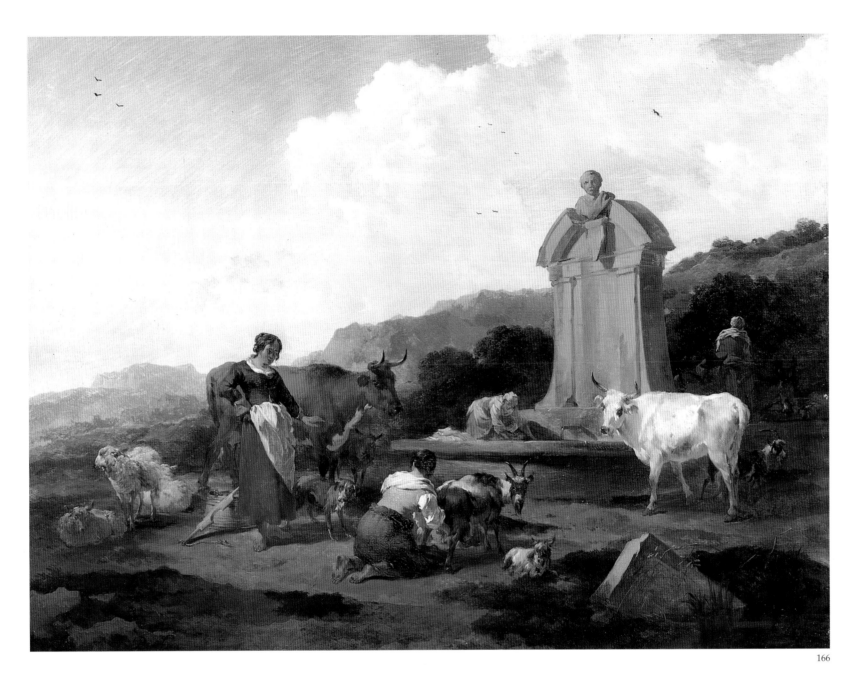

166

196 Peasants at a Ford

Signed, lower left: *B*[…]
Oak panel, 44 x 55 cm

Probably an early work. A signature, *Berchem f*, was recorded by Richter in 1880, but only a B (or cB in monogram) is now visible.

Bourgeois bequest, 1811.

HdG381.

FOLLOWER OF BERCHEM

337 Washerwomen

Signed or inscribed, bottom right *B*[…] (?)
Oak panel, 36.8 x 43.8 cm

Early catalogues record the signature *Berchem*, but only the upper part of a B (or D) is now visible.

Bourgeois bequest, 1811.

HdG288 (as Berchem).

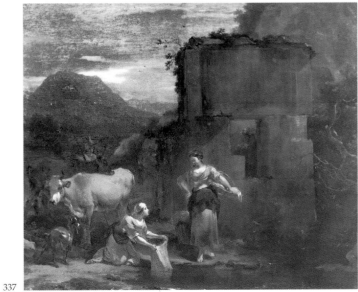

337

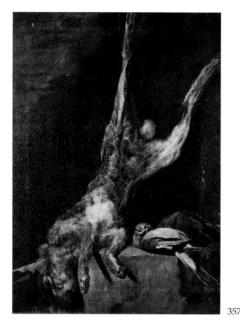

357

PIETER BOEL

Antwerp 1622–1674 Paris

Boel trained first with his father, an engraver and publisher, and then probably with Jan Fyt. He spent some years in Italy, visiting Genoa and Rome, but was back in Antwerp by 1650, when he became a member of the painters' guild. After 1668 he moved to Paris, where he worked on designs for the Gobelins tapestry factory and in 1674 was appointed *peintre du roi*. Boel was a painter of hunting scenes and game pieces.

357 Dead Game

Canvas, 82.2 x 60.6 cm

An attribution to Jan Fyt has been proposed, but DPG357 seems closer to Boel, as suggested by F. Meijer.

Cartwright bequest, 1686.

N. Kalinsky in *Mr Cartwright's Pictures*, no.75.

594 Head of a Hound

Canvas, 27.8 x 35.2 cm

The attribution was suggested by F. Meijer. DPG594 in fact appears to be a study used by Boel for his *Boar Hunt* at the Schloss in Mosigkau (photo Witt Library).

Bequest of Lady Colin Campbell in memory of her father Edmond Maghlin Blood, 1912.

CORNELIS BOL

Antwerp 1589–1666 Haarlem

Bol's biography is confused by the existence of at least one other artist of the same name. The author of DPG360 is probably the Cornelis Bol born in Antwerp in 1589 who was a pupil there of Tobias Verhaecht. He became a master in the Antwerp guild in 1615 and may be the artist of this name recorded in Haarlem in 1652. Bol's presence in London is documented in 1636 and again in 1639.

594

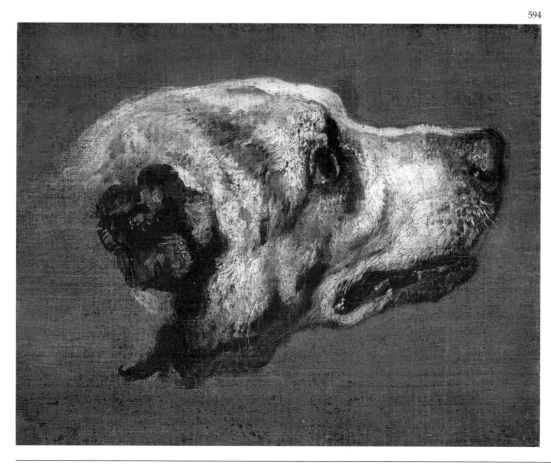

360 Westminster and the Thames

Signed, bottom right: ·CB·
Canvas, 63.5 x 108.7 cm

On the right is Old Somerset House, shown before Webb's alterations to the river façade of 1662; on the far left is Lambeth Palace; on the skyline appear (left to right) Westminster Hall, Westminster Abbey, the Banqueting House and Old Northumberland House, with its four turrets. DPG360 is a version of one of a set of Thames views painted by Bol for the diarist John Evelyn (private collection).

Probably Cartwright bequest, 1686.

R.T. Jeffree in *Mr Cartwright's Pictures*, no.66.

CARLO BONAVIA

Active 1755–died after 1787

Virtually nothing is known of Bonavia's life. He was a painter of landscapes and coast scenes, active in Naples in the mid-eighteenth century, and seems to have been influenced by Vernet (q.v.).

303 Landscape with Aqueduct

Canvas, 46.6 x 34.9 cm

Pair to DPG305. The attribution to Bonavia was first proposed by G. Aigranti (note on file, 1992).

Bourgeois bequest, 1811.

305 Castle and Waterfall

Canvas, 46.6 x 34.9 cm

See DPG303 above.

Bourgeois bequest, 1811.

ANTHONIE VAN BORSSUM

Amsterdam 1630/1–1677 Amsterdam

Van Borssum may have been a pupil of Rembrandt, c.1645–50. He worked in Amsterdam, where he was chiefly a painter of landscapes with cattle, in the manner of Paulus Potter, but also produced moonlit landscapes in the manner of Aert van der Neer. He was a talented landscape draughtsman and also made a few etchings.

133 Landscape with Cattle

Canvas, 112.7 x 154.9 cm

Cleaning (presumably that of 1949–55) revealed two cows between that in the centre and the dog on the right. These are severely abraded and had previously been repainted (possibly by Bourgeois) with a continuation of the landscape. A figure in the landscape on the right has also been painted out. A signed version is in the Städtische Kunst- und Gemäldesammlung, Bamberg.

Bourgeois bequest, 1811.

Sumowski, I, p.429, under no.199.

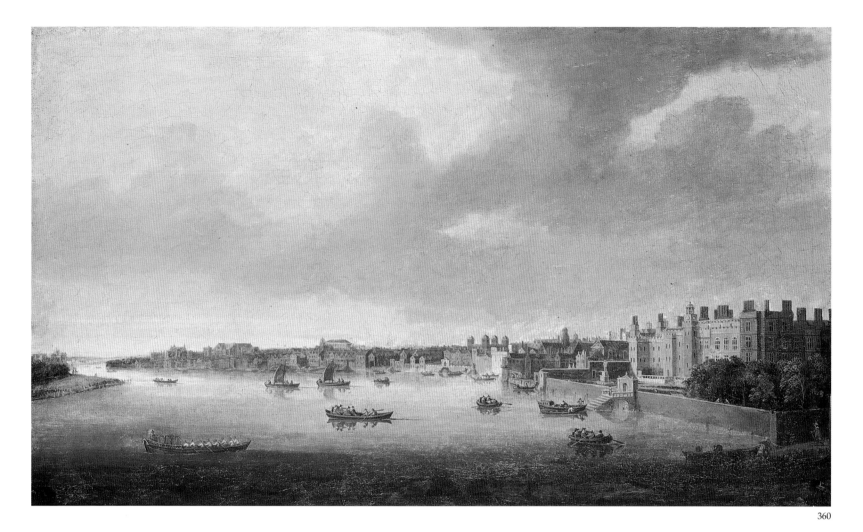

360

133

303

305

15

JAN BOTH

Utrecht? *c.*1615–1652 Utrecht

Both is said to have trained with his father, a glass painter, and with Abraham Bloemaert. He travelled to Rome, probably in 1637/8, where he painted street scenes influenced by Pieter van Laer ('Bamboccio') and idealised landscapes inspired by the works of Swanevelt and Claude (qq.v.). He returned to Utrecht in 1642 and was *overman* in the Utrecht painters' college in 1649. Both's Italianate landscape style was to have an important influence on artists such as Berchem, Cuyp and Pynacker (qq.v.). He also made numerous etchings.

15 Road by the Edge of a Lake
Oak panel, 44.1 x 39.4 cm

From Both's Roman period, according to Burke.

Bourgeois bequest, 1811.

HdG142; J.D. Burke, *Jan Both (ca.1618–1652), Paintings, Drawings and Prints*, New York/London, 1976, no.63.

208

8

208 A Mountain Path
> Signed, lower centre left: *JBoth . f* (JB in monogram)
> Canvas, 70.8 x 111.4 cm

Dated by Burke in the second half of the 1640s. A related drawing is in the Welcker collection, Leiden.

Bourgeois bequest, 1811.

HdG235; Burke, no.64; C. Brown in *Kolekcja dla Króla*, no.2.

ATTRIBUTED TO BOTH

8 Italian Landscape
> Signed or inscribed on rock, lower centre right: *JB* (in monogram)
> Canvas, 54 x 64.8 cm

Accepted by Burke as a damaged original, probably from Both's Roman period. Two other versions are known (sold Van Marle and Bignell, The Hague, 21 May 1963, lot 73; and sold Christie's, London, 11 December 1986, lot 110).

Bourgeois bequest, 1811.

HdG141 (as Both); Burke, no.60.

10

10 Italian Landscape with an Ox-Cart
Canvas, 49.1 x 40.8 cm

A copy of Both's original in the Galleria Corsini, Rome (HdG132); possibly, according to Burke, a replica painted by Both himself.

Bourgeois bequest, 1811.

HdG131 (as Both); Burke, no.61.

12 Banks of a Brook
Canvas, 55.2 x 68.9 cm

A copy of Both's original in the Koninklijk Museum voor Schone Kunsten, Antwerp (HdG115); possibly, according to Burke, a replica painted by Both himself c.1641/5.

Bourgeois bequest, 1811.

HdG234 (as Both); Burke, no.62.

12

SÉBASTIEN BOURDON
Montpellier 1616–1671 Paris

Bourdon trained as a painter in Paris and spent some time as a soldier before making a trip to Rome in 1634, where he was influenced by Pieter van Laer and his followers (the Bamboccianti). In 1637 he returned to Paris via Venice. Bourdon's work is stylistically diverse and in the 1640s he came under the influence of Poussin (q.v.). He was a founder member of the French Académie in 1648 and worked at the court of Queen Christina in Sweden (1652–4) and in Montpellier (1656–7) before settling again in Paris. In addition to painting genre and history subjects, Bourdon was a talented portrait artist.

557 A Brawl in a Guard-room
Canvas, 74.9 x 60.6 cm

One of the genre subjects painted by Bourdon in the manner of Van Laer. DPG557 compares with *Soldiers playing Cards outside their Tent* in the Gemäldegalerie, Kassel, dated 1643, and presumably dates from the same period.

Fairfax Murray gift, 1911.

G. Briganti, L. Trezzani, and L. Laureati, *The Bamboccianti: The Painters of Everyday Life in Seventeenth Century Rome*, Rome, 1983, p.240; C. Wright in *Collection for a King*, no.2 and *Kolekcja dla Króla*, no.3.

557

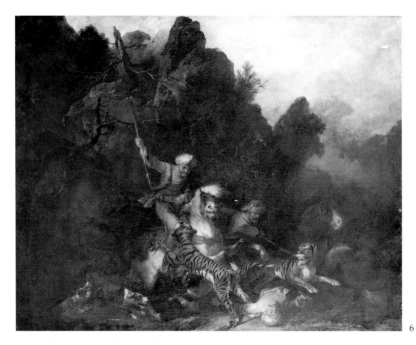

6

100

135

SIR PETER FRANCIS BOURGEOIS

London 1756–1811 London

The son of a Swiss watchmaker established in London, Bourgeois became a protégé of Noel Desenfans (see Northcote DPG28), who encouraged him to take up painting. After training with De Loutherbourg (q.v.), he completed his studies with a trip through Italy, France and Holland. On his return to London he began exhibiting at the RA in 1779 and was elected ARA in 1787 and RA in 1793. He was appointed painter to King Stanisław Augustus of Poland, who awarded him the Order of Merit in 1791. George III allowed him the rank of Knight. In 1807 Bourgeois inherited the collection of Noel Desenfans which, after making additions of his own, he bequeathed to Dulwich College.

6 Tiger Hunt
 Canvas, 114.3 x 142.2 cm

Probably the *Hunting of the Royal Tiger* exhibited at the RA in 1787.

Bourgeois bequest, 1811.

D. Agassiz, 'Sir Francis Bourgeois, 1756–1811, Un paysagiste suisse à la cour du roi George III d'Angleterre', *Revue Historique Vaudoise*, May–June, 1937, p.22.

100 Cupid
 Canvas, 60.6 x 81.9 cm

Bourgeois bequest, 1811.

Agassiz, p.21.

135 Landscape with Cattle
 Inscribed, lower left: *A C*[…p?]
 Canvas, 79.4 x 107.9 cm

The picture seems to have been hung in the early-nineteenth century as a work by Cuyp (Anon. [P.G. Patmore], *Beauties of Dulwich Picture Gallery*, 1824, p.19, no.38).

Bourgeois bequest, 1811.

Agassiz, p.21; L. Herrmann, *British Landscape Painting of the Eighteenth Century*, London, 1973, p.116.

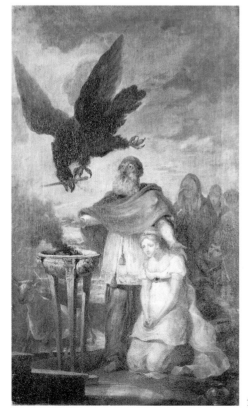

149

149 Helena brought before the Altar to be sacrificed
Canvas, 102.6 x 60.9 cm

Helen is to be sacrificed to save the city of Lacedemon from plague, but an eagle snatches the knife and drops it on a heifer, which is sacrificed in her stead. Bourgeois's source was J. Bell, *New Pantheon*, 1790, p.376. DPG149 was exhibited at the RA in 1805.

Bourgeois bequest, 1811.

Agassiz, p.21.

294 Landscape with Cattle
Canvas, 91.7 x 145.1 cm

Bourgeois bequest, 1811.

Agassiz, p.21; G.A. Waterfield, 'That White-faced Man: Sir Francis Bourgeois', *Turner Studies*, 1989, 9, p.45.

301 Funeral Procession of a White Friar
Canvas, 131.5 x 206.1 cm

Commissioned for the Polish Royal collection. Exhibited at the RA, 1793.

Bourgeois bequest, 1811.

Agassiz, p.21; Waterfield, pp.42–4.

308 Seashore
Canvas, 91.7 x 146.7 cm

Bourgeois bequest, 1811.

Agassiz, p.22.

310 Friar in Prayer
Mahogany panel, 16.5 x 12 cm (arched top)

Bourgeois bequest, 1811.

Agassiz, p.21.

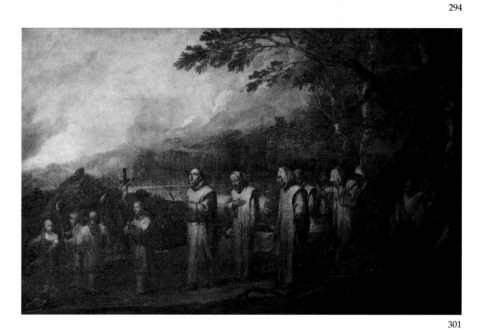

294

301

308

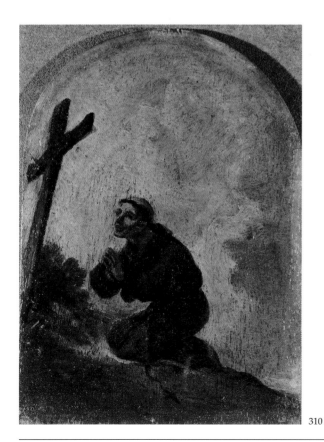

310

311

325

335

342

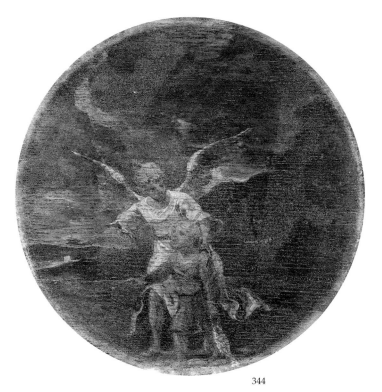

344

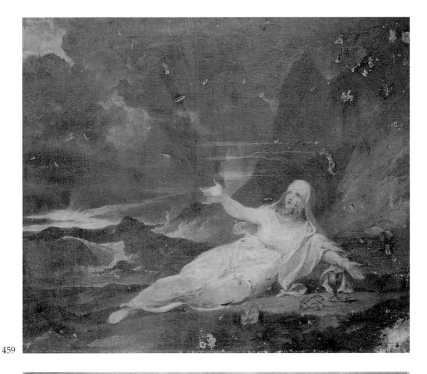

459

460

461

311 Soldiers

Mahogany panel, 16.5 x 12 cm
(arched top)

Bourgeois bequest, 1811.

325 Landscape with Cattle

Canvas, 101.9 x 127.5 cm

Bourgeois bequest, 1811.

Agassiz, p.21; Herrmann, p.116;
Waterfield, p.45.

335 Seashore

Canvas, 101 x 106.3 cm

Bourgeois bequest, 1811.

Agassiz, p.22.

342 A Man holding a Horse

Canvas on panel, 21 x 15.8 cm

Bourgeois bequest, 1811.

Agassiz, p.21.

344 Tobias and the Angel

Oak panel, 20.3 x 20.8 cm
(circular)

The subject is from the apocryphal
Book of Tobit: Tobit's son Tobias,
accompanied by the Archangel
Raphael, carries the fish that he will
use to cure his father's blindness.

Bourgeois bequest, 1811.

Agassiz, p.22.

459 'Religion in the Desert'

Canvas, 99 x 121.5 cm

Damaged, 1939/45. Inventoried in
1813 as 'Female, laying on the sea
shore. Stormy sky', but catalogued
since 1824 under the present title.

Bourgeois bequest, 1811.

Agassiz, p.21.

460 Landscape with Soldiers

Canvas, 63.8 x 75.8 cm

Bourgeois bequest, 1811.

Agassiz, p.21.

461 Figures in a Landscape

Canvas, 43.2 x 76.2 cm

Bourgeois bequest, 1811.

Agassiz, p.22.

462

463

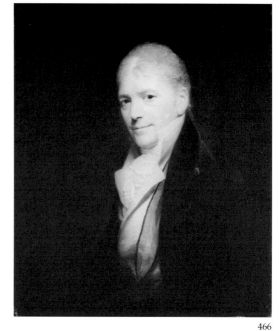

464

465

466

462 Landscape with Cattle
 Canvas, 42.9 x 53 cm

Bourgeois bequest, 1811.

Agassiz, p.21.

463 Cavalry in a Landscape
 Canvas, 40 x 67.9 cm

Possibly the *Detachment of Horse in the Costume of Charles I* exhibited at the RA 1810.

Bourgeois bequest, 1811.

Agassiz, p.22; Waterfield, p.44.

464 Self-portrait
 Canvas, 61 x 50.8 cm, including an addition
 of 4 cm at the top

Gift of the Executors of Sir Felix Agar, 1866.

Agassiz, p.21.

465 Sir Peter Francis Bourgeois (after Beechey)
 Canvas, 76.2 x 60.9

Damaged 1939/45. A copy of Beechey's portrait (DPG17).

Presumably Bourgeois bequest, 1811 (but not inventoried in 1813).

Agassiz, p.21 (or DPG466).

466 Sir Peter Francis Bourgeois (after Beechey)
 Canvas, 76.5 x 64.1 cm

Another copy of Beechey's portrait (DPG17).

Presumably Bourgeois bequest, 1811 (but not inventoried in 1813).

Agassiz, p.21 (or DPG465).

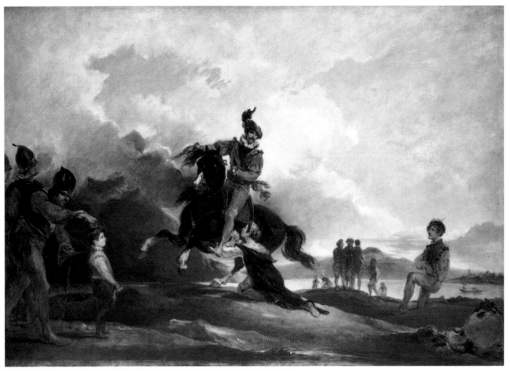

467

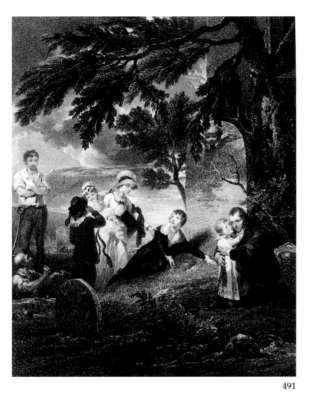

491

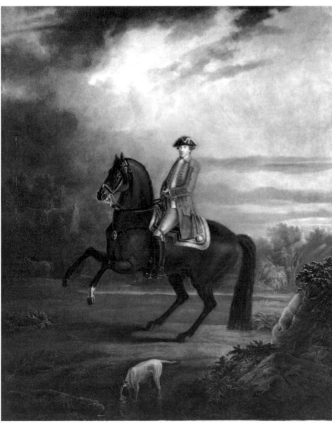

488

467 William Tell
Canvas, 76.8 x 110.2 cm

William Tell, the champion of Swiss liberty, is forced
by the Imperial governor Gesler to shoot an apple
balanced on his son's head at one hundred paces.
The supplicant female is presumably intended to
represent the boy's mother, who does not generally
feature in the legend.

Bourgeois bequest, 1811.

Agassiz, p.21.

491 Children at their Mother's Grave
Canvas, 142.2 x 114.3 cm

Destroyed 1939/45. Exhibited at the RA 1794 and
engraved by John Ogbourne (see illustration).

Purchased by Dulwich College, 1889.

Agassiz, p.21; Waterfield, p.44.

ASCRIBED TO BOURGEOIS

488 A Man on Horseback, called
Noel Desenfans
Canvas, 119.7 x 101 cm

DPG488 is the only picture in the collection that
could conceivably be identified with no.273 in the
1813 inventory ('Desenfans up on Horse' by
Bourgeois). The attribution to Bourgeois, however,
seems impossible and the identity of the sitter
indeterminate.

Bourgeois bequest, 1811 (?).

621

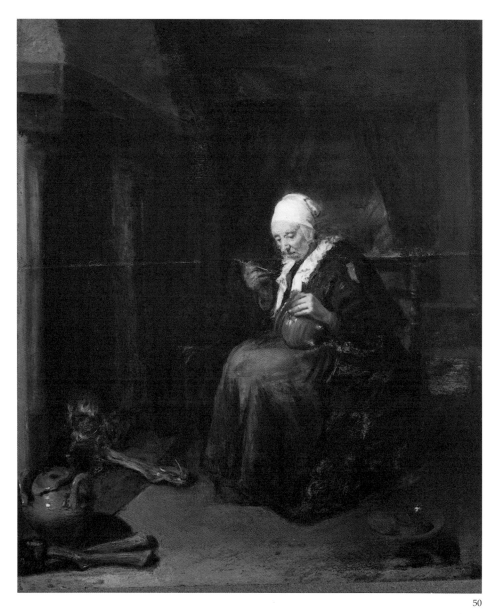

50

RICHARD BRAKENBURGH

Haarlem 1650–1702 Haarlem

According to different sources, Brakenburgh was a pupil of Hendrik Mommers, Adriaen van Ostade (q.v.) and/or Jan Steen. He entered the Haarlem guild in 1687, but by 1689 seems to have moved to Leeuwarden. He was a modestly gifted imitator of Jan Steen and also worked as a portrait painter.

621 Celebration of a Birth

> Signed and dated, lower left: *R. Brakenbürgh./1683*.
> Oak panel, 40.3 x 54.9 cm

DPG621 depicts the traditional celebration following the birth of a child (cf. *Celebrating the Birth* by Jan Steen in the Wallace Collection, London).

Bequest of Miss Gibbs, 1951.

QUIRINGH VAN BREKELENKAM

Zwammerdam? after 1622–*c*.1669 Leiden

Van Brekelenkam entered the Leiden painters' guild in 1648 and seems to have been active there until his death. Although influenced by Dou (q.v.), he was not necessarily a pupil. He specialised in genre subjects but also painted a few still lifes and portraits.

ATTRIBUTED TO BREKELENKAM

50 Old Woman eating

> Oak panel, 47.9 x 40.5 cm

Catalogued as Dou (q.v.), from whom the motif derives, until 1905, when given to Brekelenkam. This attribution is rejected by Lasius, though still accepted by F. Meijer (oral communication, 1997). Hofstede de Groot suggested an attribution to Abraham de Pape (1620–66), which seems possible (note on photograph mount in Rijksbureau voor Kunsthistorische Documentatie, The Hague). A copy bearing the monogram of Dominicus van Tol (*c*.1635–1676) was sold at Sotheby's, 16 June 1965 (lot 89).

Bourgeois bequest, 1811.

A. Lasius, *Quiringh van Brekelenkam*, Doornspijk, 1992, C18.

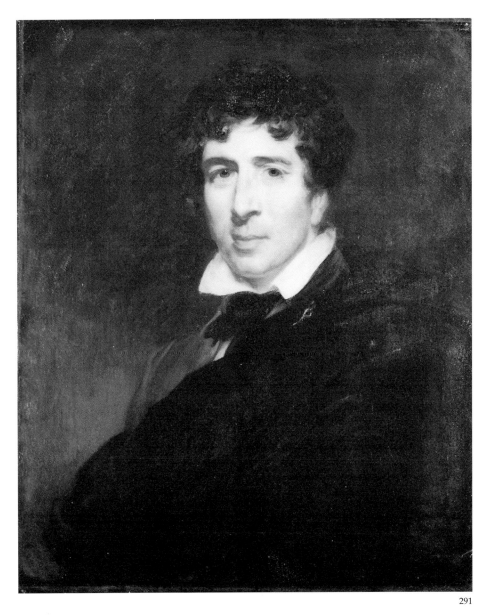

291

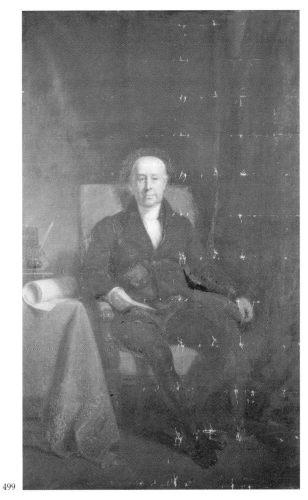

499

632

HENRY PERRONET BRIGGS

London (Walworth) 1791/93–1844 London

Briggs was a student at the RA Schools from 1811 and exhibited at the RA 1814–44 and at the British Institution 1819–35. He was elected ARA in 1825 and RA in 1832. He was a painter of historical subjects and portraits, but from *c*.1835 concentrated mainly on the latter.

291 Charles Kemble
 Canvas, 76.5 x 63.8 cm

Charles Kemble (1775–1854): brother of John Philip Kemble (see Beechey DPG111) and Mrs Siddons (see Reynolds DPG318); a versatile actor, most successful in comic roles; manager at Covent Garden from 1822. DPG291 may be one of the portraits of Kemble exhibited by Briggs at the RA in 1832 and 1835.

Gift of George Bartley, 1854.

499 Charles Druce
 Canvas, 238.4 x 146.7 cm

Charles Druce (1762–1845): Steward of the Manor of Dulwich; solicitor to Dulwich College.

Gift of the family of C. Druce, 1846.

BRITISH SCHOOL, see p.274

KATE S. BRODIE

Active 1891–1900

A Glasgow painter of landscapes and interiors, Brodie seems to have been living in Edinburgh *c*.1892–5. She exhibited at both the Glasgow Institute of Fine Arts and the Royal Scottish Academy in the 1890s.

632 Landscape
 Signed, bottom left: *K. S. Brodie*
 Canvas, 91.4 x 60.9 cm

Anonymous gift, 1956.

108

ADRIAEN BROUWER

Oudenaarde 1605/6–1638 Antwerp

Brouwer probably first trained with his father, a
tapestry designer, but came to the United Provinces
*c.*1621 and is said to have studied with Frans Hals in
Haarlem. He was in Amsterdam in 1626, but then
returned to Haarlem. He was back in the Southern
Netherlands by 1631/2, when he became a member
of the Antwerp painters' guild, and seems to have
spent much of the year 1633 in jail. Brouwer painted
vigorous low-life genre scenes, which were admired
by both Rembrandt and Rubens and which exerted
an important influence on David Teniers the younger
(qq.v.).

ATTRIBUTED TO BROUWER

108 Interior of a Tavern

Oak panel, 32.4 x 43.2 cm

An autograph replica or copy of a signed picture
formerly in the d'Arenberg collection (offered for sale

at Lempertz, Cologne, 26 November 1970, lot 32)
and now in an unknown American private collection
(HdG106). Knuttel thought DPG108 a copy, but had
not seen the original, which remains untraced.

Bourgeois bequest, 1811.

HdG111 (as replica); G. Knuttel, *Adriaen Brouwer. The Master
and his Work*, The Hague, 1962, pp.59–60, 114, 115n, 185.

GUIDO CAGNACCI

Santarcangelo di Romagna (near Rimini) 1601–1663
Vienna

MANNER OF CAGNACCI

160 Cleopatra

Canvas, 75.3 x 62.3 cm

DPG160 seems to be a copy of a picture currently in
the collection of Richard E. Spear, which is close in
style to Cagnacci.

Bourgeois bequest, 1811.

160

ABRAHAM VAN CALRAET

Dordrecht 1642–1722 Dordrecht

Calraet was the son of a wood-carver and is said to have learnt drawing from the sculptors Aemilius and Samuel Huppe. He probably trained as a painter – as did his brother – with Cuyp (q.v.). He seems to have remained throughout his life in Dordrecht, where he married in 1680. He painted still lifes of fruit and is taken to be the author of a group of pictures, signed with the initials A.C., mostly of stable and riding school scenes. These are largely dependent on the example of Cuyp, but sometimes show the influence of Wouwermans (cf. DPG296).

63 Cows and Sheep
Signed, bottom right: *AC*.
Oak panel, 37.2 x 51.5 cm

Until 1953 catalogued as Cuyp. A comparable composition by Calraet is in the Rijksmuseum, Amsterdam. A repetition of the right half only was with M. de Hevesi, Vienna, 1937.

Bourgeois bequest, 1811.

HdG696 (as Cuyp).

65 White Horse in a Riding School
Signed on plank, bottom right: *AC*
Oak panel, 34.9 x 52 cm

Until 1953 catalogued as Cuyp. There are versions in the collection of the Duke of Bedford at Woburn Abbey, and sold Phillip's, 14 February 1989 (lot 9).

Bourgeois bequest, 1811.

HdG604 (as Cuyp); A. Chong, *Aelbert Cuyp and the meaning of landscape*, diss., New York University, 1992, no.239 (as Calraet).

63

65

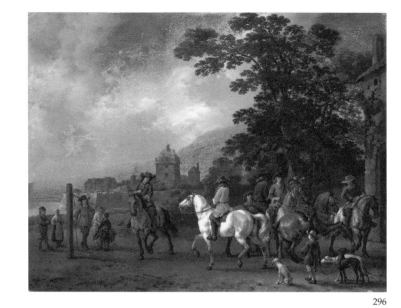

71

296

181

CALRAET

71 Two Horses

Signed, bottom left: *AC*
Oak panel, 29 x 40.4 cm

Until 1953 catalogued as Cuyp. The attribution to Calraet was proposed by Bredius in 1919. Copies or versions are recorded in the De Fursac sale, Brussels, 1 December 1923, lot 50 and with R. Zomer, Wageningen, 1953.

Bourgeois bequest, 1811.

HdG551 (as Cuyp); A. Bredius, 'Further Light upon the Painter Calraet (Kalraet)', *The Burlington Magazine*, XXXV, 1919, p.120; Chong, no.240 (as Calraet).

296 A Riding School in the Open Air

Signed, bottom left: *AC*.
Oak panel, 39 x 51.6 cm

Until 1953 catalogued as Cuyp.

Bourgeois bequest, 1811.

HdG605 (as Cuyp); Chong, no.242 (as Calraet).

181 Fishing on the Ice

Oak panel, 39.1 x 51.2 cm

Until 1953 catalogued as Cuyp. DPG181 seems to be based on a comparable composition by Cuyp in the collection of the Duke of Bedford at Woburn Abbey (HdG733, 739b).

Bourgeois bequest, 1811.

HdG734 (as Cuyp); HdG in Thieme and Becker, XIX, 1926, p.483 (as Calraet); Chong, no.241 (as Calraet).

GOVERT CAMPHUYZEN

Gorinchem? 1623/4–1672 Amsterdam?

Govert Camphuyzen probably trained with his cousin Rafel Camphuyzen and was active as a portrait painter in Amsterdam by 1643. In 1652 he was in debt and his house and possessions were put up for sale. Later in the same year he is recorded as working in Schleswig-Holstein, and by 1655 he had moved to Stockholm to become court painter to Queen Hedvig Eleanora. He was back in Amsterdam by 1665. Camphuyzen was principally a painter of animal subjects.

64 Two Peasants with Cows

Signed, bottom right: *G.C*
Oak panel, 47.3 x 62.8 cm

In 1880 DPG64 bore a false signature, *Paulus Potter*. Though again recorded by Murray in 1980, this was presumably removed when the picture was last cleaned (by Hell in 1952–3) to reveal Camphuyzen's initials.

Bourgeois bequest, 1811.

A. Bredius and E.W. Moes, 'De Schilders Camphuysen', *Oud Holland*, 21, 1903, p.213.

64

CANALETTO

Venice 1697–1768 Venice

Giovanni Antonio Canal, called Canaletto, worked for his father, a painter of theatrical scenery, before becoming a member of the Venetian painters' guild in 1720. He was soon unrivalled as a painter of realistic Venetian townscapes, many of which were painted for Grand Tourists. The British consul Joseph Smith acted as his agent and was also his main patron. In 1746–55/6, apart from two return trips to Venice, Canaletto was based in England, where he painted topographical views of London and of his patrons' country houses. He returned to Venice in 1755/6 and was elected to the Venetian Academy in 1763.

599 The Bucintoro at the Molo on Ascension Day

Canvas, 58.3 x 101.8 cm

The subject is the return of the Doge's state barge, the Bucintoro, following the Ascension Day festival, in which a ring is thrown into the sea to symbolise the marriage of Venice with the Adriatic. Market stalls have been set up in the Piazzetta. DPG599 can be dated after 1755 in view of alterations to the Torre dell'Orologio that were completed in that year.

Gift of H. Yates Thompson, 1915.

W.G. Constable, *Canaletto*, 2nd ed. revised by J.G. Links, Oxford, 1976 (reprinted with supplement, 1989), no.339; J.G. Links in *Kolekcja dla Króla*, no.4.

600 Old Walton Bridge over the Thames
 Canvas, 48.8 x 76.7 cm

The wooden bridge was built in 1750 by Samuel Dicker MP, whose house is one of those on the opposite bank; it was replaced with a brick and stone bridge in 1780. According to an inscription on the reverse of the original canvas, DPG600 was painted in London in 1754 for Thomas Hollis, one of Canaletto's last major English patrons. An early catalogue of the Hollis collection describes the foreground figures as Hollis himself, his friend Thomas Brand, his Italian servant, and his dog 'Malta'. The subject was repeated in a painting and drawing (both at the Yale Center for British Art, New Haven); these show a long, raised causeway leading to the bridge, which is omitted in DPG600.

Gift of Miss E. Murray Smith, 1917.

Constable and Links, no.441; J.G. Links in *Collection for a King*, no.3.

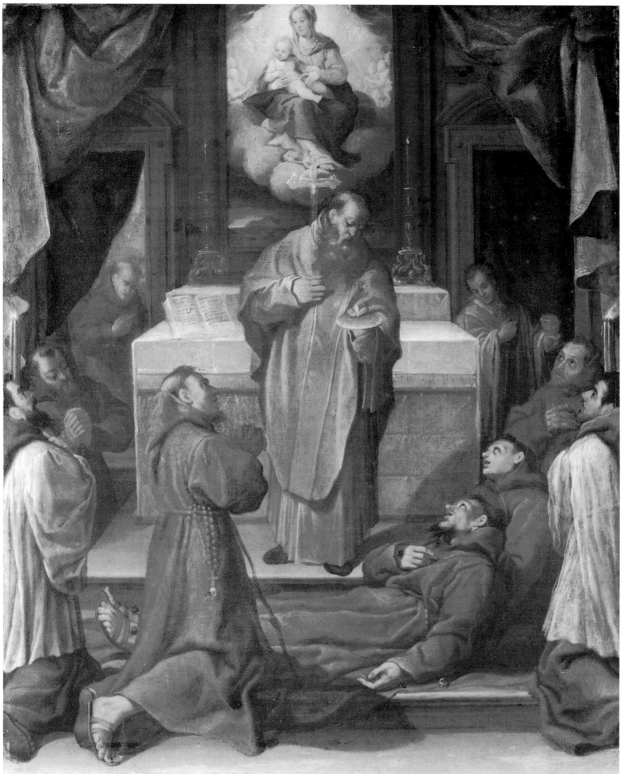

AGOSTINO CARRACCI

Bologna 1557–1602 Parma

ASCRIBED TO AGOSTINO CARRACCI

255 The Last Communion of Saint Francis

Canvas, 67 x 55.9 cm

DPG255 derives from a composition by Camillo Procaccini (*c.*1555–1629) recorded in an engraving by Anton Wierix. The engraving may reflect one of the fresco scenes of the life of Saint Francis painted by Procaccini and others in the second cloister of St Angelo, Milan (now destroyed). A related drawing, probably by Procaccini, is at the University of Missouri, Columbia. Another painting deriving from the same prototype is in the Accademia Albertina, Turin, and is attributed to Denys Calvaert. DPG255 was catalogued as by Agostino Carracci in 1880, but this attribution is rejected by G. Feigenbaum (note on file, 1981) and Stephen Pepper (note on file, 1988, suggesting an attribution to Filippo Bellini).

Bourgeois bequest, 1811.

S.E. Ostrow, *Agostino Carracci*, New York, 1966, no.I/2 (as Agostino Carracci); N. Ward Neilson, 'Camillo Procaccini: Some Partial Reconstructions', *Arte Lombarda*, L, 1978, p.101; id., *Camillo Procaccini, Paintings and Drawings*, New York/London, 1979, p.130.

ANNIBALE CARRACCI

Bologna 1560–1609 Rome

Annibale Carracci trained in Bologna with Lodovico Carracci (q.v.) and possibly with Bartolommeo Passarotti, whose influence is apparent in his early genre subjects. He then travelled in northern Italy, visiting Parma and Venice. The influence of Correggio is strongly felt in his early works but from *c*.1588 was replaced by that of the Venetian school. In 1595 Annibale moved to Rome, where he undertook his most important work, the decoration of the ceiling of the gallery of the Palazzo Farnese, 1597–1601. In Rome he adopted a classicising style, based on the example of Raphael (q.v.), which was to have a seminal influence on seventeenth-century Roman painting.

ATTRIBUTED TO ANNIBALE CARRACCI

286 Head of an Old Man
Canvas, 39.4 x 27.9 cm

Attributed to Rosa until 1880, when catalogued by Richter as Italian School. Murray suggested an attribution to Guido Reni, but this is rejected by Pepper, who regards DPG286 as a work by Annibale Carracci of *c*.1590/2 (oral communication, 1997).

Bourgeois bequest, 1811.

286

154

154 Magdalen
Canvas, 30.8 x 40 cm

A slightly reduced copy of the original in the Fitzwilliam Museum, Cambridge, which is generally given to Annibale but for which an attribution to Albani has recently been suggested (A. Brogi, 'Il laboratorio dell'Ideale: note sulla prima attività di Francesco Albani tra Bologna e Roma', *Paragone*, XLI, 1990, p.54).

Bourgeois bequest, 1811.

D. Posner, *Annibale Carracci*, London, 1971, under no.125.

162 Pietà
Paper(?) on canvas, 38 x 48.2 cm

The composition seems to be based on Annibale's etching of the *Christ of Caprarola* (Posner, II, fig.97). A related drawing was sold at Sotheby's, 11 July 1972 (lot 78).

Bourgeois bequest, 1811.

230 Madonna and Child with Saint John
Beech or fruitwood (?) panel, 26 x 20.6 cm

A good, early copy of Annibale's original in the Uffizi, Florence, which is of the same size but painted on copper.

Bourgeois bequest, 1811.

Posner, under no.96.

162

230

LODOVICO CARRACCI

Bologna 1555–1619 Bologna

Lodovico Carracci served his apprenticeship with Prospero Fontana in Bologna and is said to have travelled to Florence, Parma, Venice and Mantua, probably in the late 1570s. In 1582, with his cousins, the brothers Annibale and Agostino Carracci, he founded an Academy in Bologna. He is recorded in Rome in 1602 but based himself in Bologna, where his personal, visionary style remained largely independent of that practised in Rome by his cousins.

ATTRIBUTED TO LODOVICO CARRACCI

269 Saint Francis in Meditation
Copper, 34.9 x 25.7 cm

Catalogued by Bodmer among works attributed to Lodovico Carracci or from his workshop.

Bourgeois bequest, 1811.

H. Bodmer, *Ludovico Carracci*, Burg bei Magdeburg, 1939, p.142.

269

232

138

CIRCLE OF LODOVICO CARRACCI

232 Saints Peter and Francis of Assisi
Copper, 23.7 x 18.7 cm

Catalogued by Bodmer among works attributed to
Lodovico Carracci or from his workshop. Feigenbaum
rejects the attribution and treats DPG232 as a work
produced 'in the Carracci orbit', c.1600.

Bourgeois bequest, 1811.

Bodmer, p.142; G. Feigenbaum, *Ludovico Carracci*, diss.,
Princeton, 1984, p.486.

FRANCESCO CASANOVA

London 1727–1803 Brühl (near Vienna)

Brother of the celebrated memorialist, Francesco
Casanova trained in Venice with Gianantonio Guardi
and Antonio Joli, and also studied the battle scenes
of Francesco Simonini. In 1751 he was in Paris, but he
moved in the following year to Dresden and there
discovered the works of Wouwermans (q.v.). He was
back in Paris in 1757, where he was appointed *peintre
du roi* by 1762 and received at the Académie in 1763.
In 1767 he came to London, but he was again in
Paris in 1771, to work for the prince de Condé, and
remained there until 1783, when he moved to Vienna.
De Loutherbourg (q.v.) was his pupil.

138 Ferry Boat
Canvas, 39 x 67.9 cm

DPG138 demonstrates Casanova's debt to
Wouwermans (q.v.). According to Leporini it was
painted during the artist's stay in London in the late
1760s.

Bourgeois bequest, 1811.

H. Leporini, 'Francesco Casanova', *Pantheon*, XXII, 1964,
pp.173, 177.

LORENZO A CASTRO

Active c.1664–died c.1700?

Lorenzo a Castro is presumably the Laureys a Castro
who became a member of the Antwerp painters' guild
in 1664/5. His works suggest that he travelled in the
Mediterranean. He seems to have been in England by
1680 and is presumably the Lawrence Castro recorded
in Whitecross Street, London, in 1695. He seems to have
painted some portraits and genre subjects as well as
seapieces.

359 Seapiece: A Galley of Malta
Signed, lower left: *L. A. CAS.TRO*
Canvas, 76.2 x 134.3 cm

A fighting galley of the Knights of Malta with, on the right, the flagship of the Dutch Mediterranean force and, in the left background, an English merchantman.

Cartwright bequest, 1686.

R.T. Jeffree in *Mr Cartwright's Pictures*, no.67.

361 Seapiece: Ships in Rough Water off a Mediterranean Port
Signed, bottom left: *L. a. Castro. fec*
Canvas, 95.3 x 178.7 cm

On the right the flagship of the English Streights Fleet, beyond her the vice-admiral, and on the left the flagship of the Dutch Mediterranean squadron.

Cartwright bequest, 1686.

R.T. Jeffree in *Mr Cartwright's Pictures*, no.72.

428 Seapiece: A Sea Fight with Barbary Corsairs
Signed, on side of ship, lower left: *Castro f*
Canvas, 107 x 92.7 cm

Possibly the action on 22 May 1681, when the *Kingfisher* was attacked for ten hours before beating off seven Barbary ships.

Cartwright bequest, 1686.

R.T. Jeffree in Mr *Cartwright's Pictures*, no.69.

436 Seapiece: A Calm
Signed, bottom right: *L. CASTRO.*
Canvas, 63.2 x 76.2 cm

The principal ship is the commodore of the Levant Company fleet.

Cartwright bequest, 1686.

R.T. Jeffree in *Mr Cartwright's Pictures*, no.70.

359

361

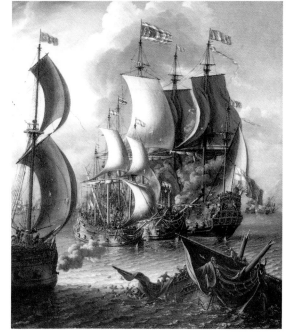

428

436

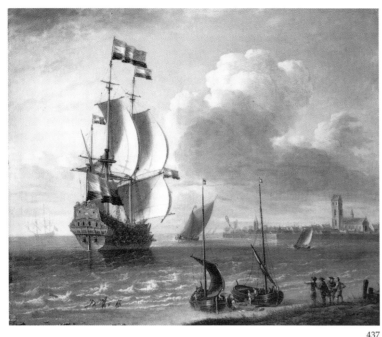

437

517

518

257

437 Seapiece: A Dutch East Indiaman off Hoorn
Signed, bottom right: *Castro*
Canvas, 63.5 x 76.5 cm

The ship can be identified from the stork on her stern as the *Ooeivaar*, a Dutch East Indiaman. She is anchored off the seaport of Hoorn in northern Holland.

Cartwright bequest, 1686.

R.T. Jeffree in *Mr Cartwright's Pictures*, no.73.

517 Seapiece: Dutch Levanters in a Rough Sea
Signed, bottom left: *Castro*.
Canvas, 47.3 x 63.8 cm

The ships flying red and white striped flags are probably English vessels of the Levant company.

Cartwright bequest, 1686.

R.T. Jeffree in *Mr Cartwright's Pictures*, no.68.

518 Seapiece: A Storm
Canvas, 33 x 52 cm

Attributed by Jeffree to Bonaventura Peeters the younger on the grounds of a possible identification with no.514 in the Cartwright inventory, which is attributed to 'Peters'. However, an old label on the verso identifies DPG518 as probably no.220 in the Cartwright inventory, described as 'an night Seascift castros'.

Cartwright bequest, 1686.

R.T. Jeffree in *Mr Cartwright's Pictures*, no.71.

CARLO CIGNANI

Bologna 1628–1719 Forlì

Cignani first trained with Giovanni Battista del Cairo, then entered the studio of Albani (q.v.). Apart from trips to Livorno *c.*1656, Rome 1662–5 and Parma 1678–81, he worked mainly in Bologna until 1686. He then transferred his studio to Forlì to paint the cupola of the cathedral, a work which he did not complete until 1706. One of the most admired Italian painters of his generation, Cignani was appointed in 1709 as *principe* of the newly founded Accademia Clementina in Bologna. He ran a large studio, and among his most favoured pupils was M. Franceschini (q.v.).

257 The Penitent Magdalen
Canvas, 97.5 cm diameter (circular)

Following the Crucifixion, according to her legend, Mary Magdalen retired to Sainte-Baume in Provence, where she lived for thirty years in penitence. DPG257 is dated 1685/90 by Buscaroli Fabbri.

Bourgeois bequest, 1811.

B. Buscaroli Fabbri, *Carlo Cignani*, Padua, 1991, no.52.

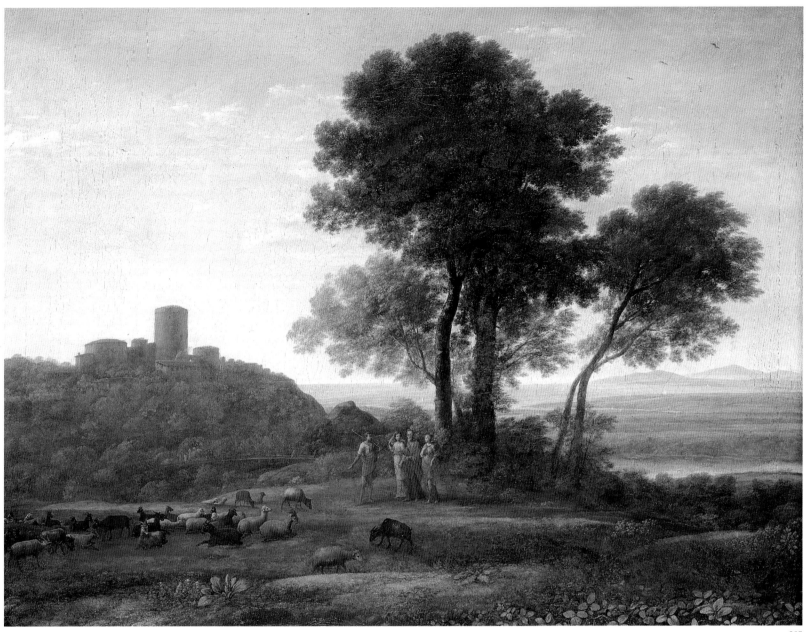

205

CLAUDE

Chamagne 1604/5?–1682 Rome

Claude Gellée, called Claude Lorrain, travelled to Rome c.1617/18 and worked as a pastry cook before studying as a painter with Goffredo Wals in Naples and then with Agostino Tassi in Rome. Apart from a brief trip to Nancy in 1625–6, he remained in Rome for the rest of his life. Claude became a member of the Accademia di San Luca in 1633 and soon established a reputation as a landscape painter. From c.1635 he recorded his paintings in a book of drawings – the *Liber Veritatis*, now in the British Museum – in which he frequently recorded the names of his patrons.

205 Jacob with Laban and his Daughters

Signed and dated, indistinctly, bottom centre left: *CLADIO IVF/ ROM. 1676*
Canvas, 72 x 94.5 cm

The subject is from Genesis XXIX, 15–19: Jacob offers to serve Laban for seven years to win the hand of his younger daughter Rachel; instead he is given the elder daughter Leah and has to serve seven years more to marry Rachel. Claude treated the subject on at least two other occasions (Norton Simon Museum, Pasadena, and Petworth House, West Sussex). DPG205 repeats the landscape from Claude's etching of the *Goatherd* dated 1663. An inscription on the *Liber Veritatis* drawing records the patron as Franz Mayer von Regensburg, counsellor to the Elector of Bavaria. There are also related drawings in the Louvre and the Pierpont Morgan Library, New York.

Bourgeois bequest, 1811.

M. Roethlisberger, *Claude Lorrain. The Paintings*, New Haven, 1961, LV188; M. Kitson in *Collection for a King*, no.4. and *Kolekcja dla Króla,* no.5.

309 Gathering Grapes
 Canvas, 50.8 x 67.3 cm

Acquired as Claude but catalogued as Swanevelt until 1880, when given by Richter to the Italian school. Denning records that Turner admired the picture and recognised it as the work of Claude. According to the inscription on the *Liber Veritatis* drawing, the picture was painted for a client in Paris. Roethlisberger suggests a date of 1641/2. The picture is considerably damaged and was in unexhibitable condition until restored by Patrick Lindsay in 1984.

Bourgeois bequest, 1811.

Roethlisberger, LV58.

CIRCLE OF CLAUDE

174 The Campo Vaccino, Rome
 Inscribed left (on the Arch of Septimus Severus): *[…]O SEPTIMIO M [F]IL: SEVERO PIO PERTINACI. AV [G PATRI]/ PATRIAE PARTHICO ARABICO ET PARTHICO A[DIABENICO]/ POTIE AX . TRIBVNIC. POTESTA. XI IMP XI/ SESTI […] IMPERIVMQ[VE] POPVLI ROMANI […] SPQ[R]* and right (on the frieze of the Temple of Saturn): *SENATVS POPVLV/ INCENDIO CONSVMP* Canvas, 78.1 x 106.1 cm

A good contemporary copy of Claude's original in the Louvre of *c*.1636, with a different group of figures bottom right.

Bourgeois bequest, 1811.

Roethlisberger, LV9/1.

AFTER CLAUDE

220 The Embarkation of Saint Paula
 Inscribed, on blocks of stone, bottom right: *PORTO DE/ OSTIA CL/ AVDIO [INV.?]* and *INBARCO/ DI SANCTA PAULA* Canvas, 50.5 x 39 cm

Following her conversion, the noble Roman widow Saint Paula became a friend of Saint Jerome and embarked for the Holy Land, where she founded a convent. DPG220 is a copy of Claude's original of 1641–2 in the collection of the Duke of Wellington.

Bourgeois bequest, 1811.

Roethlisberger, LV61/1.

174

220

312 The Rest on the Flight into Egypt
Canvas, 38.7 x 49.8 cm

The original, signed and dated 1676, is at Holkham Hall, Norfolk.

Bourgeois bequest, 1811.

Roethlisberger, under LV187.

312

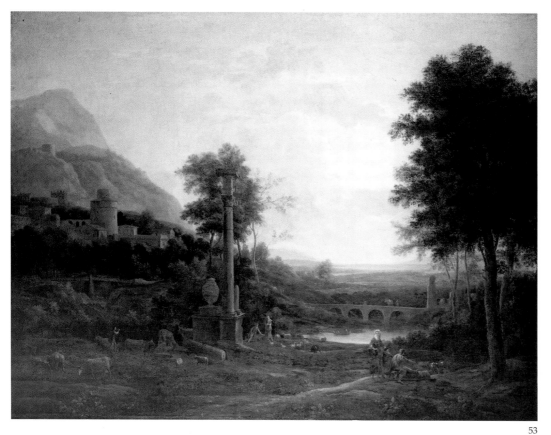

53

FOLLOWER OF CLAUDE

53 Landscape with a Column and Figures
Canvas, 104.8 x 140 cm

Murray recorded 'very faint traces' of a monogram (?)*P* followed by *F*, and suggested that DPG53 might be a landscape of approximately the same size which appears in the Desenfans sale of 8 April ff. 1786 as the work of Pierre Patel.

Bourgeois bequest, 1811.

IMITATOR OF CLAUDE

215 Classical Seaport at Sunset
Canvas, 74.3 x 99.1 cm

The composition is not directly related to any known original by Claude, but compares with the *Coast Scene with the Landing of Aeneas* at Longford Castle (*Liber Veritatis*, no.122). Roethlisberger suggests an Italian seventeenth- or eighteenth-century imitator.

Bourgeois bequest, 1811.

Roethlisberger, I, p.521, no.255.

336 Mercury and Argus
Oak panel, 32.5 x 36.5 cm

Mercury lulls to sleep and will kill the many-eyed Argus, set by Juno to watch over Io, whom Jupiter (having ravished her) had transformed into a heifer (Ovid, *Metamorphoses*, I).

Bourgeois bequest, 1811.

Roethlisberger, I, p.354, n.3.

336

215

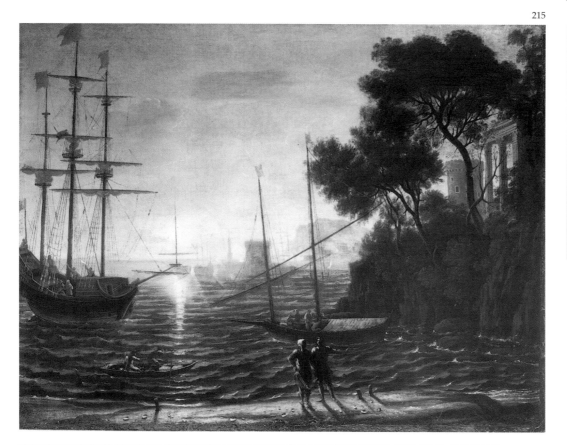

PIETER COECKE VAN AELST

Aelst (Aalst) 1502–1550 Brussels

FOLLOWER OF COECKE VAN AELST

505 The Fall of Man
Oak panel, 106.7 x 64.8 cm

Eve offers Adam the forbidden fruit from the tree of the knowledge of good and evil (Genesis, III, 6); in the left distance is the expulsion from Eden (Genesis, III, 23–4). Formerly catalogued as Circle of Mabuse (i.e. Jan Gossaert); the present attribution was suggested by Edwin Buijsen (letter on file, 1997).

Dulwich College by 1890.

505

SEBASTIANO CONCA

Gaeta 1680–1764 Gaeta

Conca trained with Francesco Solimena in Naples, where he remained until 1707, when he moved to Rome. He there pursued a brilliant career, receiving a succession of important commissions for frescoes and altarpieces, while his smaller easel paintings were much in demand among collectors throughout Europe. He served as *principe* of the Accademia di San Luca in 1729–32 and 1739–42. Apart from a trip to Tuscany in 1731–2, he worked in Rome until *c*.1752, when he moved his studio to Naples.

274 The Holy Family with Saints Elizabeth, John the Baptist and Zacharias
Canvas, 49.2 x 39 cm

A sketch for the altarpiece by Conca, signed and dated 1723, formerly in the Ortolani collection, Rome, of which there is a repetition (formerly in the Art Museum, Seattle) that bears a false signature and date *J. Mola 1657*.

Bourgeois bequest, 1811.

P. Rosenberg in *Pier Francesco Mola, 1612–1666*, cat. exh. Museo Cantonale d'Arte, Lugano/Musei Capitolini, Rome, 1989–90, p.134.

ADAM COLONIA

Rotterdam 1634–1685 London

Colonia probably trained with his father and settled shortly after 1670 in London, where he is recorded as a member of the Dutch church of Austin Friars in 1675. He painted landscapes in the manner of Pynacker and Berchem (qq.v.) and is said to have painted cattle-pieces, 'country-wakes' and 'fire-pieces', as well as copies after Bassano.

371 Sheep Shearing
Signed, bottom right: *AD Colonia* (AD in monogram)
Canvas, 99.4 x 147.9 cm

The woman lifting two baskets is taken from *Autumn* and the sheep shearer from *Summer* in the series of Seasons by Jacopo and Francesco Bassano, of which there is a set of copies at Dulwich (see After Bassano DPG386, DPG422).

Cartwright bequest, 1686.

N. Kalinsky in *Mr Cartwright's Pictures*, no.64.

431 The Flight into Egypt
Signed, bottom right: *A Colonia*
Canvas, 69.2 x 47.7 cm

Cartwright bequest, 1686.

N. Kalinsky in *Mr Cartwright's Pictures*, no.41.

431

274

442

246

468

SIR ARTHUR STOCKDALE COPE

London 1857–1940 Treniffee (Cornwall)

Cope was a student at Carey's and the RA Schools and exhibited at the RA 1876–1935, at the Grosvenor Gallery 1887 and at the Glasgow Institute of Fine Arts 1905–35. He was elected ARA in 1899 and RA 1910. Although he exhibited several landscapes, he seems to have devoted himself chiefly to portraiture. Cope received his knighthood in 1917.

442 The Reverend William Rogers

Signed and dated, lower left:
A. S. Cope/ 1894. The inscriptions on the books include: *Dulwich/ College; Bishopsgate/ Foundation/ [Instit]ute;…/ EDUCATION … ENGLAND AND WALES; CRIPPLEGATE SCHEME; ALDGATE SCHEME*
Canvas, 125.7 x 92.7 cm

The Rev. William Rogers (1819–96): Governor of Dulwich College from 1857; Chairman of the Governors, 1862–95; known because of his advocacy of secular education as 'Hang theology Rogers'. DPG442 was presented to the sitter by his friends in 1894 and exhibited at the RA in the following year.

Gift of Lorance H. Carter, 1897.

CORREGGIO

Correggio c.1494–1534 Correggio

AFTER CORREGGIO

246 Madonna and Child

Poplar panel, 31.8 x 25.1 cm

A copy, probably seventeenth-century, of Correggio's *Madonna of the Basket* in the National Gallery, London, omitting the buildings and the figure of Saint Joseph in the background.

Bourgeois bequest, 1811.

C. Gould, *The Paintings of Correggio*, London, 1976, p.220.

468 Venus and Cupid

Mahogany (?) panel, 49.5 x 27.3 cm

A partial copy of the *School of Love* by Correggio in the National Gallery, London, omitting the figure of Mercury, reversing that of Cupid, and adding the arrow held by Venus and the doves.

Bourgeois bequest, 1811.

121

PIETRO DA CORTONA

Cortona 1596–1669 Rome

AFTER PIETRO DA CORTONA

121 The Age of Bronze
Canvas, 81.9 x 65.4 cm

Formerly catalogued as a *modello* by Cortona, but DPG121 is probably a copy after Cortona's fresco in the Sala della Stufa of the Palazzo Pitti, Florence.

Bourgeois bequest, 1811.

G. Briganti, *Pietro da Cortona o della Pittura Barocca*, 2nd ed., Florence, 1982, p.393.

226 Saint Martina calling down Lightning on the Idols
Canvas, 115.3 x 87 cm

Saint Martina refused to worship at the Temple of Apollo, which was destroyed when she called down a bolt of lightning. DPG226 is a copy of Cortona's original in the Palazzo Pitti, Florence, probably of the early to mid-1640s.

Bourgeois bequest, 1811.

Briganti, pp.259, 393.

226

605

JAN COSSIERS

Antwerp 1600–1671 Antwerp

Cossiers trained with his father and then with Cornelis de Vos (q.v.), before making a trip via Aix-en-Provence to Rome *c.*1624. He was back in Antwerp by 1627 and became a member of the painters' guild in the following year. In the 1630s he was one of many artists employed by Rubens (q.v.). Cossiers painted genre subjects and, following Rubens's death in 1640, became one of the leading painters of religious subjects in Antwerp. He painted in a free and fluent style reflected also in his portrait drawings.

ATTRIBUTED TO COSSIERS

605 A Young Man
Oak panel, 62.2 x 48.9 cm

DPG605 has generally been regarded as a self-portrait by Jan Lievens, presumably on the grounds of a certain resemblance to Lievens's features as recorded in Van Dyck's *Iconographie*. The style, however, suggests a Flemish painter. An attribution to Cossiers has been tentatively suggested by H. Vlieghe (letter on file, 1997).

Fairfax Murray gift, 1917.

H. Schneider, *Jan Lievens, sein Leben und seine Werke* (with supplement by R.E.O. Ekkart), Amsterdam, 1973, no.247 (as Lievens); Sumowski, III, no.1287 (as Lievens).

MARMADUKE CRADOCK

Somerton (Somerset) *c*.1660–1716/17 London

Cradock served his apprenticeship with a house painter in London and later taught himself, making a speciality of bird and animal painting.

519 Ducks on a Pond

Canvas, 45.4 x 55.3 cm

The attribution was suggested by F. Meijer.

Dulwich College by 1890.

GASPAR DE CRAYER

Antwerp 1584–1669 Ghent

Possibly a pupil of Raphaël Coxie, De Crayer became a master in the Brussels painters' guild in 1607 and served as its dean in 1611–16. He was painter to the court of the Cardinal Infante Ferdinand from 1635, and later to that of the Archduke Leopold Wilhelm. In 1664 he settled in Ghent. He was a prolific painter of altarpieces in a style which reflects the influence of both Rubens and Van Dyck (qq.v.).

190 Saint Augustine in Ecstasy

Oak panel, 46.3 x 34 cm

Modello for an altarpiece by De Crayer from the Augustinian priory of Groenendaal-lez-Bruxelles, now in the Musée des Beaux-Arts, Valenciennes, dated by Vlieghe within the period *c*.1638–*c*.1648 (H. Vlieghe, *Gaspar de Crayer, sa vie et ses œuvres*, Brussels, 1972, A120).

Bourgeois bequest, 1811.

JOHN DE CRITZ THE ELDER

Antwerp *c.*1551/2–1642 London

De Critz was brought to England as a child and served his apprenticeship in London with Lucas de Heere, *c.*1567–71. In the 1580s he benefited from the patronage of Sir Francis Walsingham and made several trips to France, where he came into contact with the school of Fontainebleau. In 1603 he was appointed Serjeant Painter and was extensively employed at court on decorative work. No surviving painting can be attributed to him with certainty.

ATTRIBUTED TO DE CRITZ

548 James VI and I
Canvas, 200.5 x 129.5 cm

James VI of Scotland and I of England (1566–1625). DPG548 is one of four known full-length versions of a type originated probably by De Critz in 1606. The others are at Loseley Park, in the Prado and in a private collection. DPG548 was attributed in 1926 to Gheeraerts and said to be signed, but the 'signature' (which had already been doubted) was presumably false and must have been removed during cleaning in 1953.

Gift of H. Yates Thompson, 1898.

A. Sumner in *Death, Passion and Politics*, no.12.

AFTER DE CRITZ

384 James VI and I
Oak panel, 57.8 x 38.1 cm

Possibly one of the set of Kings and Queens of England acquired by Edward Alleyn in 1618/20 (see British School, DPG522–536), but not a product of the same workshop as the other sixteen.

Probably Alleyn bequest, 1626.

S. Foister in *Edward Alleyn*, pp.39–51.

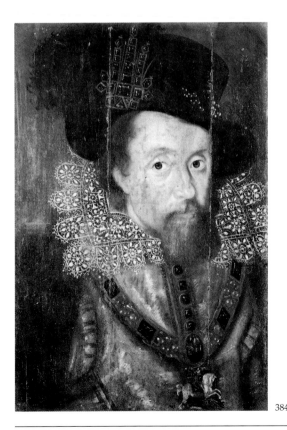

384

548

4

96

AELBERT CUYP

Dordrecht 1620–1691 Dordrecht

Aelbert Cuyp trained with his father, Jacob Gerritsz.
Cuyp. His earliest landscapes are painted mostly in the
manner of Jan van Goyen and Salomon van Ruysdael,
but from the mid-1640s he came under the influence of
the Italianate landscape style of Both (q.v.) and others.
His drawings show that he travelled in the United
Provinces and along the Rhine, but he is not known
ever to have settled outside Dordrecht. He seems to
have given up painting shortly after his marriage to
a wealthy widow in 1658. Cuyp was principally a
painter of landscapes and river scenes, but also
produced portraits and biblical subjects. His work
seems to have been little known outside Dordrecht
until the late 18th century, when it began to attract the
admiration of English collectors in particular.

4 View on a Plain
 Signed, bottom centre: *A. cúÿp*
 Oak panel, 48 x 72.2 cm

An early work, dated by Chong *c*.1644. The distant
town is Rhenen, which Cuyp drew in 1641 (Teylers
Museum, Haarlem).

Bourgeois bequest, 1811.

HdG694; S. Reiss, *Aelbert Cuyp*, London, 1975, no.42;
A. Chong, *Aelbert Cuyp and the meaning of landscape*, diss.,
New York University, 1992, no.69; A. Chong in *Conserving
Old Masters*, no.7.

60 Landscape with Cattle
 Signed, lower right: *A cuÿp*
 Oak panel, 16 x 36.8 cm, excluding additions
 of 8.9 at the top and 1.8 at the bottom

An early work in the manner of Van Goyen, painted
probably *c*.1640. DPG60 formerly had additions top
and bottom (of 8.9 and 1.8 cm respectively) and
remnants of a group of cows in the foreground centre

left. Analysis proved these to be post-17th-century
additions and they were removed in 1998. All were
probably the work of Bourgeois (q.v.), as stated by
Denning in his manuscript catalogue of the collection.
The group of cows, as recorded in old photographs,
repeats that in a landscape by Cuyp in the Los Angeles
County Museum of Art (HdG249). A preliminary
drawing by Cuyp is in a private collection, Amsterdam.

Bourgeois bequest, 1811.

HdG695; G.A. Waterfield, 'That White-faced Man: Sir Francis
Bourgeois', *Turner Studies*, 1989, 9, pp.45–6; Chong, no.29.

96 An Evening Ride near a River
 Signed, bottom left: *A. cúÿp*.
 Oak panel, 48.9 x 64.1 cm

The attribution to Cuyp was rejected by Reiss. Chong
suggests that the picture is by a pupil working under
Cuyp's supervision.

Bourgeois bequest, 1811.

HdG434, 467; Reiss, p.194; Chong, C14.

124

348

124 A Road near a River
 Canvas, 115.6 x 170.6 cm

One of Cuyp's last works, dated by Chong to the end
of the 1650s.

Bourgeois bequest, 1811.

HdG435; Reiss, no.138; Chong, no.170; P. Sutton in cat. exh.
El Siglo de Oro del Paisaje Holandés, Fundación Colección
Thyssen-Bornemisza, 1994, no.19; A. Chong in *Conserving
Old Masters*, no.9.

128 Herdsmen with Cows
 Signed, lower right: *A. cúyp*
 Canvas, 101.4 x 145.8 cm

Dated by Chong 'slightly later' than DPG4, thus
probably *c*.1645. DPG128 was especially admired and
extensively copied in the nineteenth century.

Bourgeois bequest, 1811.

HdG237e(?), 330; Reiss, no.44; Chong, no.80; A. Chong in
Conserving Old Masters, no.8.

348 Landscape with Cattle and Figures
 Signed, lower right: *A cúÿp*.
 Oak panel, 37.5 x 57.5 cm

An early work, influenced by Van Goyen, datable
c.1640/1. As noted by Reiss, the goats were taken
from drawings made by Cuyp's father for a set of
engravings published by Nicolaes Visscher in 1641
under the title *Diversa Animalia Quadrupedia*.

Bourgeois bequest, 1811.

HdG239, 697; Reiss, no.15; Chong, no.12.

144

469

192

315

245

AFTER CUYP

144 Cattle near the Maas, with Dordrecht in the distance

Inscribed, bottom right: *A. cuyp*
Mahogany panel, 76.2 x 106.4 cm

Formerly catalogued as Cuyp, but this attribution rejected by Chong. DPG144 may be based on a Cuyp composition, but no certain original is known. Chong regards a version in the Boymans-van Beuningen Museum, Rotterdam (HdG384) as 'conceivably a damaged original'.

Bourgeois bequest, 1811.

HdG201a (as Cuyp); Reiss, no.80 (as Cuyp); Chong, (as possibly recording a Cuyp composition).

469 Landscape with Shepherds

Oak panel, 47.6 x 73.6 cm

A copy, possibly by Bourgeois (q.v.), of a picture in an American private collection (Reiss, no.53).

Bourgeois bequest, 1811.

576

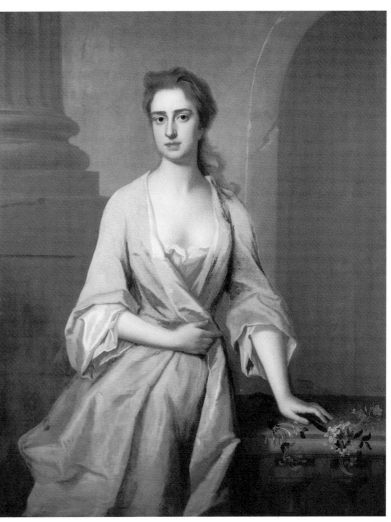

575

IMITATOR OF CUYP

192 Cattle near a River
Inscribed, bottom left: *A. Cuÿp*
Oak panel, 59.1 x 74 cm

An eighteenth-century pastiche, according to Chong (letter on file, 1984), possibly by Jacob van Strij (1756–1815), of Cuyp's original formerly on loan to the J. Paul Getty Museum.

Bourgeois bequest, 1811.

HdG201 (as Cuyp).

MANNER OF CUYP

245 Cattle near a River
Inscribed, bottom right: *A. Cuÿp*
Canvas, 93 x 119.4 cm

Bourgeois bequest, 1811.

HdG350 (as Cuyp).

315 View on the Maas
Inscribed, bottom left: *A.Cuyp* (worn)
Canvas, 63.5 x 81 cm

Bourgeois bequest, 1811.

HdG371 (as Cuyp).

MICHAEL DAHL

Stockholm 1656/9–1743 London

After training in Stockholm with Martin Hannibal and David Klöcker Ehrenstrahl, Dahl came to London in 1682 and made the acquaintance of Kneller (q.v.). In 1684 he embarked with Henry Tilson on a trip to Paris, Venice and Rome (where he converted to Roman Catholicism), returning to London in 1688/9. He then set up a highly successful portrait practice, becoming, after Kneller's death in 1723, the leading portrait painter in London.

575 Portrait of a Woman
Canvas, 125.7 x 101.6 cm

Fairfax Murray gift, 1911.

576 Portrait of a Man
Canvas, 125.7 x 101.6 cm

Fairfax Murray gift, 1911.

DIRCK VAN DELEN

Heusden (near 's-Hertogenbosch) 1604/5–1671
Arnemuiden

Van Delen was possibly a pupil of Hendrik Arts, a
painter of architectural fantasies. He had settled in
Arnemuiden, near Middelburg, by 1626 and is
recorded as a member of the Middelburg painters'
guild from 1639. For most of his life he was also a
member of the Arnemuiden town council, mostly as
Burgomaster. In 1666 he made a trip to Antwerp to
paint a large allegory for the Antwerp painters' guild.
Van Delen specialised in architectural painting,
producing fanciful views of palaces and church
interiors.

470 The Entrance to a Palace
Signed and dated, on top step, lower right:
D. V. DELEN.F.1654
Oak (?) panel, 49.5 x 54 cm

Bourgeois bequest, 1811.

H. Jantzen, *Das niederländische Architekturbild*, Leipzig, 1910,
no.129; T.T. Blade, *The Paintings of Dirck van Delen*, Ann Arbor,
1980, no.81.

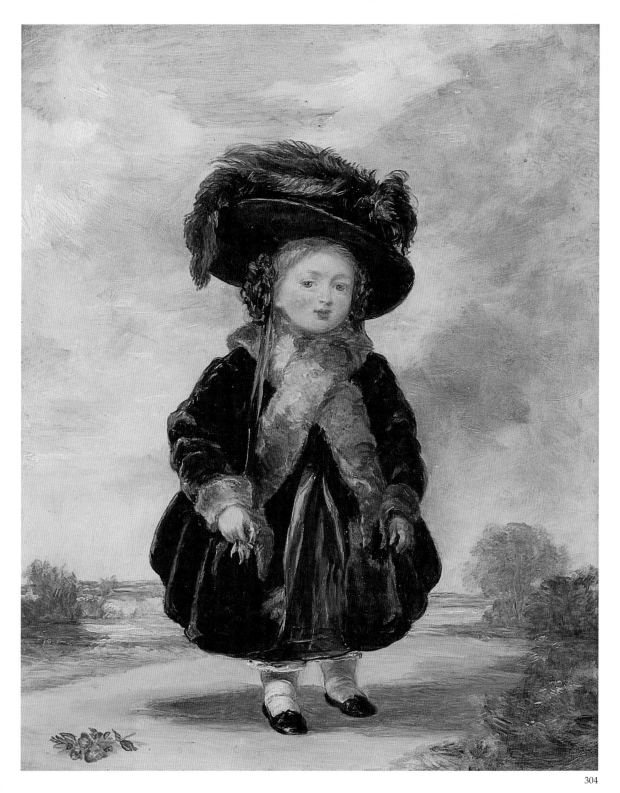

304

STEPHEN POYNTZ DENNING

*c.*1787–1864 London (Dulwich)

A pupil of John William Wright in London, Denning exhibited portraits at the RA 1814–52 and the Society of British Artists 1829, and two genre scenes at the British Institution 1844. He was curator of Dulwich Picture Gallery from 1821.

304 Queen Victoria, aged Four
 Mahogany panel, 27.9 x 22.7 cm

Victoria (1819–1901), Queen of the United Kingdom of Great Britain and Ireland, and Empress of India. As a girl, Victoria lived with her mother, the Duchess of Kent, in Kensington Palace and was often to be seen walking in Kensington Gardens.

Purchased by Dulwich College, 1891.

655 A Woodman
 Canvas, 76.2 x 63.8 cm

Probably the picture of this title exhibited at the British Institution in 1844.

Presumably purchased from or given by the artist.

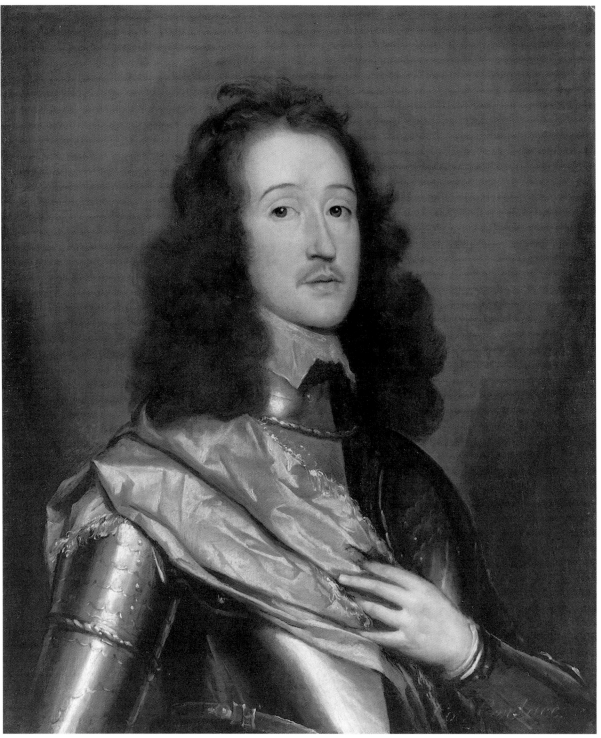

363

WILLIAM DOBSON

London 1610/11–1646 London

Dobson served his apprenticeship with William Peake, probably *c*.1626–32, and further trained in the studio of Francis Cleyn. He followed the court to Oxford in 1641/2 and painted portraits of the King, his family and courtiers. After the King's flight in 1646, he returned to London. In the same year Dobson was nominated Steward of the Painter-Stainers' Company, but he died soon afterwards.

ATTRIBUTED TO DOBSON

363 Richard Lovelace
Canvas, 74.9 x 63.5 cm

Richard Lovelace (1617–*c*.1657): cavalier poet; friend of Lely; served in the Scottish expeditions, 1639; imprisoned 1642 (when he wrote the song 'Stone walls do not a prison make'); rejoined the King at Oxford in 1645 and fought for the French at the siege of Dunkirk, 1646; again imprisoned 1648–9, then worked on the publication of his collected poetry, which appeared

under the title *Lucasta* in 1649. DPG363 is regarded by M. Rogers as an autograph work by Dobson of *c*.1645/6.

Cartwright bequest, 1686.

C.H. Collins Baker, *Lely & the Stuart Portrait Painters*, London, 1912, I, p.99, pl. opp. p.99, pp.102–4 (as 'F. How'); R.T. Jeffree in *Mr Cartwright's Pictures*, no.14.

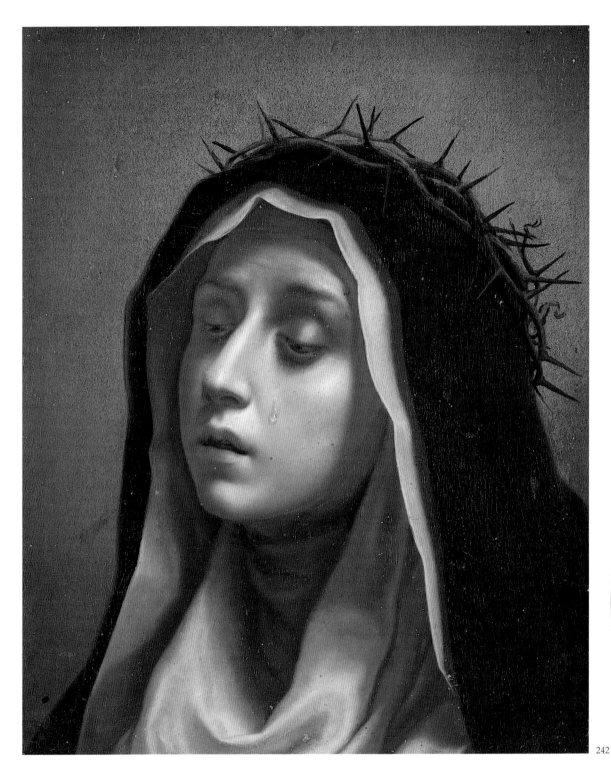

242

382

CARLO DOLCI

Florence 1616–1687 Florence

Dolci studied under Jacopo Vignali. A child prodigy, he was painting portraits by the age of fifteen. Apart from a trip to Innsbruck in 1675 to paint a portrait of Claudia Felice de' Medici, he remained in Florence, where he was a member of the Accademia del Disegno from 1648. Dolci painted a number of large altarpieces as well as portraits and still lifes, but his reputation rests chiefly on his meticulous small-scale devotional works, normally half-length single figures, in which he aimed to inspire a state of intense devotion.

242 Saint Catherine of Siena
 Cedar panel, 24.4 x 18.1 cm

Saint Catherine is shown in the habit of a Dominican tertiary with a crown of thorns. This refers to a vision in which Christ offered her the choice between a crown of gold and a crown of thorns and she chose the latter. Dated by Baldassari c.1665–70.

Bourgeois bequest, 1811.

C. McCorquodale in *Kolekcja dla Króla*, no.6; F. Baldassari, *Carlo Dolci*, Turin, 1995, no.122.

AFTER DOLCI

382 Mater Dolorosa
 Oak panel, 40 x 31.1 cm (oval)

A copy of Dolci's *Madonna del dito*, lost but known in an engraving by Bartolozzi and several other copies.

Dulwich College by 1890.

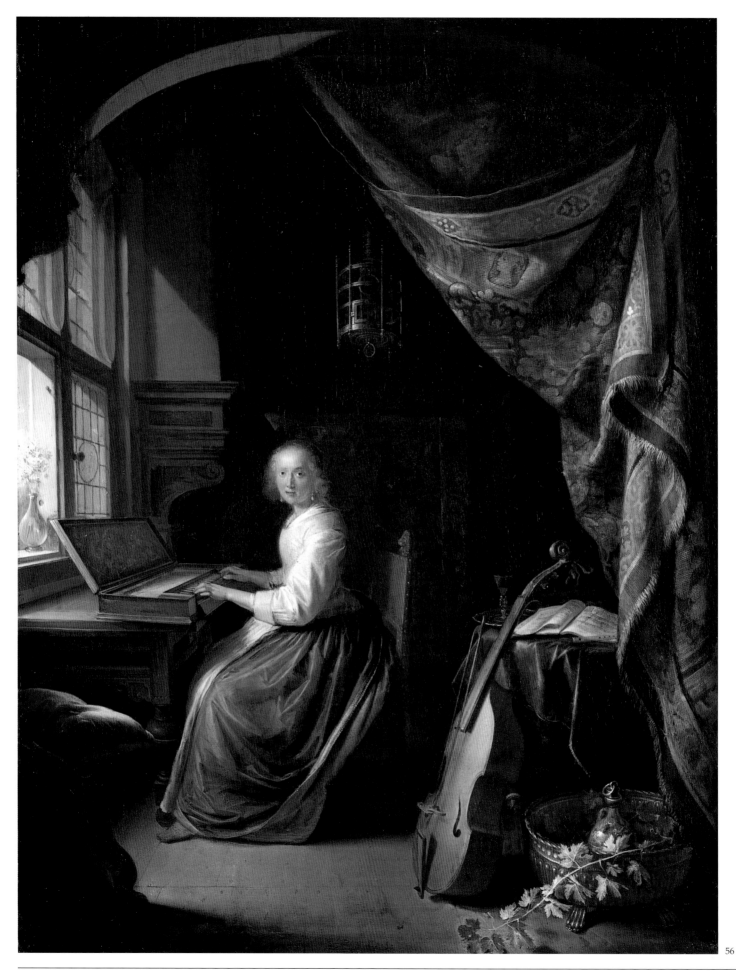

56

GERRIT DOU

Leiden 1613–1675 Leiden

Son of a glass engraver, Dou studied first with an engraver then a glass engraver and worked in his father's studio, entering the glaziers' guild, before becoming a pupil of Rembrandt in 1628. When Rembrandt moved to Amsterdam in 1631/2, Dou remained in Leiden, where he became a founder member of the painters' guild in 1648 and where he worked for the rest of his life. He painted genre scenes, as well as some portraits and still lifes, working on a small scale with obsessive technical precision. Dou was founder of the Leiden school of *fijnschilders* ('fine' painters).

56 A Woman playing a Clavichord
Oak panel, 37.7 x 29.8 cm

A signature on the side of the clavichord was recorded in 1947, but it is questionable whether slight traces remain. DPG56 is probably one of the paintings by Dou recorded in the collection of De Bye in Leiden in 1665. Baer suggests a date of *c.*1665. An infra-red photograph shows that the tablecloth on the right was painted over a metal ewer, suggesting that the whole still life was changed.

Bourgeois bequest, 1811.

HdG132 and 133a(?); Sumowski, I, no.287; P. Hecht in *De Hollandse Fijnschilders: Van Gerrit Dou tot Adriaen van der Werff*, cat. exh. Rijksmuseum, Amsterdam, 1989, no.8; R. Baer, *The Paintings of Gerrit Dou (1613–1675)*, diss., New York University, 1990, no.111.

GUILLAM DUBOIS

Haarlem 1623/5–1680 Haarlem

Guillam Dubois entered the Haarlem guild in 1646. His work shows the influence of Salomon van Ruysdael and later of Jacob van Ruisdael (q.v.). He made a trip to Germany in 1652–3, during which he worked under Abraham Cuyper in Cologne.

118 View on the Rhine
Canvas, 79.8 x 102.2 cm

A 'Hobbema' signature was recorded in 1874, but the attribution to Hobbema was rejected by Richter in 1880 in favour of Dubois. This attribution is accepted by J. Giltay (letter on file, 1996). The subject, as Giltay notes, would imply a date after 1653.

Bourgeois bequest, 1811.

SIMON DUBOIS

Antwerp 1632–1708 London

Simon Dubois studied with Philips Wouwermans (q.v.), 1652–3, and soon afterwards visited Italy (he is recorded in Venice in 1657). He was back in Haarlem by 1661 and by 1682 had moved to London, where he practised as a painter of portraits and miniatures, landscapes and battle scenes. One of Dubois's principal patrons was the Lord Chancellor Somers (see Riley DPG565). He also produced imitations of Italian old masters which he sold as originals. In 1706 he married a daughter of Willem van de Velde the younger (q.v.).

118

584

585

584 Portrait of a Man, called Sir William Jones
Signed, bottom right: *S. du . Bois . fecit*; dated, top left: *AD1682*; and inscribed, top right: *Æt 77*; and, bottom left: *S.ʳW.ᵐ Jones/ Father to L.ʸ/ Pelham*.
Canvas, 75.9 x 63.2 cm

The date and age inscribed at the top imply a sitter born *c.*1605. The inscription bottom left, which was doubtless added later, seems to refer to the lawyer Sir William Jones (1631–82), whose daughter married John Pelham of Laughton, Sussex. The inscription identifying the sitter is probably, therefore, untrustworthy and the same is likely of the companion portrait (DPG585 below).

Fairfax Murray gift, 1911.

C.H. Collins Baker, *Lely & the Stuart Portrait Painters*, 1912, II, p.68.

585 Portrait of a Woman, called Lady Jones
Signed and dated, bottom right: *S. du . Bois . fecit . 1682*; and inscribed, bottom left: *L.ʸ Jones/ Mother to L.ʸ/ Pelham*.
Canvas, 75.9 x 63.2 cm

See DPG584 above.

Fairfax Murray gift, 1911

Collins Baker, II, p.68.

656

70

30

GASPARD DUGHET

Rome 1615–1675 Rome

Dughet was the son of a French pastry cook. His sister Anne married Nicolas Poussin (q.v.) in 1630 and he became Poussin's pupil, 1631–5. He made trips to Milan and Castiglione del Lago in 1635 and visited Florence and Naples in the early or mid-1640s. In 1657 he became a member of the Accademia di San Luca in Rome. Dughet was one of the most successful landscape painters in Rome and undertook several important decorative commissions in fresco, as well as paintings on canvas. His works were especially admired by British collectors in the eighteenth century.

656 Landscape with Travellers
 Canvas, 144.7 x 220.9 cm

An early work, dated *c*.1638–9 by Boisclair.

Presented by the Linbury Trust, 1994.

M.-N. Boisclair, *Gaspard Dughet, 1615–1675*, Paris, 1986, no.61.

AFTER DUGHET

70 Landscape in the Roman Campagna
 Canvas, 73.4 x 98.5 cm

A reduced copy of Dughet's original formerly in the collection of the Duke of Sutherland (Boisclair, no.194).

Bourgeois bequest, 1811.
Boisclair, R37.

FOLLOWER OF DUGHET

30 Castle in a Wood
 Canvas, 47 x 36.8 cm

According to Boisclair, the work of an imitator of Dughet, also showing the influence of Tempesta.

Bourgeois bequest, 1811.
Boisclair, R36.

217 Village near a Lake
 Canvas, 49 x 60.7 cm

Bourgeois bequest, 1811.

479 Mountainous Landscape
 Canvas, 50.2 x 65.4 cm

See below.

Bourgeois bequest, 1811.

480 Fishermen near a Rocky Gateway
 Canvas, 49.5 x 65.7 cm

Possibly a pair to DPG479 above.

Bourgeois bequest, 1811.

217

479

480

72

KAREL DUJARDIN

Probably Amsterdam 1621/2–1678 Venice

Dujardin trained with Berchem (q.v.) in Haarlem and probably made a trip to Italy during the 1640s. In 1650 he was in Paris. By 1652 he was back in Amsterdam, working there and in The Hague (1656–8) until 1675, when he embarked on a second trip to Italy. He visited Tangier before settling mainly in Rome. Dujardin was chiefly a painter of Italianate landscapes but also produced portraits, and history, genre and animal subjects, and made a number of etchings.

72 Peasants and a White Horse
Canvas, 44.1 x 39.7 cm

A late work. Brochhagen saw a date, bottom left, '.676', but this seems to be a misreading of meaningless strokes.

Bourgeois bequest, 1811.

HdG70; E. Brochhagen, *Karel Dujardin. Ein Beitrag zum Italianismus in Holland im 17. Jahrhundert*, diss., Cologne, 1958, p.128; C. Brown in *Kolekcja dla Króla*, no.8.

82 A Smith Shoeing an Ox
Signed, bottom right: *. K . DV. IARDIN . fe*
Canvas, 38 x 42.8 cm

Probably painted in the late 1650s. A copy is in the National Gallery of Scotland, Edinburgh (HdG336).

Bourgeois bequest, 1811.

HdG under no.336; Brochhagen, p.57; C. Brown in *Collection for a King*, no.5 and *Kolekcja dla Króla*, no.7.

FOLLOWER OF DUJARDIN

48 A Woman with Cows
Oak panel, 23.2 x 18.4 cm

Bourgeois bequest, 1811.

82

FRIEDRICH DÜRCK

Leipzig 1809–1884 Munich

Dürck was a pupil in Leipzig of Schnorr von Carolsfeld and studied at the Munich Academy 1824–9. After a trip to Italy in 1836–7 he settled in Munich. He worked as a portrait painter – as such being called to the courts of Sweden and Austria – and later specialised in genre subjects and scenes of children.

643 A Neapolitan Woman

Signed and dated, lower left:
F. Dürck/ 1876
Canvas, 75.8 x 62.8

Gift of Miss Davies, 1961.

48

643

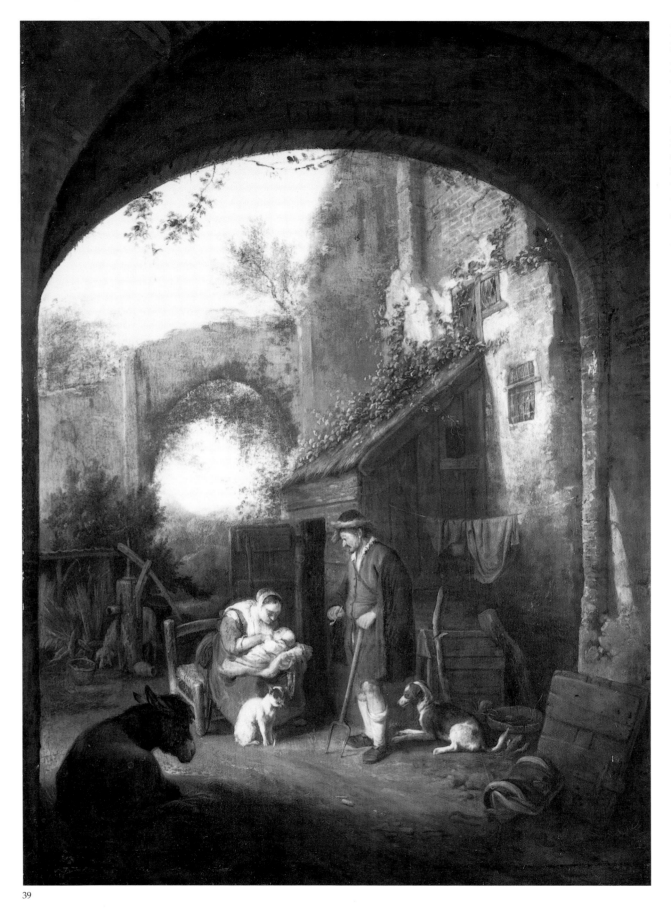

39

CORNELIS DUSART

Haarlem 1660–1704 Haarlem

Dusart was a pupil of Adriaen van Ostade (q.v.) and entered the Haarlem painters' guild in 1679, serving as dean of the guild in 1692. On Ostade's death in 1685, Dusart took over his studio and made use of his master's drawings. His earliest works are wholly dependent on Ostade, but he was later also influenced by Jan Steen. He was a prolific draughtsman and engraver.

39 Figures in the Courtyard of an old Building
Signed and dated, indistinctly on side of kennel, lower right:
C. Dusart 1682
Oak panel, 49 x 37.2 cm

Bourgeois bequest, 1811.

DUTCH SCHOOL, see p.295

ANTHONY VAN DYCK

Antwerp 1599–1641 London

Van Dyck was a pupil of Hendrik van Balen and was active as an independent master by 1618. He worked in Rubens's studio until 1620, when he spent some months in London before setting off for Italy in 1621. He spent six years in Italy, working mainly in Genoa but making trips to Sicily in 1623 and southern France in 1625. By 1628 he was back in Antwerp, where he was appointed court painter to the Archduchess Isabella. In 1632 he was called to England to become Principal Painter to Charles I and for most of the rest of his life he worked for the English court. Van Dyck made return trips to the Netherlands in 1634–5, 1640 and 1641, on both the last two occasions returning to London via Paris.

90 The Madonna and Child
Canvas, 153.7 x 116.5 cm, including an addition of approximately 30 cm at the top

DPG90 is one of the best versions of a composition repeated in numerous copies and replicas. Larsen suggests a date of *c*.1630–2. A variant, which differs principally in the angle of the Virgin's head, is in the Fitzwilliam Museum, Cambridge.

Bourgeois bequest, 1811.

E. Larsen, *The Paintings of Anthony Van Dyck*, 2 vols., Freren, 1988, no.647.

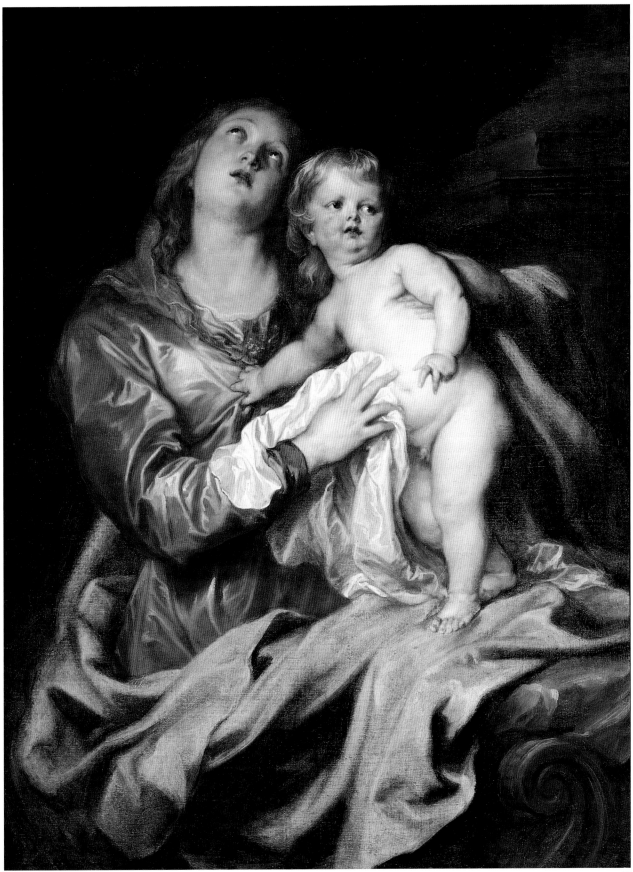

90

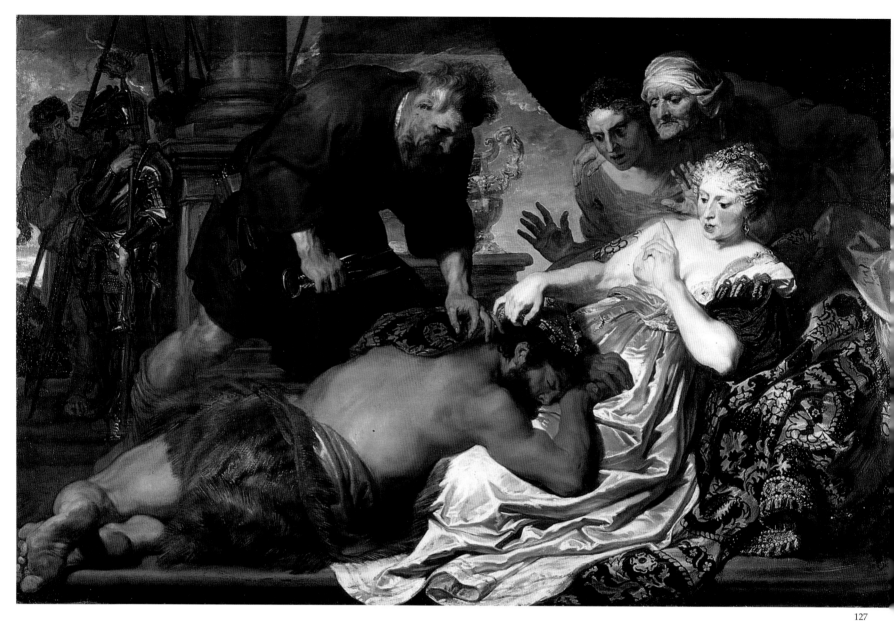

127 Samson and Delilah

Canvas, 151.4 x 230.5 cm, including an addition
of approximately 10 cm at the top

The subject is from Judges XVI, 19: Van Dyck depicts
the moment immediately before Samson's hair is shorn
and his strength thereby lost. The picture was probably
painted c.1619–20, while Van Dyck was working in
Rubens's studio. The composition derives from Rubens's
treatment of the subject in the National Gallery, London
of c.1609, but the composition is reversed and is
therefore probably taken from the print by Jacob
Matham. Two related drawings are recorded: a first idea
formerly at Bremen (now destroyed), and a squared
preparatory drawing in the Kupferstichkabinett, Berlin.

Bourgeois bequest, 1811.

Larsen, A38 (as an 18th-century copy); S.J. Barnes in *Anthony
Van Dyck*, cat. exh. National Gallery of Art, Washington, 1990–1
(catalogue by A.K. Wheelock, S.J. Barnes and J.S. Held), no.11.

170 George, Lord Digby, later 2nd Earl of Bristol

Canvas, 103.2 x 83.2 cm

George Digby (1612–77): married Anne Russell,
daughter of the Earl of Bedford, 1632; elected MP
for Dorset, 1640; created Baron Digby, 1641; ardent
Royalist during the Civil War; fled to France and
served in the French army; appointed secretary of state
by Charles II, 1657, but converted to Catholicism and
lost favour; he was also a poet and playwright.
DPG170 is datable c.1638–9.

Bourgeois bequest, 1811.

Larsen, no.945; M. Rogers in *Kolekcja dla Króla*, no.9;
A. Sumner in *Death, Passion and Politics*, no.7.

173 Emmanuel Philibert of Savoy, Prince of Oneglia

Canvas, 126 x 99.6 cm

Emmanuel Philibert (1588–1624): son of Charles
Emmanuel I, Duke of Savoy; created Prince of Oneglia,
1620, and Viceroy of Sicily, 1621. The armour, decorated
with emblems of the House of Savoy, survives in the
Royal Armouries at Madrid. Painted during Van
Dyck's stay in Palermo in the spring and summer of
1624; at this time there was an outbreak of plague,
from which Emmanuel Philibert died on 3 August.
The composition seems to be based on a lost portrait
by Titian of the Emperor Charles V. Barnes refers to an
oil sketch of the head and a possible *modello*, both of
unknown whereabouts.

Bourgeois bequest, 1811.

M. Rogers in *Collection for a King*, no.6; L.G. Boccia and
J.A. Godoy, 'La armadura del Príncipe Emanuele Filiberto de
Saboya (1588–1624)', *Reales Sitios*, XXIV, no.93, 1987, pp.64–5;
Larsen, no.368; S.J. Barnes in Washington 1990–1, no.38.

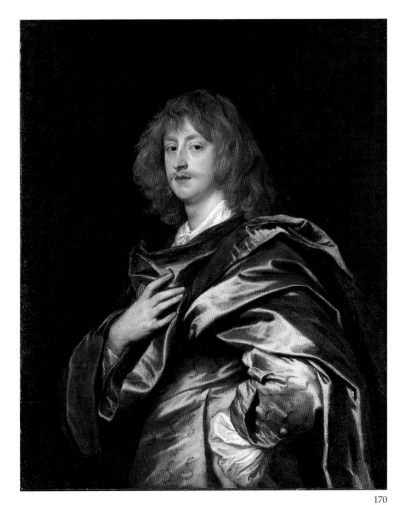

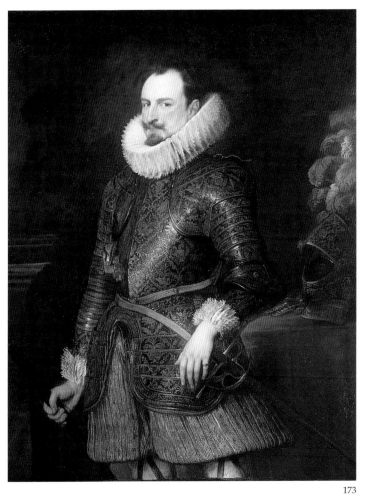

170

173

**194 Venetia Stanley, Lady Digby,
on her Death-bed**
Canvas, 74.3 x 81.8 cm

Venetia Stanley (1600–33): daughter of Sir Edward
Stanley; a notorious beauty; secretly married Sir
Kenelm Digby, seventh cousin of George Digby
(see Van Dyck DPG170), 1625; died unexpectedly
in her sleep during the night of 30 April–1 May
1633. Two days later Van Dyck was summoned
to paint DPG194, which he delivered in seven
weeks. The withered rose is a symbol of
transience. A copy in miniature by Peter Oliver
is at Sherborne Castle, Dorset.

Bourgeois bequest, 1811.

G.A. Waterfield in *Collection for a King*, no.7; Larsen,
no.845; A. Sumner in *Death, Passion and Politics*, no.31.

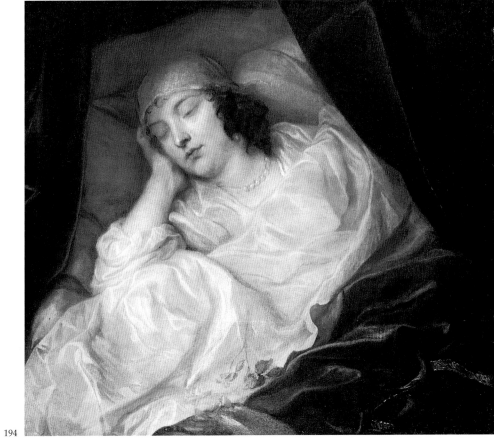

194

132

ATTRIBUTED TO VAN DYCK

132 Sunset Landscape with a Shepherd and his Flock
Canvas, 107.6 x 158.1 cm

DPG132 was catalogued as Rubens until 1880 and then as a copy after Rubens until Jaffé proposed the attribution to Van Dyck, suggesting a date early during the artist's stay in Italy. The shepherd and flock derive from an anonymous engraving after Titian. The cows seem to be taken from a drawing at Chatsworth, which has been attributed to Rubens but which Jaffé gives to Van Dyck.

Bourgeois bequest, 1811.

M. Jaffé, 'A Landscape by Rubens, and another by Van Dyck', *The Burlington Magazine*, CVIII, 1966, pp.410–14.

81

352

STUDIO OF VAN DYCK

81 Charity
Canvas, 141.9 x 105.4 cm

A replica, probably produced in Van Dyck's studio, of a composition dating from shortly after the painter's return to Antwerp from Italy in 1627/8. Autograph versions are in the National Gallery, London, and formerly in the Methuen collection, Corsham Court.

Bourgeois bequest, 1811.

Larsen, A160/1.

AFTER VAN DYCK

352 The Infants Christ and Saint John the Baptist
Inscribed, on the banderole: *[EC]CE AGN[US DEI] … IT E*
Canvas, 75.3 x 62.6 cm

A copy of Van Dyck's original in the Royal Collection.

Cartwright bequest, 1686.

N. Kalinsky in *Mr Cartwright's Pictures*, no.44.

381

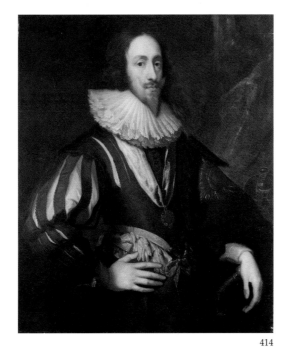

414

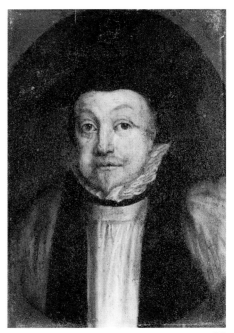

420

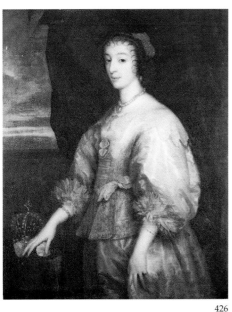

426

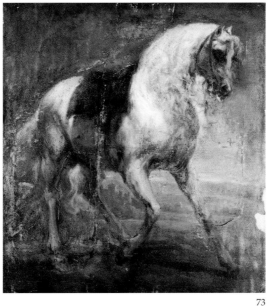

73

201

381 Queen Henrietta Maria
 Canvas, 67 x 54.6 cm

One of several copies or versions after a lost three-quarter length original by Van Dyck of the type known as 'the Queen in blue'.

Cartwright bequest, 1686.

R.T. Jeffree in *Mr Cartwright's Pictures*, no.9.

414 Charles I
 Canvas, 98.7 x 81.6 cm

An early copy of a lost Van Dyck portrait.

Cartwright bequest, 1686.

R.T. Jeffree in *Mr Cartwright's Pictures*, no.5.

420 Archbishop Laud
 Oak panel, 21.6 x 15.9 cm

William Laud (1573–1645): pre-eminent churchman under Charles I; archbishop of Canterbury, 1633; opponent of Puritanism; his attempt to interfere with the Scottish church led to his downfall; he was impeached of high treason by Parliament, 1640, and executed, 1645. DPG420 is a bust-length grisaille copy of a portrait by Van Dyck known in several versions.

Cartwright bequest, 1686.

N. Kalinsky in *Mr Cartwright's Pictures*, no.17.

426 Queen Henrietta Maria
 Canvas, 104.8 x 84.7 cm

An early copy of Van Dyck's original in the Royal Collection.

Cartwright bequest, 1686.

R.T. Jeffree in *Mr Cartwright's Pictures*, no.6.

MANNER OF VAN DYCK

73 A Grey Horse
 Paper on oak panel, 47.6 x 43.6 cm

On the verso is a crude sketch of a figure with outstretched arms (Moses?).

Bourgeois bequest, 1811.

**201 A Woman, called
 Lady Penelope Naunton**
 Canvas, 121.6 x 95.6 cm

Formerly catalogued as a portrait of Penelope Naunton, probably under the mistaken impression that the subject is the wife of the sitter in DPG170, who was formerly identified as the 5th Earl of Pembroke.

Bourgeois bequest, 1811.

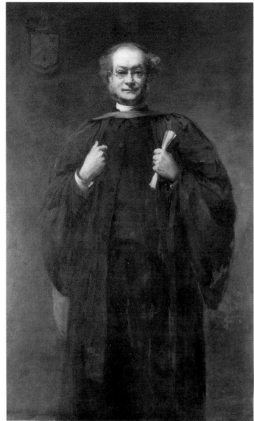

441

497

353

JOHN ELLYS

*c.*1701–1757 London

Ellys studied with Thornhill from the age of about fifteen before entering Vanderbank's Academy. He obtained permission to copy pictures in the Royal collection and was appointed Principal Painter to the Prince of Wales in 1736. Through his association with Sir Robert Walpole, for whom he acted as agent in acquiring pictures, Ellys was appointed to the post of 'Master Keeper of the Lyons at the Tower of London'.

441 James Allen

Signed, lower right: *J Ellys p*; and inscribed, on the scroll: *Sussex &/ Wigorn} ss Rotulus Jacobi Allen*; and lower centre right: *JA/ 42/ 1724*
Canvas, 239.7 x 147.3 cm

James Allen (*c.*1682–1746): Warden of Dulwich College, 1712; Master, 1721; founder of James Allen's Girls' School. The signature was revealed in cleaning, 1988, and is confirmed by a payment in the College accounts. An inscription is recorded on the verso: *This for The Right Honourable my Lady Pitsligo.*

Commissioned by Alleyn's College, 1724.

SAMUEL MELTON FISHER

London 1860–1939 Camberley

Fisher was educated at Dulwich College and studied at the Lambeth School of Art and the RA Schools, where he was awarded a gold medal and a travelling studentship. He then studied in France with Jules Bonnaffé and spent several years in Italy. He exhibited at the RA 1878–1940, being elected ARA in 1917 and RA in 1924. Fisher painted portraits, and figure subjects, genre scenes (often in Italian settings), flower pieces and garden landscapes.

497 The Reverend A. J. Carver

Signed and dated, bottom left: *S. Melton Fisher. 1882*
Canvas, 151.4 x 93.9 cm

The Rev. Alfred James Carver (1826–1909): in 1858 appointed Master of Alleyn's College of God's Gift, which, under his mastership, divided to become Dulwich College and Alleyn's School; responsible for the rebuilding of the College by Charles Barry Junior, 1866–70; retired, 1883. DPG497 was exhibited at the RA in 1882.

Gift of Francis Peek, 1883.

FLEMISH SCHOOL, see p.297

FRANS FLORIS

Antwerp 1519/20–1570 Antwerp

MANNER OF FLORIS

353 Marine Deities

Oak panel, 62.8 x 78.8 cm

Cartwright bequest 1686.

N. Kalinsky in *Mr Cartwright's Pictures*, no.53.

JEAN-HONORÉ FRAGONARD

Grasse 1732–1806 Paris

Fragonard studied briefly
with Chardin and then with
Boucher, winning the *prix de
Rome* in 1752 and pursuing
his studies there from 1753.
In 1760–1 he travelled in Italy
with his patron, the abbé de
Saint-Non, and returned with
him to Paris. Fragonard was
agréé at the Académie in
1765 but never produced a
reception piece. He made two
trips to the Netherlands and
another to Italy in 1773–4.

74 Young Woman
Signed, lower right:
FRago (overpainted);
and inscribed, below
the signature: *Grimou*
Canvas, 62.9 x 52.7 cm

The inscription is a false
signature (apparently added
by the artist) referring to
Jean-Alexis Grimou
(1678–1733). The style and
bravura handling are
certainly Fragonard's, as was
first recognised by Rosenberg
and Compin, and as the
overpainted signature
confirms. Rosenberg suggests
a date of *c.*1769.

Bourgeois bequest, 1811.

P. Rosenberg and I. Compin,
'Quatre nouveaux Fragonards',
Revue du Louvre, 1974, 3,
pp.183–92; *Fragonard*, cat. exh.
Grand Palais, Paris/Metropolitan
Museum of Art, New York,
1987–8 (catalogue by
P. Rosenberg), no.103.

74

BALDASSARE FRANCESCHINI (IL VOLTERRANO)

Volterra 1611–1690 Florence

CIRCLE OF FRANCESCHINI

252 Saint Catherine of Siena
Canvas, 87.6 x 103.5 cm

For the subject, see Dolci DPG242. The traditional attribution to Andrea Sacchi is rejected by Zeri, who instead proposes a Florentine artist close to Volterrano (see G. Viroli, *La Pinacoteca Civica di Forlì*, Forlì, 1980, p.305). Sutherland Harris no longer accepts DPG252 as the work of Sacchi (letter on file, 1997).

Bourgeois bequest, 1811.

A. Sutherland Harris, *Andrea Sacchi*, Oxford, 1977, no.47 (as Sacchi); *Les Vanités dans la Peinture au XVIIᵉ siècle*, cat. exh. Musée des Beaux-Arts, Caen, 1990, F21 (as Sacchi).

252

MARCANTONIO FRANCESCHINI

Bologna 1648–1729 Bologna

Marcantonio Franceschini studied with Giovanni Maria Galli-Bibiena before entering the studio of Cignani (q.v.). As an independent painter from the early 1680s, he produced frescoes and altarpieces, as well as small mythological and pastoral subjects, which were much prized by foreign collectors. From 1691 he was engaged on an extensive decorative series for the Gartenpalais Liechtenstein outside Vienna. In 1711 he was called to Rome to make cartoons for mosaics in St Peter's, for which he was knighted by Pope Clement XI. Franceschini was a founder member of the Accademia Clementina in Bologna, succeeding Cignani as its director, 1719–22.

313 The Guardian Angel
Canvas, 100.3 x 75.3 cm

First attributed to Franceschini by D. Miller, as 'a fine picture … of the artist's maturity' (letter on file, 1972). Probably, according to Miller, one of the versions of this subject noted in Franceschini's account book on 5 August and 20 December 1716.

Bourgeois bequest, 1811.

313

629

379

629 Lot and his Daughters
 Canvas, 105.8 x 89.8 cm

The subject is from Genesis XIX, 33–5: Lot's daughters ply him with wine in order to seduce him. DPG629 was attributed to Gennari until recognised by D. Miller as a replica of an early work by Franceschini (of 1676/7), last recorded in the Motta collection, Bologna, in 1956 (letters on file, 1972, 1996).

Gift of Captain A.E.F. Fuller, 1951.

ISAAC FULLER

Active 1644–died 1672 London

Fuller is first recorded at Oxford in 1644. A Royalist, he moved to Paris probably in 1645 and there trained with François Perrier. He was back in England by 1650 and published a drawing book in 1654. Fuller painted history subjects and portraits, undertook wall-paintings in Oxford colleges and London taverns, and worked as a scene painter, in which capacity he probably came into contact with William Cartwright (see Greenhill DPG393). See also British School DPG569.

379 Head of a Girl
 Canvas, 40.6 x 35.8 cm

Attributed to Fuller in the Cartwright inventory. The costume suggests a date in the early 1660s.

Cartwright bequest, 1686.

R.T. Jeffree in *Mr Cartwright's Pictures*, no.39.

FRENCH SCHOOL, see p.298

66

140

302

THOMAS GAINSBOROUGH

Sudbury (Suffolk) 1727–1788 London

Gainsborough studied in London from c.1740 with Gravelot and probably Francis Hayman and worked in Sudbury, Ipswich and Bath before returning to London in 1774. He was the first great English landscape painter, basing his style on Ruisdael and Wijnants (qq.v.). During his Bath period he increasingly became known as a fashionable portrait painter, sending pictures to the Society of Artists in 1761–8. Gainsborough was a founder member of the RA in 1768 and exhibited there in 1769–72 and 1777–83, as well as at the Free Society in 1774 and 1783. In London he was, with Reynolds (q.v.), the leading portrait painter. From the late 1770s he began to paint 'fancy pictures', which owe their inspiration to the genre scenes of Murillo (q.v.).

66 Philippe Jacques de Loutherbourg
 Canvas, 76.5 x 63.2 cm

For the sitter, see Loutherbourg below. Exhibited at the RA in 1778.

Bourgeois bequest, 1811.

E. Waterhouse, *Gainsborough*, London, 1958, no.456; L. Stainton in *Collection for a King*, no.8 and *Kolekcja dla Króla*, no.10; G.A. Waterfield in *A Nest of Nightingales*, no.14:6.

140 Thomas Linley the elder
 Inscribed on the sheet of music:
 ELEGY/ [fo]r Three Voices
 Canvas, 76.5 x 63.5 cm

Thomas Linley the elder (1733–95): father of eight musical children, seven of whom are represented in portraits at Dulwich (Gainsborough DPG302, DPG320, DPG331; Lawrence DPG178, DPG475; Attributed to Lawrence DPG474; Oliver DPG476; for their mother, see Lonsdale DPG456). He was himself a music teacher, performer and composer, and directed a series of concerts at the Assembly Rooms in Bath in which the performances of his children were well received. He was also involved with the London theatre and in 1776 became part-owner and musical director of the Drury Lane Theatre. In DPG140, Linley is shown holding a manuscript of his *Elegies for Three Voices*, published in 1770. The portrait is dated by Waterhouse to the later 1760s.

Linley bequest, 1831/5.

Waterhouse, no.446; S. Wallington in *A Nest of Nightingales*, no.1:1.

302 Samuel Linley
 Canvas, 75.8 x 63.5 cm

Samuel Linley (1760–78): second son of Thomas Linley the elder (see Gainsborough DPG140); sang in his father's concerts, 1774–5, and played the oboe. In 1778 he became a midshipman on HMS Thunderer, aboard which he contracted the fever from which he died. In DPG302, Samuel Linley seems to be represented in midshipman's uniform, thus the portrait probably dates from 1778. According to family tradition, it was painted in 48 minutes.

Linley bequest, 1831/5.

Waterhouse, no.445; L. Stainton in *Collection for a King*, no.9 and *Kolekcja dla Króla*, no.11; G.A. Waterfield in *A Nest of Nightingales*, no.6:1.

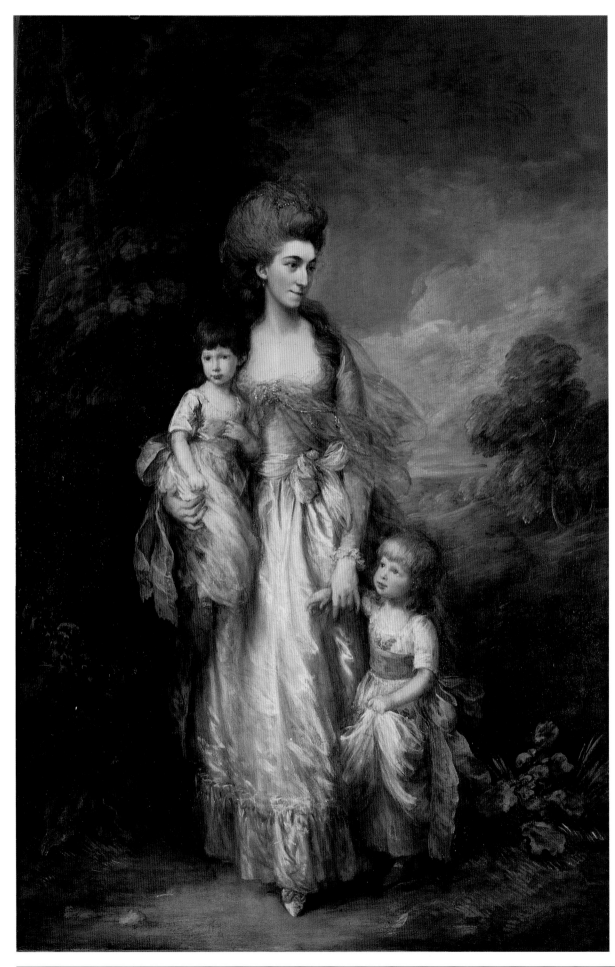

316 Mrs Elizabeth Moody
and her two Sons
Canvas, 234 x 154.2 cm

Elizabeth Moody, née Johnson
(1756–82). In 1779 she married Samuel
Moody (see Russell DPG601), to whom
she bore two sons, Samuel (b.1781) and
Thomas (b.1782). An X-ray reveals that
DPG316 was originally painted as a
single portrait, the sitter's right hand
raised to finger a string of pearls at her
chest. The portrait in this state was
probably painted *c*.1779/80. The
children must have been added after
their mother's death – probably, from
the evidence of their apparent ages, in
1784/5.

Gift of Captain Thomas Moody, 1831.

Waterhouse, no.498; A. Sumner in *Conserving
Old Masters*, no.12.

320 The Linley Sisters
(Mrs Sheridan and Mrs Tickell)
Canvas, 199 x 153.1 cm

Elizabeth Anne Linley (1754–92) and
Mary Linley (1758–87): the eldest
daughters of Thomas Linley the elder
(see Gainsborough DPG140). Both were
talented singers and performed in Bath
and London until their respective
marriages to playwrights, Elizabeth
to Richard Brinsley Sheridan in 1773
and Mary to Richard Tickell in 1780.
DPG320 was probably painted in
1771/2 and retouched by the artist
in 1785.

Gift of W. Linley, 1831.

Waterhouse, no.450; N. Kalinsky in *A Nest of
Nightingales*, no.3.3.

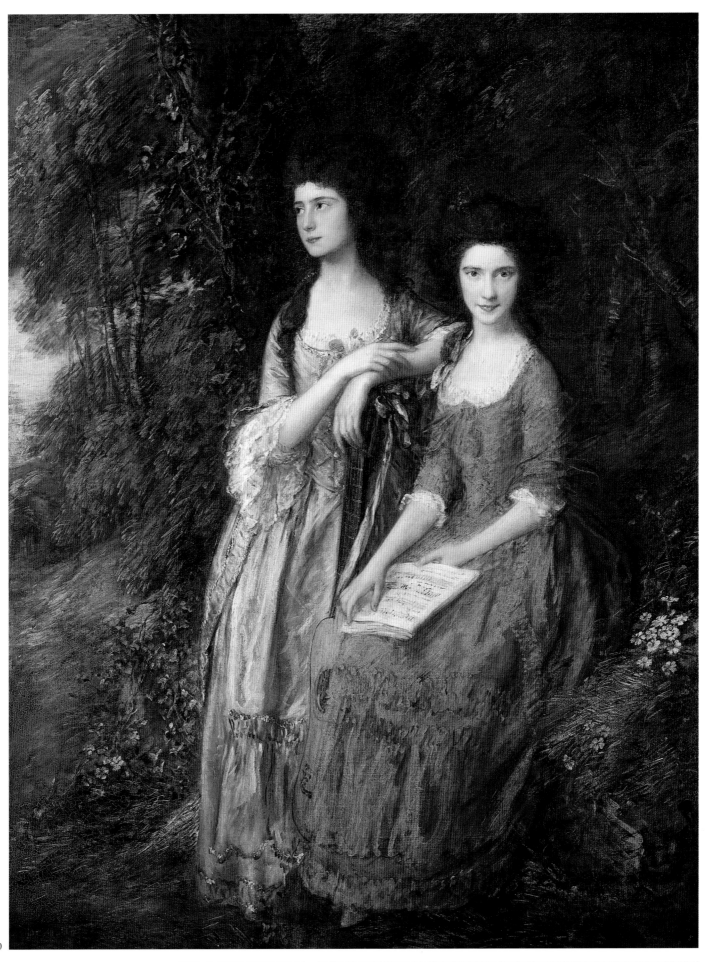

331

331 Thomas Linley the younger
Canvas, 75.9 x 63.5 cm

Tom Linley (1756–78): first son of
Thomas Linley the elder (see
Gainsborough DPG140). A singer,
violinist and composer, he studied the
violin with Nardini in Florence, where
he met Mozart in 1770. He returned to
England in 1771 and performed in the
concerts directed by his father in Bath
and at the Drury Lane oratorios. He
composed violin sonatas and concertos
as well as choral works, and provided
most of the music for Sheridan's opera
The Duenna (1775). Tom Linley drowned
in a boating accident aged 22. DPG331
was probably painted shortly after his
return to England in 1771.

Linley bequest, 1835.

Waterhouse, no.447; S. Wallington in *A Nest of
Nightingales*, no.5:1.

588 An Unknown Couple
in a Landscape
Canvas, 76.2 x 67 cm

Dated by Waterhouse to the mid-1750s
and identified as a companion to the
Girl seated in a Park in the Fitzwilliam
Museum, Cambridge. An X-ray reveals
an underlying half-length female
portrait. Gainsborough turned the
canvas upside down before repainting
it with the present composition.

Fairfax Murray gift, 1911.

Waterhouse, no.753; L. Stainton in *Collection
for a King*, no.10.

ARENT DE GELDER

Dordrecht 1645–1727 Dordrecht

De Gelder studied with Samuel van Hoogstraten in Dordrecht, c.1660–2, before moving to Amsterdam to become a pupil of Rembrandt, probably 1662–4. He then returned to Dordrecht, and is recorded there from 1669. For the rest of his life he remained a prominent and wealthy citizen of Dordrecht, where he held various posts in the civic militia. De Gelder was a painter mainly of biblical subjects and portraits, working in a style that remained largely dependent on the late work of Rembrandt.

126 Jacob's Dream

Signed, lower right: *AD Gelder*
(AD in monogram)
Canvas, 66.7 x 56.9 cm

The subject is from Genesis XXVIII, 12: Jacob dreamt of a ladder reaching from earth to heaven with angels passing up and down. The picture was much admired as a work by Rembrandt until Richter rejected the attribution in 1880. Hofstede de Groot recognised the hand of De Gelder in 1914, and the signature was discovered during cleaning in 1946. Sumowski suggests a date of 1710/15.

Bourgeois bequest, 1811.

HdG, VI, p.456 n.8; Sumowski, II, no.781; C. White in *Collection for a King*, no.11 and *Kolekcja dla Króla*, no.12; J.W. von Moltke, *Arent de Gelder, Dordrecht 1645–1727*, Doornspijk, 1994, no.9.

GELLÉE, see Claude

MARCUS GHEERAERTS THE YOUNGER

Bruges 1561/2–1636 London

Gheeraerts came to London in 1568 with his father, Marcus the elder, a painter from whom he probably received his first training. He may have further studied with Lucas de Heere and probably travelled in the Low Countries before establishing himself in London. He married the sister of John de Critz (q.v.) in 1590. From c.1592, under the patronage of Sir Henry Lee, Gheeraerts became the most successful court portrait painter of the period, being referred to in 1611 as 'His Mat[ies] Paynter'. However, with the arrival of Paul van Somer and Daniel Mijtens, he lost favour at court.

389 Portrait of a Woman

Inscribed, bottom left: *[Q].ⁿ Elizabet[h]*
Oak panel, 114 x 83.5 cm

The attribution to Gheeraerts was proposed by Strong (letter on file, 1987) and confirmed by cleaning. Probably painted c.1615/18.

Cartwright bequest, 1686.

R.T. Jeffree in *Mr Cartwright's Pictures*, no.34.

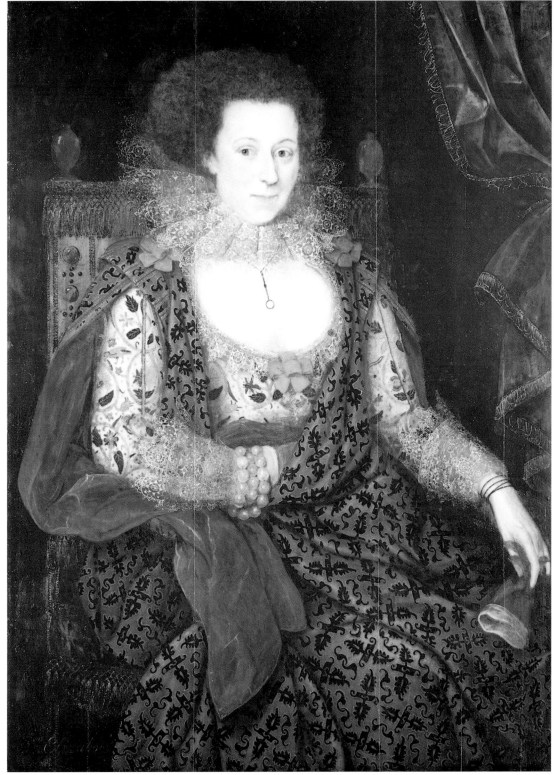

389

350

406

433

JAN PAUWEL GILLEMANS THE ELDER

Antwerp 1618–after 1674 Antwerp

FOLLOWER OF GILLEMANS

350 Still Life with Fruit and a Squirrel
Canvas, 51.7 x 108.6 cm

Pendant to DPG433 below and probably by the same artist as DPG406 below. Bergström (letter on file, 1987) suggested an attribution for this group to Gillemans. F. Meijer, however, regards the pictures as the work of an unidentified Flemish artist, possibly a pupil of Gillemans.

Cartwright bequest, 1686.
N. Kalinsky in *Mr Cartwright's Pictures*, no.78.

406 Still life with Fruit, Flowers and Crayfish
Canvas, 64.7 x 108.6 cm

See DPG350 above.

Cartwright bequest, 1686.
N. Kalinsky in *Mr Cartwright's Pictures*, no.79.

433 Still Life with Fruit and a Bird
Canvas, 51.4 x 108.6 cm

Pair to Follower of Gillemans DPG350 (q.v.).

Cartwright bequest, 1686.
N. Kalinsky in *Mr Cartwright's Pictures*, no.77.

602

GIULIO ROMANO

Rome 1499?–1546 Mantua

AFTER GIULIO ROMANO

602 Madonna and Child with Saints Elizabeth (or Anne) and John
Pine panel, 148.3 x 117.2 cm

A copy of the *Holy Family* (known as *La Perla*) in the Prado, Madrid, painted by Giulio Romano, probably after a design by Raphael.

Fairfax Murray gift, 1917.

ANTON GOUBAU

Antwerp 1616–1698 Antwerp

Goubau was a pupil in Antwerp of Johannes de Farcas (or Farius) and became a member of the painters' guild in 1636/7. In the 1640s he made a trip to Rome, where his presence is securely documented in 1646–8. He was back in Antwerp by 1650 and there became a member of the Jesuit order in 1655. Goubau painted mainly market scenes with numerous figures.

ATTRIBUTED TO GOUBAU

20 Landscape with Figures
Copper, 20.4 x 30 cm

Formerly catalogued as 'Attributed to Jan Miel'. Murray recorded possible traces of a monogram *JM*, but this seems to be a misreading of meaningless strokes. Kren rejected the attribution to Miel, proposing that to Goubau. Trezzani rejected the attribution to Goubau, suggesting analogies with the work of Bourdon (q.v.) and the Master of the Small Trades. DPG20 might also be the work of Jacob van Staveren, as P. Sutton proposed (letter on file, 1990), citing a comparable composition sold as Van Staveren at Sotheby's, Amsterdam,

22 May 1989 (lot 1). Kren maintains the attribution to Goubau (letter on file, 1997).

Bourgeois bequest, 1811.

T. Kren, *Jan Miel (1599–1604), a Flemish Painter in Rome*, diss., Yale University, 1978, D57; L. Trezzani, 'Anton Goubau', in G. Briganti et al., *The Bamboccianti*, Rome, 1983, p.295 n.3.

MADELINE GREEN

Died Bedford? 1947

A member of the Society of Women Artists, 1923, Madeline Green exhibited at the RA 1912–43, at the Glasgow Institute of the Fine Arts 1916–46, and at the Royal Scottish Academy 1934. She painted figure studies, animals and occasional townscapes.

618 The Chenille Net
Signed, centre right: *M.G.*
Canvas, 40.6 x 25.4 cm

A self-portrait, exhibited under the above title at the RA and at the Glasgow Institute in 1938 and awarded a gold medal at the Paris Salon of 1947.

Bequest of the artist's sister, 1951.

618

374

387

JOHN GREENHILL

Orchardleigh (Somerset) 1642–1676 London

Greenhill's early years were spent in Salisbury, but by 1662 he had joined Lely's studio in London. Soon afterwards he set up his own practice, painting portraits in oil and pastel. He was a friend of William Cartwright, who owned six paintings by him as well as some pastels and drawings (the latter in an album which he bequeathed to Dulwich College). Greenhill also became acquainted with other actors, some of whom, reputedly, led him into the dissipation which resulted in his death.

374 Portrait of a Man
Signed, bottom left: *J.G.*
Canvas, 75.5 x 62.8 cm

Probably painted in the mid-1660s. A drawing by Greenhill of the same sitter is in the Cartwright album of drawings at Dulwich College.

Cartwright bequest, 1686.

R.T. Jeffree in *Mr Cartwright's Pictures*, no.35.

387 Jane Cartwright
Canvas, 74.5 x 60 cm

Unattributed in the Cartwright inventory, but the sitter is there identified as Cartwright's last wife, Jane Hodgson, whom he married in 1654.

O. Millar records having seen a signature 'J.G.' when the picture was restored after the War, but no trace of this can now be found. Probably painted in the early 1660s.

Cartwright bequest, 1686.

R.T. Jeffree in *Mr Cartwright's Pictures*, no.23.

393 William Cartwright the younger
Canvas, 102.8 x 84.9 cm

William Cartwright the younger (1606–86): probably the son of William Cartwright the elder (see British School DPG400); actor at the Salisbury Court Theatre until the Civil War; bookseller during the Commonwealth; joined the King's Men, 1660, under the management of Thomas Killigrew; bequeathed the major part of his estate, including a numerous collection of pictures, to Dulwich College (see Introduction, p.15). The dog collar is embossed with the sitter's initials. No artist's name is given in the Cartwright inventory, but DPG393 is attributable to Greenhill and probably dates from the mid-1660s. The pose is directly based on Van Dyck's portrait of Killigrew at Weston Park. A preliminary drawing is in the Cartwright album of drawings at Dulwich College.

Cartwright bequest, 1686.

R.T. Jeffree in *Mr Cartwright's Pictures*, no.19.

393

399 Portrait of a Woman, called Mrs Cartwright
Signed, on stone trough, bottom centre right: *J.G*
Canvas, 94.3 x 73 cm

DPG399 has traditionally been identified with no.78 in Cartwright's inventory, described as 'my first wifes pictur Like a Sheppardess…'. However, a label on the verso identifies the picture almost certainly as no.186, which occurs on one of the missing pages of the inventory. The hairstyle and costume suggest a date in the mid-1660s.

Cartwright bequest, 1686.

R.T. Jeffree in *Mr Cartwright's Pictures*, no.22.

399

416

418 Self-portrait
Canvas, 106.3 x 82.9 cm

Probably an early work painted immediately after Greenhill left Lely's studio. The pose seems to be based on Van Dyck's *Self-portrait with a Sunflower* in the collection of the Duke of Westminster. The sitter holds a portrait drawing of himself by Lely, now in the British Museum (cat. exh. *Sir Peter Lely, 1618–80*, National Portrait Gallery, London, 1978–9, no.82).

Cartwright bequest, 1686.

R.T. Jeffree in *Mr Cartwright's Pictures,* no.18.

CHARLES GRIGNION THE YOUNGER

London 1754–1804 Livorno

Grignion was a pupil of Giovanni Battista Cipriani, then at the RA Schools, where he was awarded a gold medal in 1776 and a travelling scholarship to Rome in 1782. He remained in Italy until the Napoleonic invasion and then retired to Livorno. Grignion painted portraits and some history subjects and is said to have painted landscapes, but few of his works are securely identified.

ATTRIBUTED TO GRIGNION

595 Haines the Younger
Canvas, 61 x 50.1 cm

With his father, Haines was proprietor of Tom's Coffee House in Great Russell Street, Covent Garden. Catalogued since 1926 as the work of Charles Grignion the elder (1716–1810), an engraver, but this is presumably a confusion with the painter, Charles Grignion the younger.

Fairfax Murray gift, 1915.

416 James, Duke of York
Canvas, 74.9 x 62.2 cm

James Stuart (1633–1701), Duke of York; later King James II. Attributed to Greenhill in the Cartwright inventory. Probably painted in the early 1660s.

Cartwright bequest, 1686.

R.T. Jeffree in *Mr Cartwright's Pictures,* no.8.

418

644

FRANCESCO GUARINO

Sant'Agata Irpina (near Solofra) 1611–1654 Gravina di Puglia

AFTER GUARINO

644 Saint Agatha
Canvas, 86.9 x 71.4 cm

Saint Agatha was a Christian noblewoman of Catania who was tortured for refusing to worship idols: her breasts were cut off. DPG644 is a copy of Guarino's original in the Museo di Capodimonte, Naples.

Gift of Miss Davies, 1961.

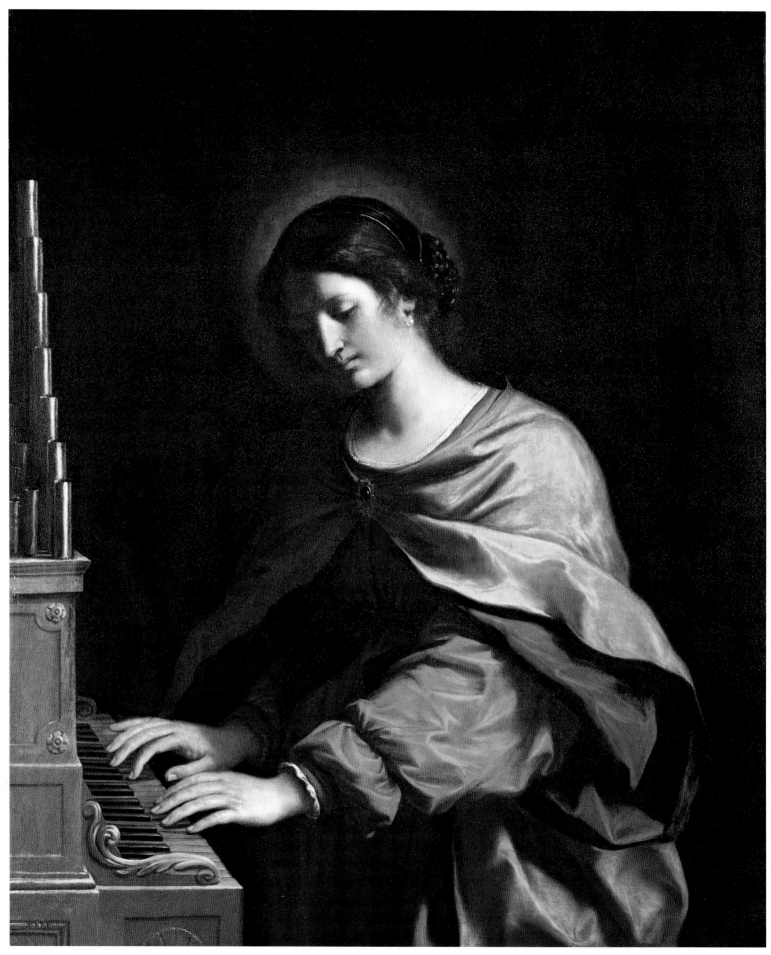

237

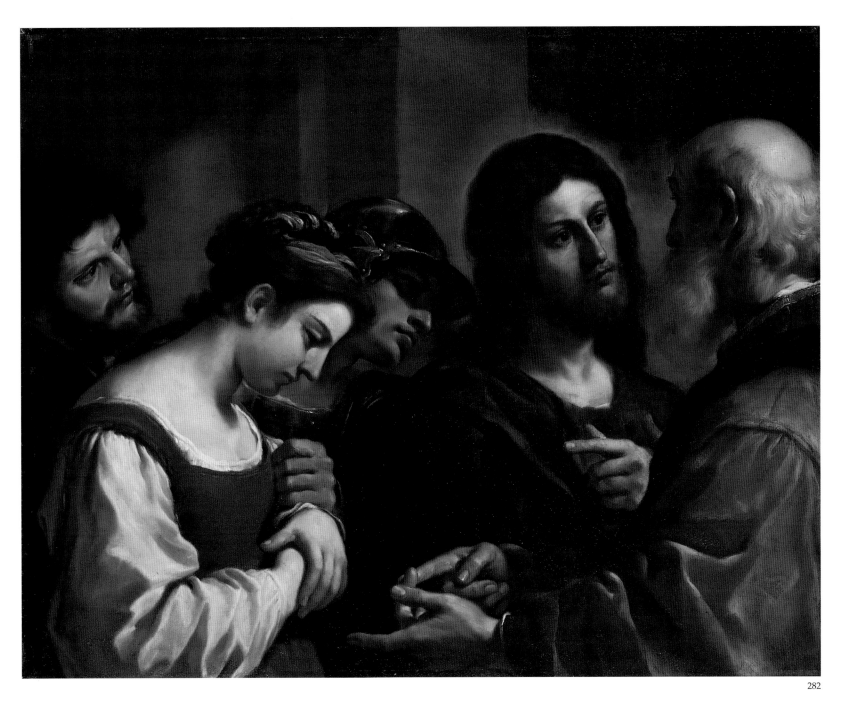

282

GUERCINO

Cento 1591–1666 Bologna

Giovanni Francesco Barbieri, nicknamed Guercino ('squint-eyed'), served his apprenticeship in Cento from 1607 with Benedetto Gennari the elder and received his first major public commission in Cento in 1613. After a trip to Venice, he was called to Rome by Pope Gregory XV in 1621 and remained there until the Pope's death in 1623. He then returned to Cento, where he remained until 1642. Following the death of Guido Reni (q.v.) in that year, Guercino moved his studio to Bologna. The vigorous, dramatic style of his early years was modified after his visit to Rome in favour of a more restrained and classical manner.

237 Saint Cecilia
Canvas, 121.9 x 101 cm

Saint Cecilia was a Roman virgin martyr who, from the fifteenth century, was represented as the patron saint of music. DPG237 was catalogued by Richter in 1880 as the work of Guercino's pupil Benedetto Gennari the younger, but was recognised

as an autograph Guercino by D. Mahon. It may be the half-length *Saint Cecilia* painted for the marchesa Virginia Turca Bevilacqua, for which payments of 1648 and 1650 are recorded in the artist's account books.

Bourgeois bequest, 1811.

L. Salerno, *I Dipinti del Guercino*, Rome, 1988, no.266.

282 The Woman taken in Adultery
Canvas, 98.2 x 122.7 cm

The subject is from John VIII, 3–7: the Pharisees brought before Christ a woman caught in the act of adultery, asking whether, in accordance with the law of Moses, she should be stoned. 'He that is without sin among you,' replied Christ, 'let him first cast a stone at her.' Dated by Mahon 1621. A drawing bearing preparatory studies, recto and verso, is in the Albertina, Vienna.

Bourgeois bequest, 1811.

D. Mahon in *Collection for a King*, no.12; Salerno, no.75.

609

572

553

ADRIAEN HANNEMAN

The Hague 1604?–1671 The Hague

Hanneman trained in The Hague with the portrait painter Anthonie van Ravesteyn the younger. He was in London, probably 1626–38, where he was influenced by Van Dyck, possibly being employed in his studio. In 1640 he became a member of the painters' guild in The Hague, where he enjoyed a successful career as a portrait painter. Hanneman served as dean of the guild in 1645 and was also dean of the painters' confraternity in The Hague, *Pictura*, in 1656–9 and 1663–6. There are no dated works after 1668 and it is possible that his career was cut short by ill health.

572 Portrait of a Man
 Dated and signed, lower right:
 An.º 1655/ Adr. Hanneman/ F.
 Canvas, 82.2 x 65.4 cm

A female portrait in the Metropolitan Museum of Art, New York, is possibly a pendant (Ter Kuile, no.24).

Fairfax Murray gift, 1911.

O. ter Kuile, *Adriaen Hanneman, 1604–1671, een haags portretschilder*, Alphen aan den Rijn, 1976, no.32.

ATTRIBUTED TO HANNEMAN

609 Portrait of a Man
 Canvas, 56.2 x 45.7 cm

The attribution to Hanneman was rejected by Ter Kuile, but remains possible according to R. Ekkart

(oral communication, 1997). De Jongh suggests that the pearls are symbolic of Chastity or Faith, but they may identify the sitter as a jeweller. A copy is in the Staatliche Kunsthalle, Karlsruhe.

Bequest of H. Margaret Spanton, 1934.

E. de Jongh, 'Pearls of virtue and pearls of vice', *Simiolus*, 8, 1975/6, pp.89–90; Ter Kuile, p.126 (rejected attributions).

E. HASTAIN

Dates unknown

553 The Reverend A. J. Carver
 Canvas, 81.3 x 66 cm

For the sitter, see DPG497.

Gift of W. Miller, 1908.

JAN VAN DER HEYDEN

Gorinchem 1637–1712 Amsterdam

Van der Heyden is said to have trained with a glass painter. His pictures show that he travelled extensively in the Netherlands and the Rhineland; he may also have visited London. From 1668 he was increasingly concerned with improvements to street lighting and fire-fighting equipment in Amsterdam and he seems to have painted little after c.1680. Apart from his townscapes, which are normally fanciful though containing real buildings, he also painted landscapes and some still lifes.

155 Two Churches and a Town Wall
> Signed, bottom left: *VHeijde* (VH in monogram)
> Oak panel, 28.2 x 33.6 cm

The view is fanciful, though the church, as Wagner notes, resembles that of Saint Francesca Romana, Rome. The figures have been attributed to Adriaen van de Velde (q.v.).

Bourgeois bequest, 1811.

HdG126; H. Wagner, *Jan van der Heyden, 1637–1712*, Amsterdam/Haarlem, 1971, no.188.

566

561

JOSEPH HIGHMORE

London 1692–1780 Canterbury

Highmore studied law before becoming a pupil in Kneller's Academy from 1713 and at the St Martin's Lane Academy from 1720. He made a trip to the Low Countries in 1732 and visited Paris and Versailles in 1734. He exhibited at the Society of Artists in 1760 and at the Free Society of Artists in 1761. Highmore painted portraits, conversation pieces and a few subject pictures. He was also a prolific essayist. In 1761 he gave up painting and retired to Canterbury, devoting himself to literary pursuits.

566 Portrait of a Woman in Blue
Signed and dated, lower left:
J. Highmore/ pinx: 1734
Canvas, 91.4 x 73.6 cm

A label on the verso reads 'Lady Ellenborough'; this cannot refer to the sitter but may be the name of a former owner. The sitter is identified on a photograph in the National Portrait Gallery Library as Mrs Arundel Windham, but the grounds for this are unknown.

Fairfax Murray gift, 1911.

A.S. Lewis, *Joseph Highmore, 1692–1780*, diss. Harvard University, 1975, no.212.

WILLIAM HOARE

Eye (Suffolk) *c.*1707–1792 Bath

Hoare studied with Giuseppe Grisoni in London and accompanied his master to Italy, where he remained until 1737, continuing his studies in Rome with Francesco Imperiali. On his return he set up a successful portrait practice in Bath, producing both oils and pastels. Hoare exhibited at the Society of Artists in 1760 and 1761 and at the RA (of which he was a founder member) in 1770, but never succeeded in establishing himself in London.

ATTRIBUTED TO HOARE

561 Portrait of a Man
Canvas, 127 x 102.2 cm

Acquired by Fairfax Murray as a portrait of the Earl of Egremont by Richard Wilson. However, the sitter wears the badge of the Order of the Bath and therefore cannot be Egremont; his identity remains elusive. Constable regarded the attribution to Richard Wilson as 'doubtful' and Murray instead proposed Benjamin Wilson. This is rejected by E. Newby, who has suggested a possible attribution to Hoare (oral communication, 1997). The portrait probably dates from the early 1740s.

Fairfax Murray gift, 1911.

W.G. Constable, *Richard Wilson*, 1953, p.232, pl.133b (doubtful as R. Wilson).

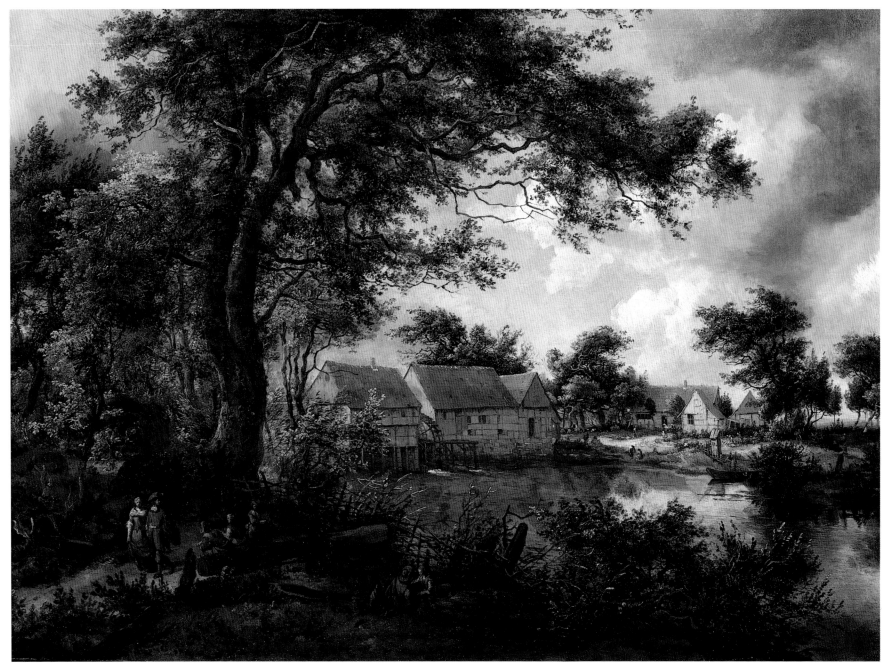

87

MEINDERT HOBBEMA

Amsterdam 1638–1709 Amsterdam

Hobbema served his apprenticeship in the late 1650s with Ruisdael (q.v.) in Amsterdam. There are dated pictures from 1658. Some of his early works show a strong debt to Ruisdael, but in the mid-1660s he developed his own characteristic landscape style. In 1668 he married and also became a wine-gauger in the Amsterdam *octroi*. After this date, Hobbema's activity as a painter seems to have declined.

87 Wooded Landscape with Water-mill

Signed, bottom centre right: *m Hobbema*
Oak panel, 61.9 x 85.4 cm

The group of buildings recurs with differences of detail in another painting by Hobbema of unknown whereabouts (Broulhiet, no.219), suggesting that the site is a real one. Brown proposes a date in the early 1660s.

Bourgeois bequest, 1811.

HdG82; G. Broulhiet, *Meindert Hobbema (1638–1709)*, Paris, 1938, no.218; C. Brown in *Kolekcja dla Króla*, no.13.

446

492

493

THOMAS F. HODGKINS

Born Dublin, active 1835–died 1909
London (Dulwich)

A history, animal and landscape painter,
Hogkins exhibited at the Society of
British Artists 1835–53, at the RA 1836–9
and at the British Institution 1836–54. He
was Keeper of Dulwich Picture Gallery
from 1864 until his death.

446 Tribute Money
 (after Rembrandt)
 Canvas, 64.5 x 86.7 cm

The original is at Bywell,
Northumberland (Viscount Allendale).

Gift of the artist, 1894.

492 Samson and the Lion
 (after an unknown artist)
 Poplar panel, 31.7 x 101 cm

Copied, like DPG493 below, from
a picture at Charlecote Park,
Warwickshire, which at the time
was given to Titian.

Gift of the artist, 1892.

493 Samson and the Philistines
 (after an unknown artist)
 Poplar panel, 31.7 x 101 cm

See DPG492 above.

Gift of the artist, 1892.

GERARD HOET

Zaltbommel 1648–1733 The Hague

Hoet trained with his father, a glass painter, and with Warnard van Ryssen. He moved to The Hague in 1672 and shortly afterwards travelled to France, spending a year in Paris. He was in Brussels for a time before settling in Utrecht, where he set up a drawing academy. In 1714 he moved back to The Hague. Hoet specialised primarily in small-scale Arcadian landscapes, but also painted some portraits and genre pieces. He published a book on drawing in 1712.

176 Apollo and Daphne

Signed, bottom right: *G. Hoet*
Canvas, 38.4 x 47.3 cm

Fleeing Apollo, the nymph Daphne calls on the aid of her father, the river god Peneus, and is transformed into a laurel tree (Ovid, *Metamorphoses*, I). Both DPG176 and its pair DPG179 (below) were attributed to Gérard de Lairesse until the signatures were discovered during cleaning in the 1940s.

Bourgeois bequest, 1811.

A. Roy, *Gérard de Lairesse (1640–1711)*, Paris, 1992, P.R.26 (as Hoet).

179 Pan and Syrinx

Signed on rock, lower centre right: *G. Hoet*
Canvas, 38.3 x 47.5 cm

Pair to DPG176. Pursued by Pan, Syrinx prays to the nymphs of Ladon to transform her, and is turned into reeds (Ovid, *Metamorphoses*, I).

Bourgeois bequest, 1811.

Roy, P.R.27 (as Hoet).

176

179

562

WILLIAM HOGARTH

London 1697–1764 London

Hogarth trained as a silver engraver and was practising as an engraver by 1720. After studying in Vanderbank's and Thornhill's Academies, he became active as a painter c.1728; in 1735 he set up his own drawing academy in St Martin's Lane. At first he painted conversation pieces, but he achieved his greatest success with the 'modern moral subjects' (beginning with the *Harlot's Progress*) that he engraved himself and sold by subscription to a wide public. He also painted history subjects and, in the 1740s, applied himself to portraiture. In 1757 he was appointed Serjeant Painter to the King. Hogarth exhibited at the Society of British Artists in 1761 and was elected to the committee of the Society in the same year. His *Analysis of Beauty* was published in 1753.

562 A Fishing Party
('The Fair Angler')
Canvas, 54.9 x 48.1 cm

Murray recorded the remains of a signature, lower left centre, but these cannot now be found. DPG562 is a conversation piece painted probably c.1730. Old photographs show the man on the left baiting the hook, but this was an alteration which has since been removed, presumably during cleaning in 1947–68. The line now ends at the float held by the mother.

Fairfax Murray gift, 1911.

R.B. Beckett, *Hogarth*, London, 1949, p.42 and fig.29; G.A. Waterfield in Collection for a King, no.13; R. Paulson, *Hogarth*, 3 vols., New Brunswick and Cambridge, 1991–3, I, p.212.

580 Portrait of a Man
Signed and dated, bottom left:
W Hogarth Anglus pinxt 1741
Canvas, 76.2 x 63.8 cm

Associated by Beckett with a portrait, bearing the same unusual form of the signature ('Hogarth Anglus'), that was recorded in 1817 as being in the possession of the widow of Edward Coxe and said to be 'a family portrait'.

Fairfax Murray gift, 1911.

Beckett, p.51 and fig.132; Paulson, II, p.173.

580

652

571

GERRIT VAN HONTHORST

Utrecht 1592–1656 Utrecht

Honthorst trained with Abraham Bloemaert before travelling, possibly as early as 1610, to Rome, where he came under the influence of Caravaggio. He returned to Utrecht in 1620, becoming a member of the Utrecht painters' guild in 1622 and serving as the guild's dean in 1625–6 and 1628–9. In 1628 Honthorst visited England to work for Charles I. He abandoned his Caravaggesque style in the early 1630s and concentrated on portraiture, attracting commissions from court circles in The Hague, where he was a member of the painters' guild from 1637. In 1652 he returned to Utrecht.

571 Anna van den Corput
Inscribed, signed and dated, centre left:
Æ 40/ GHonthorst .1639 (GH in monogram)
Oak panel, 74 x 60 cm

See DPG652 below.

Fairfax Murray gift, 1911.

652 Jacob de Witt
Inscribed, signed and dated, centre left:
Æ 50/ GHonthorst. 1639 (GH in monogram)
Oak panel, 72 x 60 cm

Jacob de Witt (1589–1674): burgomaster of Dordrecht, ambassador extraordinary to Sweden and Norway, Grand Pensionary. He was briefly imprisoned in 1650 for his part in the opposition of the States of Holland to William II's military policy. The sitter is identified in an engraving by J. Houbraken of 1760, made from a drawing by A. Schouman based on the original portrait. De Witt married Anna van den Corput (1599–1645), who is represented in the pendant portrait DPG571 (above).

Purchased 1990, with the aid of grants from the Friends of Dulwich Picture Gallery, the Stanley Scott Fund and the National Art Collections Fund.

E.J. Wolleswinkel, 'Drie voorbeelden van teruggevonden pendant-portretten', *Jaarboek van het Centraal Bureau voor Genealogie en het Iconographisch Bureau*, 40, 1986, pp.139–44.

CAREL CORNELISZ. DE HOOCH

Active 1620–died 1638 Utrecht

De Hooch is recorded as a painter in Haarlem in 1628 and undertook work in the same year in Utrecht, where he became a member of the painters' guild in 1633. His work shows the influence of Bartholomeus Breenbergh and of Poelenburch (q.v.) and it seems probable that he visited Italy. Little is known of his life.

ATTRIBUTED TO DE HOOCH

23 A Ruined Temple
Oak panel, 16.2 x 23.7 cm

There are conceivably traces of an 'H' in the rocks bottom left. The traditional attribution of DPG23 and its pair (DPG26 below) to Breenbergh is rejected by Roethlisberger, who suggests that they may be attributed to De Hooch.

Bourgeois bequest, 1811.

M. Roethlisberger, *Bartholomeus Breenbergh. The Paintings*, Berlin/New York, 1981, no.317 (as 'very possibly' De Hooch).

26 Landscape with a Roman Ruin
Signed and dated indistinctly on rock, lower right:
H[…][t?]/ 1633
Oak panel, 16.2 x 23.7 cm

See DPG23 above. The signature is very small and damaged. A figure to the left of the boy has been painted out.

Bourgeois bequest, 1811.

Roethlisberger, no.318 (as 'very possibly' De Hooch).

23

26

607

WALTER CHARLES HORSLEY

London 1855–1904 London?

Horsley was a student at the RA Schools from 1873. As artist for the *Graphic* he was sent to India in 1875, and he later visited Egypt. He exhibited at the RA from 1875 and at the Society of British Artists 1879–80. Horsley was a painter of historical and genre subjects – frequently with oriental settings – and portraits.

607 Old-time Tuition at Dulwich College
Signed, bottom left: *Walter C. Horsley*
Canvas, 84.1 x 107.3 cm

DPG607 illustrates one of the recollections of John Callcott Horsley (1817–1903), the painter's father, who, writing in his late eighties, remembered being invited as a boy of about eleven to stay with one of the fellows of Dulwich College, Mr Lindsay: 'He was not an early riser, so he arranged that his class should come up to his bedroom for their lessons at eight o'clock every morning' (J.C. Horsley, *Recollections of a Royal Academician*, London, 1903, pp.294–5). John Lindsay, a contemporary at Dulwich of Ozias Thurston Linley (see Oliver DPG476), was Usher of Dulwich College 1814–34 and Vicar of Stanford-on-Avon and Swinford.

Gift of the relatives of Alexander Horsburgh Turnbull, 1920.

G.A. Waterfield in *A Nest of Nightingales*, no.8:3.

GERRIT WILLEMSZ. HORST

Muiden *c.*1612–1652 Amsterdam

Horst first trained with the still-life painter A. de Lust, but became a pupil in Rembrandt's studio *c.*1631. Little is known of his life. He painted historical subjects, allegories, genre scenes and, later in his career, some still lifes.

214 Isaac blessing Jacob
Signed and dated on stool, lower left: *Horst 1638*; and inscribed indistinctly, lower right: *Rembrandt ./ 1653.*

Canvas, 163.2 x 201.3 cm

The subject is from Genesis XXVII, 22–3: on the instruction of Rebekah, Jacob impersonates his brother Esau to receive the blessing of his father, Isaac. Catalogued as Rembrandt until 1880, when Richter proposed an attribution to Jan Victors. The signature was revealed on removal of a false Jan Victors signature during cleaning in 1952/3. Horst treated the subject on at least two other occasions (Sumowski, nos.907, 909).

Bourgeois bequest, 1811.

Sumowski, II, p.1390, no.908.

214

ARNOLD HOUBRAKEN

Dordrecht 1660–1719 Amsterdam

Houbraken served his apprenticeship with Jacobus Levecq and trained further with Samuel Hoogstraten, *c.*1674–8, entering the painters' guild at Dordrecht in 1678. In 1709/10 he moved to Amsterdam, where, apart from a trip to England *c.*1713, he remained until his death. Houbraken was active as a painter of history and genre subjects, portraits and landscapes, and as a draughtsman and engraver, but he is now best known for his collection of artists' biographies, the *Groote Schouburgh*.

ATTRIBUTED TO HOUBRAKEN

471 Landscape with Sportsman
Signed or inscribed, bottom right: *A. Houbraken*
Canvas, 49.8 x 43.6 cm

The signature is incised in the paint and cannot be a later addition, although DPG471 seems to bear no resemblance to anything that is known of Houbraken's work.

Bourgeois bequest, 1811.

471

579

THOMAS HUDSON

Devonshire 1701–1779 London (Twickenham)

Hudson came to London in the mid-1720s and studied with Jonathan Richardson, whose daughter he married. He was active as a painter in Devon by 1728. In the 1740s he became the most fashionable London portrait painter of his day, employing the brothers Joseph and Arnout van Aken to paint his draperies. In 1748 he made a visit to France and the Netherlands and in 1752 he travelled to Italy in the company of Roubiliac (see Soldi DPG603). Hudson exhibited at the Society of Artists in 1761 and 1766, but retired from painting in 1767. His notable collection of paintings and drawings was dispersed after his death.

578 Portrait of a Woman

Signed and dated, bottom right:
T Hudson Pinxit. / 1750.
(TH in monogram)
Canvas, 127.3 x 102 cm

See DPG579 below.

Fairfax Murray gift, 1911.

E.G. Miles, *Thomas Hudson (1701–1779):
Portraitist to the British Establishment*, diss.
Yale University, 1976, no.199; *Thomas
Hudson*, cat. exh. Kenwood House,
London, 1979 (catalogue by E.G. Miles
and J. Simon), no.47.

579 Portrait of a Man

Signed and dated, bottom right:
T Hudson Pinxit / 1750.
(TH in monogram)
Canvas, 127.3 x 102 cm

Pair to DPG578. The pictures
formerly belonged to Robert
Hollond of Stanmore Hall, but are
not necessarily family portraits.
The poses, in particular that of the
man, were frequently repeated in
Hudson's practice. The costumes
were probably painted by J. or
A. van Aken.

Fairfax Murray gift, 1911.

Miles, no.200; London 1979, no.46.

578

596

362

596 Portrait of a Man, possibly the 4th Duke of Leeds
　　Canvas, 76.2 x 63.5 cm

An attribution to Ramsay was rejected by A. Smart, who suggested that
DPG596 might be a work by Hudson of the mid- to late 1740s (letter on file, 1977).
Independently, J. Simon suggested Knapton or Hudson (note on file, 1992).
E.G. Miles accepts an attribution to Hudson (letter on file, 1997). A version was
sold at Sotheby's, 9 July 1980 (39), as a portrait by Knapton of Thomas Osbourne,
4th Duke of Leeds (1713–89).

Fairfax Murray gift, 1911.

JACOB HUYSMANS

Antwerp *c.*1630–*c.*1696 Antwerp

Huysmans served his apprenticeship with Frans Wouters in Antwerp and had settled
in London by 1662. He was a Catholic and found favour at the court of Queen
Catherine of Braganza, reputedly calling himself the Queen's Painter. As a portrait
painter, Huysmans was the chief rival to Lely (q.v.). He also painted history subjects.

362 Portrait of a Woman
Canvas, 74.9 x 62.5 cm

Attributed to Huysmans ('housman') in the Cartwright inventory. Probably painted
in the early 1660s. Only the head is finished.

Cartwright bequest, 1686.

R.T. Jeffree in *Mr Cartwright's Pictures*, no.37.

JAN VAN HUYSUM

Amsterdam 1682–1749 Amsterdam

Jan van Huysum studied with his father Justus van Huysum the elder, a flower
painter, and is not known ever to have left his native city. Although he painted some
landscapes, he specialised chiefly in paintings of flowers and fruit, a genre in which
he achieved unparalleled success.

120 Vase with Flowers
　　Signed, bottom left: *Jan van Húÿsúm fecit*
　　Mahogany panel, 79.1 x 60.6 cm

The nest includes a cuckoo's egg. Probably to be dated shortly before 1720.

Bourgeois bequest, 1811.

HdG125; M.H. Grant, *Jan Van Huysum, 1682–1749*, Leigh-on-Sea, 1954, no.86; P. Taylor in
Dutch Flower Painting, no.29.

139

IMITATOR OF VAN HUYSUM

139 Vase with Flowers
 Inscribed, bottom right:
 Jan Van Huysum
 Canvas, 84.1 x 62.2 cm

Formerly catalogued as Van Huysum
but probably the work of an eighteenth-
century imitator.

Bourgeois bequest, 1811.

HdG126; Grant, no.87; I. Gaskell in *Collection
for a King*, no.16 (all as Van Huysum).

MICHIEL VAN HUYSUM

Amsterdam 1703–1777 Amsterdam

Michiel was the brother of Jan van
Huysum (q.v.) and, like him, trained
under their father Justus van Huysum
the elder. Virtually nothing seems to be
known of his life. He painted flower and
fruit pieces in the manner of Jan van
Huysum and made some landscape
drawings.

42 A Delft Bowl with Fruit
 Signed, lower left: *f. [M.] van Húÿsúm*
 Oak panel, 40 x 32.4 cm

See DPG61 below.

Bourgeois bequest, 1811.

HdG205; Grant, no.164 (both as Jan van
Huysum).

61 A Delft Vase with Flowers
 Signed, lower left: *f [M]. van Huÿsúm*
 Oak panel, 40 x 32.4 cm

As noted by F. Meijer, DPG42 and
DPG61 are versions of a pair in the
Fitzwilliam Museum, Cambridge, signed
by Michiel van Huysum, one of which
bears the date 1729. The signatures on
the Dulwich paintings have both been
converted at some time to read 'Jan van
Huysum' and in each case the 'M' is now
defaced.

Bourgeois bequest, 1811.

HdG114; Grant, no.75 (both as Jan van
Huysum).

ITALIAN SCHOOL,
see p.300

JARDIN, see Dujardin

42

61

CHARLES JERVAS

Dublin c.1675–1739 London

Jervas came to London to study with Kneller, 1694–5. In 1699 he was in Paris and by 1703 he had settled in Rome. He returned to London in 1708/9 and set up a fashionable portrait practice, succeeding Kneller as Principal Painter to the King in 1723. Jervas made a number of trips to Ireland and in 1738–9 was again in Italy to acquire pictures for the Royal Collection. He was a friend of Alexander Pope, to whom he gave painting lessons.

567 Dorothy, Lady Townshend

Inscribed, below coat-of-arms:
Dorothy, Sister of Sir Robert Walpole &/ Second Wife of Charles Lord Viscount/ Townshend
Canvas, 127 x 103.8 cm

Dorothy Walpole (1686–1726): sister of Sir Robert Walpole; married Charles, 2nd Viscount Townshend of Raynham in 1713. The coat-of-arms is that of Townshend impaling Walpole. The sitter wears Turkish-style dress of a kind fashionable from c.1718. A somewhat simplified version of the picture is in the National Portrait Gallery. The hand from an underlying figure is visible in the sky, but no X-ray has been taken.

Fairfax Murray gift, 1911.

A. Moore and C. Crawley, *Family and Friends: A Regional Survey of British Portraiture*, London, 1992, pp.106–7, no.38.

CORNELIUS JONSON THE ELDER

London 1593–1661 Utrecht

Although born in London, Jonson may have trained in the Netherlands, returning to London c.1618. He painted portraits and miniatures and was appointed the King's 'Picture drawer' in 1632. He returned to the Netherlands in 1643 and is recorded at Middelburg (1644), Amsterdam (1646), The Hague (1647) and Utrecht (1652).

80 Portrait of a Woman in White

Canvas, 73.3 x 54.6 cm

Finberg suggests a date of c.1639. M. Rogers accepts the attribution (letter on file, 1997).

Bourgeois bequest, 1811.

A.J. Finberg, 'A Chronological List of Portraits by Cornelius Johnson or Jonson', *Walpole Society*, X, 1921–2, p.31, no.91.

89 Portrait of a Woman in Blue

Canvas, 75.8 x 62.8 cm

Finberg records 'traces of signature – C. J. – partly visible' and suggests a date of c.1639. M. Rogers accepts the attribution (letter on file, 1997).

Bourgeois bequest, 1811.

Finberg, p.31, no.90.

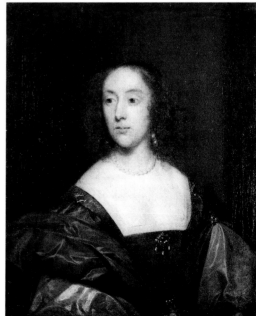

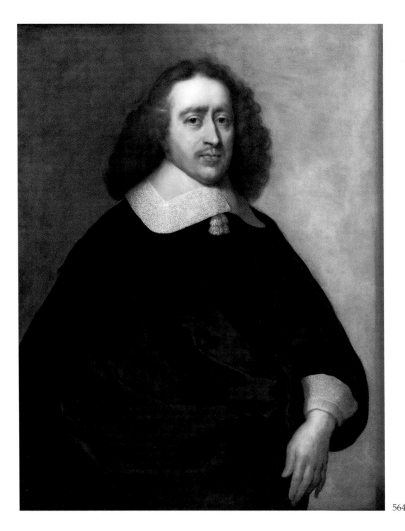

CORNELIUS JONSON THE YOUNGER

London 1634–after 1700

Although born in London, Cornelius Jonson the younger accompanied his parents to Holland in 1643 and probably never returned to England. He presumably trained with his father, Cornelius the elder (q.v.), whose style he imitated.

564 A Dutch Gentleman

Signed and dated, upper left: *Cornelius Jonson/ van Ceulen/ fecit/ 1657*
Canvas, 92 x 72.4 cm

The signature and date, at one time said to have been 'washed off', remain clearly legible. The attribution to Cornelius the younger was proposed by Collins Baker and retained by Murray, though Finberg had accepted DPG564 as the work of Cornelius the elder.

Fairfax Murray gift, 1911.

C.H. Collins Baker, 'Nederlansche Portretten in de Dulwich Gallery', *Onze Kunst*, 1915, pp.102–3; Finberg, no.114.

JOOS VAN CLEVE

Active 1511–died 1540/1 Antwerp

AFTER VAN CLEVE

271 Salvator Mundi

Oak panel, 27.5 x 21.3 cm

A simplified version of Van Cleve's original in the Louvre.

Bourgeois bequest, 1811.

M.J. Friedlaender, *Early Netherlandish Painting*, IXa, Leyden/Brussels, 1972, no.34b.

JACOB JORDAENS

Antwerp 1593–1678 Antwerp

AFTER JORDAENS

293 Satyr and Peasants

Paper on canvas, 47.3 x 55.9 cm

Copy of Jordaens's original of *c.*1620 in the Staatliche Gemäldegalerie, Kassel.

Bourgeois bequest, 1811.

564

271

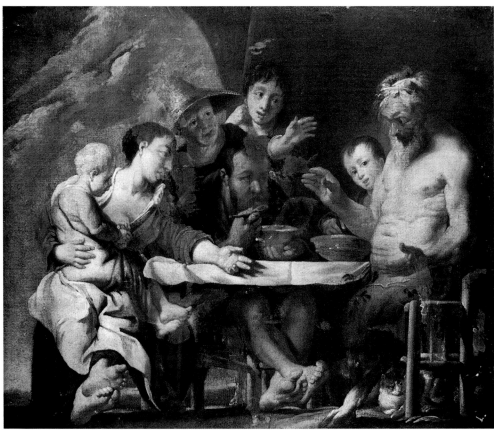

29

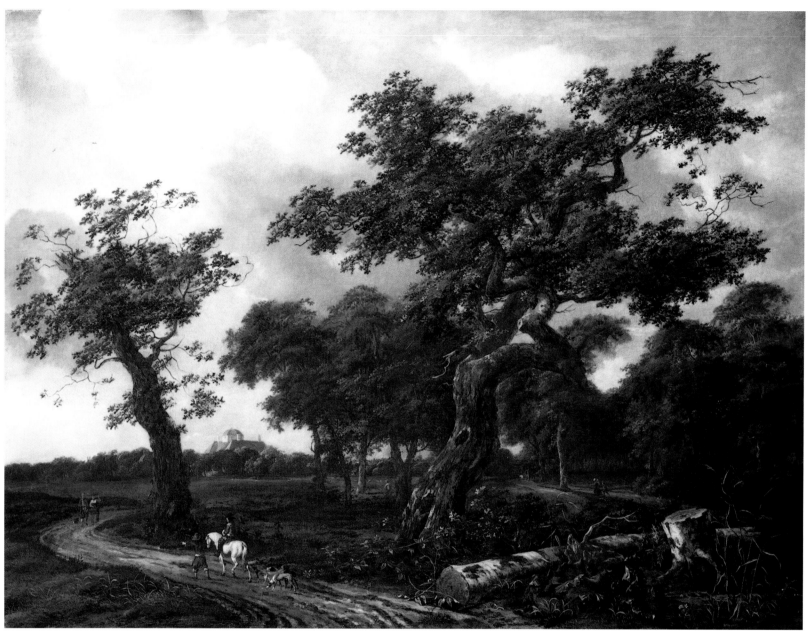

JAN VAN KESSEL

Amsterdam 1641–1680 Amsterdam

Little is known of Van Kessel's life. He is thought to have trained with Jacob van Ruisdael and was active in Amsterdam as a painter of landscapes and topographical views. His works show the influence of Ruisdael and Hobbema, and later of Wijnants (qq.v.).

210 A Wood near The Hague, with a View of the Huis ten Bosch

Canvas, 118.7 x 154.9 cm

A view in the Haagse Bos to the east of The Hague with, in the background, the Huis ten Bosch built 1645–52 for Amalia van Solms, wife of the Stadholder, Prince Frederik Hendrik of Orange. Richter recorded a JVR monogram (for Ruisdael), but this was presumably a later addition, since removed. An attribution to Van Kessel was first proposed by Simon in 1927 and is accepted by Davies, who proposes a date of *c*.1665. A study for the central tree is at Brussels (Davies, D32). The figures have been attributed to Adriaen van de Velde and to Lingelbach but, according to Davies, are characteristic of Kessel.

Bourgeois bequest, 1811.

HdG761 (as Ruisdael with figures by Lingelbach); K.E. Simon, *Jacob van Ruisdael*, Berlin, 1927/30, p.75 (as Van Kessel); C. Brown in *Collection for a King*, no.35 (as Wijnants); A.I. Davies, *Jan van Kessel (1641–1680)*, Doornspijk, 1992, no.21.

582

583

TILLY KETTLE

London 1734–1786 Aleppo (Syria)

Probably first trained by his father, Kettle continued his studies at Shipley's Academy, at the St Martin's Lane Academy and in the Duke of Richmond's Gallery. He exhibited at the Free Society of Artists, 1761, and at the Society of Artists, 1765–76. In 1769–76 he was in India, where his portrait practice proved lucrative. On his return to England he exhibited at the RA 1777 and 1781–3, but he never achieved success in England. He made visits to Dublin and Brussels, but then set out again for India, dying en route.

582 Eliza and Mary Davidson

Canvas, 127 x 101.9 cm

The sitters were daughters of Alexander Davidson (d.1791), Governor of Madras, 1785–6. The portrait was presumably painted in India (i.e. 1769/76).

Fairfax Murray gift, 1911.

J.D. Milner, 'Tilly Kettle, 1735–1786', *Walpole Society*, XV, 1927, pp.72–3, 94–5, pl.XXVI.

583 Portrait of a Woman

Signed, lower left: *T. Kettle./ Pinx.*
Canvas 68.5 cm diameter (circular)

An early work, dated by Milner 1760–1. Possibly the female portrait exhibited by Kettle at the Free Society of Artists in 1761.

Fairfax Murray gift, 1911.

Milner, pp.52, 80–1, pl.XIVA.

606

570

GEORGE KNAPTON

London 1698–1778 London

Knapton was apprenticed to Jonathan Richardson 1715–22, and studied at the St Martin's Lane Academy. After a trip to Italy in 1725–32, he started making pastel portraits. He was a founder member of the Society of Dilettanti and official painter to the Society, 1740–63. In the early 1760s Knapton seems to have given up painting. He was a notable connoisseur and was appointed Surveyor and Keeper of the King's Pictures in 1765.

606 Lucy Ebberton
Canvas, 76.5 x 64.1 cm

Engraved by J. McArdell, 1746/65, as the work of Knapton. The sitter is identified in an inscription by Horace Walpole on his own copy of the McArdell engraving, which states that she was the wife of 'Capt Grieg of the Marines'. Her identity is otherwise obscure. The costume suggests a date in the late 1740s.

Fairfax Murray gift, 1917/18.

A. Staring, 'De Van der Mijns in England II', *Nederlands Kunsthistorisch Jaarboek*, 19, 1968, pp.200–2 (as Frans van der Mijn); G.A. Waterfield in *Collection for a King*, no.17.

SIR GODFREY KNELLER

Lübeck 1646–1723 London

Kneller was a pupil in Amsterdam of Ferdinand Bol and possibly of Rembrandt in the 1660s. In *c.*1672 he travelled to Italy, staying in Rome and later in Venice before returning to Germany *c.*1675. By 1677 he had settled in England, where he became the leading court portrait painter. He was sent to France in 1684 to paint the portrait of Louis XIV. In 1688 he was appointed Principal Painter to William and Mary, a post which he shared with Riley (q.v.) until the latter's death in 1691. Kneller was knighted in 1692 and made a baronet in 1715.

570 Two Children, perhaps of the Howard family
Signed and dated, lower left: *G. Kneller. f./ 1694*
Canvas, 127.3 x 102.9 cm

The last digit of the date has been altered by the artist from a '5'. The sitters have traditionally been identified as 'Lord Carlisle and his Sister', but this cannot be substantiated. A label on the verso, inscribed 'Hon[ble] Mary Howa[rd]', presumably refers to an earlier owner of the picture. Two preparatory drawings are in the British Museum.

Fairfax Murray gift, 1911.

J.D. Stewart, *Sir Godfrey Kneller and the English Baroque Portrait*, Oxford, 1983, no.133.

SIR EDWIN LANDSEER

London 1802–1873 London

AFTER LANDSEER

447 John Allen
(Not illustrated)
Canvas, 45.7 x 60.9 cm

Lost. John Allen (1771–1843): historian; trained as a surgeon in Edinburgh; accompanied Lord Holland to Spain, 1802–5 and 1808; became an inmate of Holland House, where he managed to remain whilst Warden of Dulwich College 1811–20 and Master from 1820. DPG447 is a copy of Landseer's original of 1835 in the National Portrait Gallery.

Gift of Colonel Fox, 1843.

449

500

SAMUEL LANE

King's Lynn 1780–1859 Ipswich

Lane studied with Joseph Farington and Lawrence (q.v.), becoming Lawrence's chief studio assistant. He was much in demand as a portrait painter and many of his works were exhibited at the RA 1804–57, as well as at the British Institution 1819 and the Society of British Artists 1832. Lane was a friend and correspondent of Constable. In 1853 he retired to Ipswich.

449 George Bartley
Canvas, 76.2 x 63.5 cm

George Bartley (c.1782–1858): comic actor; engaged by Sheridan at Drury Lane, 1802; stage manager of Covent Garden, 1829–30. DPG449 is possibly the portrait of Bartley exhibited by Lane at the RA in 1822.

Gift of George Bartley, 1854.

500 Sarah Bartley
Canvas, 136.5 x 102.2 cm

Sarah Smith (or O'Shaughnessy or Williamson; 1783–1850): tragic actress; engaged at Covent Garden, 1805; moved to Drury Lane, 1813; married George Bartley (see above), 1814. Briefly, she seemed the successor to Mrs Siddons (see Reynolds DPG318), but she was eclipsed by Miss O'Neill.

Gift of George Bartley, 1854.

648 Fred Lane
Canvas, 76.2 x 63.5 cm

The identity of the sitter is recorded in a recent chalk inscription on the stretcher. Lane exhibited a portrait of 'Mr F. Lane' at the RA in 1806.

Gift of Mrs E.M. Hulton, date unknown.

648

JAN LAPP

The Hague *c.*1600?–after 1662 Amsterdam

Lapp is recorded as a member of the painters' guild at The Hague in 1625. Although he probably visited Italy, this cannot be confirmed. His works are rare; there are dated examples from 1636.

330 Italian Landscape with Figures and Cattle

Signed, indistinctly, on plinth, centre left: *I… L…ap*
Canvas, 56.8 x 64.3 cm

The signature is damaged, but the style is consistent with Lapp's work.

Bourgeois bequest, 1811.

Anon. in Thieme and Becker, XXII, 1928, p.377.

330

FILIPPO LAURI

Rome 1623–1694 Rome

Filippo Lauri was first a pupil of his father, then of his brother Francesco Lauri and his brother-in-law Angelo Caroselli. He became a member of the Accademia di San Luca in 1654 and served as *principe* in 1684–5. He painted some fresco decorations, but specialised mainly in cabinet pictures of religious or mythological subjects.

164 Apollo and Marsyas

Canvas, 48.9 x 36.8 cm

Apollo prepares to flay the satyr Marsyas, who has challenged him unsuccessfully in a musical contest (Ovid, *Metamorphoses* VI). The attribution to Lauri has been retained since 1813. A copy or version is in the Musée Magnin, Dijon.

Bourgeois bequest, 1811.

164

475

474

SIR THOMAS LAWRENCE

Bristol 1769–1830 London

Lawrence received no formal training, but the portrait drawings produced in his father's inn at Devizes revealed a precocious talent. In Bath, where his family was living in 1780, he produced portraits in pastel and began painting in oils. By 1787 he had moved with his father to London and in that year he exhibited a pastel at the RA. His full-length portraits in oils exhibited in 1790 established his reputation and in 1792 he succeeded Reynolds as Painter-in-Ordinary to the King. Lawrence was elected ARA in 1791 and RA in 1794 (at the age of only twenty-four). From 1814 his principal patron was the Prince Regent, who sent him abroad to paint portraits of European sovereigns and statesmen. He was knighted in 1815 and elected President of the RA in 1820.

178 William Linley
Canvas, 76.2 x 63.5 cm

William Linley (1771–1835): youngest son of Thomas Linley the elder (see Gainsborough DPG140); joined the East India Company and was in India 1790–5 and 1800–5; retired from the company in 1810 and devoted himself to singing, composing and writing, and to a convivial social life; bequeathed his family portraits to Dulwich Picture Gallery. Lawrence was a friend of the Linley family. Exhibited at the RA in 1789, DPG178 was presumably painted in that year or shortly before.

Linley bequest, 1835.

K. Garlick in *Collection for a King*, no.18; K. Garlick in *A Nest of Nightingales*, no.10:1; K. Garlick, *Sir Thomas Lawrence, A complete catalogue of the oil paintings*, Oxford, 1989, no.496.

475 Maria Linley
Pastel on paper on panel, 31.5 x 26 cm (oval)

Maria Linley (1763–84): daughter of Thomas Linley the elder (see Gainsborough DPG140); trained as a singer by her father; performed in the Drury Lane oratorios and in concerts until her early death. An inscription on a piece of paper, verso, almost certainly taken from the original backing, is in Lawrence's hand according to Garlick. DPG475 was presumably executed in Bath c.1780.

Linley bequest, 1831/5.

K. Garlick 'A Catalogue of the paintings, drawings and pastels of Sir Thomas Lawrence', *The Walpole Society*, XXXIX, 1962–4, p.263; K. Garlick in *A Nest of Nightingales*, no.7:2.

ATTRIBUTED TO LAWRENCE

474 Ozias Thurston Linley as a Boy
Pastel on paper on canvas, 30.4 x 25.6 cm (oval)

Ozias Thurston Linley (1765–1831): son of Thomas Linley the elder (see Gainsborough DPG140); graduated at Corpus Christi College, Oxford 1789; minor canon of Norwich Catheral, 1790; Junior Fellow and Organist at Dulwich College from 1816; noted for his eccentricity and strong language.

Linley bequest, 1831/5.

Garlick 1962–4, p.263 (as Lawrence); K. Garlick in *A Nest of Nightingales*, no.8:1 (as attributed).

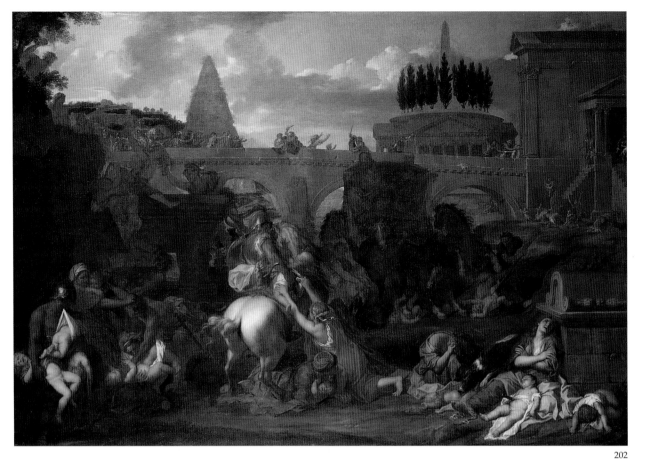

202

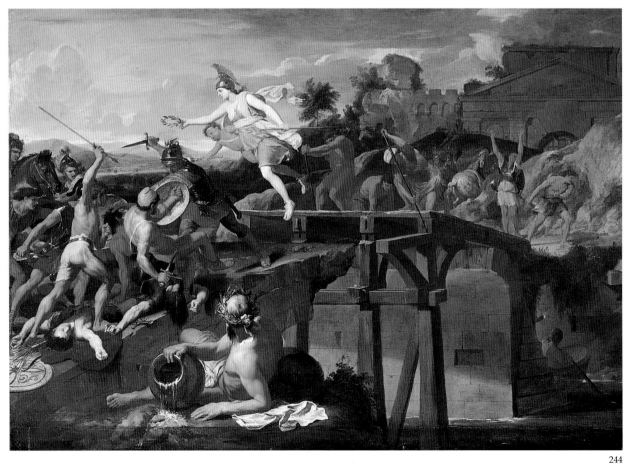

244

CHARLES LE BRUN

Paris 1619–1690 Paris

After training in Paris with François Perrier and Simon Vouet, in 1642–5 Le Brun visited Rome, where he was much influenced by Poussin (q.v.). He became first painter to Louis XIV and worked extensively on the decoration of Versailles, while directing the Gobelins tapestry factory and producing designs for sculpture and the decorative arts. Le Brun became Director of the Académie and published an influential treatise on the expression of the passions.

202 The Massacre of the Innocents
Canvas, 133 x 187.4 cm

The subject is from Matthew II, 16–18: having learnt from the wise men of the birth in Bethlehem of the King of the Jews, Herod ordered that the young children of the city be put to death. The picture was begun in 1647, or shortly after, but was left unfinished probably until the mid-1660s, when it was completed for Gédéon du Metz, keeper of the Royal Treasury. There are several preliminary drawings in the Louvre.

Bourgeois bequest, 1811.

M. Kitson in *Collection for a King*, no.19; J. Montagu in *Kolekcja dla Króla*, no.14; J. Montagu in *Courage and Cruelty*, no.11.

244 Horatius Cocles defending the Bridge
Canvas, 121.9 x 171.8 cm, including a later addition of about 9 cm at the bottom

The story is told in Livy's *History of Rome* (though Le Brun's source may be the shorter account given by Valerius Maximus): Horatius Cocles alone defends the Sublician bridge against the Etruscans while it is demolished behind him; above hovers an allegorical figure of Rome and in the foreground is a River God representing the Tiber. DPG244 was painted under Poussin's influence early during Le Brun's stay in Rome.

Bourgeois bequest, 1811.

J. Montagu in *Courage and Cruelty*, no.2.

CLAUDE LEFEBVRE

Fontainebleau 1632–1675 Paris

Lefebvre is said to have studied with
Eustache Le Sueur before entering Le Brun's
studio, where he was advised to concentrate
on portraiture. He was received at the
Académie in 1663 and exhibited at the Salon
of 1673. Lefebvre was one of the leading
portrait painters in Paris in the third quarter
of the seventeenth century, though few of his
works have been identified.

ATTRIBUTED TO LEFEBVRE

188 Portrait of a Man, called Michel Baron

Canvas, 73.7 x 60.4 cm

The sitter, traditionally called Molière, has
more recently been identified as Michel
Baron (1653–1729), an actor in Molière's
company. However, he does not greatly
resemble the sitter in Jean de Troy's portrait
of Baron at the Comédie Française, Paris.
Formerly catalogued as School of Le Brun;
the attribution to Lefebvre was proposed
by Boyer.

Gift of George Bartley, 1854.

J.-C. Boyer, 'Quatre portraits rendus à Claude
Lefebvre', *Bulletin des Musées de Dijon*, 2, 1996,
pp.47–8, 49n.

188

SIR PETER LELY

Soest (Westphalia) 1618–1680 London

Pieter van der Faes, known as Lely, studied with Frans Pietersz. de Grebber in Haarlem before coming to London in 1641/3. He became a freeman of the Painter-Stainers' company in 1647, on the same day as his friend, the poet Richard Lovelace (see Dobson DPG363). Lely was the leading court portrait painter of his generation, and became Principal Painter to the King in 1661. He was naturalised in 1662 and knighted in 1680. His extensive collection of paintings, drawings and prints was dispersed after his death.

555 Nymphs by a Fountain
Canvas, 128.9 x 144.8 cm

An Arcadian subject of the type painted by Lely during his early years in England (and presumably before his arrival), but which he later abandoned in favour of portraiture. A signature and date were recorded in the 1926 Dulwich catalogue, while Beckett saw only a signature; neither is now visible. Millar dates the picture '? c.1650'. A drawing related to the nymph in the right foreground was sold at Sotheby's, Amsterdam, 18 April 1977 (lot 40).

Fairfax Murray gift, 1911.

R.B. Beckett, *Lely*, London, 1951, no.594; *Sir Peter Lely, 1618–80*, cat. exh. National Portrait Gallery, London, 1978–9 (catalogue by O. Millar), no.25; M. Rogers in *Collection for a King*, no.20; O. Millar, 'Peter Lely', in J. Turner (ed.), *The Dictionary of Art*, 34 vols., London, 1996, 19, p.120.

555

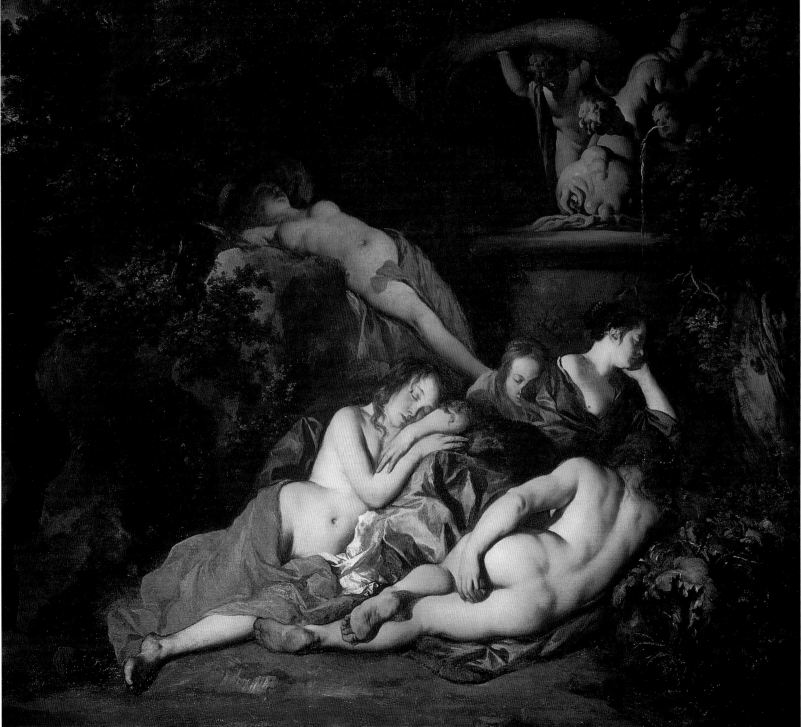

563 Young Man as a Shepherd

Signed, lower right:
PL (in monogram)
Canvas, 91.4 x 75.6 cm

Dated by Millar *c*.1658–60. The portrait may have been painted for Mary Beale (q.v.), since it belonged to Edward Lovibond, who is said to have owned 'several' pictures from Beale's collection, and the head was on at least one occasion copied by her son, Charles. Rogers suggests that the sitter may be Beale's elder son Bartholomew (1656–1709), who is thought to be the sitter in a group of portraits by Beale (see Beale DPG574). This would require the dating of DPG563 to be substantially advanced: Rogers proposes *c*.1665, but the sitter appears to be more than nine years old.

Fairfax Murray gift, 1911.

Beckett, no.129; London 1978–9, no.28; M. Rogers in *Collection for a King*, no.21 and *Kolekcja dla Króla*, no.15.

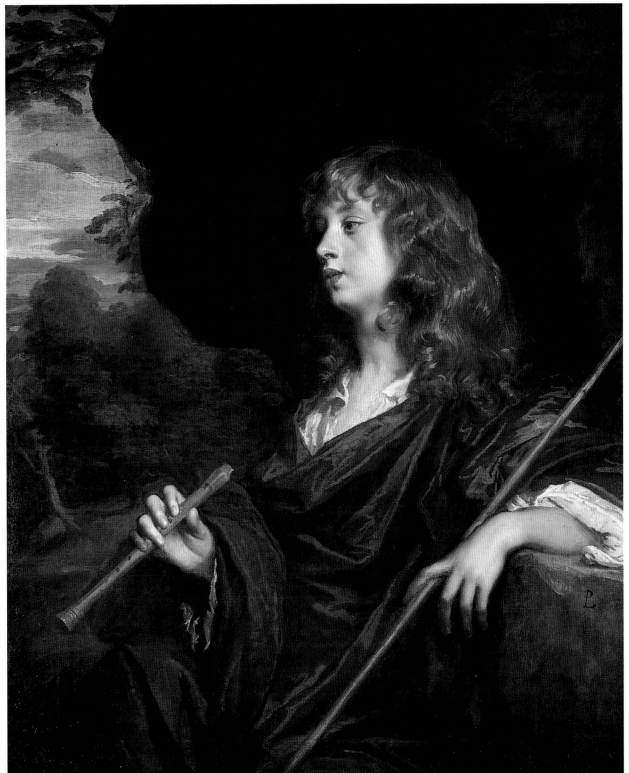

563

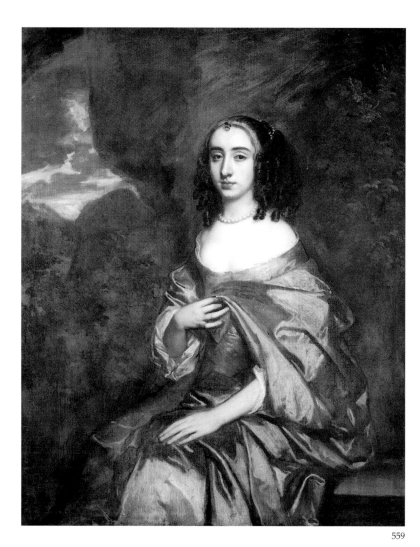

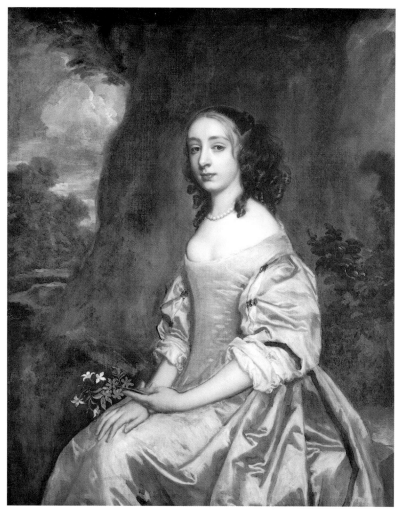

559

560

559 Portrait of a Woman in Blue
Signed, indistinctly, bottom right:
PL (in monogram)
Canvas, 126.7 x 102.5 cm

Probably a pair to DPG560 below. Collins Baker dated both *c*.1660.

Fairfax Murray gift, 1911.

C.H. Collins Baker, 'Nederlandsche Portretten in de Dulwich Gallery', *Onze Kunst*, 1915, p.107.

560 Portrait of a Woman in Blue holding a Flower
Canvas, 126.7 x 102.5 cm

See DPG559 above.

Fairfax Murray gift, 1911.

Collins Baker, p.107.

AFTER LELY

408 Susanna and the Elders
Canvas, 35.3 x 58.4 cm

A reduced copy of Lely's original of which there are versions in the Tate Gallery, Birmingham City Art Gallery and Burghley House.

Cartwright bequest, 1686.

R.T. Jeffree in *Mr Cartwright's Pictures*, no.47.

MATHIEU LE NAIN

Laon 1602/10?–1677 Paris

Le Nain was one of three brothers from Laon who established a successful studio in Paris, specialising chiefly in genre scenes but also producing portraits and history subjects. All three brothers were founder members of the Académie in 1648, but Louis and Antoine both died in the same year. There is no certainty as to the attribution of individual works to one or other of the three brothers.

ATTRIBUTED TO MATHIEU LE NAIN

180 Musicians
Canvas, 32.4 x 40 cm

Although the drawing and execution are in places weak, DPG180 is accepted by Rosenberg as a work by Mathieu Le Nain of *c*.1650. The figure on the right is perhaps taken from the same model as the figure similarly placed in the unfinished group portrait in the National Gallery, London. A larger version omitting this figure is in a French private collection (Rosenberg, no.73).

Bourgeois bequest, 1811.

P. Rosenberg, *Tout l'œuvre peint des Le Nain*, Tours, 1993, no.72.

JAN LINGELBACH

Frankfurt am Main 1622–1674 Amsterdam

Lingelbach's family had settled in Amsterdam by 1634. He made a trip to France in 1642 and thence, two years later, to Rome, where he was strongly influenced by the work of Pieter van Laer and his followers (the Bamboccianti). He left Rome in 1650 and by 1653 was back in Amsterdam, where he is recorded until his death. He painted genre scenes of markets and traders in the streets of Rome as well as exotic port scenes.

55 Roman Blacksmith's Shop
Canvas, 57.8 x 48.5 cm

The twin towers of the church of Trinità dei Monti are seen in the background. A version, said to have traces of a signature, was sold at Hôtel Drouot, Paris, 28 November 1980, lot 227 (see also G. Briganti et al., *The Bamboccianti*, Rome, 1983, p.268).

Bourgeois bequest, 1811.

326 Italian Seaport
Signed and dated on circular stone, bottom left:
I LINGELBACH/ FECIT/ 1670
Canvas, 69.5 x 87.3 cm

Bourgeois bequest, 1811.

C. Burger-Wegener, *Johannes Lingelbach 1622–1674*, diss., Berlin, 1976, no.91.

408

180

55

326

PIETRO LONGHI

Venice 1702–1785 Venice

FOLLOWER OF LONGHI

307 Girls Sewing
 Canvas, 56 x 73.3 cm

There are related figures in paintings by Longhi in the Ca' Rezzonico, Venice, and the Wadsworth Atheneum, Hartford, and in two drawings in the Museo Correr, Venice (T. Pignatti, *Pietro Longhi*, Venice, 1968, pls.96, 99, 100, 325).

Bourgeois bequest, 1811.

R. Bagemihl, 'Pietro Longhi and Venetian Life', *Metropolitan Museum Journal*, 23, 1988, pp.243, 245, fig.17, 247 n.32 (as Longhi).

307

456

JAMES LONSDALE

Lancaster 1777–1839 London

As a young man Lonsdale was encouraged as an artist by the Duke of Hamilton. In 1799 he came to London to study with Romney and at the RA Schools. He regularly exhibited portraits at the RA 1802–38 and was much involved with the foundation of the Society of British Artists, where he was also an exhibitor 1824–37. Lonsdale's noble clients included the Duke of Norfolk and the Duke of Sussex and he was appointed portrait painter to Queen Charlotte.

456 Mrs Thomas Linley
 Canvas, 76.5 x 63.5 cm

Mary Johnson (1729–1820): married Thomas Linley (see Gainsborough DPG140), 1752; in her youth she was noted for her voice, in later life for her parsimony. The costume suggests a date of 1815/20. The portrait was exhibited at the RA in 1820, shortly after the sitter's death.

Linley bequest, 1835.

S. Wallington in *A Nest of Nightingales*, no.2:3.

PHILIPPE JACQUES DE LOUTHERBOURG

Strasbourg 1740–1812 London
(Chiswick)

The son of a miniature painter and engraver, De Loutherbourg trained in Paris with Carle Vanloo and Francesco Casanova (q.v.), and in Jean-Georges Wille's engraving academy. He was *agréé* at the Académie in 1762 and received in 1767, in the same year being appointed *peintre du roi*. He exhibited mainly landscapes and sea-pieces at the Salons, 1763–71. In 1771 he moved to London, where he was employed by David Garrick at Drury Lane and proved himself an innovator in the art of stage design. De Loutherbourg exhibited at the RA 1772–1812 and was elected ARA in 1780 and RA in 1781. In 1807 he was appointed Historical Painter to William Frederick, Duke of Gloucester. See also Gainsborough DPG66.

297 Landscape with Cattle
Signed and dated, bottom right:
P J de Loutherbourg 1765
Canvas, 57 x 70.5 cm

Bourgeois bequest, 1811.

339 Landscape with Cattle and Figures
Signed, lower left:
P. I. De Loutherb[ourg]
Canvas, 70.8 x 97.2 cm

Possibly a picture briefly described by Diderot at the Paris Salon of 1765.

Bourgeois bequest, 1811.

N. Kalinsky in *Kolekcja dla Króla*, no.16.

297

339

279

332

558

ALESSANDRO MAGNASCO

Genoa 1667–1749 Genoa

As a child, Magnasco was taken to Milan; he later became a pupil of Filippo Abbiati there. By 1703 he was in Florence, working for the Medici court. He also visited Venice. By 1709 he was back in Milan, where he entered the Accademia di San Luca. In 1735 he returned to his birthplace of Genoa, remaining there for the rest of his life. Magnasco's vigorous yet sombre style and his novel (often macabre) subject matter were well received and his works were extensively copied and imitated.

ATTRIBUTED TO MAGNASCO

279 The Entombment of Christ
Canvas, 54.3 x 33.9 cm

The composition is repeated in a number of 'sketches' by or derived from Magnasco, of which the strongest appears to be that formerly with the Galerie Sanct Lukas, Vienna, dated 1725–7 by L. Muti and D. de Sarno Prignano (*Alessandro Magnasco*, Faenza, 1994, no.389). No finished altarpiece is known.

Bourgeois bequest, 1811.

MASTER OF THE BÉGUINS

Active Paris, *c.*1650–70

This name was coined by J. Thuillier to describe a group of works close in style to that of the Le Nain brothers. Almost all the works in this group contain figures wearing the type of bonnet known in France as a *béguin*.

332 Peasant Family at a Well
Oak panel, 57.2 x 72.5 cm

Acquired as Le Nain (q.v.), but catalogued since *c.*1866 as the work of Guilliam I van Herp. DPG332 repeats the main figures in a painting in the Hunterian Museum and Art Gallery, Glasgow, given by Thuillier to the Master of the Béguins. Thuillier did not regard DPG322 as by the same hand, but it is accepted as such by Rosenberg.

Bourgeois bequest, 1811.

J. Thuillier in cat. exh. *Les frères Le Nain*, Grand Palais, Paris, 1978–9, under no.74; P. Rosenberg, *Tout l'œuvre peint des Le Nain*, Tours, 1993, B6.

MASTER OF THE ANNUNCIATION TO THE SHEPHERDS

Active Naples, *c.*1635–50

This is the name attached to a group of works of similar style which seem to have been produced in Naples around the second quarter of the seventeenth century. It now seems very probable that the artist in question is Bartolommeo Passante or Bassante (1618–48), who was born in Brindisi but came to Naples *c.*1629 and studied with the obscure Pietro Beato. He died in Naples.

558 The Return of the Prodigal Son
Canvas, 97.5 x 123.8 cm

The subject is from Christ's parable in Luke XV: having squandered his inheritance, the Prodigal Son is generously received by his father. DPG558 is one of a group of pictures of similar composition which have been variously attributed to Francesco Fracanzano and the Master of the Annunciation to the Shepherds (other examples are in the Museo di Capodimonte, Naples, and Bristol City Art Gallery). DPG558 is particularly close to a further example, formerly on the London art market, which is given by F. Bologna to the Master of the Annunciation to the Shepherds (*Battistello Carracciolo*, cat. exh. Castel Sant'Elmo, Naples, 1991–2, p.161, fig.176 and p.168).

Fairfax Murray gift, 1911.

277

JUAN BAUTISTA MARTINEZ DEL MAZO

Province of Cuenca *c.*1611–1667 Madrid

Mazo trained with Velázquez, whose daughter he married in 1633. Through his master's influence he received a number of court appointments, including that of Professor of Painting to the Infante Baltasar Carlos, 1643–6. He succeeded Velázquez as *Pintor de Cámara* in 1661. Apart from making a trip to Naples in 1657–8, Mazo appears to have remained in Madrid, where he collaborated with Velázquez and painted copies of his works (cf. After Velázquez DPG249). He also painted a few landscapes.

277 Luis del Mazo
Canvas, 37.8 x 27.1 cm

DPG277 is a study for Mazo's group portrait of his own family of *c.*1664/5 in the Kunsthistorisches Museum, Vienna. The sitter is Luis, the second of Mazo's four sons by his second wife, Francisca de la Vega.

Bourgeois bequest, 1811.

Velázquez y lo Velázqueño, cat. exh. Cason del Buen Retiro, Madrid, 1960–1, no.133.

75

32

261

PIETRO FRANCESCO MOLA

Colrerio 1612–1666 Rome

CIRCLE OF MOLA

75 Pluto and Proserpine
Canvas, 65.4 x 48.9 cm

Pluto carries Proserpine to the underworld.
The myth is recounted in various sources,
including Ovid's *Metamorphoses* V. Rejecting
an old attribution to Mola, Richter catalogued
DPG75 as Venetian. Murray returned to
'Circle of Mola'.

Bourgeois bequest, 1811.

FOLLOWER OF MOLA

32 Hagar and Ishmael
Poplar(?) panel, 19.7 cm diameter
(circular)

For the subject, see Rubens DPG131.
The figure group is loosely derived from a
composition by Mola known in three versions
(Musée du Louvre, Paris; Christ Church
Gallery, Oxford; Suida-Manning Collection,
New York).

Bourgeois bequest, 1811.

261 Rest on the Flight
Canvas, 53.3 x 58.7 cm

Bourgeois bequest, 1811.

PETER MONAMY

London 1681–1749 London

Monamy began his apprenticeship in 1696 with William Clarke, a
house painter, and became a freeman in the Painter-Stainers' Company
in 1704. As a marine painter he seems to have been self-taught, though
he based his style on that of Willem van de Velde the younger (q.v.).
Monamy established a busy studio. In 1726 he presented a sea-piece to
the Painter-Stainers' Company and was admitted to the livery of the
Company.

STUDIO OF MONAMY

298 A Calm
Canvas, 61.5 x 75.9 cm

Related to – though not directly copied from – a work of 1691 by
Willem van de Velde the younger. Previously catalogued as Monamy,
but according to Robinson probably a work of his studio, *c.*1720.

Bourgeois bequest, 1811.

M.S. Robinson, *The Paintings of Willem van de Velde the Elder and the Younger*,
London, 1990, II, pp.708–9, no.95[4].

298

410

MONOGRAMMIST I.C.

410 Saint Jerome
Signed, upper right: *I C fecit* and inscribed: *S. HIERONYMUS*
Canvas, 67.3 x 61.3 cm

Cartwright bequest, 1686.

N. Kalinsky in *Mr Cartwright's Pictures*, no.31.

CAREL DE MOOR

Leiden 1655–1738 Leiden or Warmond

The son of a frame-maker and art dealer from Antwerp, De Moor studied with Dou (q.v.), Abraham van den Tempel, Frans van Mieris the elder and Godfried Schalcken, becoming a member of the Leiden painters' guild in 1683. He served on a number of occasions as *hoofdman* and dean of the guild and was a co-founder and co-director of the Leiden Drawing Academy. In 1714 he received a knighthood from the Emperor Charles VI. De Moor painted genre scenes in the manner of the Leiden *fijnschilders* ('fine' painters), but came to specialise increasingly in portraiture. He also produced some engravings and mezzotints.

116 Boy with a Flagon and a Bird's Nest
Oak panel, 16.2 x 12.1 cm (arched top)

Gudlaugsson's attribution to De Moor (on photograph mount, Rijksbureau voor Kunsthistorische Documentatie, The Hague) is supported by the presence of a De Moor signature on a comparable child study of a boy playing with a puppy, in which the model appears to be the same (sold Sotheby's Colonnade, 16/19 March 1993, lot 99).

Bourgeois bequest, 1811.

HdG124 (as Slingelandt).

116

549

551

WILLIAM BRIGHT MORRIS

Salford 1844–after 1900

Morris trained at the Manchester School of Art under William Jabez Muckley and then at the South Kensington and RA Schools. He was a landscape, genre and portrait painter, exhibiting at the RA, 1869–1900, the Grosvenor Gallery, 1890, and the Glasgow Institute of the Fine Arts, 1897. In 1876 he made a trip to Spain.

549 Francis Bacon (after an unknown artist)
Canvas, 139.6 x 96.5 cm

For the subject, see British DPG445. DPG549 is recorded in the 1914 Dulwich catalogue as a copy by Morris after the version of this portrait type in the National Portrait Gallery. This information presumably comes from the donor, who may well have commissioned the copy.

Gift of H. Yates Thompson, 1901.

551 Edward Alleyn (after an unknown artist)
Canvas, 139.6 x 96.5 cm

A three-quarter-length copy of British School DPG443. Morris is identified as the copyist in the 1914 Dulwich catalogue.

Gift of H. Yates Thompson, 1901.

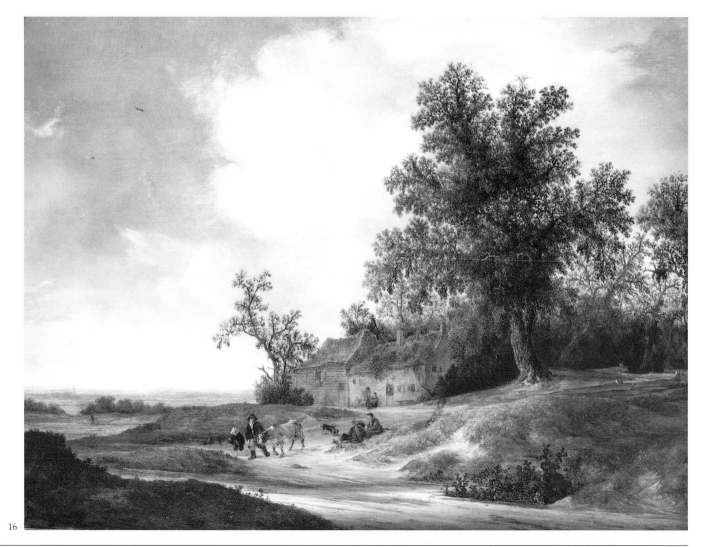

16

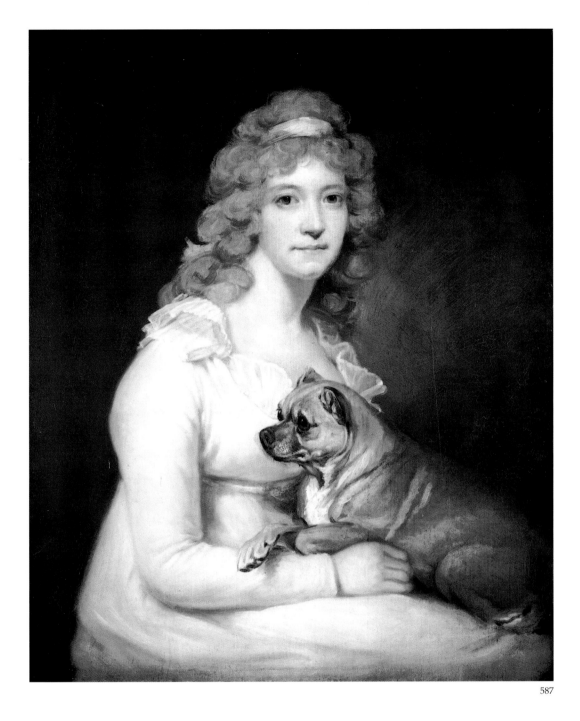

587

JAKOB VAN MOSCHER

Active in Haarlem *c*.1635–1655

Nothing seems to be recorded of Van Moscher's life. A small group of signed works are of a consistent style, which shows the influence of Pieter de Molijn and Salomon van Ruysdael.

16 A Road near Cottages
Signed, lower left: *J van [m?]o…*
Oak panel, 50.2 x 65.3 cm

A closely comparable landscape in the Národní Galerie, Prague, bears a full signature (Beck no.912).

Bourgeois bequest, 1811.

H.-U. Beck, *Künstler um Jan van Goyen, Maler und Zeichner*, Doornspijk, 1991, no.905.

ROBERT MULLER

1773–after 1800

Muller entered the RA Schools in 1788 and exhibited portraits at the RA 1789–1800. Virtually nothing seems to have been recorded of his life.

587 Mrs George Morland
Canvas, 76.3 x 63.5 cm

Anne (Nancy) Ward, the sister of James Ward (q.v.), married the painter George Morland in 1786 but was cruelly treated by him and they separated. She was nevertheless so affected by the news of her husband's death in 1804 that she herself died three days later. Muller's portrait of Morland in the Lady Lever Art Gallery, Port Sunlight was probably painted as a pendant to DPG587. The dog is said to have been painted by H.B. Chalon (1770–1849), the sitter's brother-in-law; this information probably comes from a label on the verso which is no longer legible.

Fairfax Murray gift, 1911.

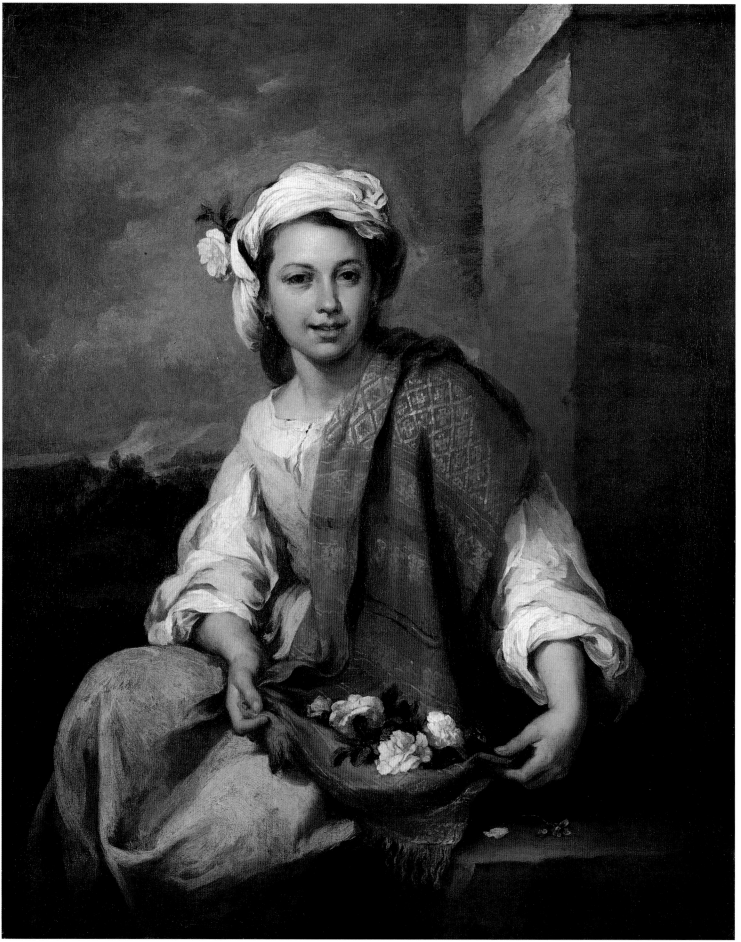

199

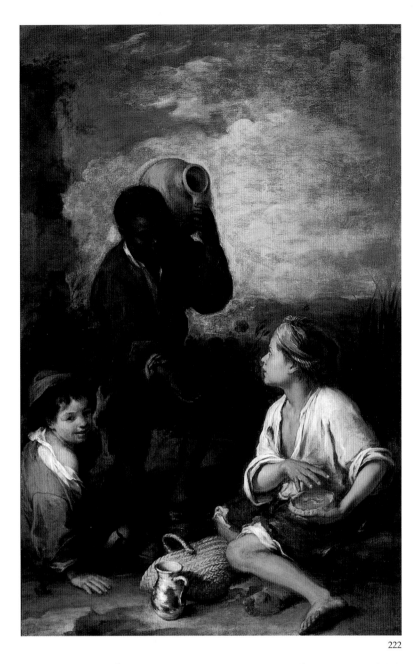

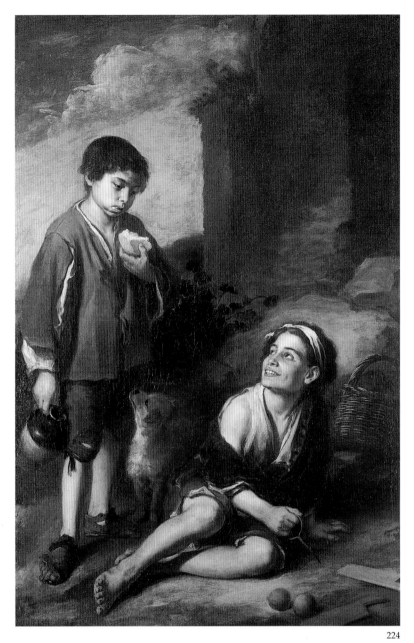

222

224

BARTOLOMÉ ESTEBAN MURILLO

Seville 1617 1682 Seville

Murillo served his apprenticeship with Juan del Castillo in Seville, where his early work was influenced by Alonso Cano and Francisco de Zurbarán. By the 1650s he was the leading painter in Seville, receiving a succession of major religious commissions. On a trip to Madrid in 1658 he studied works by Titian and Rubens, which affected his style. Murillo was president of the newly founded Real Academia de Belles Artes in Seville, 1660–3, and in 1662 became a lay member of the Franciscan Order. As well as religious works, he painted portraits and genre subjects of children; of the last, three major examples are at Dulwich.

199 The Flower Girl
Canvas, 121.3 x 98.7 cm, including additions of *c*.7.5 cm top, bottom and left, and *c*.5 cm right

The additions probably date from the eighteenth century. According to Angulo the flowers are a Vanitas motif, the picture thus evoking the transience of youth and beauty. The model recurs in other works by Murillo and is possibly his daughter, Francisca. Angulo suggests a date of *c*.1670. The picture was one of the most extensively copied at the Gallery in the nineteenth century.

Bourgeois bequest, 1811.

D. Angulo Iñiguez, *Murillo: Su vida, su arte, su ombra*, Madrid, 1981, no.395; *Murillo*, cat. exh. Museo del Prado, Madrid/Royal Academy of Arts, London, 1982–3 (cat. by D. Angulo Iñiguez et al.), no.69; J. Fletcher in *Collection for a King*, no.22 and *Kolekcja dla Króla*, no.17.

222 Two Peasant Boys and a Negro Boy
Canvas, 168.3 x 109.8 cm

Pair to DPG224 below (q.v.). Two street urchins prepare to enjoy a pilfered meal, which a black servant boy (on an errand to fetch water) seeks to share. Dated by *c*.1670 by Angulo. The model for the black boy may have

been Felipe (b.1657), the son of Murillo's mulatto servant. If the dating is correct, then, as noted by E. Harris, the other boys could be Murillo's own sons.

Bourgeois bequest, 1811.

Angulo 1981, no.383; Madrid/London 1982–3, no.68; E. Harris, 'Murillo en Inglaterra', *Goya*, 169–71, 1982, p.10; J. Fletcher in *Collection for a King*, no.23.

224 Invitation to the Game of Pelota
Canvas, 164.9 x 110.5 cm

Pair to DPG222 above. A boy running an errand is tempted by a street urchin to join in a round of the Basque game *pelota*, played with the bat and balls in the foreground. Dated by Angulo *c*.1670. Though condemned by Ruskin, DPG224 and its companion were among the most celebrated paintings at Dulwich in the early nineteenth century.

Bourgeois bequest, 1811.

Angulo 1981, no.382; Madrid/London 1982–3, no.67.

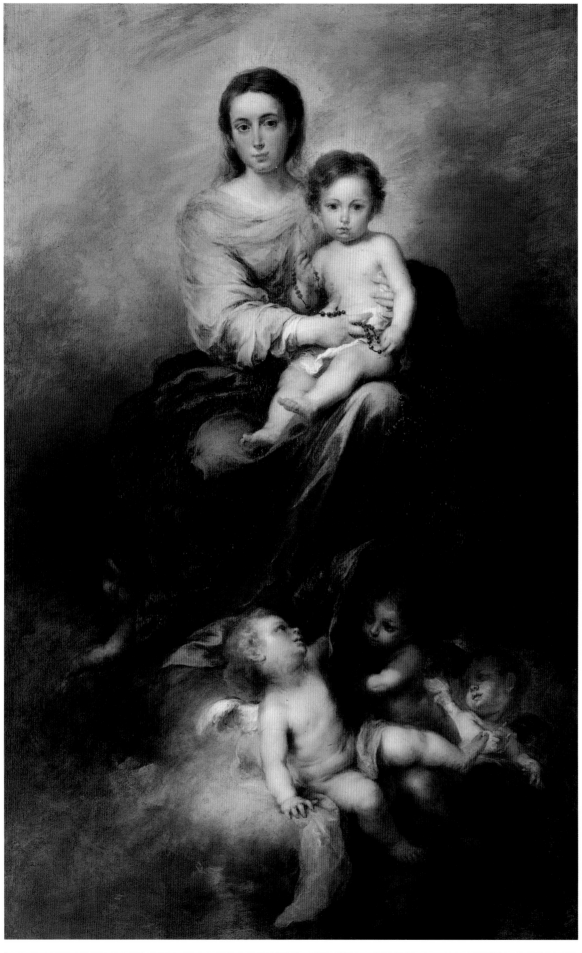

281

281 The Madonna of the Rosary
Canvas, 200.8 x 128.2 cm

Dated by Angulo 1670–80. Murillo painted this subject on a number of occasions (mostly earlier in his career), which possibly reflects his association from 1644 with the Confraternity of the Rosary of the Magdalen in Seville. What appears to be a sketch for DPG281, in which the Christ Child holds an orb rather than the rosary, was formerly with Silberman, Vienna (Angulo, no.178).

Bourgeois bequest, 1811.

Angulo 1981, no.152; X. Brooke in *Conserving Old Masters*, no.6.

AFTER MURILLO

187 The Immaculate Conception
Canvas, 37.5 x 29.8 cm

Probably an early copy of a lost work by Murillo. Another copy is in the Colegio de Santamarca, Madrid (Angulo, pl.514). A lost picture by Murillo, almost identical to these except for the fact that the Virgin is looking heavenward, is recorded in an engraving by F. de Paula Marti of 1794 (Angulo, no.780).

Bourgeois bequest, 1811.

Angulo 1981, under no.780.

272 The Infant Christ as the Good Shepherd
Canvas, 44.8 x 33 cm

Probably an early copy of Murillo's original in the Lane collection, Ashton Wold, Peterborough (Angulo, no.204). Brown regards DPG272 as an original oil sketch by Murillo.

Bourgeois bequest, 1811.

J. Brown, *Murillo & His Drawings*, cat. exh. Art Museum, Princeton University, 1976–7, pp.36, 98, and Appendix 2, no.6; Angulo 1981, under no.204 (as copy).

275 Two Child Angels contemplating the Crown of Thorns
Canvas, 21 x 27.3 cm

Probably a partial copy (with the addition of the crown of thorns) from Murillo's altarpiece of the *Virgin and Child with Saint Anne* in the church of Adanero, near Avila (Angulo, no.179). Brown regards DPG275 as an original oil sketch by Murillo.

Bourgeois bequest, 1811.

Brown, Appendix 2, no.7; Angulo, no.686 (as School or the work of a pupil).

187

272

275

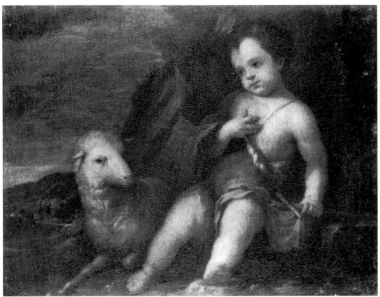

206

FOLLOWER OF MURILLO

206 The Infant Christ Asleep
 Canvas, 62.9 x 82.9 cm

Murillo treated the subject on a number of occasions, but DPG206 is not directly related to any known original. The composition, as Angulo notes, comes closer to an example by Cano in the Gudiol collection, Barcelona (H. Wethey, *Alonso Cano*, Princeton, 1955, pl.159).

Bourgeois bequest, 1811.

Angulo 1981, no.1291 (as School).

211 The Infant Saint John
 Canvas, 62.8 x 80.7 cm

The subject was frequently repeated by Murillo, but DPG211 is not directly related to any known version.

Bourgeois bequest, 1811.

Angulo 1981, no.2160 (as School).

276 Adoration of the Magi
 Canvas, 34.6 x 27.4 cm

For Angulo a work of good quality by a Murillo pupil. He cites a larger version of the composition in the Hospital de la Caridad, Seville, which is there paired with an *Adoration of the Shepherds*. Brown regards DPG276 as an original oil sketch by Murillo.

Bourgeois bequest, 1811.

Brown, Appendix 2, no.5; Angulo, no.1431.

211

612

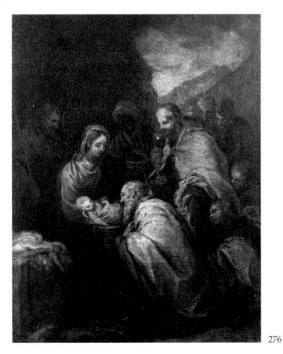

276

CHARLES FAIRFAX MURRAY

London (Bow) 1849–1919 London (Chiswick)

Fairfax Murray became a studio assistant to Edward Burne-Jones in 1866, then also to Dante Gabriel Rossetti, and later worked for Morris & Co. He exhibited at the RA in 1867 and 1871. In the 1870s he made several trips to Italy with John Ruskin, for whom he was engaged in making copies. Fairfax Murray was to spend much of the remainder of his life in Italy. He continued to exhibit in London and Florence, but particularly established a reputation as a connoisseur and collector. He made generous gifts to Birmingham City Art Gallery, the Fitzwilliam Museum, Dulwich Picture Gallery and the National Gallery. His collection of books and drawings was purchased by J. Pierpont Morgan in 1910.

612 Kings' Daughters

> Signed, bottom left: *C F M*
> Mahogany panel, 25.8 x 36.5 cm

The subject is taken from D.G. Rossetti's poem 'My Father's Close', translated from the old French, which appeared in his *Poems*, 1870. Christian suggests a date of *c*.1875. According to an inscription on the verso, the painting was given by Fairfax Murray to W.S. Spanton in May 1882. Fairfax Murray also gave Spanton the 1870 volume of Rossetti's poems, which he and his wife had particularly enjoyed (W.S. Spanton, *An Art Student and his Teachers in the Sixties*, London, 1927, pp.84, 101).

Bequest of H. Margaret Spanton, 1934.

J. Christian in *The Last Romantics. The Romantic Tradition in British Art: Burne Jones to Stanley Spencer*, cat. exh. Barbican Art Gallery, London, 1989, no.42.

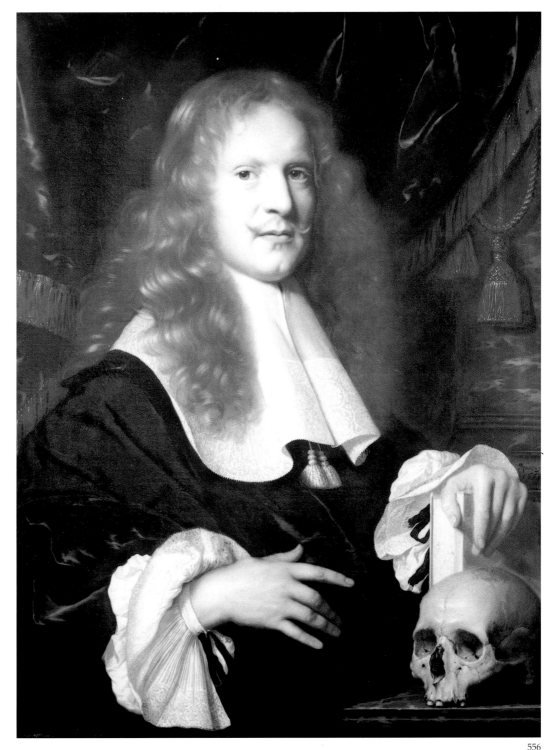

556

PIETER NASON

The Hague or Amsterdam 1612–1688/90 The Hague

Nason probably trained in Amsterdam, but in 1639 entered the painters' guild in The Hague, where he was also one of the founder members of the painters' confraternity *Pictura* in 1656. A signed and dated portrait of the Earl of Shaftesbury suggests that he was in England in 1663. He seems otherwise to have been active mainly in The Hague.

556 Portrait of a Man

> Signed and dated, lower right: *P Nason f / 1663*
> (PN in monogram)
> Canvas, 89.5 x 67.7 cm

Since Nason appears to have been in England in 1663, it is possible that DPG556 was painted there. However, the costume suggests that the sitter is Dutch. A similarly-dated female portrait in the Walters Art Gallery, Baltimore may be a pendant.

Fairfax Murray gift, 1911.

C.H. Collins-Baker, 'Nederlansche Portretten in de Dulwich Gallery', *Onze Kunst*, 1915, pp.108–9.

PEETER NEEFFS THE ELDER

Antwerp, active 1605– after 1655 Antwerp

Neeffs may have been a pupil of Hendrik van Steenwijck the elder or the younger. He is listed in the painters' guild at Antwerp in 1609 and married there in 1612. He specialised in church interiors, in which the figures were often added by other artists.

141 Interior of a Gothic Church
Signed on step, bottom left: *PEETER NEEffS*
Oak panel, 54.4 x 85.7 cm

The church is loosely based on the Cathedral of Notre-Dame in Antwerp. The figures have been attributed to Frans II Francken (1581–1642).

Bourgeois bequest, 1811.

H. Jantzen, *Das niederländische Arkitekturbild*, Leipzig, 1910, no.268.

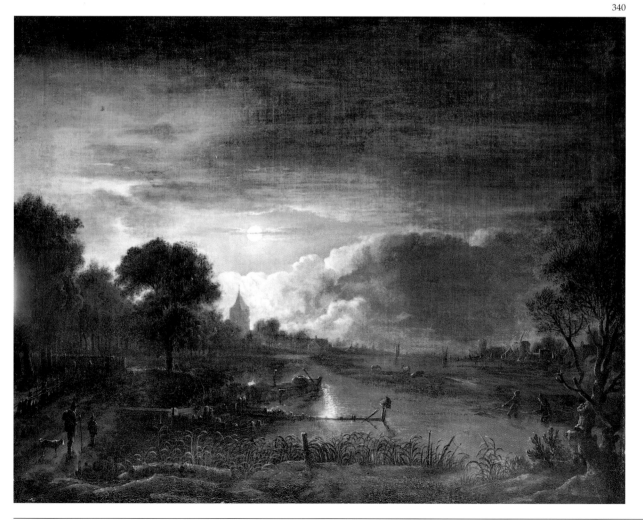

AERT VAN DER NEER

Amsterdam 1603/4– 1677 Amsterdam

AFTER VAN DER NEER

340 River Scene by Moonlight
Signed or inscribed, bottom right: *AV DN* (AV and DN each in monogram)
Canvas, 57.5 x 74 cm

Copy or replica of a picture in the collection of the Duke of Sutherland.

Bourgeois bequest, 1811.

HdG, under no.228.

NETHERLANDISH SCHOOL, see p.304

28

JAMES NORTHCOTE

Plymouth 1746–1831 London

Northcote entered the RA Schools in 1771 and worked
as an assistant in Reynolds's studio 1771–6. After
practising briefly as a portrait painter in Plymouth, he
made a trip to Italy, 1777–80, and was elected a fellow
of the Academies at Florence, Rome and Cortona. In
1781 he settled in London, where he painted portraits,
fancy pictures and history subjects. Northcote exhibited
at the RA 1773–1828 and at the British Institution
1806–31, being elected ARA in 1786 and RA in 1787.
He wrote a biography of Reynolds (q.v.).

28 Noel Joseph Desenfans
　　Canvas, 73.3 x 60.9 cm (oval)

Noel Desenfans (1744–1807): born in Douai and
educated at the universities of Douai and Paris.
He came to London in 1769 as a language teacher and
married Margaret Morris, the aunt of two of his pupils,
in 1776 (see After Reynolds DPG627). Active as a
picture dealer from the 1770s, in 1790–5 he was
engaged in assembling a collection of old master
paintings for the King of Poland. However, because of
the King's enforced abdication in 1795, this was never
delivered. After failing to persuade the Government to
establish a British National Gallery, and finding himself
unable to dispose of his collection on satisfactory
terms, Desenfans bequeathed the pictures to his friend
Sir Francis Bourgeois (q.v.), who in turn bequeathed
them to Dulwich College. (See also Unknown
DPG503.) DPG28 is listed by Northcote among
portraits painted in 1796 and is recorded in his account
book for that year.

Bourgeois bequest, 1811.

S. Gwynne, *Memorials of an Eighteenth Century Painter*, London,
1898, p.275, no.305; J. Simon, 'The Account Book of James
Northcote', *Walpole Society*, LVIII, 1995/6, p.66, no.320.

172

172 Sir Peter Francis Bourgeois
Canvas, 76.2 x 63.5 cm

For the sitter, see Bourgeois above. DPG172 is probably the 'Portrait of an artist' exhibited at the RA in 1794, identified in an annotated copy of the catalogue as Bourgeois (National Gallery Library). It is presumably also the portrait of Bourgeois that Northcote listed as painted in 1795, which was engraved in that year by Levey (in oval format). A photograph by Emery Walker shows modifications to the hairstyle; these have since been removed (National Portrait Gallery Library).

Bourgeois bequest, 1811.

Gwynne, p.275, no.301.

CARLO FRANCESCO NUVOLONE

Milan 1609–1662 Milan

Nuvolone trained with his father Panfilo Nuvolone and then with Cerano at the Accademia Ambrosiana in Milan. His early work was strongly influenced by Giulio Cesare Procaccini. He painted a number of important fresco decorations and altarpieces as well as portraits.

235 The Creation of Eve
Canvas, 182.2 x 194.3 cm

The subject is from Genesis II, 21–2. The picture was catalogued as Procaccini until 1880, when Richter suggested the attribution to Nuvolone.

Gift of the heirs of Peter Carry Tupper, 1845.

235

29

PIETER NYS

Amsterdam 1624–1681 Amsterdam

Nys was a pupil of the still-life painter Evert van Aelst. He made several trips to Rotterdam and travelled in the Southern Netherlands and Germany in the early 1650s. He is said to have been in London in 1666 and married in Amsterdam in 1670.

29 A Woman Spinning
Signed and dated, verso, on stretcher: *P. NYS Fecit / 1652*
Canvas, 59 x 60.6 cm

Bourgeois bequest, 1811.

476

417

ARCHER JAMES OLIVER

1774–1842 London

Oliver studied at the RA schools from 1790 and established a fashionable portrait practice in New Bond Street. He exhibited at the RA 1791–1841 and at the British Institution 1809–41. He was elected ARA in 1807. From *c*.1820 failing health contributed to the collapse of his portrait practice. He was appointed curator at the RA Schools in 1835, but his health further declined and he was supported in later life from RA funds.

476 The Reverend Ozias Thurston Linley
Canvas, 76.8 x 64.2 cm

For the sitter, see Attributed to Lawrence DPG474. DPG476 was catalogued until 1980 as a portrait of Noel Desenfans by Owen, but the confusion was rectified by Murray. Probably to be dated *c*.1805/10.

Linley bequest, 1835.

G.A. Waterfield in *A Nest of Nightingales*, no.8:2.

ISAAC OLIVER

Rouen? 1558/68–1617 London

AFTER OLIVER

417 Henry, Prince of Wales
Canvas, 141 x 126.8 cm

Henry Frederick (1594–1612), Prince of Wales, eldest son of James VI and I (see Attributed to De Critz DPG548). The image derives ultimately from a lost drawing by Oliver showing the prince full length but is probably taken from one of the engravings after this drawing, examples of which appeared as the frontispiece to M. Drayton's *Poly-Olbion* of 1612 (see British School DPG430) and in H. Holland's *Herωlogia Anglica* of 1620.

Possibly Alleyn bequest, 1626.

S. Foister in *Edward Alleyn*, p.51.

BALTHASAR-PAUL OMMEGANCK

Antwerp 1755–1826 Antwerp

Ommeganck was a pupil of Henri-Joseph Antonissen and studied drawing at the Antwerp Academy. He entered the Antwerp painters' guild in 1767 and was elected its dean in 1789. In 1796 he became a professor at the Antwerp School of Fine Arts. Ommeganck was a highly successful landscape and animal painter who acquired an international reputation.

145 A Bull
Oak panel, 38.7 x 50.2 cm

Bourgeois bequest, 1811.

145

213

CRESCENZIO ONOFRI

Rome 1632?–c.1713 Florence

Onofri was a pupil in Rome of Gaspard Dughet (q.v.), whose style he imitated with great success, collaborating with his master on landscapes in the throne room of the Palazzo Doria-Pamphilj. In 1689 Onofri moved to Florence to work for prince Ferdinando de' Medici. He also produced landscape engravings and was a prolific draughtsman. The figures in his paintings seem often to be the work of other artists.

ATTRIBUTED TO ONOFRI

213 Destruction of Niobe's Children
Canvas, 93.4 x 135 cm

Apollo and Diana slay all of Niobe's fourteen children to avenge their mother Leto, to whom Niobe has declared herself superior on account of her fecundity (Ovid, *Metamorphoses*, VI). Formerly given to the school of Dughet, the attribution to Onofri was proposed by Boisclair, who suggests that the figures may be the work of Pietro Dandini (1646–1712).

Bourgeois bequest, 1811.

M.-N. Boisclair, *Gaspard Dughet, 1615–1675*, Paris, 1986, R38.

JOHN OPIE

St Agnes (Cornwall) 1761–1807 London

Opie was the son of a carpenter. His talent was recognised by John Wolcot, who trained him and brought him to London in 1781. Opie achieved immediate success as a portrait painter (becoming known as the 'Cornish Wonder') and from 1784 painted a distinguished series of subject pictures. He exhibited at the RA 1782–1807, being elected ARA in 1786 and RA in 1787. In 1805 he was elected Professor of Painting at the RA; the lectures which he delivered in 1807 were published posthumously.

94 Self-portrait
Canvas, 60.3 x 50.8 cm

Probably painted *c.*1790 – the sitter appears a few years older than in the self-portrait dated 1785 in the National Portrait Gallery, and younger than in a self-portrait of 1793/4 recorded in a miniature copy by Bone (Bonhams, Knightsbridge, 19 March 1996, lot 87).

Bourgeois bequest, 1811.

A. Earland, *John Opie and his Circle*, London, 1911, p.300.

94

45

98

113

ADRIAEN VAN OSTADE

Haarlem 1610–1685 Haarlem

Ostade is said to have trained with Frans Hals at the same time as Brouwer (q.v.).
By 1634 he was a member of the painters' guild in Haarlem. In 1657 he married as his
second wife, the daughter of a wealthy Catholic family, and he may himself have become
a Catholic. He served as *hoofdman* of the painters' guild in 1647 and 1661 and as dean in
1662. Ostade specialised in peasant genre scenes and, besides painting, produced
numerous etchings and watercolour drawings.

45 Interior of a Cottage
Signed, lower right: *Av Ostade* (Av in monogram)
Oak panel, 34.1 x 27.5 cm

According to Hofstede de Groot, a work of Ostade's later period. A version is recorded in
the Weustenberg sale, Berlin, 1908 (photograph Witt Library).

Bourgeois bequest, 1811.

HdG290 (and probably 294).

98 A Woman with a Beer-jug
Signed on table edge, bottom left: *Av. Ostade*. (Av in monogram)
Oak panel, 16.2 x 14.2 cm

Pendant to DPG113; both are late works, according to Hofstede de Groot.
Another signed version was in the Merveldt sale, Lempertz, Cologne,
6 November 1928 (lot 171).

Bourgeois bequest, 1811.

HdG221.

113 A Man Smoking
Signed, on table edge lower left: *Av. Ostade*. (Av in monogram)
Oak panel, 15 x 14.1 cm, excluding an addition of 2.1 cm at the bottom

See DPG98 above.

Bourgeois bequest, 1811.

HdG174.

115

115 Three Peasants at an Inn
Signed and dated, bottom right: *Av Ostade 1647*
(Av in monogram)
Oak panel, 27.1 x 21.6 cm

Bourgeois bequest, 1811.

HdG327.

AFTER OSTADE

619 Peasants Drinking
Inscribed on block of wood, bottom right:
Ostade (or *Ostads?*)
Oak panel, 41 x 49 cm

A crude imitation based on Ostade's *Peasants at an Inn* of 1676 at Kassel (HdG427).

Bequest of Miss Gibbs, 1951.

619

287

PASQUALE OTTINO

Verona 1578–1630 Verona

Ottino served his apprenticeship in Verona with Felice Brusasorci and by 1614 had acquired some reputation as a painter. His works suggest that he visited Bologna and he is also said to have visited Rome, though the date of this trip is uncertain. He otherwise seems to have remained in Verona.

287 Madonna with Saint Lorenzo Giustiniani and a Venetian Nobleman
Marble, 49.5 x 26 cm (arched top)

Lorenzo Giustiniani (1381–1455) entered the Augustinian monastery of San Giorgio in Alga, becoming general of the congregation; he was later appointed first bishop of Grado and from this derived the reputation of being the first Patriarch of Venice; he was canonised in 1690. Formerly catalogued as Alessandro Turchi, but correctly attributed to Ottino by Magagnato in 1974. A version was sold at Christie's, 4 April 1986 (lot 39).

Bourgeois bequest, 1811.

L. Magagnato, 'Pasquale Ottino' in P. Brugnoli (ed.), *Maestri della Pittura Veronese*, Verona, 1974, p.298.

GIOVANNI BATTISTA PAGGI

Genoa 1554–1627 Genoa

Son of a noble family, Paggi served no formal apprenticeship, but took up painting with the encouragement of Luca Cambiaso. In 1581 he was tried for murder and had to flee Genoa. He stopped briefly in Aulla and Pisa but then settled in Florence, where he entered the Accademia del Disegno in 1586. He was permitted to return to Genoa in 1599 and there published a treatise on painting in 1607.

248 Venus and Cupid
Canvas, 84.8 x 64.2 cm

Catalogued by Richter as a late work by Luca Cambiaso, but the composition was engraved as the work of Paggi by C. Galle. DPG248 is presumably an early work painted under Cambiaso's influence. Frabetti records versions in Vienna and at the Palazzo Bianco, Genoa; others are in private collections in Genoa and Rome.

Bourgeois bequest, 1811.

B. Suida Manning and W. Suida, *Luca Cambiaso; la vita e le opere*, Milan, 1958, p.103; G. Frabetti, 'Due cose del Paggi', *Genova*, 2, 1958, p.17.

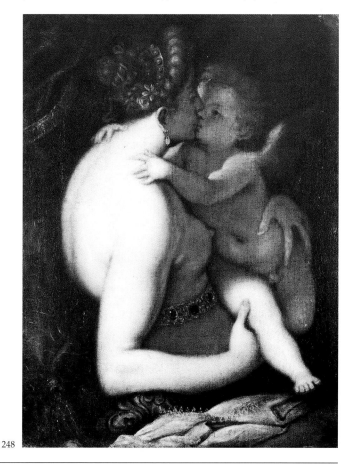

248

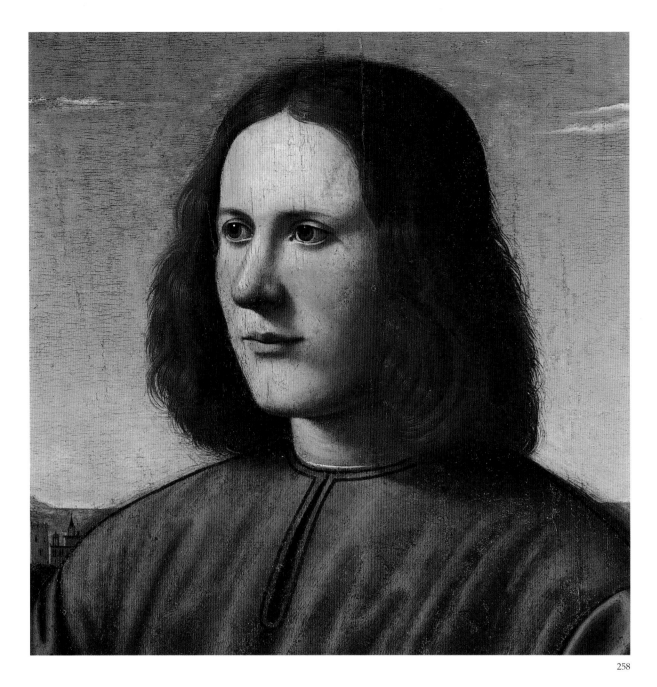

258

CORNELIS VAN POELENBURCH

Utrecht 1594/5–1667 Utrecht

Poelenburch trained with Abraham Bloemaert. By 1617 he was in Rome, and he also worked at the Medici court in Florence 1620–1. He was back in the Netherlands by 1627 and settled in Utrecht, where, apart from trips to Paris in 1631 and London in 1637–41, he remained for the rest of his life. He served in the Utrecht painters' college as *overman* in 1656 and as dean in 1657–8 and 1664. Poelenburch painted some religious and mythological subjects and portraits, but specialised chiefly in Italian landscapes with ruins and small figures.

25 Nymphs and Satyr
Signed, lower right: *C.P*
Oak panel, 38.4 x 51.2 cm
(oval)

N. Sluijter-Seiffert cautiously expresses some doubt as to the attribution (letter on file, 1997).

Bourgeois bequest, 1811.

338 Valley with Ruins and Figures
Poplar panel, 34.5 x 44.5 cm
(oval)

Formerly catalogued as Breenbergh, but attributed to Poelenburch by Chiarini in 1972. Roethlisberger accepts the attribution and suggests a date shortly following Poelenburch's return to Utrecht in 1627, although the fact that DPG338 is on poplar suggests a work painted in Italy. N. Sluijter-Seiffert also accepts the attribution, but suggests that the figures – especially the extravagantly dressed pair in the left foreground – might have been painted by Breenbergh.

Bourgeois bequest, 1811.

M. Chiarini , 'Filippo Napoletano, Poelenburgh, Breenbergh e la Nascita del Paesaggio realistico in Italia', *Paragone*, 269, 1972, p.30, pl.41a; M. Roethlisberger, *Bartholomeus Breenbergh, The Paintings*, Berlin/New York, 1981, no.58; N. Sluijter-Seiffert, *Cornelis van Poelenburch (ca.1593–1667)*, diss., Leiden, 1984, p.116.

PIERO DI COSIMO

Florence 1461/2–1521? Florence

By 1480 Piero di Cosimo was a pupil of Cosimo Rosselli, whom, according to Vasari, he assisted on fresco decorations in the Sistine chapel in the Vatican, 1481–2. Piero was established as an independent painter by the later 1480s and also worked on designs for triumphal processions. He is recorded as a member of the *compagnia di S. Luca*, 1503–5, and joined the Florentine painters' guild in 1504.

258 A Young Man
Poplar panel, 41.2 x 41 cm, excluding capping strips of 0.8 cm top, left and right and a mahogany addition of 7.6 cm at the bottom

The panel is a fragment made up with an addition at the bottom (at present concealed by the frame). Attributed in 1813 to Leonardo da Vinci and later to Boltraffio, the attribution to Piero di Cosimo seems now to be generally accepted, although Bacci expresses reservations. A date in the first years of the sixteenth century seems probable.

Bourgeois bequest, 1811.

M. Bacci, *Piero di Cosimo*, Milan, 1966, no.59 (as possibly by Ridolfo del Ghirlandaio); M. Bacci, *L'opera completa di Piero di Cosimo*, Milan 1976, no.66 (as Attributed).

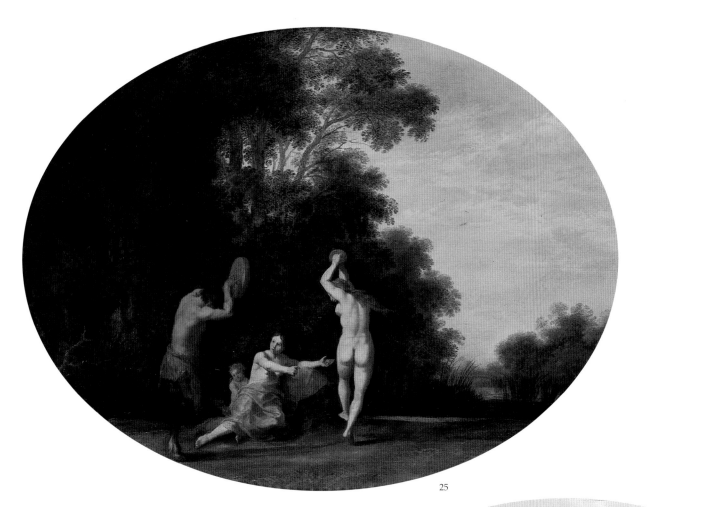

25

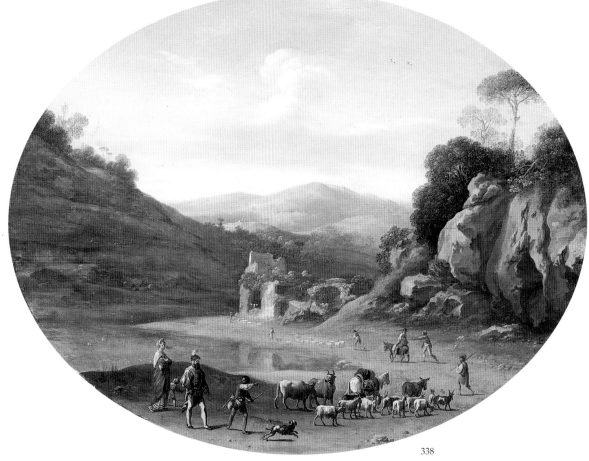

338

334

343

324

PAULUS POTTER

Enkhuizen 1625–1654 Amsterdam

AFTER POTTER?

334 Cattle and Sheep
 Inscribed, bottom right: *Paulus Potter*
 Oak panel, 38.4 x 53

DPG334 may be a copy of a lost work by
Potter of 1650, as suggested by the existence
of two other versions of the same
composition, neither of autograph quality,
both recorded as bearing a signature and the
date 1650 (La Broderie sale, Lucerne, 19 July
1927, lot 82, and Sotheby's, 18 November
1985, lot 12).

Bourgeois bequest, 1811.

MANNER OF POTTER

343 A Cow
 Canvas on panel, 19.8 x 13.6 cm,
 including a made-up strip of
 approximately 1.9 cm at the right edge

Apparently a fragment.

Bourgeois bequest, 1811.

324 Cattle
 Oak panel, 13.9 x 17.4, excluding
 additions of 2.9 cm at the top,
 1.9 cm at the bottom, 2.8 cm on the left
 and 3 cm on the right

Bourgeois bequest, 1811.
HdG77j(?).

234

NICOLAS POUSSIN

Les Andelys 1594–1665 Rome

After training possibly with Noël Jouvenet in Rouen, and briefly with Georges Lallemant and Ferdinand Elle in Paris, Poussin arrived in Rome in 1624 and, apart from a trip to Paris in 1640–2, remained there for the rest of his life. His early mythologies were based on a study of Titian, but he was increasingly influenced by the example of Raphael and antique sculpture and evolved a measured, intellectual style which was to have a seminal influence on the future of French painting.

234 The Nurture of Jupiter
Canvas, 96.2 x 119.6 cm

Jupiter was saved from being devoured by his father Saturn and sent to Mount Ida on Crete, where he was tended by nymphs who fed him honey and the milk of the goat Amalthea (Poussin's source is probably Callimachus's *Hymn to Jupiter*). Datable *c.*1636–7. The suckling group in the centre foreground is taken from an engraving after Giulio Romano. A slightly later treatment of the same subject by Poussin is in the Staatliche Museen, Berlin.

Bourgeois bequest, 1811.

A. Blunt, *The Paintings of Nicolas Poussin: a critical catalogue*, London, 1966, no.161; *Nicolas Poussin, 1594–1665*, cat. exh. Grand Palais, Paris, 1994–5 (catalogue by P. Rosenberg and L.-A. Prat), no.59.

236

236 The Triumph of David

Canvas, 118.4 x 148.3 cm

The subject is David's return to Jerusalem with the head of the Philistine giant
Goliath, whom he had slain. The episode is mentioned (though not described) in
I Samuel XVII, 54. The picture is not recorded in the early sources and the attribution
to Poussin has been doubted, particular suspicion being aroused by the associated
drawings at Windsor Castle and Chantilly. However, there seems no persuasive
reason to doubt either the painting or the drawings. The picture may be dated within
the period 1631–3. The group of maidens on the left and the general lines of the
composition derive from an engraving after Giulio Romano. The X-ray reveals
numerous changes, notably to the portico, which was originally arcaded, and to the
group of maidens on the left, which was originally placed further to the right.

Bourgeois bequest, 1811.

Blunt 1966, no.33; R. Verdi in *Collection for a King*, no.24 and *Kolekcja dla Króla*, no.18; *Nicolas
Poussin, 1594–1665*, cat. exh. Royal Academy of Arts, London, 1995 (catalogue by R. Verdi), no.24.

238

238 Rinaldo and Armida

Canvas, 82.2 x 109.2 cm

The subject is from Tasso's *Gerusalemme Liberata*: the Saracen sorceress Armida has enchanted and is about to kill the Christian warrior Rinaldo, but her hand is stayed by love. Probably painted within the period 1628–30. The X-ray reveals an underlying composition of a dead or wounded man with a putto and the arm of a third figure, possibly an earlier version of the same subject.

Bourgeois bequest, 1811.

Blunt 1966, no.202; R. Verdi in *Collection for a King*, no.25; Paris 1994–5, no.25.

240 The Return of the Holy Family from Egypt (?)
Canvas, 117.8 x 99.4 cm

Traditionally called a *Flight into Egypt*, but the age of the Christ Child has suggested the much less usual subject of the return of the Holy Family from Egypt (Matthew II, 21). If the pyramid and obelisk on the far bank are intended to evoke Egypt (as suggested by Verdi), then the subject must be the flight, as the Holy Family is clearly embarking and not disembarking. There seems to be no direct textual source for the vision of the Cross – a clear presage of Christ's Passion, which, according to a number of commentators, began with the flight to Egypt. A similar vision can be found in other, later examples of the Flight (by Castiglione and Camassei, for example). DPG240 was probably painted within the period 1628–30. Another version in the Cleveland Museum of Art seems to be slightly earlier.

Bourgeois bequest, 1811.

Blunt 1966, no.68; R. Verdi in *Kolekcja dla Króla*, no.19.

263 The Translation of Saint Rita of Cascia
Poplar panel, 48.8 x 37.8 cm

Saint Rita had wished to become a nun, but submitted to her parents' will and married; after the violent death of her cruel husband, she was miraculously transported to the Augustinian convent of Cascia, near Spoleto. She was canonised in 1900. The town in DPG263 appears to be Spoleto and is almost unique in Poussin's *œuvre* for its plausible topography. X-rays reveal that the panel was first painted with the figure of a reclining nymph, and was cut down before being reused for the present composition, painted probably in the mid-1630s.

Bourgeois bequest, 1811.

Blunt 1966, no.94.

263

481

481 Venus and Mercury
Canvas, 80.2 x 87.5 cm, including a later addition of approximately 5 cm on the left

DPG481 is a fragment of a larger composition of which the left-hand part, showing music-making *putti*, is now in the Louvre. A drawing in the Louvre and an etching by Fabrizio Chiari of 1636 show that both the surviving fragments have been cut at the top and that the composition originally included an airborne *putto* aiming a dart at Mercury. A *putto* in the Louvre fragment prepares to award wreaths to the fighting *putti* in DPG481, who have generally been identified as Anteros and Eros, suggesting that the subject is an allegory of the antagonism between spiritual and sensual love. E. McGrath (letter on file, 1997) notes that the fighting *putti* could be read as Cupid and the infant Pan and need not, therefore, signify more than the ascendancy of love over all things ('omnia vincit amor'). DPG481 has generally been dated *c*.1627, but is placed by Mahon within the period 1629–31.

Bourgeois bequest, 1811.

Blunt 1966, no.184; *Nicolas Poussin, Venus and Mercury* (cat. exh. Dulwich Picture Gallery, 1986–7); E. Cropper and C. Dempsey, *Nicolas Poussin, Friendship and the Love of Painting*, Princeton, 1996, pp.231–7.

203

AFTER POUSSIN

203 A Roman Road
Canvas, 79.3 x 100 cm

Identified by Blunt as the landscape '*où est un grand chemin*' which, according to Félibien, Poussin painted in 1648. However, DPG203 is more probably a copy of a lost original by Poussin, as suggested by Thuillier and Mahon (note on file, 1983). The X-ray shows that the canvas was first used for a partial copy of *Moses trampling Pharaoh's Crown* in the Louvre. Poussin's original seems to have been painted as a pair to the *Landscape with a Man washing his Feet at a Fountain* (or the *Greek Road*) in the National Gallery, London, the pictures together illustrating the contrasting effects on landscape of Roman and Greek civilisation (see Cropper and Dempsey, pp.284–8).

Bourgeois bequest, 1811.

Blunt 1966, no.210; J. Thuillier, *L'Opera completa di Nicolas Poussin*, Milan, 1974, no.157.

225 Holy Family
Canvas, 66.1 x 50.8 cm

A copy of Poussin's original in the Louvre, probably of 1656.

Bourgeois bequest, 1811.

Blunt 1966, no.57/1.

227 The Adoration of the Magi
Canvas, 129.2 x 141 cm

The original, signed and dated 1633, is in the Gemäldegalerie, Dresden.

Bourgeois bequest, 1811.

Blunt 1966, no.44/1.

229 Inspiration of Anacreon
Canvas, 96.2 x 74 cm

The original is in the Niedersächsische Landesgalerie, Hanover.

Bourgeois bequest, 1811.

Blunt 1966, under no.125.

477 The Nurture of Bacchus
Canvas, 73.6 x 99.4 cm

The original is in the National Gallery, London.

Bourgeois bequest, 1811.

Blunt 1966, no.133/1.

227

225

229

477

101

231

482

615

FOLLOWER OF POUSSIN

101 Landscape
 Canvas, 55.2 x 93.4 cm

Bourgeois bequest, 1811.

231 Putti in a Landscape
 Canvas, 23.4 x 33 cm

Bourgeois bequest, 1811.

MANNER OF POUSSIN

482 Nymph and Satyr
 Canvas on panel, 67.7 x 50.2 cm

Bourgeois bequest, 1811.

CORNELIS PRONK

Amsterdam 1691–1759 Amsterdam

Pronk was a pupil of Jan van Houten and Arnold Boonen. In the earlier part of his career he painted portraits and made copies in watercolour after seventeenth-century Dutch masters. He later became a topographical draughtsman. From 1734 Pronk made designs for porcelain decoration for the East India Company.

615 Portrait of a Man
 Dated and signed, on the letter, bottom left: *[Amsterd]am 1714/ C. Pronk;* possibly signed again on the letter, bottom centre right: *Pronk [D…?];* and inscribed on the same letter: *Monsr*.
 Canvas, 90.5 x 70.2 cm

There are various simulated inscriptions.

Gift of Professor C.D. Broad, 1946.

ADAM PYNACKER

Schiedam 1620/1–1673 Amsterdam

Pynacker was the son of a wine merchant and may have begun his career working for his father. He was in Italy for three years, probably 1645–8. On his return he was frequently in Delft, where his friend the wine merchant and painter Abraham Pick probably helped him to establish himself as a painter. Pynacker worked in Schiedam until *c*.1661, when he settled in Amsterdam. His early work was inspired by Jan Both (q.v.), but he later evolved a bolder and more theatrical landscape style.

86 Landscape with Sportsmen and Game
Signed, bottom centre right:
A Pynacker (AP in monogram)
Canvas, 137.8 x 198.7 cm

Possibly one of the pictures by Pynacker that comprised the decoration of a room in the house of Cornelis Backer at 548 Herengracht, Amsterdam, described in a poem by Pieter Verhoek. If DPG86 was painted for Backer, it is unlikely to date before 1665, the date of the completion of his house. Harwood accepts a date of *c*.1665. The defecating dog seems to derive from the work of *Ludolf de Jongh* (R.E. Fleischer, *Ludolf de Jongh*, Doornspijk, 1989, p.57 and fig.48). The foreground leaves have turned blue through the fading of a yellow pigment.

Bourgeois bequest, 1811.

HdG9 (and possibly 72); L.B. Harwood, *Adam Pynacker*, Doornspijk, 1988, no.77.

86

183

183 Bridge in an Italian Landscape
Signed indistinctly above lily leaves, lower right:
APijnaker (AP in monogram?)
Oak panel, 43.8 x 52.7 cm

An early work displaying the influence of Both. Harwood proposes a date of 1653/4 (in Williamstown/Sarasota 1994–5). A copy was formerly in the Gemäldegalerie, Dresden (Harwood, no.32a).

Bourgeois bequest, 1811.

HdG74; Harwood, no.32; *A Golden Harvest, Paintings by Adam Pynacker*, cat. exh. Sterling and Francine Clark Art Institute, Williamstown/John and Mable Ringling Museum of Art, Sarasota, 1994–5 (catalogue by L.B. Harwood), no.6.

ERASMUS QUELLINUS

Antwerp 1607–1678 Antwerp

Quellinus was the son of a sculptor of the same name, from whom he probably learned to draw. He also seems to have taken a degree in philosophy. From 1633/4 he was a member of the painters' guild in Antwerp, and in the 1630s he worked under Rubens on the triumphal entry of the Cardinal-Infante Ferdinand and on the decoration of the Torre de la Parada for Philip IV of Spain. As an independent painter, he painted history subjects in a classicising style which brought him considerable success. He often worked in collaboration with other artists, in particular the flower painters Daniel Seghers and Jan Philips van Thielen.

322 Cartouche with the Virgin and Child and Saint Anne See Seghers.

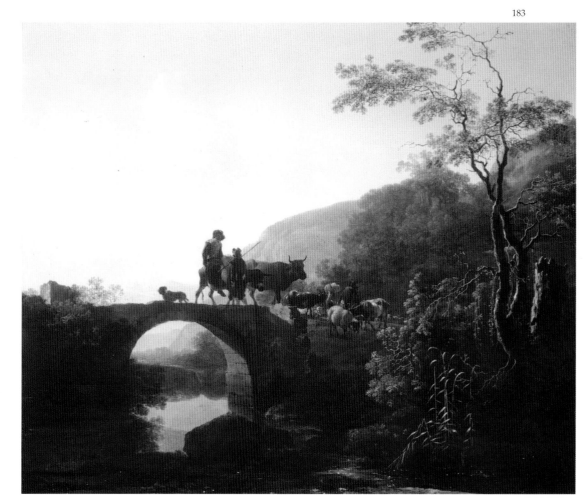

241

243

507

RAPHAEL

Urbino 1483–1520 Rome

Raphael – Raffaelo Santi, or de' Santi – was the son of a painter, but his father died when he was eleven years old and it is said that he then trained with Perugino. He was active as an independent master by the age of sixteen. Raphael's earliest altarpieces were painted for Città di Castello and Perugia (see below). In 1504–8 he was in Florence. He was then called to Rome, where he worked extensively as a painter and architect for Popes Julius II and Leo X. Although his career was short, Raphael became one of the most admired and influential of all artists.

241 Saint Francis of Assisi
Poplar panel, 25.8 x 16.8 cm

Saint Francis is identified by the wound in his side (the absence of the stigmata in his hands and feet is presumably the result of wear). With DPG243 below, this is one of the two outer panels from the predella of the 'Colonna altarpiece' painted by Raphael, probably c.1502, for the Franciscan nuns of Saint Anthony of Padua in Perugia. The main part of the altarpiece, together with one predella panel, is in the Metropolitan Museum of Art, New York. The other predella panels are in the National Gallery, London and the Isabella Stewart Gardner Museum, Boston.

Bourgeois bequest, 1811.

L. Dussler, *Raphael: A Critical Catalogue of his Pictures, Wall-Paintings and Tapestries*, London and New York, 1971, p.16; K. Oberhuber, 'The Colonna Altarpiece in the Metropolitan Museum and Problems of the Early Style of Raphael', *Metropolitan Museum Journal*, 12, 1977, p.75.

243 Saint Anthony of Padua
Poplar panel, 25.6 x 16.4 cm

Saint Anthony is identified by the lily. See DPG241 above.

Bourgeois bequest, 1811.

AFTER RAPHAEL

507 The Transfiguration
Canvas, 376.6 x 264.8 cm

An early, slightly reduced copy of Raphael's altarpiece now in the Pinacoteca Vaticana, Rome.

Gift of Thomas Mills of Saxham Hall, Sussex, 1796.

REMBRANDT

Leiden 1606–1669 Amsterdam

After studying for a brief period at Leiden University, Rembrandt Harmensz. van Rijn trained with Jacob van Swanenburgh in Leiden and Pieter Lastman in Amsterdam. He worked first in Leiden, but moved in 1631/2 to Amsterdam, where he achieved success as a painter of portraits and history subjects. In 1656 Rembrandt was declared bankrupt and two years later his property was put up for auction. Thereafter he worked as the employee of his common-law wife Hendrickje Stoffels and his son Titus.

99 Jacob III de Gheyn

Signed and dated, top left:
RH 'van Ryn/ 1632
(RH in monogram)
Oak panel, 29.9 x 24.9 cm

Jacob III de Gheyn (*c*.1596–1641): grandson of a glass painter and miniaturist, and son of a painter and engraver, both of the same name. He was active as an engraver in The Hague by 1614 and also produced drawings and a small number of paintings. After trips to London in 1618 (with Constantijn Huygens) and Sweden in 1620, he settled in Utrecht, where he became a canon of the Mariakerk, and where he died. The sitter is identified by an inscription on the verso. The likeness was criticised by Huygens in a series of epigrams. De Gheyn bequeathed DPG99 to Huygens's brother, Maurits, who is the subject of a companion portrait by Rembrandt (now Kunsthalle, Hamburg).

Bourgeois bequest, 1811.

HdG745; A. Bredius (revised by H. Gerson), *Rembrandt. The Complete Edition of the Paintings*, London, 1971, no.162; J. Bruyn et al., *A Corpus of Rembrandt Paintings*, II, Dordrecht/ Boston/Lancaster, 1986, A56.

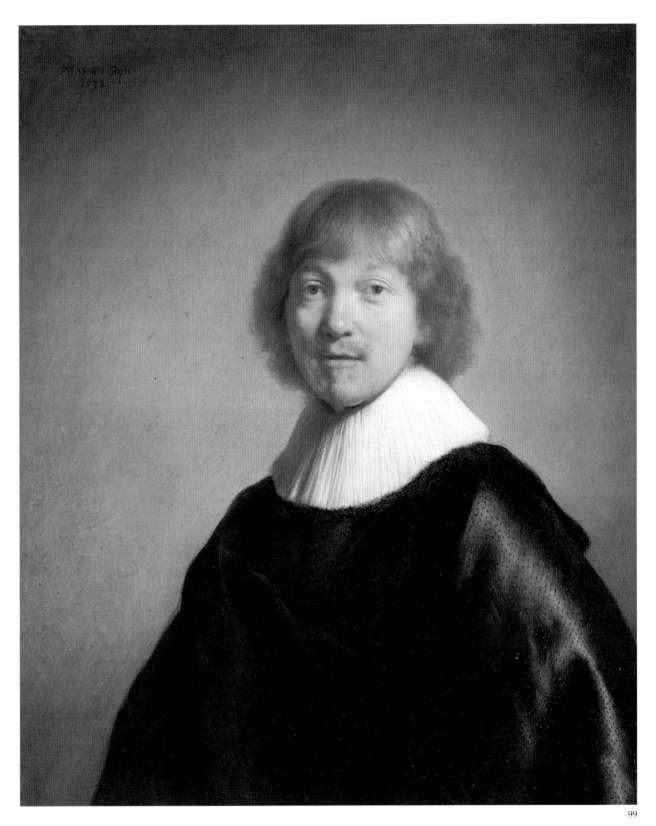

99

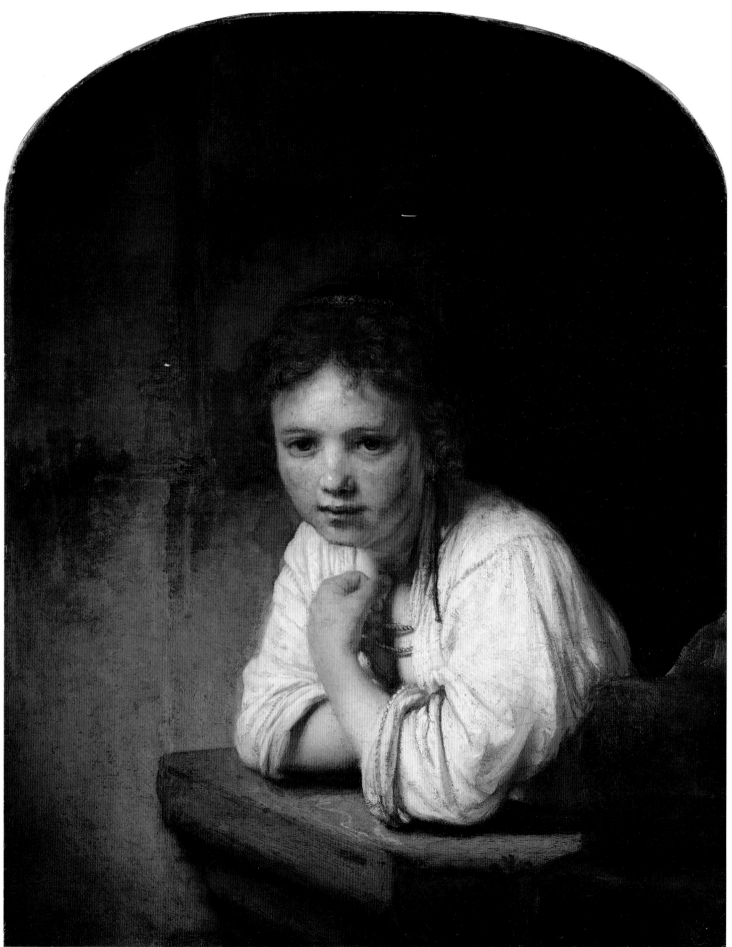

163

163 A Girl at a Window

Signed and dated, lower right:
Rembrandt/ ft. 1645.
Canvas, 81.6 x 66 cm

The title is traditional, though (as stated by White) the girl seems to be leaning on a pedestal rather than a sill. The architectural setting remains unresolved. DPG163 is a figure study rather than a portrait, the model traditionally being identified as a servant of the artist. A probable early owner, the seventeenth-century French art critic Roger de Piles, records (or more probably invents) an anecdote by which Rembrandt placed the picture in his window, deceiving passers-by with the lifelikeness of the image. The X-ray shows that the canvas, now curved at the top, was probably originally rectangular and that the rectangular blocks of stone bottom right were added as an afterthought. A related drawing is in the Courtauld Institute Galleries, London (Prince's Gate Collection). The picture was extensively copied in the eighteenth and nineteenth centuries.

Bourgeois bequest, 1811.

HdG327; Bredius/Gerson, no.368; C. White in *Collection for a King*, no.26; C. White in *Rembrandt's Girl at a Window*, no.1.

ATTRIBUTED TO REMBRANDT

221 Portrait of a Young Man

Said to be signed and dated: *R … f … 63*
Canvas, 82.6 x 67.2cm, including made-up strips of 2.1 cm at the top, 2 cm at the bottom, 1.5 cm on the left and 2 cm on the right (the original canvas measures 78.6 x 64.2 cm)

Fragments of a signature and date were found during cleaning in 1949–53, but such possible traces as have since been discovered (lower left) do not seem convincing. The traditional attribution to Rembrandt was rejected by Richter in 1880, but reinstated by Valentiner and has now been widely, though not universally, accepted. Doubts have recently been expressed by Tümpel. The identification of the sitter as Rembrandt's son, Titus (proposed by Valentiner in 1909) is not generally accepted.

Bourgeois bequest, 1811.

HdG705; W.R. Valentiner, *Rembrandt: wiedergefundene Gemälde*, Berlin/Leipzig, 1921, p.xxiii, no.86; Bredius/Gerson, no.289; C. White in *Collection for a King*, no.27 and *Kolekcja dla Króla*, no.20 (all as Rembrandt); C. Tümpel, *Rembrandt, All Paintings in Colour*, Antwerp, 1993, A97 (as Circle of Rembrandt).

IMITATOR OF REMBRANDT

628 A Man in Armour

Oak panel, 40 x 30.1 cm

A variant on such bust-length figure studies as the *Man in a Gorget and a Plumed Cap* in the J. Paul Getty Museum, Malibu. DPG628 is probably a later imitation rather than the work of a pupil or follower.

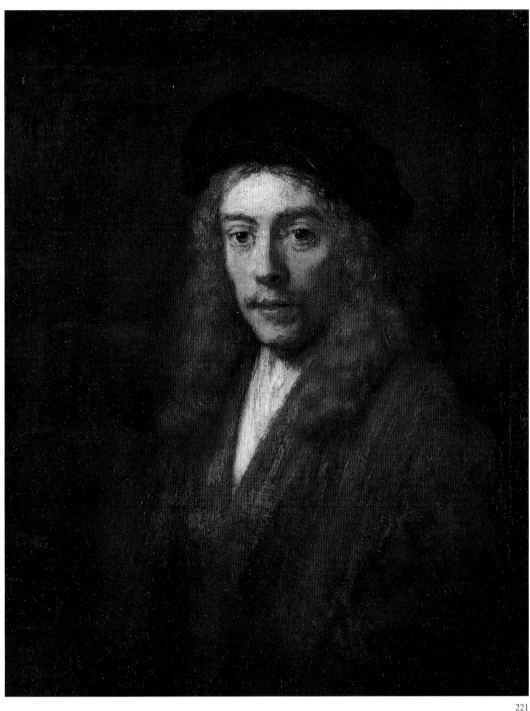

221

628

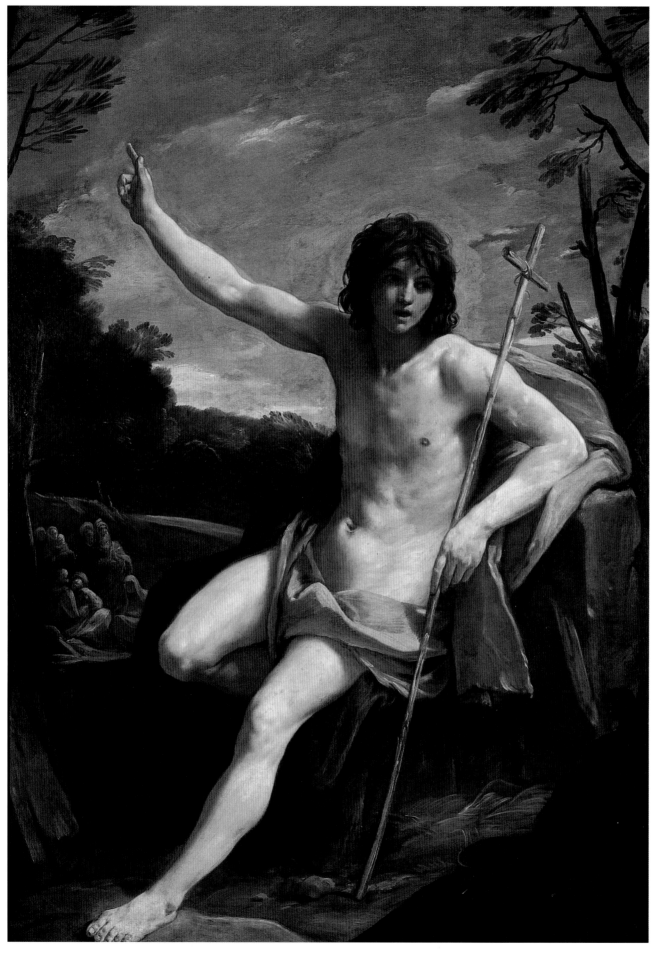

GUIDO RENI

Bologna 1575–1642 Bologna

Reni studied with Denys Calvaert before entering the Carracci Academy in 1594/5. In 1601 he moved with Albani (q.v.) to Rome, where he received important commissions from Pope Paul V and his nephew Cardinal Scipione Borghese. In 1614 he returned to Bologna, where, apart from a trip to Naples and Rome in 1621 and further visits to Rome in 1627 and 1632, he remained until his death. Reni was the leading painter of the Bolognese school and exerted a wide influence through his many pupils.

262 Saint John the Baptist in the Wilderness

Canvas, 225.4 x 162.2 cm

John preached in the Jordan valley, foretelling the coming of Christ and baptising the converted (Matthew III, 1–6; Mark I, 1–8; Luke III, 3–18; John I, 6–28). Reni treated the same subject on at least two occasions in the 1620s (Pepper 1984, nos.90, 92). DPG262 is a late work, dated by Pepper 1636–7. The picture is recorded by the artist's biographer Malvasia (1678) in the collection of G. Francesco Maria Balbi in Genoa.

Bourgeois bequest, 1811.

D.S. Pepper, *Guido Reni*, Oxford 1984, no.165; D.S. Pepper, *Guido Reni*, Novara, 1988, no.156.

268 Saint Sebastian

Canvas, 170.1 x 131.1 cm

Sebastian was a Roman soldier condemned to death by the Emperor Diocletian for aiding the Christians; his arrow wounds were not fatal (see Bellucci DPG46) and he was later clubbed to death. Reni's painting was one of the most celebrated at Dulwich in the nineteenth

262

century, but was catalogued in 1880 as a studio work and in 1980 as a copy. Pepper now accepts DPG268 as one of two autograph replicas of an original in the Prado, Madrid of 1617–18, the other being in the Louvre. Both replicas differ from the Prado picture in the inclusion of Sebastian's left hand, in the more revealing loin-cloth, and in the figures added to the landscape. In the Dulwich version a pentiment shows that the loin-cloth has been reduced. Pepper dates the Louvre version to the same period as the Prado original and the Dulwich version to the early 1630s.

Bourgeois bequest, 1811.

Pepper 1984, no.54/5 (as copy); Pepper 1988, no.54/5 (as copy); D.S. Pepper in *Kolekcja dla Króla*, no.21 (as Reni).

AFTER RENI

204 Death of Lucretia
Canvas, 99 x 76 cm

Lucretia committed suicide after being raped by her cousin Sextus, son of Tarquinius Superbus (Livy, *History of Rome,* I, LVIII). DPG204 is a copy of a composition by Reni known in autograph versions in private collections in New York and Reggio Emilia (Pepper, 1984, no.89 [1988, no.134], and Pepper 1988, App. I, no.22).

Bourgeois bequest, 1811.

Pepper 1984, no.89/1; Pepper 1988, no.134/1.

212 The Rape of Europa
Canvas, 114.7 x 88.4 cm

Taking the form of a white bull, Jupiter won the confidence of Europa and her companions, who decked him with garlands; he then carried Europa off to sea (Ovid, *Metamorphoses*, II; see also After Titian DPG273). DPG212 is a studio variant, according to Pepper, of a composition by Reni known in versions in the National Gallery of Canada, Ottawa, and the collection of Sir Denis Mahon, London (Pepper 1984, nos.164, 184). In DPG212 the drapery colours differ from both the autograph versions, the shoulder strap is repositioned and a garland of flowers added around the bull's neck.

Bourgeois bequest, 1811.

Pepper 1984, no.184/2; Pepper 1988, no.176/2.

284 Mater Dolorosa
Canvas, 48.1 x 37 cm (oval), extended to a rectangle 50.9 x 48.4 cm

Originally oval, the picture has been extended and repainted as a tondo, presumably to make a pair with Italian School (Bolognese) DPG280. Catalogued by Pepper as a studio variant of the *Addolorata* in the Palazzo Corsini, Rome.

Bourgeois bequest, 1811.

Pepper 1984, no.57/4; Pepper 1988 no.57/4.

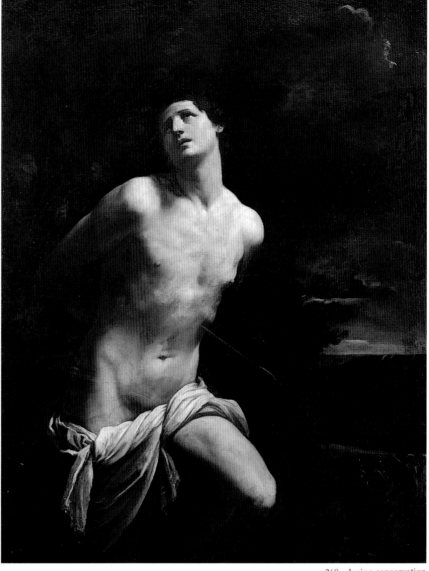

268 during conservation

204

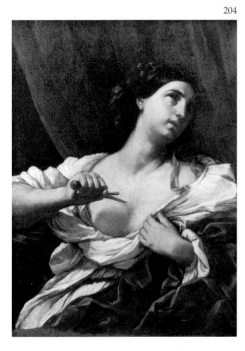

212

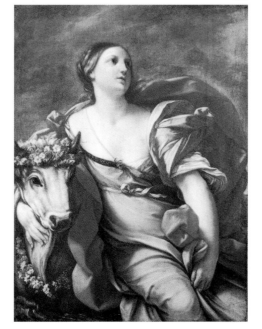

284

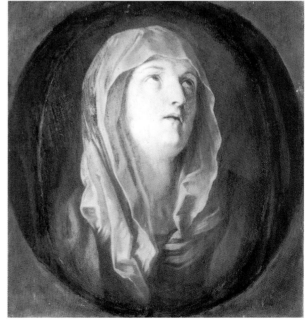

SIR JOSHUA REYNOLDS

Plympton 1723–1792 London

Reynolds served his apprenticeship in London with Hudson (q.v.), 1740–3. After working as a portrait painter in Devonport and London he sailed for the Mediterranean in 1749, arriving the following year in Rome, where he studied the Antique and Italian masters. He returned to London in 1752, travelling through Italy and France. Although drawn to history painting, his livelihood depended on portraiture, and his 'grand manner' in the latter tended to conflate the two genres. He exhibited at the Society of Artists 1760–8 and at the RA 1769–90. Reynolds was elected first President of the Royal Academy in 1768 and was knighted the following year. In 1784 he succeeded Allan Ramsay as Painter in Ordinary to the King. At the Academy he delivered his famous series of *Discourses*.

17A A Girl with a Baby

Mahogany (?) panel, 74.9 x 62.2 cm

Beechey's portrait of Bourgeois (DPG17) was painted on the verso of this panel, apparently in order to preserve it. The painting is, nevertheless, in ruinous condition.

Gift of W. Beechey, 1836.

102 Recovery from Sickness, an Allegory

Canvas, 70.8 x 91.1 cm

A mother nurses her sick child while Death is driven off by an angel. Dated 1768–9 by Waterhouse. DPG102 was acquired by Bourgeois at the Reynolds studio sale of 1796.

Bourgeois bequest, 1811.

A. Graves and W.V. Cronin, *A History of the Works of Sir Joshua Reynolds P.R.A.*, 4 vols., London, 1899–1901, III, p.1191; E.K. Waterhouse, *Reynolds*, London, 1941, p.60.

17A

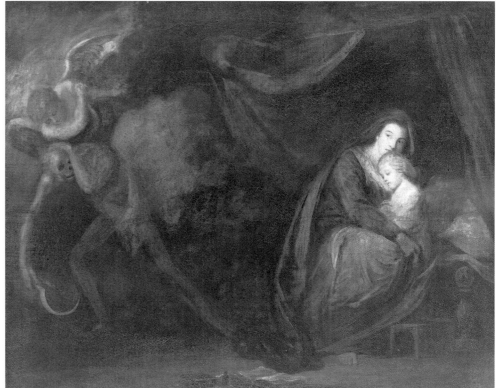

102

318 Mrs Siddons as the Tragic Muse

Signed and dated, on the edge of the
drapery slung over her knees, lower
centre: *REYNOLDS PINXIT 1789*
Canvas, 239.7 x 147.6 cm

Sarah Kemble (1755–1831): sister of John
Philip and Charles Kemble (see Beechey
DPG111 and Briggs DPG291); married William
Siddons, 1773. After a triumphant success at
Drury Lane in 1782 she became the leading
tragic actress in the country, until her
retirement from the stage in 1812. Mrs
Siddons is represented in DPG318 as the
Tragic Muse (Melpomene), whose attributes
of a dagger and cup are held by allegorical
figures of Pity and Terror. The treatment was
possibly suggested by W. Russell's poem of
1783 *The Tragic Muse: A Poem Addressed to
Mrs Siddons*. The pose, which according to
the actress's own account she struck
spontaneously, appears to be based on
Domenichino's *Saint John the Evangelist*
(Glyndebourne, Sussex). DPG318 is a replica
of Reynolds's original of 1784 now in the
Huntington Art Gallery, San Marino and was
painted for Noel Desenfans (see Northcote
DPG28) in exchange for a painting by Rubens.

Bourgeois bequest, 1811.

Graves and Cronin, III, pp.896–8, IV, p.1141;
Waterhouse, p.75; D. Mannings in *Reynolds*, cat. exh.
London, 1986 (catalogue edited by N. Penny), no.151.

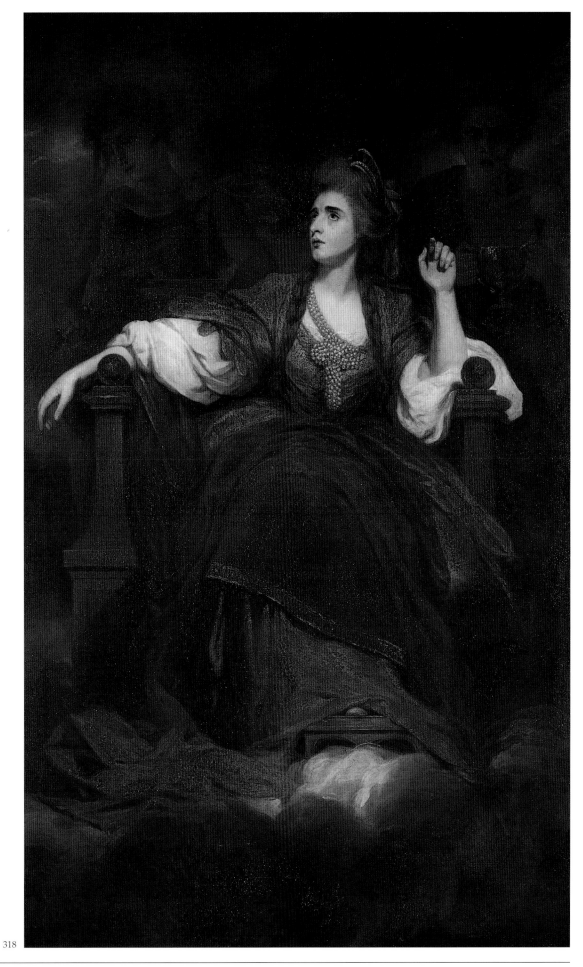

318

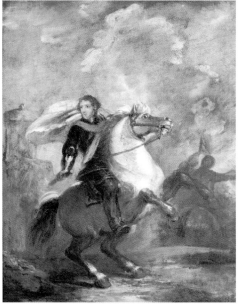

333

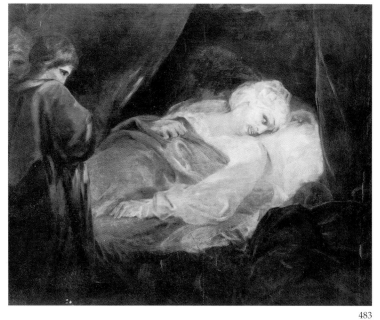

483

598

104

333 A General on Horseback
Canvas, 77.2 x 64.1 cm

A sketch for an equestrian portrait. The composition derives from Bernini's equestrian statue of Louis XIV (Versailles). An underlying portrait is clearly visible above the horse's mane (as first detected in the nineteenth century by the copyist W.S. Spanton, see Postle), but no X-ray has yet been taken. The picture remained in Reynolds's possession and was acquired by Bourgeois at the Reynolds studio sale of 1796.

Bourgeois bequest, 1811.

Graves and Cronin, III, p.1090; M. Postle, 'Gainsborough's "lost" picture of Shakespeare; "A little out of the simple portrait way"', *Apollo*, December 1991, pp.374–6.

483 Death of Cardinal Beaufort
Canvas, 134 x 165.7 cm

Destroyed 1944. Probably Reynolds's early version of the subject, which he repeated on a larger scale and in upright format in 1788 (Petworth House, Sussex). The illustration is taken from an old photograph.

Bourgeois bequest, 1811.

Graves and Cronin, III, p.1146, IV, p.1453; Waterhouse, p.81; M. Postle, *Sir Joshua Reynolds: The Subject Pictures*, Cambridge, 1995, p.259.

598 Robert Dodsley
Inscribed, on letter: *To/ M.ʳ Dodsley/ in Bruton Street/ London*
Canvas, 75.8 x 63.5 cm

Robert Dodsley (1703–64): poet, dramatist and notable publisher of works by Pope, Dr Johnson, Goldsmith and others. A first payment for the portrait is recorded in Reynolds's ledger for 1760–1. DPG598 was given by the sitter to his friend, the poet William Shenstone, in exchange for a portrait of Shenstone.

Gift of H. Yates Thompson in memory of George Smith, 1917.

Graves and Cronin, I, pp.255–6; Waterhouse, p.48.

223

627

STUDIO OF REYNOLDS

104 Self-portrait
Canvas, 76.2 x 63.8 cm

A studio replica of Reynolds's original of *c*.1788 in the Royal Collection (London 1986, no.149). The sitter's left arm, which in the original is raised as if in the act of painting, has been lowered.

Bourgeois bequest, 1811.

Graves and Cronin, II, p.806 (as Reynolds); D. Mannings in London 1986, p.322.

223 The Calling of Samuel
Canvas, 76.3 x 68.9 cm

The calling of the child Samuel is described in I Samuel III, 2–10. According to Waterhouse DPG223 is a studio replica of the original at Knole of *c*.1776. The picture seems to have remained in the painter's possession and was purchased by Bourgeois at the Reynolds studio sale of 1796.

Bourgeois bequest, 1811.

Graves and Cronin, III, p.1202, IV, p.1461 (as Reynolds); Waterhouse, p.67.

AFTER REYNOLDS

627 Miss Margaret Morris, later Mrs Desenfans
Canvas, 75.9 x 63.5 cm

Margaret Morris (1737–1814): sister of Sir John Morris of Clasemont, Glamorganshire; married Noel Desenfans (see Northcote DPG28) in 1776. She inherited a life interest in the Desenfans–Bourgeois collection in 1811, but surrendered it to Dulwich College, contributing substantially to the cost of Soane's new gallery. She bequeathed to the Gallery much of the furniture now on display, together with plate and linen and a sum of £500 for the entertainment of members of the Royal Academy on their annual visitations. DPG627 is a copy by Moussa Ayoub (q.v.) of Reynolds's original of 1757, which appeared in the sale of Sir Robert Morris and others, Christie's, 29 April 1938, lot 45 (Waterhouse, p.42).

Commissioned by Dulwich College, 1930.

JUSEPE DE RIBERA

Játiva (near Valencia) 1591–1652 Naples

FOLLOWER OF RIBERA

233 The Locksmith

Canvas, 132.3 x 99.5 cm, including an addition of 12 cm at the top

The locksmith's gesture seems charged with meaning and suggests a proverb – possibly, as Murray proposed: *'Chiave incinto, Martino dinto'* ('You can lock up your wife/daughter and keep the key on your belt, but her lover will get in'). The attribution remains uncertain. The picture was catalogued by Murray as the work of a Neapolitan follower of Ribera. An attribution to Luca Giordano has been proposed by S. Pepper (note on file, 1988) and independently by R. Herner (oral communication, 1997).

Bourgeois bequest, 1811.

233

SEBASTIANO RICCI

Belluno 1659–1734 Venice

Ricci trained in Venice with Federico Cevelli and in Bologna with Giovanni dal Sole. He was called to Parma by Ranuccio II Farnese, who sent him to Rome to complete his studies. He worked variously in Milan, Venice, Vienna, Bergamo and Florence before making a trip to England in 1711/12–16. He then returned through France and possibly Holland to Venice, where he finally settled. Ricci was elected to the French Académie in 1716 and to the Accademia Clementina in Bologna in 1723.

134 The Fall of the Rebel Angels

Canvas, 82 x 67.8 cm, including made-up strips of approximately 2 cm top and bottom and 1 cm left and right

The Archangel Michael casts out the rebel angels (Revelation XII, 9). Datable *c.*1720. There are related drawings at Windsor and in the Galleria dell'Accademia, Venice.

Bourgeois bequest, 1811.

J. Daniels, *Sebastiano Ricci*, Hove, 1976, no.176.

195 The Resurrection

Canvas, 88.3 x 118.7 cm

A sketch for Ricci's apse decoration in the chapel of the Royal Hospital, Chelsea, executed *c.*1715–16. The commission was probably given by George I to recompense Ricci for his loss to Thornhill of that for St Paul's. A second sketch in the South Carolina Museum of Art, Columbia, seems to be an autograph replica of DPG195.

Bourgeois bequest, 1811.

Daniels, no.177; J. Daniels in *Collection for a King*, no.28 and *Kolekcja dla Króla*, no.22; *Sebastiano Ricci*, cat. exh. Villa Manin di Passariano, Udine, 1989, no.38.

195

83

85

565

HYACINTHE RIGAUD

Perpignan 1659–1743 Paris

Rigaud trained at Montpellier with Paul Pezet and Antoine Ranc and then in Lyon before settling in Paris in 1681. He won the *prix de Rome* at the Académie in the following year, became *agréé* in 1684, and was received as an Academician in 1700. Rigaud swiftly established himself as the leading portrait painter in France and pursued a long career as a portrait painter to the court of Versailles. In 1727 he was made a chevalier of the Order of Saint Michael and in 1733 he was appointed Director of the Académie.

STUDIO OF RIGAUD

83 Portrait of a Man
 Canvas, 81 x 65.1 cm

Previously identified as Nicolas Boileau by comparison with a portrait of Boileau at Versailles; however, the sitter does not seem to be the same.

Bourgeois bequest, 1811.

AFTER RIGAUD

85 Louis XIV
 Canvas on panel, oval extended to a rectangle, 91.4 x 72.1 cm

A reduced copy of a three-quarter-length portrait by Rigaud of which there is a version in the château de Chenonceau. Another half-length copy is at Versailles.

Bourgeois bequest, 1811.

JOHN RILEY

London 1646–1691 London

Riley was a pupil of Isaac Fuller and Gerard Soest (qq.v.). On Lely's death in 1680 he was introduced to Charles II by Chiffinch (see below), but his portrait of the King was not well received. ('Is this like me?', the King is said to have remarked, 'Then oddsfish, I'm an ugly fellow.') In 1682 Riley became a freeman of the Painter-Stainers' Company and in 1688 he was appointed Principal Painter to William and Mary, jointly with Kneller (q.v.). He formed a partnership with John Closterman, painting the heads while Closterman undertook the draperies.

565 John Somers
 Canvas, 70.5 x 63.5 cm

John Somers (1651–1716): Solicitor-General and knighted, 1689; Lord Keeper, 1693; Baron Somers, 1697; Lord Chancellor of England, 1697–1700. The sitter is identified in an inscription, verso, which reads: 'S.ʳ John Sommers Knight/ by M.ʳ Riley…' He appears no older than twenty-five and cannot be represented after having received his knighthood at the age of 38. The portrait was perhaps painted on the occasion of his being called to the bar in 1676.

Fairfax Murray gift, 1911.

568

568 William Chiffinch

Inscribed, top left: *W.ᵐ CHIFFINCH*
Canvas, 76.1 x 64.4 cm

William Chiffinch (*c*.1602–88): succeeded his brother as Keeper of the King's Jewels and of His Majesty's Closet, 1666; 'carried the abuse of backstairs influence to scientific perfection' (DNB), not least in pimping for the King. According to Walpole, Chiffinch sat to Riley after Lely's death and showed the portrait to the King when recommending the young artist. This would suggest a date for DPG568 of *c*.1680. Several copies/versions are recorded.

Fairfax Murray gift, 1911.

C.H. Collins Baker, *Lely & the Stuart Portrait Painters*, London, 1912, II, pp.23–4.

WILLIAM ROMEYN

Haarlem *c*.1624–1692/4 Amsterdam

Romeyn was a pupil of Berchem (q.v.) and became a member of the Haarlem painters' guild in 1646. He made a trip to Rome, where he is recorded in 1650–1, and specialised in Italianate landscapes with figures and animals. In 1659 he served as *hoofdman* in the Haarlem guild.

3 Classical Landscape

Signed, bottom right: *W ROMEŸN* (WR in monogram)
Canvas, 35.2 x 41.9 cm

Bourgeois bequest, 1811.

5 Landscape

Signed, bottom right: *W ROMEŸN* (WR in monogram)
Canvas, 35.7 x 41.9 cm

Bourgeois bequest, 1811.

3

5

440

GEORGE ROMNEY

Beckside (near Dalton-le-Furness, Lancashire) 1734–1802 Kendal

After two years' apprenticeship under Christopher Steele, Romney set himself up in Kendal in 1757. He moved to London in 1762, exhibiting at the Free Society, 1763–9, and the Society of Artists, 1770–2. He visited Paris in 1764 and Italy in 1773–5. On his return from Italy he established a fashionable portrait practice in Cavendish Square. His interest in history painting, encouraged by his friend W. Hayley (see below), resulted in a large number of drawings but few finished paintings. In the 1790s Romney suffered from ill health and he painted little after *c.*1796. In 1799 he retired to Kendal.

440 Joseph Allen
Canvas, 128.3 x 102.2 cm

Joseph Allen, MD (1713–96): travelled round the world with Lord Anson; Warden of Dulwich College 1745–6, Master 1746–75. DPG440 was commissioned following a resolution of the Corporation of Dulwich College of 4 September 1775. Sittings are recorded in October–November 1778. The statue of Æsculapius refers to Allen's medical training.

Commissioned by Dulwich College, 1775/8.

H. Ward and W. Roberts, *Romney*, 2 vols., London, 1904, I, p.87, II, p.3; B. Maclean-Eltham, *George Romney, Paintings in Public Collections*, Kendal, 1996, p.14.

590 William Hayley
Canvas, 76.2 x 63.3 cm

William Hayley (1745–1820): poet; friend and biographer of Romney, to whom he addressed his *Epistle on Painting* (1777). His most successful poem, *The Triumphs of Temper* (1781), was ridiculed by Byron. 'Everything about that man is good,' wrote his friend Southey, 'except his poetry.' Hayley sat on at least thirteen occasions to Romney between 1777 and 1779 and again, once, in 1788. Several portraits are known. DPG590 was engraved in mezzotint in 1779.

Fairfax Murray gift, 1911.

Ward and Roberts, p.74; Maclean-Eltham, p.36.

590

JOHANN HEINRICH ROOS

Reipoltskirchen 1631–1685 Frankfurt am Main

After training in Amsterdam with Guilliam Dujardin, Cornelis de Bie and Barent Graat, Roos returned to Germany, where he was working at Mainz in 1653 and at Rheinfels for the court of the Landgrave of Hesse, 1654–9. In 1664 he became court painter to the Elector Palatine at Heidelberg. He painted subject pictures and portraits, but is best known for his idealised pastoral landscapes.

617 Landscape with a Cowherd, Cattle, Sheep and Goat
Mahogany panel, 61.6 x 74.6 cm

The attribution was suggested by F. Meijer (oral communication, 1997). The cows and standing sheep are repeated in a composition by Roos at Dresden, signed and dated 1681.

Gift of Professor C.D. Broad, 1946.

SALVATOR ROSA

Arenella, Naples 1615–1673 Rome

Rosa was a pupil in Naples of his uncle Domenico Greco, and of Francesco Fracanzano and Aniello Falcone. In 1635 he moved to Rome, where his intense ambition and violent temperament made him a prominent and controversial figure. He was again in Naples in 1638 and was working in Viterbo 1638–9. In 1640 he moved to Florence, where he became the centre of a sophisticated literary circle, producing satirical poetry and involving himself with music and theatre. He returned to Rome in 1649. In his early career Rosa painted mainly battle scenes and landscapes, the latter notable for their depiction of the rugged aspect of nature. From the 1650s he increasingly established his reputation as a history painter, frequently of complex and recondite subjects.

617

137

216

216 Soldiers Gambling

Signed, lower right: *S Rosa* (SR in monogram)
Canvas, 77 x 61.3 cm

The standing soldier repeats in reverse a figure in
one of Rosa's etchings from the series known as the
Figurine (Bartsch 38), and the composition compares
with other etchings from the same series. DPG216
probably dates from the period of the first *Figurine*
or shortly afterwards (i.e. 1656–8).

Bourgeois bequest, 1811.

L. Salerno, *L'opera completa di Salvator Rosa*, Milan 1975,
no.136; R.W. Wallace, *The Etchings of Salvator Rosa*, Princeton,
1979, under no.29 (as copy or imitation); M. Kitson in *Kolekcja
dla Króla*, no.23.

FOLLOWER OF ROSA

137 Monks Fishing

Canvas, 73 x 42.2 cm

A version is in the collection of the
Earl of Yarborough.

Bourgeois bequest, 1811.

MANNER OF ROSA

457 Mountainous Landscape

Canvas, 48.9 x 66 cm

Bourgeois bequest, 1811.

457

19

PETER PAUL RUBENS

Siegen 1577–1640 Antwerp

Rubens trained in Antwerp with Tobias Verhaecht, Adam van Noort and Otto van Veen, becoming a master in 1598. He went to Italy in 1600 and entered the service of the Duke of Mantua. His travels included a diplomatic mission to Spain in 1603. He returned to Antwerp in 1608, in the same year marrying Isabella Brant and becoming court painter to the Archduke Albert and Archduchess Isabella. He made a second diplomatic trip to Spain in 1628, trying to promote peace in the Netherlands, and was sent to England to pursue negotiations. He was back in Antwerp in 1630 and in that year married Helena Fourment. Besides his prodigious output as a painter and his diplomatic activity, Rubens was also a notable scholar, antiquarian and collector.

19 Romulus setting up a Trophy
Oak panel, 49.6 x 15.6cm, excluding capping strips of 0.6 cm on all sides

After his victory over the Caeninenses, Romulus set up on the capitol a trophy comprising the arms of the vanquished King Acron (Plutarch, *Romulus*, XVI, 5–6; Livy, I, X). DPG19 is one of three known *modelli* by Rubens for a tapestry series of the story of Romulus. There is a related set of tapestry cartoons in the National Museum of Wales, Cardiff, though these are not generally accepted as Rubens's work. The cartoon corresponding to DPG19 expands the composition to a squarer format and shows the trophy attached to the tree. A tapestry probably made from this cartoon was recorded in 1879, but is now lost. Held suggests a date for DPG19 of *c*.1625/7.

Bourgeois bequest, 1811.

J.S. Held, *The Oil Sketches of Peter Paul Rubens: A Critical Catalogue*, Princeton, 1980, no.279; M.Jaffé, *Rubens, Catalogo completo*, Milan, 1989, no.1390; E. McGrath, *Corpus Rubenianum*, XIII, *Subjects from History*, 2 vols., London, 1997, II, no.30.

40 Saints Amandus and Walburga
Oak panel, 66.6 x 25 cm

DPG40 and DPG40A (see below) are *modelli* for the outer sides of the wings of the altarpiece of the *Raising of the Cross* commissioned from Rubens for the church of St Walburga, Antwerp, in 1610 (now in Antwerp Cathedral). In the final paintings the mitres of the male saints are held above by cherubs. A drawing related to DPG40, in which this change already appears, is at the Courtauld Institute (Prince's Gate Collection).

Bourgeois bequest, 1811.

M. Rooses, *L'Œuvre de Rubens*, 5 vols., Antwerp, 1886–92, II, no.279bis; Held, no.350A; Jaffé, no.132.

40A Saints Catherine of Alexandria and Eligius
Oak panel, 66.6 x 25 cm

See DPG40 above.

Bourgeois bequest, 1811.

Rooses, II, no.279bis; Held, no.350B; Jaffé, no.133.

40, 40A

43 Ceres (?) and two Nymphs with a Cornucopia

Oak panel, 30.9 x 24.4 cm

Modello for a painting in the Prado, Madrid, which was one of eight pictures presented to Philip IV of Spain by Rubens on his arrival in Madrid in 1628. The Prado picture was described in 1636 as showing Ceres and two nymphs, though the identification of one of the figures as the goddess Ceres is doubtful. In the finished picture the pose of the left-hand figure (Ceres?) is changed. Held suggests a date of *c.*1625/7; Jaffé gives *c.*1617.

Bourgeois bequest, 1811.

Rooses, III, no.651bis; Held, no.255; Jaffé, no.440.

43

125

125 Saint Barbara fleeing from her Father

Oak panel, 32.6 x 46.2 cm

Saint Barbara, whose conversion to Christianity enraged her father, found refuge in a tower, whence she was rescued by angels. DPG125 is a *modello* for one of the ceiling paintings commissioned from Rubens in 1620 for the Jesuit church in Antwerp. The finished ceiling painting was octagonal and placed in the south aisle. The whole scheme was destroyed by fire in 1718. The grisaille *bozzetto* which precedes DPG125 is in the Ashmolean Museum, Oxford.

Bourgeois bequest, 1811.

Rooses, I, no.31bis; J.R. Martin, *Corpus Rubenianum*, I, *The Ceiling Paintings for the Jesuit Church in Antwerp*, London/ New York, 1968, no.31B; Held, no.30; Jaffé, no.625.

131 Hagar in the Desert
Oak panel, 71.5 x 72.6 cm

Hagar is banished by Abraham to the wilderness with their son Ishmael and left without water. She fears for her son's life until an angel appears, showing her water and proclaiming that Ishmael will be the forefather of a great nation (Genesis XXI, 17–18). DPG131 seems to have been cut down and overpainted. An engraving by Frans De Roy of *c.*1750 shows the composition extended at the top, with an angel in the sky behind Hagar's head and the prostrate figure of Ishmael in the middle distance on the far left. One wing and the arms of the angel are still faintly discernible, especially in infra-red photographs, though they do not appear in the X-ray. The model was, in all probability, Rubens's second wife Helena Fourment, although this is disputed by d'Hulst and Vandenven. Jaffé suggests a date of *c.*1630/2.

Bourgeois bequest, 1811.

Rooses, II, no.471; R.-A. d'Hulst and M. Vandenven, *Corpus Rubenianum*, III, *The Old Testament*, London/New York, 1989, no.11; Jaffé, no.1052.

131

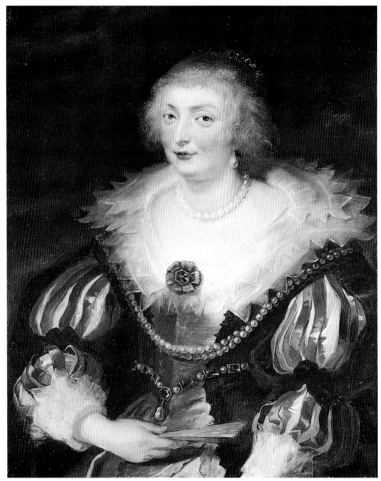

143

143 Catherine Manners, Duchess of Buckingham (?)
Oak panel, 79.7 x 65.7 cm

The verso has a white gesso priming overpainted in brown, with underlying traces of drawing. Huemer suggests that the panel has been cut at the bottom and possibly on the right. Only the head is completely finished. The attribution has been disputed but, since cleaning c.1950, is now generally accepted. A chalk study for DPG143 in the Albertina, Vienna, bears an old inscription identifying the sitter as Catherine Manners. The reliability of this inscription is questionable since the sitter does not resemble Catherine Manners as she is shown in authentic likenesses, for example by Honthorst (Buckingham Palace) and Van Dyck (Duke of Rutland). However, Rubens would not have been working from life and may have been misled by his source. Jaffé accepts the identification of the sitter and suggests a date of c.1625.

Bourgeois bequest, 1811.

F. Huemer, *Corpus Rubenianum*, XIX, *Portraits*, 2 vols., Brussels/London/New York, 1977, I, no.6; Jaffé, no.390.

148 The Miracles of Saint Ignatius of Loyola
Oak panel, 73.7 x 50.2 cm

Saint Ignatius of Loyola (1491–1556); founder of the Jesuit Order; canonised, 1622. DPG148 refers to his miracles (the curing of the possessed woman, the woman whose withered arm was healed when she washed the Saint's linen) and probably, in the women and children, to his role as intercessor in difficult births. The painting seems to be an autograph *modello* for Rubens's altarpiece of the *Miracles of Saint Ignatius*, painted for the chapel of St Ignatius in the Jesuit church of Sant'Ambrogio, Genoa, c.1619 (Jaffé, no.517). Although the picture is rejected by Vlieghe as a copy, the attribution to Rubens is accepted by Jaffé and Held. This view is supported by the presence of underlying figures (upside down in relation to the present composition) that are revealed in the X-ray.

Bourgeois bequest, 1811.

H. Vlieghe, *Corpus Rubenianum*, VIII, *Saints*, 2 vols., London/New York, 1973, II, under no.116A; Held, no.411; Jaffé, no.516.

148

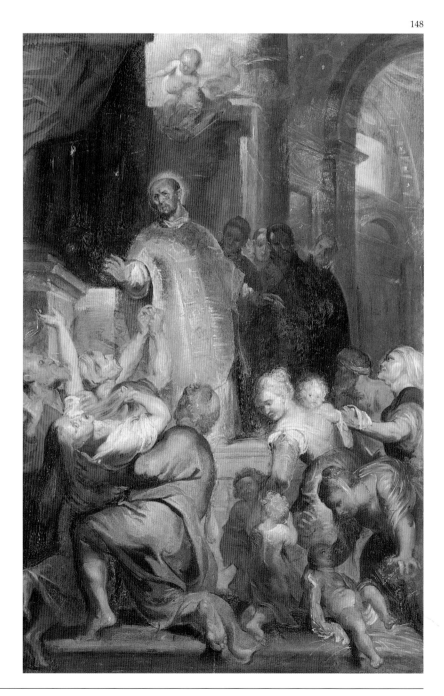

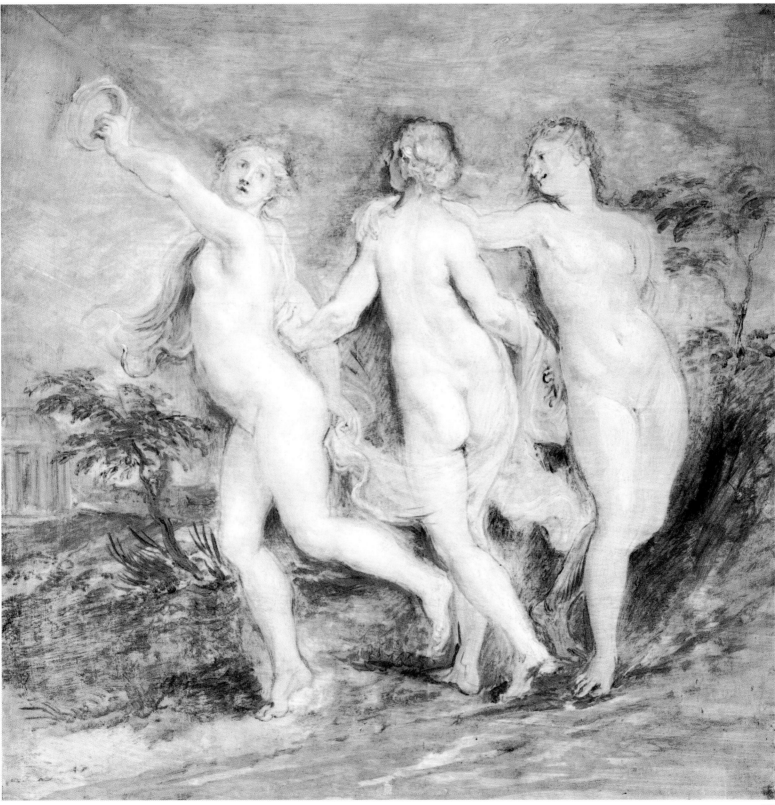

264

264 The Three Graces
 Oak panel, 39.9 x 39.9 cm

The Graces – Euphrosyne, Thalia and Aglaea – were daughters of Zeus and goddesses of beauty and kindness.
An irregular section above the heads of the figures has been cut away and replaced. Held suggests a date of
c.1625/8, Jaffé gives *c*.1636. A preliminary drawing is at Christ Church, Oxford.

Bourgeois bequest, 1811.

Rooses, III, p.100 (as doubtful); Held, no.239; Jaffé, no.1224.

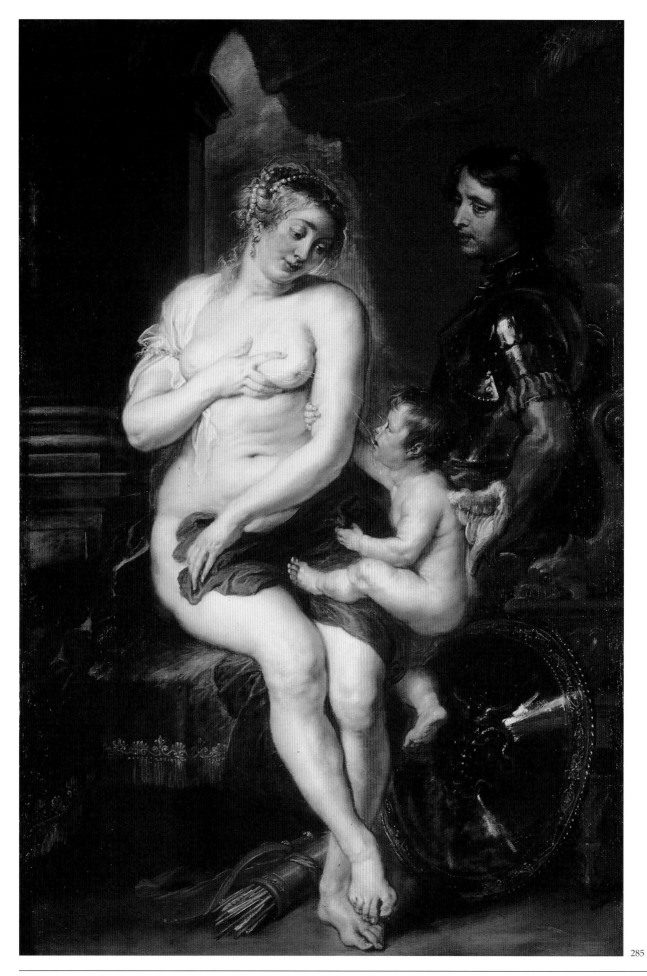

285

285 Venus, Mars and Cupid

Canvas, 195.2 x 133 cm

Venus feeds Cupid, who was her son (according to some accounts) by an adulterous union with Mars. DPG285 was probably painted in the early to mid-1630s. The figures of Mars and Cupid seem to derive from Dürer's print of the *Penance of Saint John Chrysostom*, while Venus repeats the figure of Peace in Rubens's *'Peace and War'* in the National Gallery, London. The X-ray reveals that originally Cupid's left leg was tucked back; Venus's drapery, at which Cupid tugs, was taut; and Venus's left leg swayed to the right, ending in front of the shield.

Bourgeois bequest, 1811.

Rooses, III, no.704 (as the work of a pupil); Jaffé, no.974; M. Jaffé in *Conserving Old Masters*, no.2.

451 Venus mourning Adonis

Oak panel, 47 x 66.4 cm, excluding an addition of 1.6 cm at the top edge

The mortal Adonis, killed by a boar while hunting, is mourned by Venus, his lover (Ovid, *Metamorphoses*, X). Rubens's source may have been Bion's *Lament for Adonis*, which mentions mourning nymphs, and cupids (*erotes*) breaking their bows and arrows in grief. DPG451 is a *modello* related to two paintings, one now untraced which seems to have been cut in pieces in the 1950s (which Jaffé, from reproductions, judged a copy), the other formerly with Duits, London, and now in the collection of Mr and Mrs Saul P. Steinberg, New York. Held and Jaffé agree on a date of *c*.1614.

Bourgeois bequest, 1811.

Rooses, III, under no.696; Held, no.267; Jaffé, no.253; M. Jaffé in *Conserving Old Masters*, no.3.

451

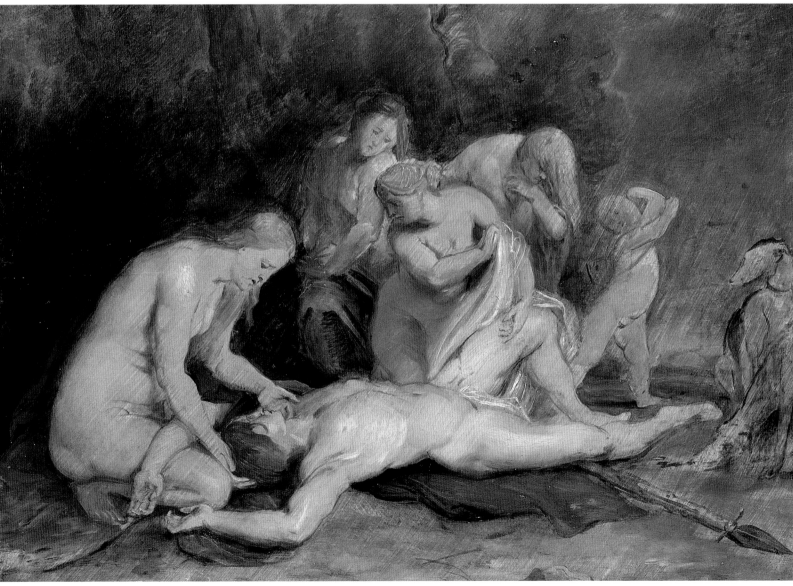

218 403 630

165

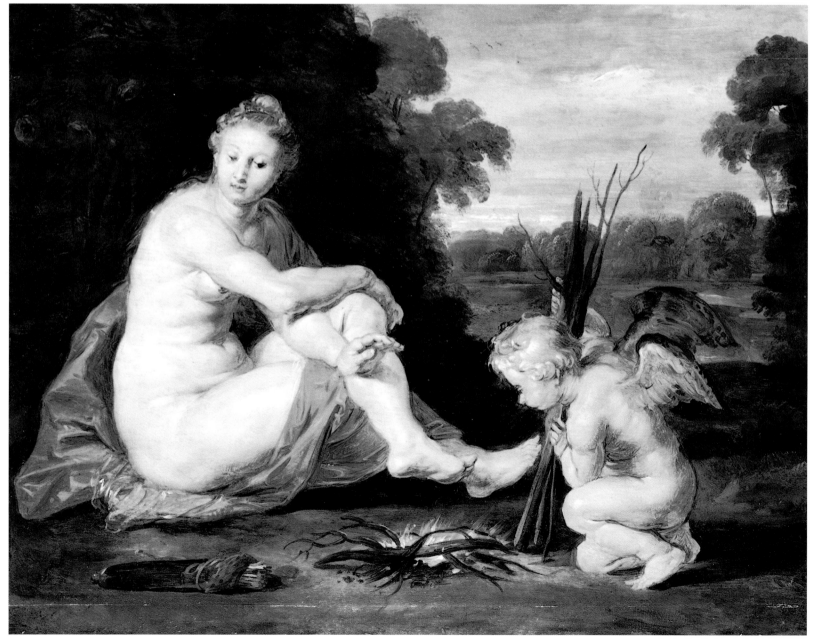

1

130

450

AFTER RUBENS

218 Evening Landscape
Oak panel, 45.4 x 42.5 cm

A copy of the right-hand half of Rubens's *Landscape with a Shepherd and his Flock* in the National Gallery, London (Jaffé, no.1193).

Bourgeois bequest, 1811.

403 A Boy lighting a Candle from one held by an Old Woman
Canvas, 44.5 x 36.8 cm

Copy of Rubens's original of *c.*1616–17, present whereabouts unknown (Jaffé, no.430). Formerly catalogued as Schalcken.

Gift of the Reverend John Vane, *c.*1830.

630 Judgement of Paris
Canvas, 95 x 127 cm

Copy of Rubens's original in the National Gallery, London (Jaffé, no.1084).

Anonymous gift, 1955.

FOLLOWER OF RUBENS

165 Venus and Cupid warming themselves (Venus frigida)
Oak panel, 33.5 x 46.6 cm, excluding a probable addition of 2 cm at the bottom

The subject is taken from a saying quoted by Terence (*The Eunuch*, 732): '*Sine Baccho et Cerere friget Venus*' ('Without Bacchus and Ceres, Venus grows cold'). DPG165 seems to be a sketch for a picture in the Akademie der bildenden Künste, Vienna. Both were published by Müller-Hofstede in 1967 as Rubens, but the attribution is not generally accepted.

Bourgeois bequest, 1811.

Rooses, III, p.186 (as studio of Rubens); J. Müller-Hofstede, 'Vier Modelli von Rubens', *Pantheon*, XXV, 1967, pp.430–2.

MANNER OF RUBENS

1 Putti: a ceiling decoration
Canvas, 172.7 x 133.7 cm

Bourgeois bequest, 1811.

130 Madonna and Child
Oak panel, 32.1 x 26.7 cm

Bourgeois bequest, 1811.

450 Cupids Harvesting
Oak panel, 50.5 x 83.4 cm

Bourgeois bequest, 1811.

JACOB VAN RUISDAEL

Haarlem 1628/9–1682 Amsterdam?

Ruisdael probably trained with his father, a frame-maker, painter and picture dealer, and with his uncle, the landscape painter Salomon van Ruysdael, before becoming a member of the Haarlem painters' guild in 1648. He travelled to Bentheim in Germany *c*.1650 in company with Berchem (q.v.) and by 1657 had settled in Amsterdam. There is inconclusive evidence that he later graduated in medicine at the university of Caen and practised as a surgeon. Ruisdael made etchings as well as paintings, and was the leading interpreter of northern landscape active in the Netherlands in the second half of the seventeenth century.

105 A Waterfall
Signed, lower centre right: *JvRuifdael*
(JvR in monogram)
Canvas, 98.5 x 83.4 cm

Dated by Rosenberg in the second half of the 1660s. In his manuscript catalogue Denning records two signatures, one added by Bourgeois (now removed).

Bourgeois bequest, 1811.

HdG247; K.E. Simon, *Jacob van Ruisdael, Eine Darstellung seiner Entwicklung*, Berlin, 1927 (reprinted with errata and addenda, 1930), p.74, no.247 (as Van Kessel); J. Rosenberg, *Jacob van Ruisdael*, Berlin, 1928, no.190.

168 Landscape with Windmills near Haarlem
Signed, bottom right: *JvR* (monogram)
Oak panel, 31.5 x 33.9 cm

The Groote Kerk, Haarlem, is seen in the distance. DPG168 is an early work, dated *c*.1650/2 by Hofstede de Groot. A horse and figures centre left (since overpainted) and a rider and boy on the right were shown by pigment analysis to be post-seventeenth-century additions and were removed in 1997. They are partially recorded in a copy made by Constable in 1831 (G. Reynolds, *The Later Paintings and Drawings of John Constable*, New Haven and London, 1984, no.32.44, pl.855).

Bourgeois bequest, 1811.

HdG175; Simon, p.74, no.175 (as eighteenth-century); Rosenberg, no.115.

FOLLOWER OF RUISDAEL

9 Landscape with a Church
Signed indistinctly on the rocks, lower left:
p[.]am…[?], with possible traces of a date *164[.]*?

Oak panel, 43.7 x 53.9 cm

Attributed to Hobbema until 1880, when catalogued as Adriaen Verboom. Although this attribution seems not unreasonable, there are traces of a signature on the rocks, lower left, which cannot be Verboom's.

Bourgeois bequest, 1811.

168

9

349 Canal with Bridge

Signed or inscribed, bottom right: *R*
Oak panel, 40.5 x 53 cm

Bourgeois bequest, 1811.

JOHN RUSSELL

Guildford 1745–1806 Hull

Russell studied crayon painting with Francis
Cotes before entering the RA Schools in 1770.
He exhibited at the Society of Artists in 1768
and at the RA 1769–1806, and was elected
ARA in 1772, RA in 1788. Following his
'conversion' to methodism in 1764, he became
much engaged in evangelical activities –
sometimes directed at his sitters. Although he
painted a few portraits in oils, he was primarily
a pastellist. In 1789 Russell began to receive
royal commissions and in 1790 he was styled
'Painter to the King and the Prince of Wales'.
He published his *Elements of Painting with
Crayons* in 1772.

601 Samuel Moody

Pastel on paper, 60.3 x 44.8 cm (oval)

Samuel Moody (1733–1808): married Elizabeth
Johnson (see Gainsborough DPG316) in 1779;
took as his second wife Mary Paterson, 1786.

Gift of H. Yates Thompson, 1917.

A. Sumner in *Conserving Old Masters*, under no.12.

349

601

626

59

JAN MICHIEL RUYTEN

Antwerp 1813–1881 Antwerp

Ruyten trained at the School of Fine Arts in Antwerp and under Ignatius van Regemorter. In 1837–8 he was in Holland, where he studied with Antonie Waldorp, Andreas Schelfout and Wijnand Jan Joseph Nuyen. His works consist mainly of views of Antwerp.

626 The 'Metsys Well' at Antwerp
 Canvas, 52.7 x 38.3 cm

DPG626 shows the sixteenth-century wrought-iron well-head next to the Cathedral in the Handschoenmarkt, Antwerp, traditionally thought to be the work of Quentin Metsys.

Gift of Miss A.G. Ingoldby, 1952.

PIETER SAENREDAM

Assendelft 1597–1665 Haarlem

AFTER SAENREDAM

59 Interior of S. Bavo, Haarlem
 Oak (?) panel, 42.9 x 33.5 cm

A copy of Saenredam's original of 1633 in the Art Gallery and Museum, Glasgow.

Bourgeois bequest, 1811.

HERMAN SAFTLEVEN

Rotterdam 1609–1685 Utrecht

Son of the history painter Herman Saftleven the elder and brother of Cornelis Saftleven. By 1633 he had settled in Utrecht, where, between 1655 and 1667, he served on several occasions as *overman* and dean in the guild. In his early years he painted barn interiors similar to those of his brother, but from the mid-1630s he started to paint Italianate landscapes inspired by the works of of Poelenburch and Both (qq.v.). Herman Saftleven travelled in the Rhineland and Moselle regions and, from the 1650s, developed a speciality in imaginary panoramic Rhineland views and river landscapes. He also made a number of etchings.

44 View on the Rhine
 Signed and dated, bottom left:
 HSL 1656 (HSL in monogram)
 Oak panel, 42.8 x 57.8 cm

Bourgeois bequest, 1811.

W. Schulz, *Herman Saftleven, 1609–1685: Leben und Werke*, Berlin/New York, 1982, no.92.

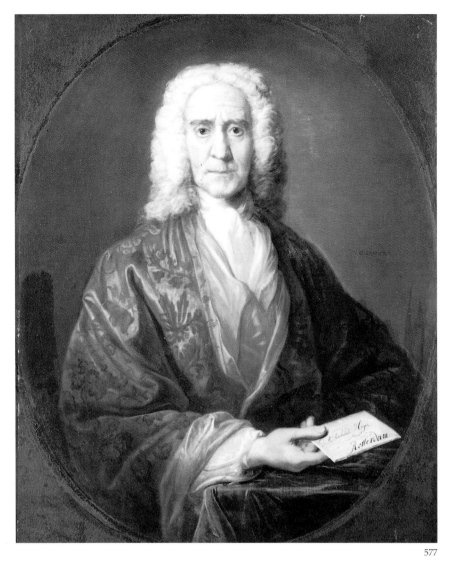

577

GERARD SANDERS

Wesel 1702–1767 Rotterdam

Sanders was a pupil of his stepfather, Tobias van Nijmegen, and his uncle, Elias van Nijmegen. He was active as a painter of history subjects, landscapes and portraits. He undertook a decorative commission for the town hall of Middelburg in 1764, but little otherwise seems to be recorded of his career.

577 Archibald Hope the Elder
Signed and dated, centre right: *G. SANDERS./ 1737*; and inscribed, on the letter: *To Mr Archibald Hope/ Mercht/ in/ Rotterdam*
Canvas, 86.6 x 72.7 cm

The original canvas is oval and has been made up to a rectangle. Archibald Hope (1664–1743), of the Hopes of Hopetoun, was a Scottish merchant who was born and lived in Rotterdam. His sons set up the Hope Bank in Amsterdam. The art collector and theorist Thomas Hope of Deepdene was his grandson.

Fairfax Murray gift, 1911.

228

251

191

161

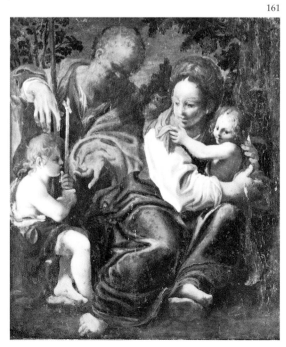

ANDREA DEL SARTO

Florence 1487–1531 Florence

AFTER DEL SARTO

228 Madonna and Child with Saint John
Poplar panel, 84.4 x 63.8 cm

DPG228 is a copy of a lost original by or from the studio of Del Sarto. Other copies are in S. Salvi, Florence, and the Prado, Madrid.

Bourgeois bequest, 1811.

J. Shearman, *Andrea del Sarto*, Oxford, 1965, Studio Works, no.9 (v).

251 Holy Family
Canvas, 107.7 x 144.8 cm

A variant, possibly produced in Del Sarto's studio, of the original in the Palazzo Pitti, Florence. DPG251 adds the figure of Saint Joseph.

Bourgeois bequest, 1811.
Shearman, no.93 (vii).

GODFRIED SCHALCKEN

Made 1643–1706 The Hague

IMITATOR OF SCHALCKEN

191 Ceres at the Cottage
Oak panel, 41.9 x 37.2 cm

Searching for her daughter Proserpine, Ceres is offered a drink at a humble cottage and is mocked by a boy whom she will transform into a lizard (Ovid, *Metamorphoses*, V). The composition derives loosely from Adam Elsheimer's lost *Mocking of Ceres* engraved by Hendrik Goudt.

Bourgeois bequest, 1811.
HdG65 (as Schalcken); T.S. Beherman, *Godfried Schalcken*, Paris, no.261 (as imitator).

BARTOLOMEO SCHEDONI

Formigine (near Modena) 1578–1615 Parma

Schedoni was sent to Rome by the Duke of Parma to study with Federico Zuccari, but fell ill and soon returned to his father, a mask-maker, with whom he was living in Parma by 1598. His style was formed mainly by the example of Correggio. In 1602–7 he was working in Modena at the d'Este court, later becoming official painter to the Farnese court in Parma, where he was employed principally in producing small cabinet pictures on religious themes. In his last years Schedoni painted a few innovative religious works on a large scale, but his career was cut short by a sudden – possibly self-inflicted – death.

STUDIO OF SCHEDONI

161 Holy Family
Poplar panel, 51.7 x 45.4 cm

A reduced replica, either from Schedoni's studio or possibly by the artist himself, of a picture in the Palazzo Corsini, Rome.

Bourgeois bequest, 1811.

322

DANIEL SEGHERS

Antwerp 1590–1661 Antwerp

Seghers served his apprenticeship in the United Provinces, becoming a pupil of Jan Brueghel the elder after his return to Antwerp in 1609/10. In 1614 he became a lay brother of the Jesuit order at Mechelen. He moved to Brussels in 1621 and took his vows as a Jesuit priest in 1625, spending the next two years in Rome. Seghers returned to Antwerp in 1627 and continued to work as a painter of bouquets and floral cartouches, the latter often containing figure scenes by other artists.

322 Cartouche with the Virgin and Child and Saint Anne
Signed, bottom right: *Daniel . Seghers . Soc.^{tis} JESV*; and, centre, on the grisaille: *E.Q*
Canvas, 96.5 x 71 cm

The feigned relief is by Erasmus Quellinus (see p.189). DPG322 is probably the cartouche containing a *Virgin and Child with Saint Anne* which, according to an inventory drawn up by Seghers of his own work, was painted for Anna Maria Mechelmans (d.1666). Bruyn suggests a date of 1655/60.

Bourgeois bequest, 1811.

J.-P. Bruyn, *Erasmus II Quellinus (1607–1678), De Schilderijen met Catalogue Raisonné*, Freren, 1988, no.198; P. Taylor in *Dutch Flower Painting*, no.11.

635

637

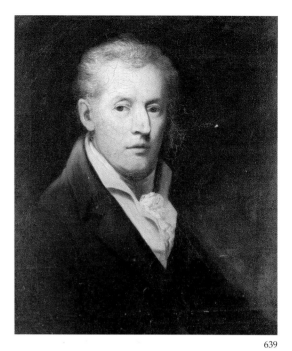

639

JOHN SMART

1756–*c*.1813

Smart worked in Ipswich as a painter of portraits and landscapes, exhibiting at the RA, 1786–1813. He is not easily distinguished from another John Smart, also an Ipswich portrait painter, who exhibited at the Society of British Artists in 1791 and at the RA in 1833 and 1850.

635 Portrait of a Man
 Canvas, 76.5 x 62.6 cm

Probably painted *c*.1795/1800, perhaps a pair to DPG637 below.

Gift of Mr Smart, 1956.

637 Miss Planner
 Canvas, 76.2 x 61.6 cm

The sitter is identified on a label, verso.

Gift of Mr Smart, 1956.

639 Self-portrait
 Canvas, 60.3 x 50.5 cm

Identified as a self-portrait by Smart on a label, verso. Probably painted *c*.1810.

Gift of Mr Smart, 1956.

634

638

J.(?) SMART

Dates unknown

634 The Painter's Sons
 Canvas, 91 x 71 cm

Probably painted *c*.1840. The sitters are identified on a label, verso, as George and Charles Smart, 'the painter's sons'.

Gift of Mr Smart, 1956.

638 Mrs J. Smart
 Canvas, 76.2 x 62.8 cm

Probably painted *c*.1840, presumably by the artist responsible for DPG634 above. The sitter is identified on a label, verso, and is perhaps the painter's wife.

Gift of Mr Smart, 1956.

PEETER SNAYERS

Antwerp 1592–1667 Brussels

Snayers served his apprenticeship with Sebastiaen Vrancx and became a master in the Antwerp painters' guild in 1612/13. In 1626/8 he moved to Brussels, where he worked as court painter to the Cardinal-Infante Ferdinand and later for Archduke Leopold Wilhelm. During his Antwerp period Snayers painted scenes of rustic banditry inspired by those of Vrancx. He subsequently specialised in panoramas of battlefields and sieges, though he also painted some portraits as well as contributing hunting scenes to the decoration of the Torre de la Parada for Philip IV of Spain.

347 A Cavalry Skirmish

> Signed, bottom centre left: *Del Sᵉ C Iˢ Pintor*
> (Del Serenissimo Cardenal Infante Pintor)
> Canvas, 74 x 109.2 cm

There are possible traces of a monogram before the signature, referring to Snayers's position as painter to the Cardinal-Infante Ferdinand, which implies a date prior to the Cardinal-Infante's death in 1641.

Bourgeois bequest, 1811.

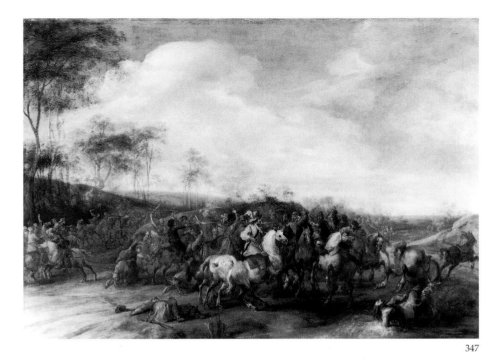

347

573

GERARD SOEST

Soest (Westphalia)? 1602–1681 London

Soest probably trained in the United Provinces before moving to England in the mid- to late 1640s. There he established a successful portrait practice, his works showing the influence of Dobson and Van Dyck (qq.v.), but never succeeded in attracting patronage at court.

573 Aubrey de Vere, 20th Earl of Oxford

> Inscribed, top right: *ÆTAT S[UAE?] / 30 1662*
> Canvas, 73.7 x 63.2

Aubrey de Vere (1626–1703): served as an officer in the Dutch army until 1648; as a Royalist, had his estates sequestrated under Cromwell and was twice imprisoned; acted as envoy to recall Charles II, but later opposed James II and joined the Prince of Orange. The inscription is worn and the sitter's age was perhaps originally given correctly as 36. The attribution to Soest was proposed by Collins Baker.

Fairfax Murray gift, 1911.

C.H. Collins-Baker, 'Some Portraits by Gerard Soest', *The Burlington Magazine*, XXXV, 1919, pp.150, 151, pl.IA.

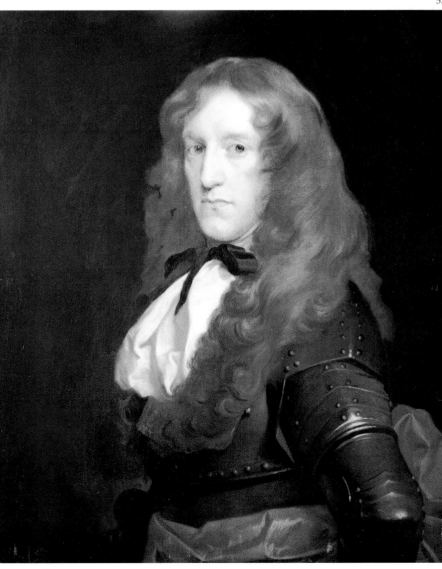

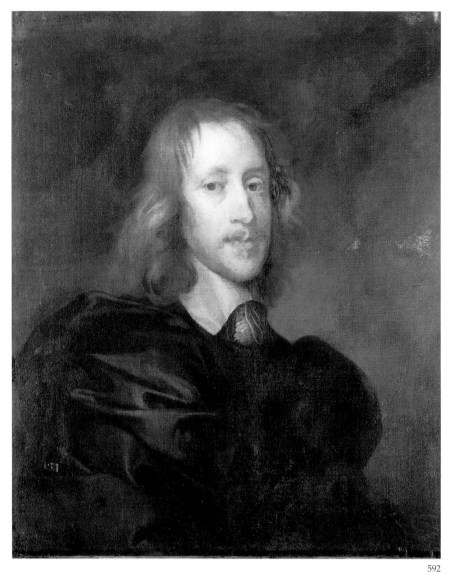

ANDREA SOLDI

Florence 1703–1771 London

After travelling in the Middle East, Soldi came to London *c.*1736 and established a successful portrait practice, attracting a number of aristocratic clients. However, a profligate lifestyle led him into debt, and in 1744 to the debtors' prison. Subsequently he seems to have toned down his style to appeal to a wider class of sitter. Soldi exhibited at the Society of Artists in 1761 and 1766, and at the Free Society in 1769. He did not maintain his success and in 1771 was receiving poor relief from the Society of Artists.

603 Louis François Roubiliac

Signed and dated, centre left: *A. Soldi / Pin.ˣ A.º 1751*
Canvas, 97.5 x 83.2 cm

Louis François Roubiliac (1702–62): born in Lyon but came to England in 1630, where, with Rysbrack, he became one of the leading sculptors. In DPG603 Roubiliac is shown working on a model of *Charity* for the monument to the Duke of Montagu in Warkton Church, Northamptonshire. He again sat to Soldi in 1757–8 (Garrick Club).

Fairfax Murray gift, 1917/18.

Rococo: Art and Design in Hogarth's England, cat. exh. Victoria and Albert Museum, London, 1984, S17.

SPANISH SCHOOL, see p.304

H. MARGARET SPANTON

Active 1901–5

Daughter of W.S. Spanton, the pupil of Charles Fairfax Murray (q.v.). She became a portrait and figure painter, exhibiting at the New English Art Club, 1901–5.

641 Nude

Signed, bottom left: *H.M. SPANTON.*
Canvas, 35.5 x 30.5 cm

Gift of Miss Gliddon, 1960.

BATHOLOMEUS SPRANGER

Antwerp 1546–1611 Prague

FOLLOWER OF SPRANGER

455 Sarah presenting Hagar to Abraham

Oak panel, 28.9 x 18.9 cm

The subject is from Genesis XVI, 1–6: Abraham's wife Sarah, having had no children by him, presents him with her Egyptian maid Hagar as a surrogate (cf. Follower of Mola DPG32 and Rubens DPG131). Previously catalogued as Flemish but, as suggested by P. van Thiel, the style seems close to Spranger (for example, his *Hercules and Omphale* in the Kunsthistorisches Museum, Vienna).

Gift of John Watts, 1894.

AFTER SPRANGER

511 Faun with Wounded Foot

Oak panel, 35 x 23.2 cm

Copy of a composition engraved by Jan Müller after a design by Spranger. DPG511 is in the same sense as the engraving.

Cartwright bequest, 1686.

N. Kalinsky in *Mr Cartwright's Pictures*, no.49.

592

ATTRIBUTED TO SOEST

592 Sir Harry Vane

Canvas, 77.5 x 63.8 cm

Sir Henry Vane the younger (1613–62): puritan; Governor of Massachussetts, 1636–7; knighted 1640; friend of Cromwell and a leading figure in Parliament during the Commonwealth; at the restoration, tried for treason and executed. An attribution to Soest was proposed by Collins Baker, who suggested a date of *c.*1655–60.

Fairfax Murray gift, 1911.

Collins Baker, p.154, pl.IID, p.155.

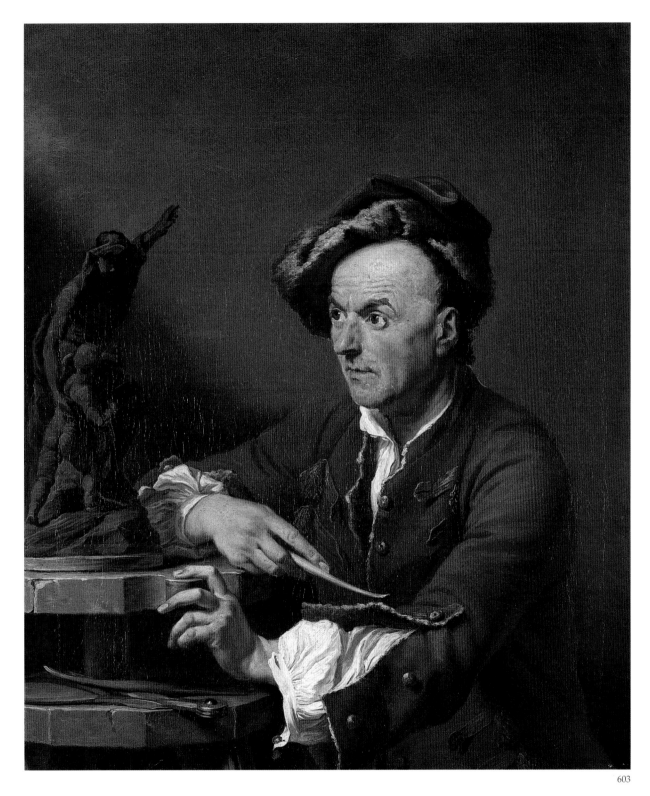

603

641

455

511

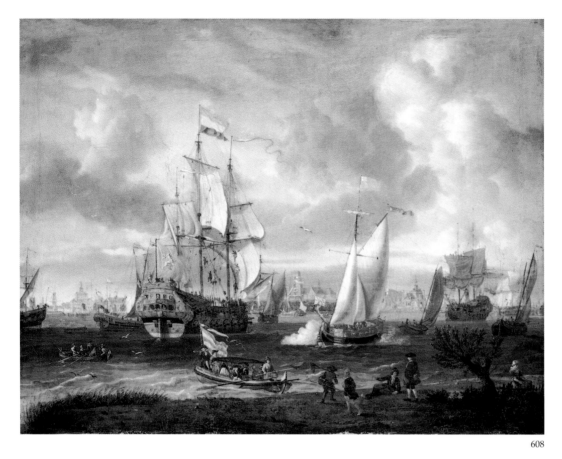

608

ABRAHAM STORCK

Amsterdam 1644–1708 Amsterdam

Abraham Storck, along with his brothers Johannes and Jacobus, trained with their father Jan Jansz. Sturckenburgh. He was a member of the Amsterdam painters' guild and, apart from a probable visit to Italy, seems to have remained active in Amsterdam throughout his career. Storck was a talented marine painter, specialising in Dutch and Mediterranean harbour scenes, the latter mostly fanciful. His work shows the influence of Ludolf Bakhuizen and Willem van de Velde the younger (qq.v.).

608 An English Yacht saluting a Dutch Man-of-War in the port of Rotterdam
Signed or inscribed, bottom centre: *A. Storck*
Canvas, 62.2 x 81.3 cm

The scene was repeated by Storck on several occasions, but the event depicted has not been identified.

Gift of Dr. E. Warters, 1926.

R. Beresford in *Conserving Old Masters*, no.11.

ROBERT STREETER

London 1621–1679 London

Streeter is said to have trained with 'Du Moulin' and may have visited Italy. He was back in England by 1658 and in 1663 became Serjeant Painter to Charles II, for whom he worked as a coach-painter and on decorations at Windsor Castle. He set up a studio in Long Acre and acquired a reputation for history, architecture and perspective as well as still life and landscape painting, also working as an etcher and engraver. Streeter's major work was the ceiling of the Sheldonian Theatre in Oxford. He also worked as a scene-painter and in this capacity probably came into contact with William Cartwright (see Greenhill DPG393).

376 Landscape
Canvas, 102.2 x 129.1 cm

Described in Cartwright's inventory as 'A Large Landscift don by Streeker …'. One of the artist's few documented works. The landscape reflects Dutch influence.

Cartwright bequest, 1686.

'Editorial: Robert Streater', *The Burlington Magazine*, LXXXIV, 1944, p.7; R.T. Jeffree in *Mr Cartwright's Pictures*, no.65.

HERMAN VAN SWANEVELT

Woerden (near Utrecht)? c.1600–1655 Paris

Swanevelt probably first trained in Utrecht. In 1623 he is recorded in Paris and by 1629 he had arrived in Rome, where he played an important part, alongside Claude (q.v.), in the early development of Italianate landscape painting. Swanevelt became a member of the Accademia di San Luca in 1634 and remained in Rome until 1641, when he returned to Paris. There he was appointed *peintre ordinaire du roi* and in 1651 was received as a member of the Académie. Besides painting, he also made numerous landscape etchings.

376

11 The Arch of Constantine
Signed and dated on masonry,
lower left: *H SWANEVELT . F . /
PARIS . 1645.*
Canvas, 89.8 x 115.6 cm

Bourgeois bequest, 1811.

11

136 Italian Landscape
Signed and dated,
bottom centre left:
*H SWANEVELT FA /
PARIS 164[5 or 8?]*
Canvas, 38.7 x 55.4 cm

Bourgeois bequest, 1811.

136

219 Italian Landscape with Bridge
Signed and dated,
bottom centre right:
H SWANEVELT/ F PAR[IS] 164[?]
Canvas, 38.4 x 55.4 cm

Bourgeois bequest, 1811.

219

DAVID TENIERS THE YOUNGER

Antwerp 1610–1690 Brussels

A pupil of his father, David Teniers the elder, Teniers entered the Antwerp painters' guild in 1632/3, serving as its dean in 1645. In *c*.1651 he moved to Brussels, where he became painter and *ayuda de cámara* to the Governor of the Southern Netherlands, Archduke Leopold Wilhelm. In this capacity Teniers served as curator of the Archduke's collection, of which he made a series of copies for engraving. In 1651 he visited England to acquire pictures from the collection of Charles I. Teniers was granted noble status in 1663 and, through his influence at court, succeeded in establishing an academy at Antwerp in 1665.

31 Gipsies in a Landscape
Signed, lower left: *DTF*
(DT in monogram)
Oak panel, 23 x 30.6 cm

Bourgeois bequest, 1811.

J. Smith, *A Catalogue Raisonné of the Works of the most eminent Dutch, Flemish and French Painters*, 8 vols., III, London, 1831, no.169.

33 A Peasant eating Mussels
Signed, bottom right: *DTF*
(DT in monogram)
Oak panel, 22.3 x 34.2 cm

Bourgeois bequest, 1811.

49 A Road near a Cottage
Signed, bottom right: *DT.F*
(DT in monogram)
Oak panel, 22.1 x 16.9 cm

Pair to DPG52.

Bourgeois bequest, 1811.

52 A Cottage
Signed, bottom left: *DT.F*
(DT in monogram)
Oak panel, 22.1 x 16.6 cm

Pair to DPG49.

31 Bourgeois bequest, 1811.

33

49

52

54 A Guard Room

Signed, bottom right: *D. TENIERS Fe*
Canvas, 72.4 x 55.8 cm, including a
possibly added strip of approximately
2.5 cm at the right edge

Probably painted in the 1640s.

Bourgeois bequest, 1811.

57 Brickmakers near Hemiksen

Signed, lower centre left:
D. TENIERS F
Oak panel, 43.8 x 67 cm

On the left is the Cistercian abbey of
St Bernard at Hemiksem on the Scheldt
south of Antwerp. The neighbouring
brickyard was one of the oldest in the
Netherlands.

Bourgeois bequest, 1811.

Smith, no.379.

76 Peasants conversing

Signed, lower centre left: *DT.F*
(DT in monogram)
Canvas, 130 x 177 cm, including
additions of 40 cm top, 18 cm bottom
and 5 cm right

The additions to the top, bottom and right
edges bring DPG76 to approximately the
same size as DPG95, allowing the two
pictures to be hung as pendants, as they
were in Bourgeois's house. They were
probably made by Bourgeois himself.

Bourgeois bequest, 1811.

G.A. Waterfield in *Conserving Old Masters*, no.4.

95 A Castle and its Proprietors

Signed, bottom centre left: *DTF*
(DT in monogram)
Canvas, 112.2 x 169.2 cm

The figures were traditionally identified as
Teniers and his wife, but the house does
not resemble Teniers's own country house
of Drij Toren (seen in a view by Teniers in
the collection of the Duke of Buccleuch,
Boughton House). The house in DPG95 is
probably fanciful.

Bourgeois bequest, 1811.

F.P. Dreher, 'The Artist as Seigneur: Chateaux
and their Proprietors in the Work of David
Teniers II', *The Art Bulletin*, LX, 1978, pp.697–8;
G.A. Waterfield in *Conserving Old Masters*, no.5.

54

57

76

95

106

110

106 A Peasant holding a Glass
 Signed, top right: *DT.F* (DT in monogram)
 Copper, 8.5 x 6.6 cm

Pair to DPG110. A similar figure appears in a drawing by Teniers in a
private collection, Paris (Antwerp 1991, no.123B).

Bourgeois bequest, 1811.

110 A Peasant
 Signed, top left: *DT.F* (DT in monogram)
 Copper, 8.5 x 6.6 cm

Pair to DPG106. A similar head appears in a drawing by Teniers in the
Nationalmuseum, Stockholm (Antwerp 1991, no.124).

Bourgeois bequest, 1811.

112

112 A Winter Scene with a Man killing a Pig
 Signed, bottom centre: *DT.F.* (DT in monogram)
 Canvas, 68.9 x 95.7 cm

Bourgeois bequest, 1811.

Smith, no.603; I. Gaskell in *Collection for a King*, no.29 and
Kolekcja dla Króla, no.24.

142

142 The Chaff-cutter
Signed, on block of
wood, bottom left:
D. TENIERS F.
Canvas, 58.6 x 84.1 cm

Bourgeois bequest, 1811.
Smith, no.402.

146 A Sow and her Litter
Signed, bottom right:
D. TENIERS . FEC.
Oak panel, 24.4 x 34.3 cm

Bourgeois bequest, 1811.
Smith, no.300.

314 Saint Peter in Penitence
Signed, bottom right:
TINIER
Oak panel, 31.1 x 53.5 cm

Pair to DPG323 below (q.v.).
The cock refers to Peter's
denials of Christ (Mark XV,
30, 60–72). There is a
preliminary drawing in the
Courtauld Institute Galleries.

Bourgeois bequest, 1811.

*David Teniers the Younger. Paintings.
Drawings*, cat. exh. Koninklijk
Museum voor Schone Kunsten,
Antwerp, 1991 (cat. by M. Klinge),
no.8B.

323 Saint Mary Magdalen in Penitence
Signed and dated,
bottom centre left:
D Tenier Iv 1634
Oak panel, 31.3 x 53.4 cm

DPG314 and DPG323 were
formerly catalogued as
'Attributed to David Teniers I
or II'. However, an attribution
to David Teniers the younger
now seems secure. The two
pictures (or very similar ones)
appear in a view of Teniers's
studio painted in 1635
(Antwerp 1991, no.11).

Bourgeois bequest, 1811.
Antwerp 1991, no.8A.

146

314

323

107

109

321

341

107 Female Pilgrim

Signed or inscribed, bottom right:
DT.F (DT in monogram)
Oak panel, 16.8 x 11.1 cm

Bourgeois bequest, 1811.

109 Pilgrim

Signed or inscribed, bottom left:
DTF (DT in monogram)
Oak panel, 16.8 x 11.1 cm

Bourgeois bequest, 1811.

321 Winter

Canvas, 67 x 42.9 cm

With DPG341 below, from a set of personifications of the four seasons. The figure of a chimney-sweep is taken from a drawing by Teniers in the Rijksmuseum (Antwerp 1991, no. 112).

Bourgeois bequest, 1811.

341 Autumn

Canvas, 67 x 42.9 cm

See DPG321 above.

Bourgeois bequest, 1811.

614 The Seven Corporal Acts of Mercy

Oak panel, 64.8 x 88.5 cm

DPG614 illustrates the seven corporal acts of mercy: to feed the hungry, to give drink to the thirsty, to clothe the naked, to give shelter to travellers, to visit the sick, to visit the imprisoned, and to bury the dead. The composition is known in several versions.

Gift of Professor C.D. Broad, 1946.

IMITATOR OF TENIERS

35 Cottage with Peasants playing Cards

Canvas, 27.5 x 37.5 cm

Bourgeois bequest, 1811.

299 Sunset Landscape with a Shepherd and his Flock

Canvas, 57.2 x 83 cm

Bourgeois bequest, 1811.

614

JACOB ERNST THOMANN VON HAGELSTEIN

Lindau 1588–1633 Lindau

Thomann von Hagelstein made a trip to Italy *c*.1605, visiting Milan, Rome, Genoa and Naples. He was particularly influenced by Adam Elsheimer, whose work inspired the idealised landscapes that he continued to paint after his return to Lindau in 1620.

ATTRIBUTED TO THOMANN VON HAGELSTEIN

22 Susannah and the Elders
Copper, 23.5 x 29.9 cm

The subject is from the Apocryphal History of Susannah, 21. The elders threaten to accuse Susannah of adultery if she will not consent to their lustful desires; though denounced, she is later proved innocent. An attribution to Johann Koenig, proposed by Bauch in 1967, is rejected by Dorsch, who regards DPG22 as more probably the work of Thomann von Hagelstein.

Bourgeois bequest, 1811.

K. Bauch, 'Die Elsheimer-Ausstellung in Frankfurt am Main', *Kunstchronik*, 1967, XX, p.90 (as Koenig); K. Andrews, *Adam Elsheimer, Paintings–Drawings–Prints*, London, 1977, A8 (as possibly Koenig, possibly Thomann von Hagelstein); K.J. Dorsch, 'Das Gemälde "Susanna im Bade" der Hamburger Kunsthalle – ein Hauptwerk Johann Königs', *Jahrbuch der Hamburger Kunsthalle*, IV, 1985, p.78 (as probably Thomann von Hagelstein).

22

123

JAN THOMAS

Ypres 1617–1673 Vienna

Thomas was a pupil of Rubens in Antwerp and became a member of the painters' guild there in 1639/40. After leaving Antwerp *c*.1654, he worked in Mainz and Frankfurt am Main before settling in Vienna. Thomas painted history and religious subjects with large figures, strongly influenced by Rubens, as well as some portraits. He also produced a number of mezzotints and etchings.

ATTRIBUTED TO THOMAS

123 Shepherd and Shepherdess
Canvas, 114 x 168 cm

A tentative attribution to Thomas has been suggested independently by H. Vlieghe (letter on file, 1997) and A. Balis (oral communication, 1997).

Bourgeois bequest, 1811.

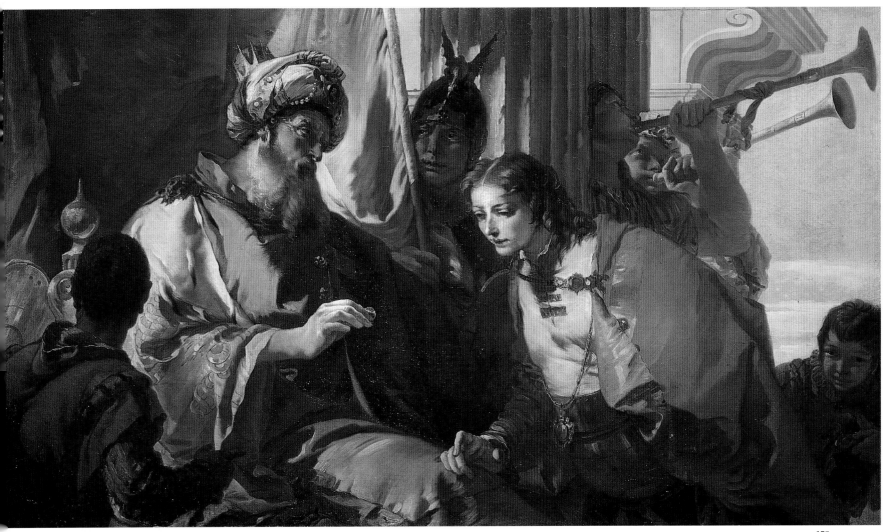

158

GIAMBATTISTA TIEPOLO

Venice 1696–1770 Madrid

Tiepolo studied with Gregorio Lazzarini in Venice and was active there as an independent painter by 1715/16, becoming a member of the painters' confraternity in 1717. He soon established his reputation and received a succession of important commissions for altarpieces and ceiling decorations in and around Venice and in other north Italian cities. In 1750–3 he was working on decorations in the Residenz at Würzburg, assisted by his sons Domenico and Lorenzo. Giambattista Tiepolo was elected president of the Venetian Academy in 1756. On the summons of Charles III of Spain, he travelled to Madrid in 1762; he remained there until his death.

158 Joseph receiving Pharaoh's Ring
Canvas, 106.1 x 179.7 cm

The subject is from Genesis XLI, 42: appointing Joseph ruler over Egypt, Pharaoh 'took off his ring from his hand, and put it upon Joseph's hand, and arrayed him in vestures of fine linen, and put a gold chain about his neck'. The more distant of the two trumpeters appears to be a self-portrait. DPG158 was catalogued by Richter in 1880 as the work of Giandomenico Tiepolo, but Morassi returned the picture to Giambattista, an attribution that is now generally accepted. Datable within the period 1733–5.

Bourgeois bequest, 1811.

M. Levey in *Collection for a King*, no. 30 and *Kolekcja dla Króla*, no. 25; M. Gemin and F. Pedrocco, *Giambattista Tiepolo. I dipinti. Opera Completa*, Venice, 1993, no. 206; A. Bayer in *Giambattista Tiepolo, 1696–1996*, cat. exh. Ca' Rezzonico, Venice/ Metropolitan Museum of Art, New York, 1996–7 (catalogue edited by K. Christiansen), no. 14.

186

189

186 Diana and a Nymph
 Canvas, 33.3 x 33 cm

189 Apollo and Nymphs
 Canvas, 33 x 33 cm

Two halves of a single sketch for the ceiling of the *Triumph of Diana* which survives in the first-floor *salone* of the Villa Cornaro at Merlengo. In the sketch, the ceiling had two viewpoints – one at each end. In the finished ceiling, however, the elements were rearranged to create a single viewpoint from one of the long sides, the composition becoming more open. Datable *c.*1750.

Bourgeois bequest, 1811.

Gemin and Pedrocco, no. 399A.

278 Virtue and Nobility putting Ignorance to Flight
Canvas, 64.2 x 35.6 cm

A sketch for the ceiling of the *salone* of the Villa Cordellina at Montecchio Maggiore, near Vicenza, painted for the lawyer Carlo Cordellina in 1743. It is likely that the embracing figures are Virtue on the left, holding a laurel wreath, and Nobility on the right, holding a statuette. They are accompanied by Fame, blowing a trumpet, and a vanquished female figure, probably Ignorance. The allegory relates to the clemency of the conquerors represented in the wall decorations of the *salone*: the *Continence of Scipio* and the *Family of Darius before Alexander*. Preparatory drawings are in the Pierpont Morgan Library, New York, and the Musei Civici di Trieste.

Bourgeois bequest, 1811.

M. Levey in *Collection for a King*, no. 31; B. Mazza in *I Tiepolo e il Settecento vicentino*, cat. exh. Vicenza/Montecchio Maggiore/Bassano del Grappa, 1990, p.312; Gemin and Pedrocco, no. 262A; *Giambattista Tiepolo, Master of the Oil Sketch*, cat. exh. Kimbell Art Museum, Fort Worth, 1993 (catalogue by B.L. Brown), no. 24.

278

198

209

266

273

TITIAN
Pieve di Cadore *c.*1487/90–1576 Venice

AFTER TITIAN

198 Girl in a Fur Coat
Canvas, 91.5 x 66 cm

Titian's original of *c.*1535 is in the Kunsthistorisches Museum, Vienna.

Bourgeois bequest, 1811.

H.E. Wethey, *The Paintings of Titian*, London 1969–75, II, no. 48/2.

209 Venus and Adonis
Canvas, 182.8 x 189.5 cm

Copy of a studio variant (the so-called 'Barberini type') of Titian's original in the Prado, Madrid.

Bourgeois bequest, 1811.

Wethey III, no. X-40/1.

266 Saint Barbara
Poplar panel, 27.3 x 21.6 cm

Apparently a fragment. The figure seems to derive from Saint Catherine in Titian's altarpiece of the *Virgin and Child with Saints* of *c.*1520–5 in the Pinacoteca Vaticana, Rome (Wethey, I, no. 63). The addition of a tower identifies her as Saint Barbara (cf. Rubens DPG125).

Bourgeois bequest, 1811.

273 Rape of Europa
Canvas, 46.7 x 57.1 cm

A copy, probably eighteenth-century, of the original in the Isabella Stewart Gardner Museum, Boston, painted for Philip II of Spain between 1559 and 1562.

Bourgeois bequest, 1811.

Wethey III, no. 32/2.

27

484

484 Sleeping Venus
 Canvas, 101.3 x 186 cm

Apparently derived from a lost painting by Titian. The prototype was based on Giorgione's *Venus* in the Gemäldegalerie, Dresden (probably finished by Titian), with the addition of roses. DPG484 adds the Cupid and loggia.

Bourgeois bequest, 1811.

Wethey, III, no. X-36/4.

FLAMINIO TORRE

Bologna 1620–1661 Modena

AFTER TORRE

27 Saint Jerome
 Copper, 7.9 x 6 cm (oval)

Copy from a half-length figure in the Galleria Pallavicini, Rome.

Possibly Bourgeois bequest, 1811.

JOHN VANDERBANK

London 1694–1739 London

Vanderbank was taught drawing by his father, a tapestry weaver, and from 1711 studied in Kneller's Academy, where he worked until 1720. With Louis Chéron, he then set up his own academy in St Martin's Lane. He was a successful portrait painter, though it was said that his promise was never fully realised. He also undertook decorative work and designed book illustrations. His extravagant lifestyle led him into debt and in 1729 he was seized and sent to Fleet Prison.

581 Portrait of a Woman in White
 Dated and signed, bottom left: *1738/ J^no Vanderbank Fecit*
 Canvas, 127 x 101.9 cm

Fairfax Murray gift, 1911.

581

Velázquez trained in Seville, first briefly with Francisco de Herrera the elder and then with Francisco Pacheco, becoming an independent master in 1617. In 1623 he was called to Madrid, where he was soon appointed *Pintor del Rey*. He made a study trip to Italy in 1629–31 and another to acquire pictures in 1649–51. In Seville he worked as a painter of religious subjects and genre scenes. In Madrid he was predominantly a court portrait painter, producing a sequence of royal portraits culminating in his masterpiece, *Las Meninas* (Prado, Madrid).

249

STUDIO OF VELÁZQUEZ

249 Philip IV, King of Spain
Canvas, 130.2 x 97.8 cm

Philip IV (1605–65), King of Spain, 1621–65. DPG249 is a copy of Velázquez's 'Fraga Philip' in the Frick Collection, New York, painted at Fraga during the Aragonese campaign against the French in 1644. The Dulwich picture has at various times been called Velázquez's original, an autograph replica, or a copy retouched by the artist. It is presumably a studio copy, possibly by Mazo (q.v.) as first suggested by Beruete. J.R. Buendia suggested an attribution to Sebastián Martínez (note on file, 1983).

Bourgeois bequest, 1811.

A. de Beruete, *Velázquez*, Paris, 1898, pp.93–4; J. López-Rey, *Velázquez. A Catalogue Raisonné of his Œuvre*, London, 1963, no.256.

AFTER VELÁZQUEZ

152 The Infante Don Baltasar Carlos on Horseback
Canvas, 97.1 x 81.3 cm

A reduced copy of Velázquez's original in the Prado, Madrid.

Bourgeois bequest, 1811.

López-Rey, no. 203.

152

ADRIAEN VAN DE VELDE
Amsterdam 1636–1672 Amsterdam

Adriaen van de Velde probably first trained with his father Willem van de Velde the elder, along with his brother Willem the younger (q.v.), before becoming a pupil of Jan Wijnants (q.v.) in Haarlem. He had settled in Amsterdam by 1657. Although he painted some history subjects, genre pieces and portraits, he was principally a painter of idealised pastoral landscapes. These show the influence of Berchem and Dujardin (qq.v.). He also made a number of etchings.

51 Cows and Sheep in a Wood
Oak panel, 18.4 x 22.5 cm

The drinking cow recurs in a picture dated 1669 (HdG178). A copy was sold Bearne's, Torquay, 15 July 1981, lot 415.

Bourgeois bequest, 1811.

HdG192.

51

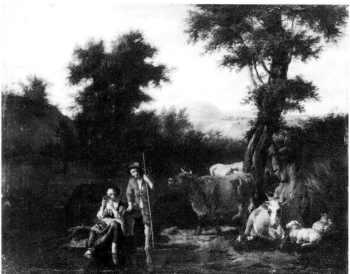

177

AFTER VAN DE VELDE?

177 Peasants and Cattle
Canvas on oak panel, 28.8 x 38 cm

The mooing cow centre right and the cow and sheep bottom right recur in works by Adriaen van de Velde, for example a picture signed and dated 1663, formerly with Hoogendijk, Amsterdam (HdG216). However, DPG177 is not of autograph quality; it may be a copy of a lost painting by Van de Velde.

Bourgeois bequest, 1811.

WILLEM VAN DE VELDE THE YOUNGER

Leiden 1633–1707 London

The Van de Velde family had settled in Amsterdam by 1636. Along with his brother Adriaen (q.v.), Willem probably first trained with their father, Willem the elder. From *c.*1648 he studied with Simon de Vliegher at Weesp. He married in Amsterdam in 1652 and there worked in his father's studio, producing finished paintings from the sketches made by his father at sea. In 1672/3 both father and son came to London, where they received commissions from Charles II for tapestry designs as well as paintings. Much of their English work was executed in Greenwich, where they were granted a studio in the Queen's House.

103 A Brisk Breeze
Signed on floating plank, lower left: *W V V.*
Canvas, 52.1 x 65 cm

Dated by Robinson *c.*1665.

Bourgeois bequest, 1811.

HdG493; D. Cordingly in *Collection for a King*, no.32 and *Kolekcja dla Króla*, no.26; M.S. Robinson, *The Paintings of Willem van de Velde the Elder and the Younger*, 2 vols., London, 1990, II, pp.810–11, no.103.

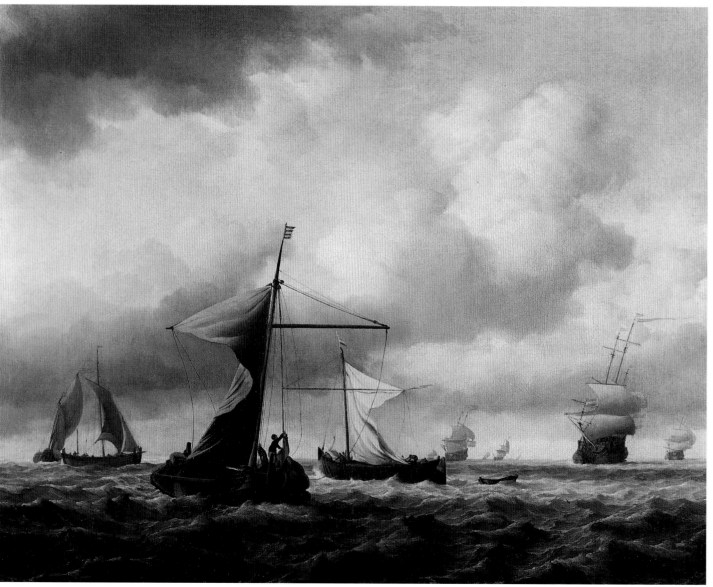

103

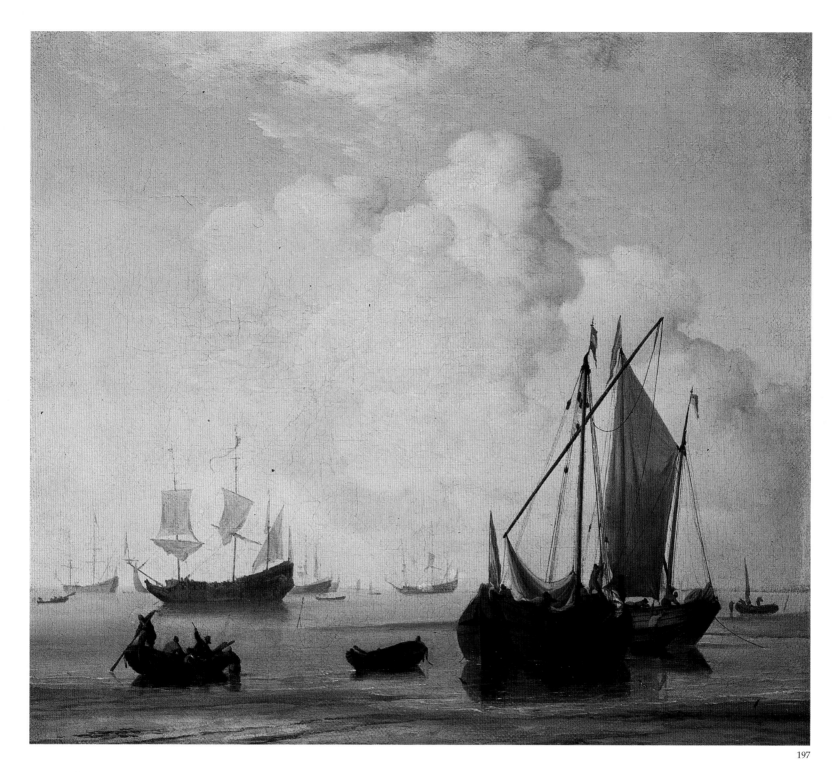

197

197 A Calm

Signed and dated, bottom right: *W.V.V. 1663*
Canvas on panel, 34 x 37.5 cm

Bourgeois bequest, 1811.

HdG201 and probably 340A; Robinson, I, p.493, no.102.

AFTER VAN DE VELDE

68 A Calm

Signed or inscribed on floating plank,
bottom left: *W…* (worn)
Canvas, 60 x 75.5 cm

According to Robinson, a studio or eighteenth-
century copy of a picture by Van de Velde of
unknown whereabouts.

Bourgeois bequest, 1811.

HdG200; Robinson, I, p.356, no.104[3].

68

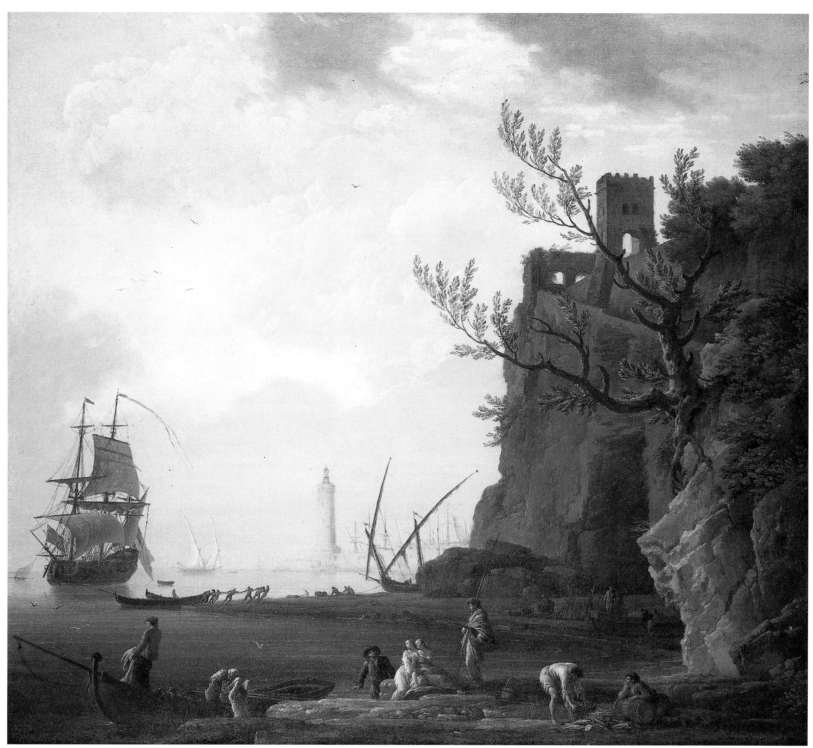

CLAUDE-JOSEPH VERNET

Avignon 1714–1789 Paris

Vernet trained first with his father in Avignon and then with Philippe Sauvan at Aix-en-Provence. In 1734–52 he was in Rome, where he may have studied further with Adrien Manglard. He established a reputation there as a painter of landscapes and coast scenes. On his return to France, Vernet was received at the Académie in 1753 and commissioned to paint a series of the *Ports de France* for the King; he finally abandoned the project in 1763, having completed fifteen canvases. He then settled in Paris, where his work met with a favourable reception at the *Salons*.

319 An Italianate Harbour Scene

Signed and dated, lower right: *Joseph Vernet/ f Romae/ 1749*
Canvas, 104.4 x 117.8 cm

The vessel on the left flies the Union Jack. Murray suggests that DPG319 might be a picture recorded in the artist's account book as commissioned by 'M. Sauvan' in January 1749, but that picture was of upright format.

Bourgeois bequest, 1811.

F. Ingersoll-Smouse, *Joseph Vernet*, 2 vols., Paris, 1926, I, no.237(?).

328

328 Italian Landscape

 Signed and dated, bottom left: *Fait a Rome Par J. Vernet/ 1738*
 Canvas, 123.8 x 174 cm

One of Vernet's earliest dated works, painted during his stay in Italy and displaying
the influence of Salvator Rosa (q.v.). According to Conisbee (1993), DPG328 was
possibly painted as a pendant to Vernet's *View of Tivoli* in the Cleveland Museum
of Art.

Bourgeois bequest, 1811.

Ingersoll-Smouse, I, no.466; P. Conisbee in *Collection for a King*, no.33 and *Kolekcja dla Króla*,
no.27; P. Conisbee, 'Vernet in Italy' in *Pittura Toscana e Pittura Europea nel Secolo dei Lumi.*
Atti del Convegno, Domus Galilaeana, 3–4 Dicembre 1990 (ed. R.P. Ciardi, A. Pinelli and C.M. Sicca),
Florence, 1993, p.136.

300

306

623

STUDIO OF VERNET

300 Seaport at Sunrise (Morning)

Signed or inscribed and dated, bottom right: *J. Vernet 175*[*9?*]
Canvas, 67.6 x 99.7 cm

DPG300 and DPG306 (below) are probably studio replicas of two pictures from a set of four, representing the times of the day, commissioned by M. Journû of Bordeaux in 1759. The date on DPG300 seems to read *175*[*9?*] and not *176*[*7?*] as once recorded. The date was presumably applied retrospectively, since the original, in the Art Institute, Chicago, is dated 1760.

Bourgeois bequest, 1811.

Ingersoll-Smouse, II, no.873.

306 Seaport at Sunset (Evening)

Canvas, 67.6 x 99 cm

See DPG300 above.

Bourgeois bequest, 1811.

Ingersoll-Smouse, II, no. 874.

AFTER VERNET

623 Coastal View (*La Pêche Heureuse*)

Canvas, 54.1 x 82 cm

A copy of Vernet's original engraved by Zwingg in 1759 (Ingersoll-Smouse, no.701).

Bequest of Miss Gibbs, 1951.

FOLLOWER OF VERNET

610 A Shipwreck

Canvas, 44.1 x 62.2 cm

Bequest of H. Margaret Spanton, 1934.

610

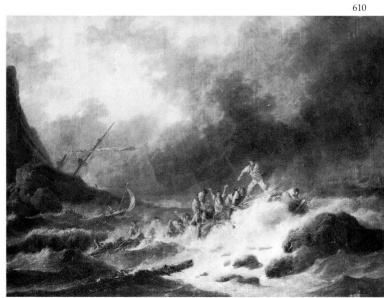

PAOLO VERONESE

Verona 1528–1588 Venice

Paolo Caliari, called Veronese, trained in Verona with
Antonio Badile and Giovanni Caroto and was active
as a painter there in the 1540s. In 1553 he moved to
Venice, where, with Titian and Tintoretto, he became
one of the leading painters, undertaking a formidable
series of commissions for altarpieces and decorative
cycles. He also painted portraits. In 1573 Veronese
was called before the Inquisition to account for his
treatment of the *Last Supper* (Accademia, Venice),
which was considered indecorous, but he simply
re-titled the picture as the *Feast in the House of Levi*.

270 Saint Jerome and a Donor

Canvas, 224.5 x 120 cm

The canvas is a fragment of a large altarpiece of which
the lower left portion is now in the National Gallery
of Scotland, Edinburgh, and the upper portion in the
National Gallery of Canada, Ottawa. Saint Jerome is
dressed as a Cardinal and accompanied by his
traditional symbol of a lion. He holds a church, which
refers to his role as one of the four Fathers of the
Church. At the left edge are the hand holding a balance
and part of the drapery of a figure of Saint Michael
trampling the Devil (whose forearm appears at the
bottom). The altarpiece was painted for Antonio and
Girolamo Petrobelli for their chapel in the church of
San Francesco at Lendinara near Rovigo. The donor
in the Dulwich fragment is Girolamo (d.1587). An
inscription on the stone altar of the chapel bore the
date 1563 and, though usually dated later, the
altarpiece was presumably painted at approximately
the same time.

Bourgeois bequest, 1811.

T. Pignatti, *Veronese*, Venice, 1976, no.337; P.L. Bagatin,
P. Pizzamano and B. Rigobello, *Lendinara, Notizie e Immagini per
una Storia dei Beni artistici e librari*, Treviso, 1992, pp.212–13;
R. Beresford in *Conserving Old Masters*, no.1.

270

239

159

207

FOLLOWER OF VERONESE

239 The Mystic Marriage of Saint Catherine
 Inscribed, centre left: *PAVLO CALLEARI/ VERONESE*
 Canvas, 99.1 x 86.6 cm

Bourgeois bequest, 1811.

MANNER OF VERONESE

159 Portrait of a Woman
 Canvas, 97.2 x 79.7 cm

Bourgeois bequest, 1811.

207 Saint Catherine
 Canvas, 130.2 x 93.3 cm

Bourgeois bequest, 1811.

485

FRANÇOIS VERWILT

Rotterdam *c.*1620–1691 Rotterdam

Verwilt was the son of a painter and probably received his first training from his father, before becoming a pupil of Cornelis Poelenburch (q.v.) in Utrecht. He worked mainly in Rotterdam but is recorded on occasions in Middelburg (where he was a member of the painters' guild in 1661), Vlissinghen and Veere. Verwilt painted idealised landscapes with biblical and mythological subjects inspired by those of Poelenburch, as well as some portraits and occasional genre scenes and stable interiors.

485 Jupiter and Antiope
 Signed, lower right: *f.v.wilt*
 Oak panel, 37.8 x 47.3 cm

Attributed to Poelenburch until 1880, when Richter noted the signature.

Bourgeois bequest, 1811.

CORNELIS DE VOS

Hulst 1584–1651 Antwerp

The De Vos family moved *c.*1596 to Antwerp, where Cornelis trained with David Remeeus, 1599–1604. He became a member of the painters' guild in 1608, serving as dean 1619–20. In 1616, when he became a citizen of Antwerp, he was described as a picture dealer. He worked with Rubens on the triumphal entry of the Cardinal-Infante Ferdinand and the hunting scenes commissioned by Philip IV of Spain for the Torre de la Parada. Although he painted some history and genre subjects, Cornelis De Vos specialised chiefly in portraiture.

290 Portrait of a Woman
Canvas, 171.8 x 106.4 cm

Until 1880 catalogued as a portrait by Rubens of his mother. Murray's attribution to De Vos is accepted by K. Van der Stighelen, who suggests a date of 1630/5 (letter on file, 1997).

Bourgeois bequest, 1811.

290

PAUL DE VOS

Hulst 1591/2 or 1595–1678 Antwerp

AFTER DE VOS?

597 Fox and Poultry
Canvas, 115.5 x 169.9 cm

The fox recurs in a signed work by Paul de Vos in a private collection, Madrid (see cat. exh. *Le Siècle de Rubens*, Musées Royaux des Beaux-Arts de Belgique, Brussels, 1965, no.300). DPG597 may be a copy of a lost work by Paul de Vos, as suggested by the existence of another version, sold at Christie's, Amsterdam, 29 May 1986 (lot 106, as Follower of De Vos).

Bequest of Henry Louis Florence, 1915.

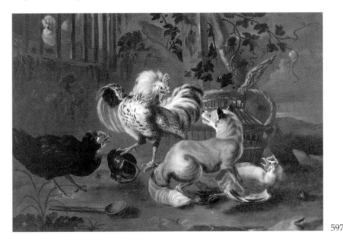

597

SEBASTIAEN VRANCX

Antwerp 1573–1647 Antwerp

AFTER VRANCX

356 A Company of Cavalry
Oak panel, 52.4 x 40.3 cm

Copy of a composition by Vrancx known in several versions.

Cartwright bequest, 1686.

N. Kalinsky in *Mr Cartwright's Pictures*, no.55.

356

7

631

429

ROELOF VAN VRIES

Haarlem 1630/1–after 1680 Amsterdam

Van Vries became a member of the Leiden guild in 1653 and of the Haarlem guild in 1657. In 1659 he married in Amsterdam. Virtually nothing appears to be known of his life. The works of Van Vries show the influence of Ruisdael (q.v.).

7 Landscape with a Tower
Oak panel, 49.8 x 41.1 cm, including additions of 0.7 cm on all sides

Catalogued as Wijnants until 1880 and then as Dutch School. The attribution to Van Vries was proposed by Murray and is accepted by J. Giltay (letter on file, 1996).

Bourgeois bequest, 1811.

J. Smith, *A Catalogue Raisonné of the Works of the most eminent Dutch, Flemish and French Painters*, 8 vols., VI, London, 1835, no. 167 (as Wijnants).

PARRY WALTON

Active c.1660–died 1702 London

Walton is said to have trained with R. Walker. For a time he shared a house in Lincoln's Inn Fields with Greenhill (q.v.). He is recorded as a still-life painter but is best known as a picture and frame dealer and picture restorer. Walton became Surveyor or Repairer of the King's Pictures to William III, and provided frames for Petworth House, Sussex.

429 Still life
Canvas, 63.9 x 55.2 cm

Attributed to Walton in Cartwright's inventory, DPG429 seems to be the artist's only known surviving work as a painter.

Cartwright bequest, 1686.

R.T. Jeffree in *Mr Cartwright's Pictures*, no. 76.

JAMES WARD

London 1769–1859 Cheshunt

Ward studied mezzotint engraving with John Raphael Smith and his brother, William Ward. He was persuaded by the example of his brother-in-law George Morland (see Muller DPG587) to take up painting and became successful as an animal painter from c.1790. He also painted landscapes, portraits and some history subjects. Ward exhibited at the Society of Artists 1790, at the RA 1792–1855, and at the British Institution 1806–47. He was elected ARA in 1807 and RA in 1811.

631 Bay Hunter
Signed and dated, bottom left:
[*J*?] *WARD R.A. 1817*
(WARD in monogram)
Panel 69.8 x 93.7 cm

Stolen, c.1987/8.

Anonymous gift, 1956.

156

JEAN-ANTOINE WATTEAU

Valenciennes 1684–1721 Nogent-sur-Marne

After receiving his initial training in Valenciennes, Watteau went to Paris *c*.1702 and worked there with Claude Gillot and Claude III Audran. The former introduced him to theatrical painting, the latter to ornamental design. In 1709–10 he returned briefly to Valenciennes. He was *agréé* at the Académie in 1712 and received in 1717 as a painter of *fêtes galantes,* a category of subject matter which he had himself invented. Watteau visited London in 1719–20, but returned to Paris sick with consumption and died in the following year.

156 Les Plaisirs du Bal
 Canvas, 52.6 x 65.4 cm

Possibly painted for François II de Boyer de Bandol, President of the *Parlement de Provence* (for the involved later provenance, see Washington/Paris/Berlin). Rosenberg proposes a date of 1716–17. There are numerous related drawings, of which one – used for the young servant slightly to the right of centre – is taken from Veronese's *Christ and the Centurion* in the Prado. The X-ray shows a more ambitious architectural setting, which Watteau replaced with the banded columns (which recall the Luxembourg Palace in Paris) and a more extensive view of the park. The composition was extensively copied (an example by Pater is in the Wallace Collection).

Bourgeois bequest, 1811.

Watteau, cat. exh. National Gallery of Art, Washington/Grand Palais, Paris/Schloss Charlottenburg, Berlin, 1984–5 (catalogue by P. Rosenberg, M. Morgan Grasselli, et al.), P51; P. Rosenberg in *Kolekcja dla Króla*, no.28.

167

620

CIRCLE OF WATTEAU

167 Fête Champêtre
Canvas, 54 x 65.7 cm

The composition is related to Watteau's *Halt during the Chase* in the Wallace Collection. The traditional attribution to Watteau was questioned in 1912 by Zimmerman, who gave the picture to Pater, an attribution accepted by Ingersoll-Smouse. However, as noted by C. Thompson (letter on file, 1982), DPG167 seems too close to Watteau to have been painted by Pater. It is perhaps a work left unfinished by Watteau at his death and finished by others.

Bourgeois bequest, 1811.

E. H. Zimmerman, *Watteau, Des Meisters Werke in 182 Abbildungen*, Stuttgart/Leipzig, 1912, pp.152, 192; F. Ingersoll-Smouse, *Pater*, Paris, 1928, no.199.

AFTER WATTEAU

620 Soldiers on the March
Canvas, 49.9 x 62.2 cm

A copy with variations, notably in the right foreground, of Watteau's *Retour de Campagne*, lost but known in Cochin's engraving of 1727.

Bequest of Miss Gibbs, 1951.

JAN WEENIX

Amsterdam 1642–1719 Amsterdam

Weenix trained with his father Jan Baptist Weenix in Utrecht and is recorded as a member of the painters' college in Utrecht 1664–8. By 1675 he had moved to Amsterdam. In *c.*1702–14 he was court painter to the Elector Palatine Johann Wilhelm in Düsseldorf. He began as a painter of Italianate landscapes and port scenes based on the style of his father, but from *c.*1680 concentrated on the still lifes of dead game and birds for which he is best known. He also painted some portraits.

47 Landscape with Shepherd Boy
 Signed and dated, bottom left: *J. Weenix/ 1664*
 Canvas, 81.6 x 99.6 cm

The boy appears to be clipping the puppy's claws. An early work painted in the style of J.B. Weenix.

Bourgeois bequest, 1811.

I. Gaskell in *Collection for a King*, no.34.

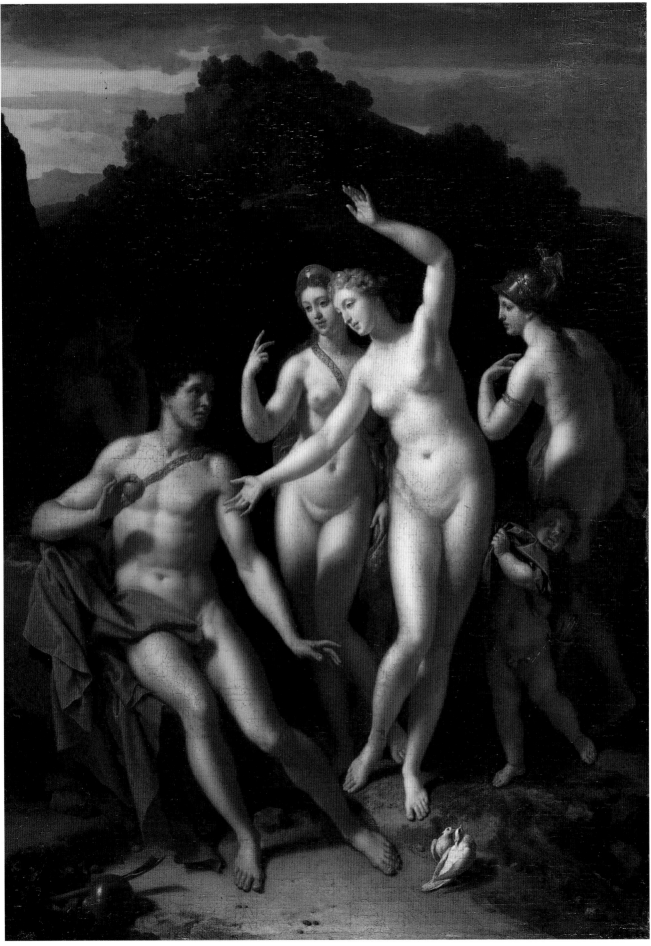

ADRIAEN VAN DER WERFF

Kralingen (near Rotterdam) 1659–1722 Rotterdam

Van der Werff trained with the portrait painter Cornelis Picolet and then with Eglon van der Neer, *c*.1671–5, before setting himself up as an independent master in 1676. In 1697 he was appointed court painter to the Elector Palatine, for whom he was obliged to work for six months of the year. In 1703 the Elector made him a knight. Beginning as a painter of portrait and genre subjects in the tradition of the Leiden *fijnschilders* ('fine' painters), Der Werff abandoned these for history subjects, painted in a polished classical manner that was greatly admired. Houbraken regarded him as the greatest of Dutch artists.

147 The Judgement of Paris
Signed and dated, lower left: *Chevr vandr/ Werff Fec/ ano 1716* Canvas, on oak panel, 63.3 x 45.7 cm

The shepherd Paris judges Juno, Venus and Minerva and awards the golden apple to Venus (Ovid *Heroides*, XVI). According to the artist's notebook, work on the picture began in September 1716, Adriaen van der Werff working on it for sixteen weeks and his brother and assistant Pieter van der Werff for ten weeks. It was acquired in 1719 by the French Regent, the duc d'Orléans. An earlier treatment by Van der Werff of the same subject, dated 1712, was formerly in the Gemäldegalerie, Dresden (destroyed).

Bourgeois bequest, 1811.

HdG117; B. Gaehtgens, *Adriaen van der Werff, 1659–1722*, Berlin, 1987, no.33.

147

BENJAMIN WEST

Springfield (Pennsylvania) 1738–1820 London

After training in Pennsylvania, West set out in 1760 for Italy, where he was in contact with Mengs, Batoni and Gavin Hamilton and became a member of the Academies at Parma, Florence and Bologna. In 1763 he settled in London, working at first as a portrait painter but exhibiting mainly history subjects at the Society of Artists, 1764–8. These works soon established him as the leading history painter in England. He was a founder member of the RA, exhibiting there 1769–1819 and at the British Institution 1806–20. West's work was admired by George III and he was appointed historical painter to the King in 1772 and Surveyor of the King's Pictures in 1790. He succeeded Reynolds as President of the Royal Academy in 1792.

586 Mother and Child, possibly Mrs Benjamin West Jr, with Benjamin III West
Signed and dated, lower right: *B. West. 1805*
Canvas, 91.4 x 71.1 cm

The portrait was acquired by Fairfax Murray at a West family sale and is therefore possibly a family portrait. The sitter may be the wife of West's younger son, Benjamin. She was described in 1804 as 'in a state likely to add to the family' and gave birth, probably in that year, to a son, also called Benjamin.

Fairfax Murray gift, 1911.

H. von Erffa and A. Staley, *The Paintings of Benjamin West*, New Haven and London, 1986, no.544.

SYDNEY W. WHITE

Active 1892–1917

White exhibited at the RA in 1897 from an address in Grimsby and in 1897–1917 from London. Besides portraits, his exhibits included a landscape and a 'bacchante'.

552 The Reverend J. Henry Smith
Signed and dated, lower right: *Sydney W. White/ 1902*
Canvas, 111.7 x 83.8 cm

The Rev. J. Henry Smith (1836–after 1902): senior curate of St Botolph's, Bishopsgate; Headmaster of the Lower School at Dulwich (from 1887 Alleyn's School), 1875–1902.

Gift of Subscribers, 1902.

THOMAS WIJCK

Beverwijck (near Haarlem) *c.*1616–1677 Haarlem

Wijck made a trip to Italy *c.*1640, visiting Rome and Naples, but was back in Haarlem by 1642, when he became a member of the painters' guild. He was apparently in London, probably during the 1660s, and is said to have painted the great fire of London, 1666. He seems otherwise to have spent his career in Haarlem painting outdoor urban genre scenes based on the drawings he brought back from Rome.

247 Italian Courtyard
Canvas on panel, 38.3 x 31.1 cm

Formerly catalogued as Jan Miel, but rejected as such by Kren. A resemblance to the work of Thomas Wijck, noted by Kren, seems sufficient to support an attribution to him.

Bourgeois bequest, 1811.

T. Kren, *Jan Miel (1599–1664), a Flemish Painter in Rome*, diss. Yale University, 1978, D24.

586

552

247

JAN WIJNANTS
Haarlem 1631/2–1684 Amsterdam

Wijnants was the son of a Haarlem picture dealer and probably studied in Haarlem, though his teacher is not known. In 1653 he is recorded in Rotterdam, but he was back in Haarlem by 1657. His earliest works were influenced by the bird painter Dirck Wijntrack, with whom he sometimes collaborated. In 1659/60 he moved to Amsterdam, where he seems to have spent the rest of his life constantly in debt, keeping an inn whilst working as a painter. Most of Wijnants's works are dune landscapes inspired by the countryside around Haarlem and showing the influence of Ruisdael and Wouwermans (qq.v.).

114 Landscape with Cow drinking
Signed, bottom right: *J wijna[n]t[s]*
Oak panel, 15.6 x 18.7 cm

Pendant to DPG117 below.

Bourgeois bequest, 1811.

HdG312.

114

117

117 Landscape
Oak panel, 15.8 x 18.8 cm

Pendant to DPG114 above.

Bourgeois bequest, 1811.

HdG590.

633

616

ATTRIBUTED TO WIJNANTS

633 Landscape

 Canvas, 78.8 x 60.9 cm

Lost. Previously catalogued as Willem de Heusch (1625–92), but from the photograph DPG633 appears closer to Wijnants (as suggested by J. Giltay, letter on file, 1996).

Gift of Mr Mather, 1957.

IMITATOR OF WIJNANTS

616 Landscape

 Inscribed, bottom right: *P[?] wijnants/ 1654*
 Canvas, 59.1 x 78.8 cm

Gift of Professor C.D. Broad, 1946.

BENJAMIN WILSON

Leeds 1721–1788 London

After training with a French artist called Longueville, Benjamin Wilson came to London and found employment as a clerk. He resumed his studies under Hudson (q.v.) and was active as a portrait painter in Dublin 1748–50 and then in London. He succeeded Hogarth as Serjeant Painter in 1764 and was appointed painter to the Board of Ordnance in 1767. He exhibited at the Society of Artists 1760–1 and at the RA 1783. As well as being a painter, Wilson was an accomplished etcher and a scientist. His electrical experiments won him a gold medal at the Royal Society in 1760.

593 Portrait of a Woman in Rustic Dress

 Inscribed, signed and dated, bottom left:
 Æ[?]0/ B. Wilson. pinxit./ 1753
 Canvas, 91.7 x 70.7 cm

An exercise in the style of Rembrandt, recalling his *Saskia as Flora* in the Hermitage, St Petersburg. The catalogue of the Christie's sale, 22 January 1898 (lot 88) records a traditional identification of the sitter as Anne, daughter of Horatio Orford.

Fairfax Murray gift, 1911.

593

RICHARD WILSON

Penegoes (Powys) 1713/14–1782 Colomendy
(near Mold, Clwyd)

Richard Wilson trained as a portrait painter with
Thomas Wright in London. In 1750 he set out for
Italy, stopping first in Venice. He had moved to Rome
by 1752 and remained there until 1756/7. In Italy he
took up landscape painting, basing his style on the
example of Claude and Dughet (qq.v.). On his return
to London he exhibited at the Society of Artists
1760–8 and at the RA (of which he was a founder
member) 1769–80. In 1776 he was appointed librarian
of the RA. In declining health, Wilson retired to Wales
in 1781.

**171 Tivoli, the Cascatelle and
the 'Villa of Maecenas'**
Canvas, 73.3 x 97.2 cm

The celebrated Cascatelle of Tivoli, with the town
of Tivoli above, and in the centre the ruins of the
Sanctuary of Hercules Victor, formerly thought to be
those of the Villa of Maecenas. A smaller version in
the National Gallery of Ireland was painted,
according to an inscription on the verso, in 1752.

Bourgeois bequest, 1811.

W.G. Constable, *Richard Wilson*, London, 1953, p.225, pl.117a;
G.A. Waterfield in *Collection for a King*, no.36.

JOHN WOOD

London 1801–1870

Wood studied at Sass's Academy and at the RA Schools,
where he was awarded a gold medal in 1825. He exhibited
at the RA 1823–62, and also at the British Institution
1823–59 and the Society of British Artists 1825–57. As a
young man he acquired a considerable reputation as a
history painter. During the latter part of his career, Wood
painted mainly biblical subjects and portraits, but his art
degenerated with failing health.

346 Thomas Stothard
Canvas, 127.2 x 101.9 cm

Thomas Stothard (1755–1834): painter and notable book
illustrator; elected RA 1794; librarian of the RA from 1812;
friend of Flaxman, Beckford and Samuel Rogers. DPG346
is presumably the portrait of Stothard exhibited at the RA
in 1833; the sitter would then have been about 78.

Gift of Miss Elizabeth Wood, 1883.

346

453

454

650

453 The Dream of Endymion

Signed and dated, bottom right:
JOHN WOOD./ 1832.
Canvas, 127 x 101.5 cm

Exhibited at the British Institution in 1833 ('Methought I lay watching the Zenith, / and lo! from opening clouds I saw emerge the lovely moon'). With DPG454 below, cited in the artist's obituary in the *Art Journal*, 1870, as one of the pictures that most contributed to extending his reputation.

Gift of Thomas Gray, 1897.

454 The Orphans

Signed and dated, bottom left: *John Wood./ 1830.*
Canvas, 143.2 x 105.4 cm

Exhibited at the RA in 1830 and at the British Institution in 1831. The RA catalogue quotes a verse by S.C. Hall (1800–89): 'Silently eloquent, By the way-side those gentle orphans stood, Not asking aid, save by those looks and tears, That tell their tale – poor desolate ones! –, The blight of winter hath come o'er their spring, Oh! for some blessed beam to cherish them.' See also DPG453 above.

Gift of Miss S. Wyatt Gray, 1897.

650 Susan Jay and her Dog

Signed (and dated), bottom right: *John Wood …*
Canvas, 68.5 x 56.5 cm

The date is illegible, but is recorded in a label formerly on the verso as 1821.

Bequest of Mrs Harriette Estill Mason, 1942.

SAMUEL WOODBURN

1780–1853 London

Woodburn was one of the leading London picture dealers of the early nineteenth century, enjoying a high reputation for his connoisseurship and integrity. He purchased the whole of Sir Thomas Lawrence's collection of old master drawings, which he had been largely instrumental in assembling, and disposed of the collection in a series of selling exhibitions. He was also an amateur engraver and made a number of etchings after Ruisdael drawings.

150 Landscape

> Inscribed, bottom left: *Ruisdael*
> Oak panel, 49.5 x 39.1 cm

Attributed in the 1813 inventory to Ruisdael, but according to Passavant 'entirely painted by Mr. Woodburn, who made this very copy for his own pleasure, and which after passing through several hands, has at length here attained to the honour of originality'.

Bourgeois bequest, 1811.

M. Passavant, *Tour of a German Artist in England*, 1836, I, p.62; S. Slive, 'Additions to Jacob van Ruisdael', *The Burlington Magazine*, CXXXIII, 1991, p.606n.

PHILIPS WOUWERMANS

Haarlem 1619–1668 Haarlem

Wouwermans was the son of a painter. He probably first trained with his father and is said to have also studied with Frans Hals. In 1638/9 he was in Hamburg, where he married. In 1640 he became a member of the painters' guild in Haarlem, and he worked there for the rest of his life. Influenced initially by Pieter van Laer ('Bamboccio'), Wouwermans evolved a personal style, specialising in landscapes with battles, military encampments and hunting scenes. He also painted a few biblical and mythological subjects.

67 The Coast near Scheveningen

> Signed, bottom right: *PHLS W*
> (PHLS in monogram)
> Canvas, 51.6 x 79 cm, including additions of approximately 2 cm top and bottom

F. Duparc has suggested a date in the first half of the 1650s (letter on file, 1997).

Bourgeois bequest, 1811.
HdG978.

77 Halt of Cavaliers at an Inn

Signed, bottom right: *PH W* (PH in monogram)

Oak panel, 43.8 x 61 cm

The monogram is of a form which seems to have been used only before 1646.
F. Duparc suggests a date of *c.*1642/3, noting the strong influence of Van Laer
(letter on file, 1997). Not, as stated by Hofstede de Groot, a pendant to DPG79.

Bourgeois bequest, 1811.

HdG425.

78

78 Halt of a Hunting Party
Signed, bottom right: *PHILS . W* (PHILS in monogram)
Canvas, 55.6 x 82.9 cm

F. Duparc suggests a date in the early 1660s (letter on file, 1997).

Bourgeois bequest, 1811.

HdG659; C. Brown in *Collection for a King*, no.37 and *Kolekcja dla Króla*, no.29.

79 Two Horsemen near a Fountain
Signed, bottom right: *PHILS . W* (PHILS in monogram)
Oak panel, 44.1 x 61.3 cm

F. Duparc suggests a date of 1650/2 (letter on file, 1997).
Not, as stated by Hofstede de Groot, a pendant to DPG77.

Bourgeois bequest, 1811.

HdG293.

79

91 **The Return from Hawking**
 Signed, bottom left: *PHILSW*
 (PHILS in monogram)
 Oak panel, 47.3 x 64.8 cm

F. Duparc suggests a date in the first half of the 1660s (letter on file, 1997).

Bourgeois bequest, 1811.

HdG705.

91

92 **Courtyard with a Farrier shoeing a Horse**
 Signed, bottom right: *PHILS W*
 (PHILS in monogram)
 Canvas, 46.3 x 55.6 cm

F. Duparc suggests a date of 1656 or slightly later (letter on file, 1997).

Bourgeois bequest, 1811.

HdG131.

92

97 Halt of Travellers

Signed, bottom left: *PHILS W* (PHILS in monogram)
Oak panel, 45.1 x 41.6 cm

An early work comparable with the *Landscape with a Rider resting* in the Museum der Bildenden Künste, Leipzig, of 1646. F. Duparc suggests a date of *c*.1647/9 (letter on file, 1997).

Bourgeois bequest, 1811.
HdG317.

182 Peasants in the Fields: Hay Harvest

Signed, bottom left: *PHILS W* (PHILS in monogram)
Oak panel, 41.3 x 35.9 cm

F. Duparc suggests a date in the second half of the 1650s (letter on file, 1997).

Bourgeois bequest, 1811.
HdG941.

97

ATTRIBUTED TO WOUWERMANS

193 Halt of Sportsmen

Oak panel, 30.8 x 36.5 cm

Hofstede de Groot recorded a 'doubtful' monogram, but this is no longer to be found. F. Duparc suggests that DPG193 might be the work of Pieter Wouwermans (letter on file, 1997).

Bourgeois bequest, 1811.
HdG660 (and possibly 677d).

193

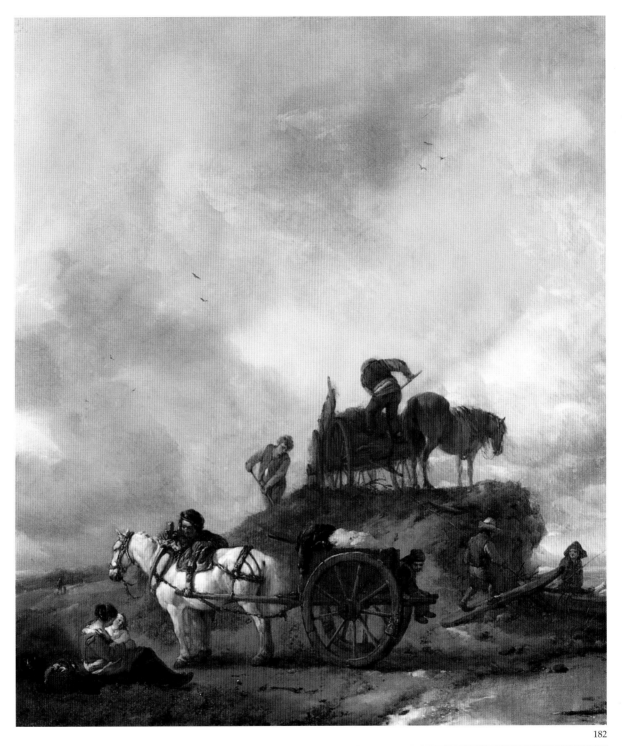

182

AFTER WOUWERMANS

18 Hay Harvest
 Canvas on panel, 46 x 60.4 cm

A copy of Wouwermans's original in the Royal Collection
(HdG940).

Bourgeois bequest, 1811.

HdG under no. 940.

18

34

36

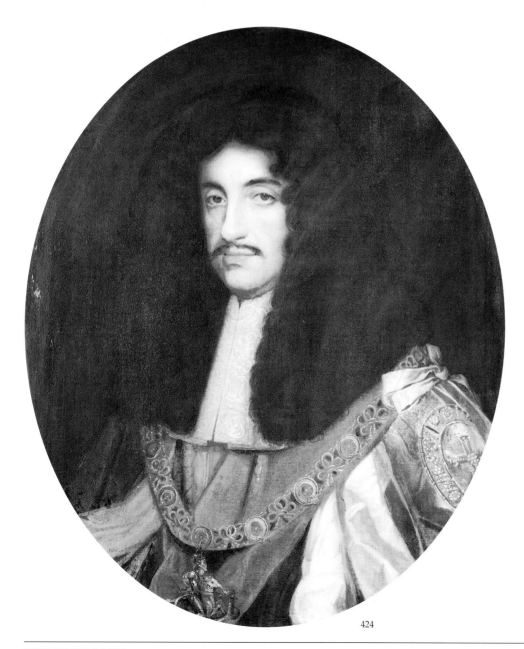

424

FOLLOWER OF WOUWERMANS

34 Sandhills with Figures
Canvas, 24.1 x 36 cm

Pendant to DPG36.

Bourgeois bequest, 1811.

36 Sandbank with Travellers
Signed, lower right: *PH* [?] (in monogram)
Canvas, 24.1 x 36 cm

Pendant to DPG34. Richter recorded the monogram as PW, but this seems to be an error.

Bourgeois bequest, 1811.

JOHN MICHAEL WRIGHT

London 1617–1694 London

AFTER WRIGHT

424 Charles II
Canvas, 76.2 x 63.5 cm

Charles Stuart (1630–85); Charles II, King of England, 1660. DPG424 is an early copy or studio replica of Wright's lost three-quarter-length portrait, known in replicas such as that in the National Portrait Gallery.

Cartwright bequest, 1686.

R.T. Jeffree in *Mr Cartwright's Pictures*, no. 7.

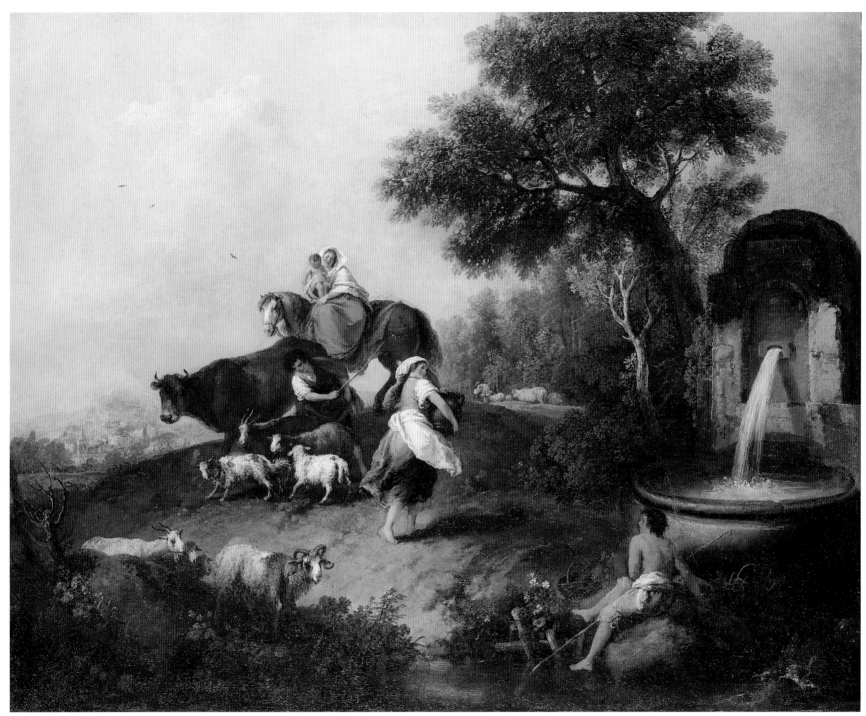

FRANCESCO ZUCCARELLI

Pitigliano (near Florence) 1702–1788 Florence

Zuccarelli trained in Florence, and then in Rome with Paolo Anesi and Giovanni Maria Morandi. He was back in Florence by 1729 but moved, *c.*1730, to Venice, where he became friendly with Richard Wilson (q.v.) and received commissions from the British Consul, Joseph Smith. In 1752 Zuccarelli came to England, where his decorative landscape style was well received and where he remained, apart from a return trip in Venice in 1762–5, until 1771. He was a founder member of the Royal Academy in 1768 and exhibited at the Free Society 1765–6, at the Society of Artists 1767–8, and at the RA 1769–71. He returned to Venice *c.*1771 and was elected President of the Venetian Academy in 1772.

175 Landscape with a Fountain, Figures and Animals
Canvas, 99.7 x 124.8 cm

A copy is in the Pinacoteca, Cremona.

Bourgeois bequest, 1811.

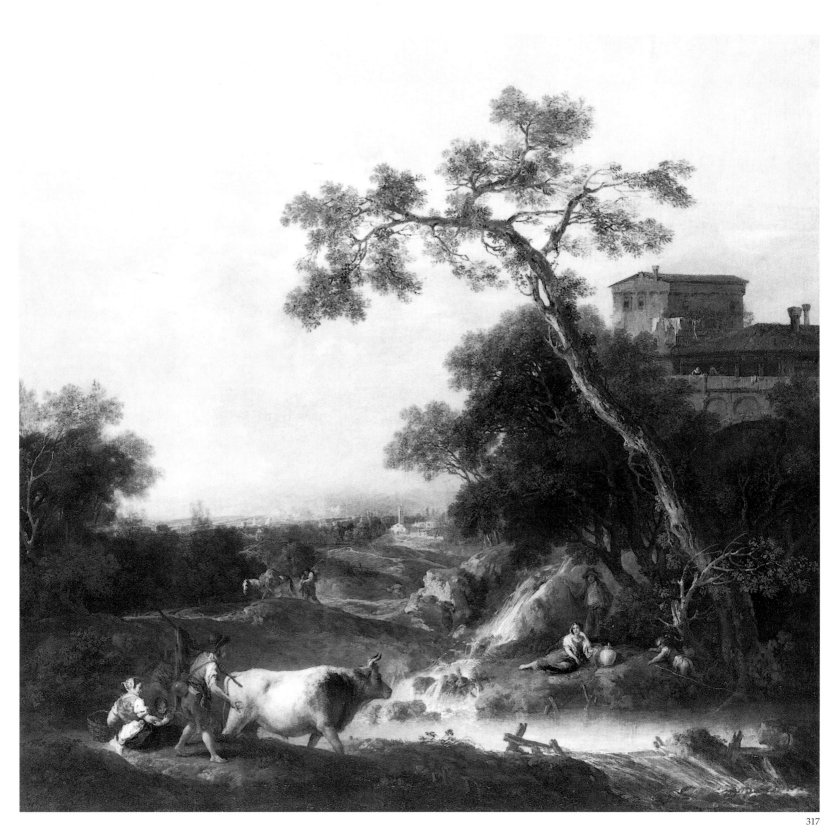

317

317 Landscape with a Waterfall
 Canvas, 90.1 x 95.5 cm

The attribution was doubted by Richter in 1880, but has been confirmed
by recent restoration.

Bourgeois bequest, 1811.

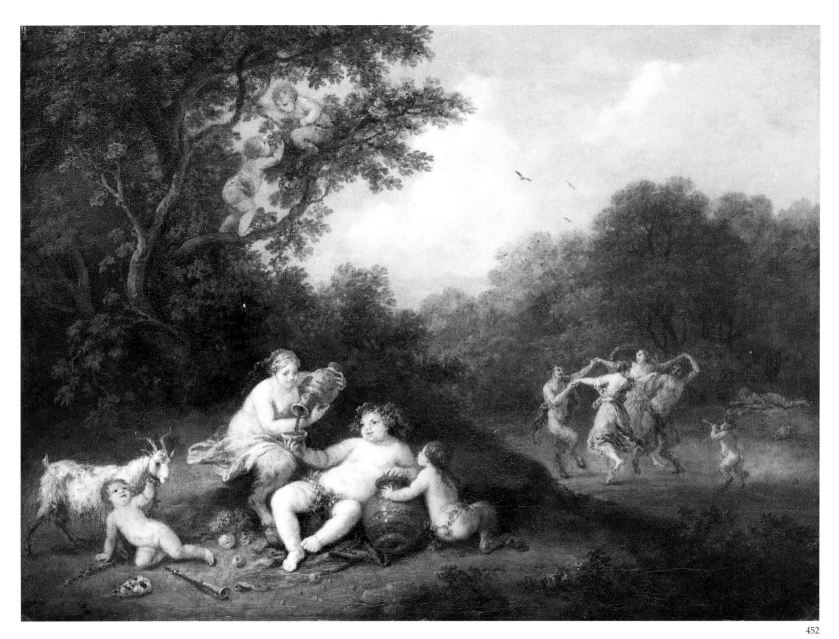

452

ATTRIBUTED TO ZUCCARELLI

452 Bacchanal
 Canvas, 34.3 x 46 cm

Bourgeois bequest, 1811.

FOLLOWER OF ZUCCARELLI

119 Landscape
 Canvas, 36.3 x 46.2 cm

Described by Desenfans in 1802 as a work by Zuccarelli painted for Richard
Dalton, Keeper of Pictures to George III. Richter catalogued the picture as by
an unknown British artist.

Bourgeois bequest, 1811.

119

151

200

354

BRITISH SCHOOL

151 Portrait of a Man
Oak panel, 54.5 x 40.6 cm

There are triangular additions in the top corners.

Bourgeois bequest, 1811.

200 Portrait of a Woman
Canvas, 89.8 x 68.3 cm

Attributed in early catalogues to Van Dyck; catalogued in 1980 as After Cornelius Jonson the elder.

Bourgeois bequest, 1811.

354 The Judd Marriage
Inscribed, top: *ÆTATIS SVE 47* and *THVS:CONSVMYTHE:OVR: TYME*; on the wool sacks beside the candle: *GOOD LEMSTER . p . DAELL*; upper centre: *WE.BEHOWLDE.OWER.ENDE*; lower centre: *ANº 1560* and *THE.WORDE.OF.GOD/ HATHE.KNIT. VS.TWAYNE/ AND.DEATH.SHALL.VS./ DIVIDE.AGAYNE*; and, at the bottom: *LYVE:TO:DYE:AND: DYE TO LYVE ETERNALLY*. The frame is inscribed: *WHEN WE ARE DEADE AND IN OWR GRAVES, AND ALL OWRE BONES ARE ROTTUN, BY THIS SHALL WE REMEMBERD BE, WHEN WE SHULDE BE FORGOTTYN.*
Oak panel, 80 x 102.2 cm

Identifiable from a label on the verso as no.190 in the Cartwright inventory (which occurs on a missing page). From the inscriptions on the recto it is clear that the portrait commemorates a marriage. From his coat-of-arms it seems likely that the man is William Judd, second son of Thomas Judd of Wykforde, Essex. There seems to be no record of his marriage, but his bride may tentatively be identified by her coat-of-arms as either Joan or Anne Cromwell, daughters of Walter Cromwell, whose brother Sir Richard was related by marriage to the Judd family. (The above from notes on file kindly provided by L. Campbell.)

Cartwright bequest, 1686.

N. Kalinsky in *Mr Cartwright's Pictures*, no. 33.

364 Thomas Lovelace

Inscribed, top left: *ÆTATIS. SVÆ. 26./ Thomas louelace Anno Domini/ .1588.*; and bottom left: *M. Tho.ˢ Lovelace*
Oak panel, 76.8 x 59.5 cm

Thomas Lovelace (1563–91): second surviving son of Serjeant Lovelace (see British School DPG372).

Cartwright bequest, 1686.

R.T. Jeffree in *Mr Cartwright's Pictures*, no.12.

365 Sir William Lovelace

Inscribed, bottom left: *Old M.ʳ Lovelace*
Oak panel, 64.7 x 54.6 cm

William Lovelace of Woolwich (1584–1627): son of Sir William Lovelace of Bethersden (see British School DPG367) and father of Richard Lovelace (see Dobson DPG363); knighted by James I in 1609; a member of the Virginia Company and incorporator of the second Virginia charter; he spent most of his career as a soldier in the Netherlands. DPG365 appears to be copy, perhaps of an original painted in the United Provinces.

Cartwright bequest, 1686.

R.T. Jeffree in *Mr Cartwright's Pictures*, no. 13.

367 Sir William Lovelace

Inscribed, top right: *Ano Dom: 1600* and, bottom right, *Sir W Lovelace*
Oak panel, 106.7 x 80.6 cm

Sir William Lovelace of Bethersden (1561–1629): son of Serjeant Lovelace (see British School DPG372); soldier; knighted 1599; member of the Virginia Company; later a Kent magistrate and MP for Canterbury; he was a friend of Sir Dudley Carleton.

Cartwright bequest, 1686.

R.T. Jeffree in *Mr Cartwright's Pictures*, no.11.

368 Théodore de Bèze

Canvas, 33.3 x 25.8 cm

Théodore de Bèze (1519–1605): French Reformed scholar and theologian. DPG368 belongs with a group of portraits of protestant reformers, probably from the collection of Edward Alleyn (cf. British DPG369, DPG370, DPG419, DPG421, and see S. Foister in *Edward Alleyn*, pp.54–6).

Probably Alleyn bequest, 1626.

364

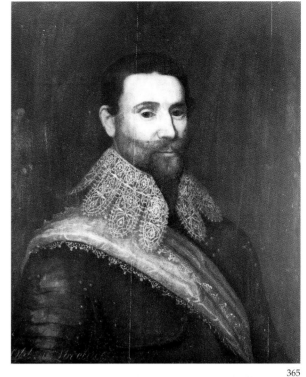

365

367

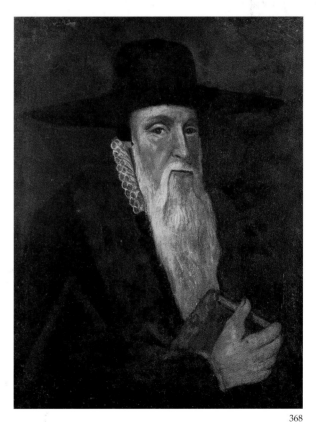

368

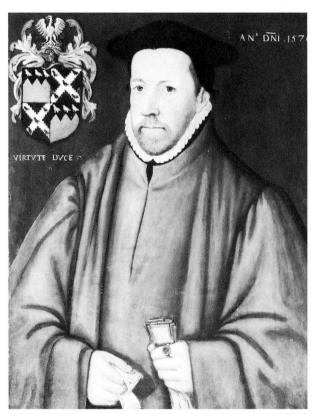

369

370

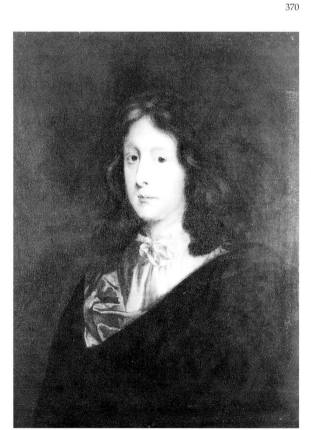

372

373

369 William Perkins

Inscribed, top left: *Perkins/ 1602*
Canvas, 30.8 x 25.4 cm

William Perkins (1558–1602):
Calvinist theologian. DPG369 may
derive from an engraved portrait in
H. Holland's *Herωlogia Anglica* of
1620. See also British School DPG368.

Probably Alleyn bequest, 1626.

370 Calvin

Canvas, 34 x 27 cm

John Calvin (1509–64): French
reformer in Geneva. See also British
School DPG368.

Probably Alleyn bequest, 1626.

372 William Lovelace

Inscribed, upper left:
VIRTVTE DVCE;
and top right: *AN⁰ DNI. 1576*
Oak panel, 66 x 52.4 cm

William Lovelace (*c*.1525/ 30–77): son
of Sir William Lovelace of Bethersen
(see British School DPG367); lawyer;
MP for Canterbury 1558, 1562, 1572;
commissioner for the Establishment
of Religion, 1559; Serjeant-at-Law
1567.

Cartwright bequest, 1686.

R.T. Jeffree in *Mr Cartwright's Pictures*,
no.10.

373 Lord Lovelace

Canvas, 75 x 63.2 cm

John Lovelace (*c*.1642–93): MP for
Berkshire, 1661–70; succeeded as
3rd Baron Lovelace of Hurley, 1670;
an ardent Whig; arrested following
the discovery of the Rye House Plot,
1683; played a prominent part in
the Revolution of 1688. DPG373
probably dates from the early 1660s
and shows the influence of Soest
(q.v.).

Cartwright bequest, 1686.

R.T. Jeffree in *Mr Cartwright's Pictures*,
no.16.

375 Portrait of a Man, called Sir Martin Frobisher
Canvas, 81.9 x 59.4 cm

Described in the Cartwright inventory as 'Sr Martin furbushers pictur…', but the sitter does not resemble the known likenesses of Sir Martin Frobisher (1538?–94). The costume is of *c*.1590. Strong suggests that DPG375 may be a copy after Hieronimo Custodis (letter on file, 1987).

Cartwright bequest, 1686.

R.T. Jeffree in *Mr Cartwright's Pictures,* no.3.

377 Mrs Dirge
Inscribed, bottom left: *A⁰ 1629*
Canvas, 74.9 x 67.3 cm

The sitter is identified in the Cartwright inventory as 'mr dirges wife in a hat & ruff'; her identity remains obscure.

Cartwright bequest, 1686.

R.T. Jeffree in *Mr Cartwright's Pictures,* no. 36.

378 Althea
Inscribed, lower left: *Althea*
Canvas, 76.2 x 63.8 cm

Described in Cartwright's inventory as 'Altheas pictur her hare descheuell…'. Althea Cartwright (d.1666) was the subject of Richard Lovelace's most famous lyric, *To Althea, from Prison,* written during his confinement in the Gatehouse in 1642 (for Lovelace, see Dobson DPG363). The sitter was presumably a relation of William II Cartwright (see Greenhill DPG393).

Cartwright bequest, 1686.

R.T. Jeffree in *Mr Cartwright's Pictures,* no.15.

385 Nathan Field
Oak panel, 56.5 x 42.2 cm

Nathan Field (1587–1619/20): one of the most celebrated actors of his generation; appeared as a member of the Queen's Revels and became the principal actor of Lady Elizabeth's Men; transferred to the King's Men, 1616, in which he was a leading player of young lovers; he was also a playwright. The sitter is identified in Cartwright's inventory. If this is correct, his age would suggest a date of *c*.1610. The hairstyle and dress, however, appear some fifteen years earlier and it seems possible that he is represented in costume.

Cartwright bequest, 1686.

G. Ashton in *Mr Cartwright's Pictures,* no.27.

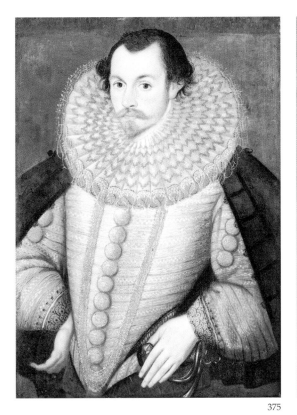

375

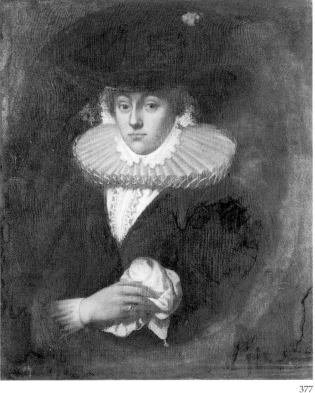

377

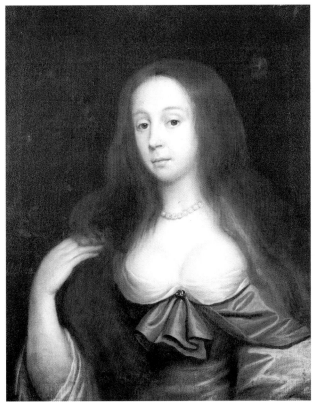

378

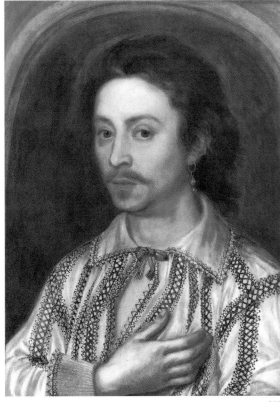

385

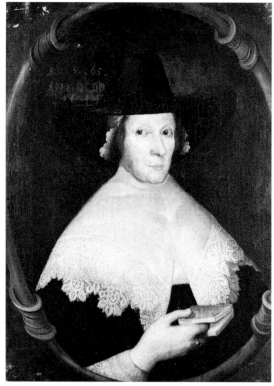

388

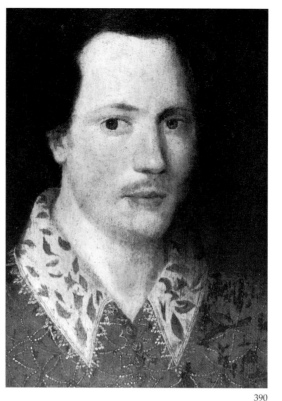

390

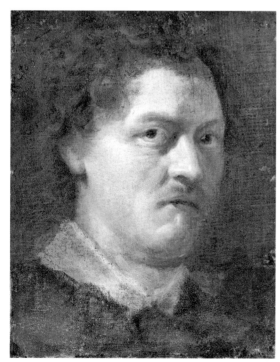

391

392

388 Mrs Cartwright's Sister

Inscribed, upper left:
ÆT . S . 65/ ANNO DO/ 1644
Canvas, 80.3 x 60 cm

Described in Cartwright's inventory as 'my Last wifes sister a book in hand & in a hatt…'. No details are known of the family of Cartwright's last wife.

Cartwright bequest, 1686.

R.T. Jeffree in *Mr Cartwright's Pictures*, no.24.

390 Portrait of a Man, called Thomas Bond

Oak panel, 39 x 31 cm

Thomas Bond (d.1635): a minor actor in the Red Bull Revels and Prince Charles's companies. The sitter is identified in Cartwright's inventory and by an inscription on the verso. However, the costume suggests a date in the mid-1590s and this is inconsistent with the few known details of Bond's career, which suggest he was born *c*.1605. Ashton suggests that DPG390 may be copied from a miniature in the manner of Isaac Oliver.

Cartwright bequest, 1686.

G. Ashton in *Mr Cartwright's Pictures*, no. 29.

391 Portrait of a Man, called William Sly

Canvas on panel, 39.4 x 31.4 cm

Traditionally identified with no.109 in the Cartwright inventory ('mr Slys pictur ye Actour'). However, a label and inscription on the verso identify DPG391 as almost certainly no.196 in the Cartwright inventory (which occurs on a missing page). Another old inscription on the verso seems to read 'by Dobson'. The style and costume suggest a date of *c*.1640.

Cartwright bequest, 1686.

G. Ashton in *Mr Cartwright's Pictures*, no.26.

392 Elizabeth, Queen of Bohemia

Canvas, 183 x 94.3 cm, including additions of 16.5 at the top and 7.6 at the bottom

Elizabeth, Queen of Bohemia (1596–1662): eldest daughter of James VI and I and Anne of Denmark; married Frederick V, Elector Palatine, 1613; Queen of Bohemia, 1619–20. The portrait compares with, and possibly derives from, an engraving after Miereveld.

Possibly Alleyn bequest, 1626.

S. Foister in *Edward Alleyn*, p.51.

395 Richard Burbage
Canvas, 30.3 x 26.2 cm

Richard Burbage (1573?–1619): became the leading actor in the Lord Chamberlain's Company (subsequently the King's Men); inherited shares in the Blackfriars Theatre and 'the Theatre' in Shoreditch in 1597. He demolished the Shoreditch theatre and used the materials to construct the Globe Theatre, where he played a succession of leading roles in plays by Shakespeare, Jonson, and Beaumont and Fletcher, originating the roles of Richard III, Hamlet, Lear and Othello, among others. There is evidence that he was also a painter and the Cartwright inventory attributes to him a 'womans head', though this cannot be identified with any picture surviving in the collection (cf. North Italian DPG380). The image appears cut down, but Ashton suggests that it was painted to be sewn into a larger canvas.

Cartwright bequest, 1686.

G. Ashton in *Mr Cartwright's Pictures*, no. 25.

396 Portrait of a Woman, called the Duchess of Suffolk
Oak panel, 105.4 x 78.1 cm

The sitter is identified in the Cartwright inventory as 'ye Duchiss of Suffouck'. This has been taken to refer to Frances Brandon, Duchess of Suffolk (1517–59), the mother of Lady Jane Grey. However, the costume appears to date from after Frances Brandon's death. Jeffree suggests that she may be Catherine Willoughby de Eresby (1519–80), fourth wife of Charles Brandon, Duke of Suffolk.

Cartwright bequest, 1686.

R.T. Jeffree in *Mr Cartwright's Pictures*, no.2.

400 Portrait of a Man, called 'Old Mr Cartwright'
Inscribed, upper left: *ÆTATIS SV./ 59*
Oak panel, 78.5 x 62.5 cm

Described in the Cartwright inventory as 'oul mr Cartwright Actour'. This is presumably the actor William Cartwright, who was a member of Palsgrave's Men and subsequently of the King and Queen of Bohemia's Men, the Red Bull/King's Company and the King's Revels Company. He was one of the group of actors from Palsgrave's Men who rented the Fortune Theatre from Edward Alleyn (see British School DPG443) and is recorded in Alleyn's diaries on four occasions as a dinner guest. He was possibly the father of William Cartwright the younger (see Greenhill DPG393). The costume suggests a date of 1615 or shortly afterwards.

Cartwright bequest, 1686.

R.T. Jeffree in *Mr Cartwright's Pictures*, no.20.

405 Portrait of a Man
Canvas, 68.6 x 57.1 cm

Dulwich College by 1890.

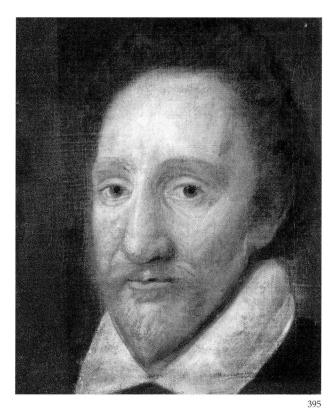

395

396

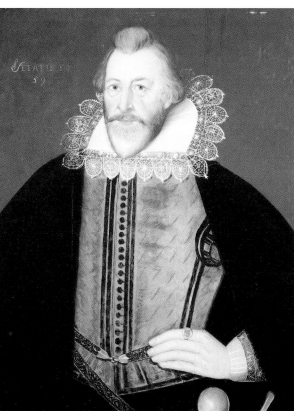

400

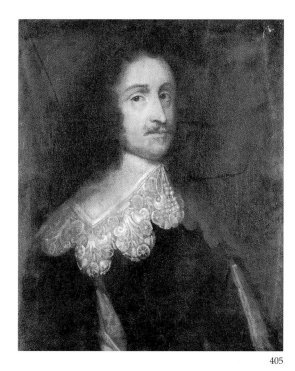

405

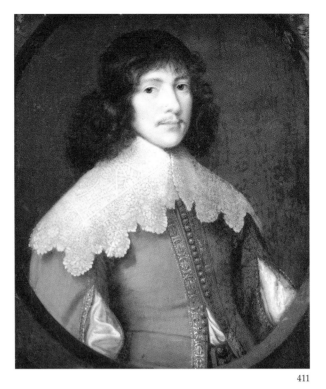

411

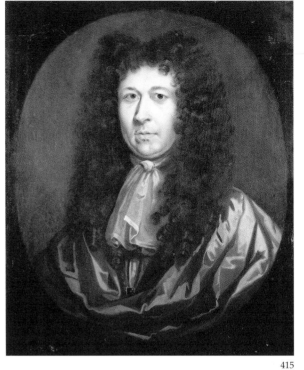

415

419

421

411 Portrait of a Man,
called 'Young Mr Cartwright'
Canvas, 66.7 x 58.1 cm

Described in Cartwright's inventory as 'young mr Cartwright, Actour'. As suggested by Murray, an attribution to Cornelius Jonson the elder seems a possibility. The costume suggests a date of *c.*1630.

Cartwright bequest, 1686.

R.T. Jeffree in *Mr Cartwright's Pictures*, no.21.

415 Portrait of a Man
Canvas, 71.7 x 61 cm

Dulwich College by 1890.

419 Alexander Nowell
Canvas, 33.7 x 26 cm

Alexander Nowell (1507?–1602): eminent puritan; Dean of St Paul's, 1560. DPG419 may derive from an engraved portrait in H. Holland's *Herωlogia Anglica* of 1620. See also British School DPG368.

Probably Alleyn bequest, 1626.

S. Foister in *Edward Alleyn,* p.55.

421 Martin Luther
Canvas, 34 x 26.9 cm

Martin Luther (1483–1546): religious reformer and theologian. See also British School DPG368.

Probably Alleyn bequest, 1626.

S. Foister in *Edward Alleyn,* p.55.

423 Richard Perkins
Canvas, 69.8 x 61.9 cm

Richard Perkins (1585?–1650): actor; a member of Queen Anne's company by 1602; involved with the formation of the Revels company; joined the King's Men in 1623/4 but moved to Queen Henrietta's company, in which he was a colleague of William Cartwright the younger. Probably painted in the late 1640s; the pose seems to derive from Van Dyck's portrait of *Charles I in three Positions* (Royal Collection).

Cartwright bequest, 1686.

G. Ashton in *Mr Cartwright's Pictures*, no.28.

427 Dante
Inscribed, top:
DANTES ALDIGERIV
Canvas, 61.9 x 49.5 cm

Dante Alighieri (1265–1321): poet. The format compares closely with Alleyn's sets of Kings and Queens and Sibyls (British School DPG521–36 and DPG537–45); DPG427 was doubtless acquired by Alleyn, very possibly from 'Mr Gibkyn' (see British School DPG537).

Probably Alleyn bequest, 1626.

430 Michael Drayton
Inscribed, bottom left: *An⁰: 1628*
Canvas, 54.5 x 41.9 cm

Michael Drayton (1563–1631): poet and playwright; reputedly a friend of Shakespeare. His most ambitious work was the *Poly-Olbion*, a topographical poem on England, dedicated to Henry, Prince of Wales (see British School DPG417). The identification of the sitter in Cartwright's inventory is confirmed by comparison with other contemporary likenesses.

Cartwright bequest, 1686.

G. Ashton in *Mr Cartwright's Pictures*, no.4.

438 Thomas Clark
Canvas, 75.3 x 63.8 cm (oval)

Thomas Clark: organist of Dulwich College, 1714–15.

Dulwich College by 1890.

423

427

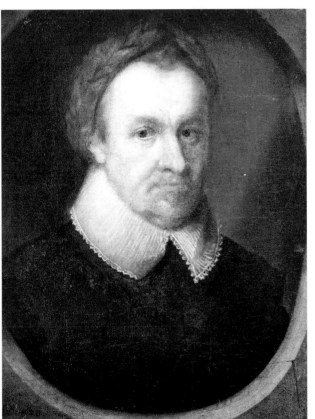

430

438

439

443

444

445

439 Miss Clark
Canvas, 74 x 61.6 cm (oval)

Traditionally identified as the sister of the sitter in DPG438 above.

Dulwich College by 1890.

443 Edward Alleyn
Inscribed, upper left: *1626*
Canvas, 203.8 x 114 cm

Edward Alleyn (1566–1626): actor and theatre entrepreneur; acted with the Earl of Worcester's Men in 1583; in 1592 married Joan Woodward, step-daughter of Philip Henslowe, and went into partnership with his father-in-law; attached to the Lord Admiral's Men, toured with Lord Strange's Men in 1593 and acted in London 1594–7; investor in the Bear Garden 1594; in 1600, with Henslowe, built the Fortune Theatre, where he headed the Lord Admiral's Men; again with Henslowe, acquired the office of Master of the Bears in 1604; purchased the manor of Dulwich in 1605 and built the College of God's Gift 1613–17, obtaining a patent for its incorporation in 1619; married Constance, daughter of John Donne, in 1623. For his biography, see S.P. Cerasano in *Edward Alleyn*.

Presumably Alleyn bequest, 1626.

444 Joan Alleyn
Inscribed: upper right: *ÆTS 22/ 1596*
Oak panel, 79.1 x 63.2 cm

The sitter is traditionally identified as Joan Woodward (*c*.1573–1623), step-daughter of Philip Henslowe, who married Edward Alleyn in 1592 (see British School DPG443). The sitter's age and the date are consistent with those given on Joan Woodward's tomb in the old College chapel. If this assumption is correct, then the picture was presumably part of Alleyn's bequest.

Presumably Alleyn bequest, 1626.
S. Foister in *Edward Alleyn*, p.58.

445 Francis Bacon
Canvas, 61 x 47 cm

Francis Bacon (1561–1626): lawyer and politician; eminent essayist and philosopher; Lord Chancellor and 1st Baron Verulam, 1618; Viscount St Alban, 1621 (see also Morris DPG549). DPG445 ultimately derives from a full-length original known in a copy at Gorhambury (Earl of Verulam). According to a tradition recorded on a label on the verso, DPG445 was given by Bacon himself to the Andrew family of Wandsworth and passed by descent to the donor.

Gift of Miss Love, 1873.

448 John Reading
 Canvas, 76.1 x 63.5 cm

John Reading (1677 or c.1685/6?–1764):
acting organist of Dulwich College,
1700–2; master of the choristers at
Lincoln Cathedral, 1703; organist in
London from 1708; published two
books of songs and anthems; the air
'Adeste Fideles' (familiar as 'O come
all ye faithful') has been attributed to
him. The identification of the sitter is
traditional.

Dulwich College by 1890.

486 Landscape with Horses
 Canvas, 37.2 x 49.2 cm

Catalogued until 1880 as Zuccarelli.

Bourgeois bequest, 1811.

494 The Duke of Marlborough
 Canvas, 75.5 x 63.1 cm

John Churchill (1650–1722), first Duke
of Marlborough.

Dulwich College by 1890.

448

486

494

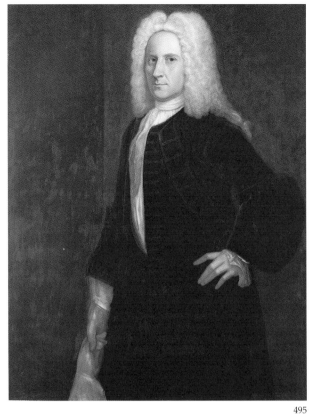

495

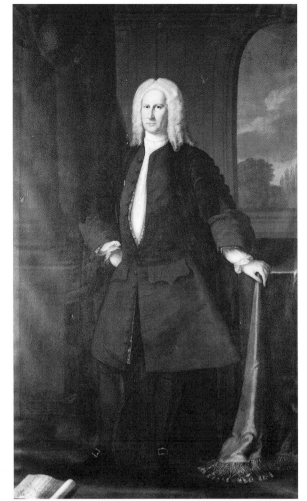

496

498

504

495 James Allen
Canvas, 102.2 x 125.7 cm

For the sitter, see Ellys DPG441, and cf. British School DPG496.

Dulwich College by 1890.

496 James Allen

Inscribed, lower left: *JA* (in monogram) *Born y.e 4th./ of May: 1683/ 1737/ Æ 54*; and on roll: *Sussex &/ Worcester} s. The Roll/ of James Allen/ of the Vacation after/ Trinity Term and of/ Michaelmas Term following. Anno/ 1737.*
Canvas, 236.1 x 147.2 cm

For the sitter, see Ellys DPG441. An inscription on the back of the canvas is no longer visible, but it is recorded in the 1926 Dulwich catalogue as reading: *J. Allen, Æ 54, 1757, G.G.C.* The date should clearly be read as 1737. The initials 'G.G.C.' might be those of the artist. An attribution to Charles Stoppelaer was proposed in 1980, but seems improbable as the artist arrived in London from Dublin only in 1738.

Dulwich College by 1890.

498 Portrait of a Woman
Canvas, 127.3 x 102.9 cm

The costume suggests a date of *c*.1700 and precludes the traditional identification of the sitter as Sarah Inwen, Lady Falkland (1714–76).

Dulwich College by 1890.

504 Head of a Man
Canvas, 75.9 x 62.9 cm

Dulwich College by 1890.

521 William the Conqueror

Inscribed, centre left:
WILLIAM / CONQVEROR.
Oak panel, 57.2 x 42.5 cm

With DPG522–536 below (and possibly
After De Critz DPG384), one of sixteen or
seventeen portraits surviving from a set
of twenty-six assembled by Edward Alleyn
in four batches from 1618 to 1620. These
may well have been acquired, like Alleyn's
similar set of Sibyls (British School
DPG537–45), from 'Mr Gibkyn'. The images
of the earlier Kings (from William Rufus
to Henry IV) seem to be taken from the
engravings of R. Elstrack in H. Holland's
Baziliωlogia, a Booke of Kings, 1618.

Alleyn bequest, 1626.

522 William Rufus

Inscribed, centre left:
WILLIAM / RVFVS.
Oak panel, 57.2 x 42.4 cm

Alleyn bequest, 1626.

523 Henry I

Inscribed, centre left: *HENRY. I.*
Oak panel, 56.8 x 42.5 cm

Alleyn bequest, 1626.

524 Henry II

Inscribed, centre left: *HENRY. II.*
Oak panel, 57.5 x 41.9 cm

Alleyn bequest, 1626.

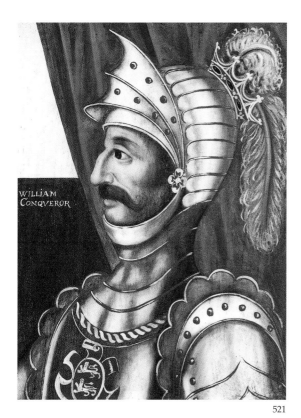

521

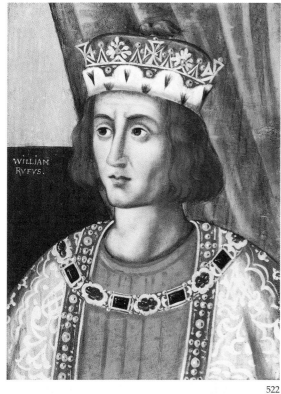

522

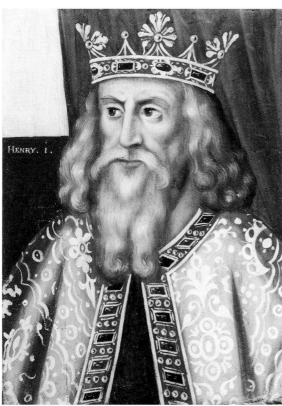

523

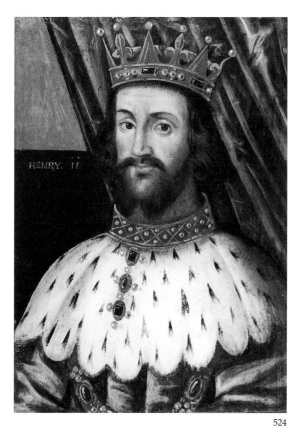

524

525

526

527

528

525 Richard I
Inscribed, centre right:
RICHARD. I.
Oak panel, 57.5 x 41.9 cm

Alleyn bequest, 1626.

526 King John
Inscribed, centre left:
K. IOHN.
Oak panel, 57.5 x 41.9 cm

Alleyn bequest, 1626.

527 Edward I
Inscribed, centre right:
EDWARD. I
Oak panel, 57.5 x 41.9 cm

Alleyn bequest, 1626.

528 Henry IV
Inscribed, centre right:
HENRIE. 4
Oak panel, 58.1 x 45.4 cm

Alleyn bequest, 1626.

529 Henry VI
Inscribed, centre left:
HENRIE. 6.
Oak panel, 57.2 x 43.8 cm

Alleyn bequest, 1626.

530 Henry V
Oak panel, 58.1 x 45.6 cm

Alleyn bequest, 1626.

531 Richard III
Inscribed, centre right:
RICHARD. 3
Oak panel, 57.8 x 44.8 cm

Alleyn bequest, 1626.

532 Henry VII
Inscribed, centre right:
HENRIE. 7
Oak panel, 55.2 x 41.3 cm

Alleyn bequest, 1626.

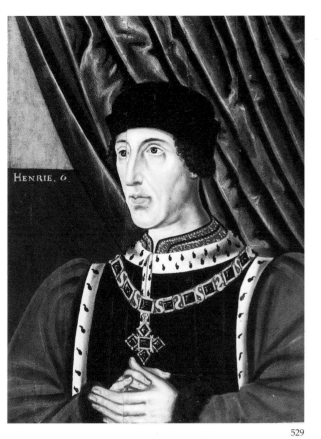

529

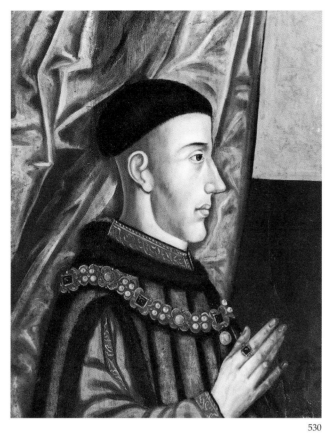

530

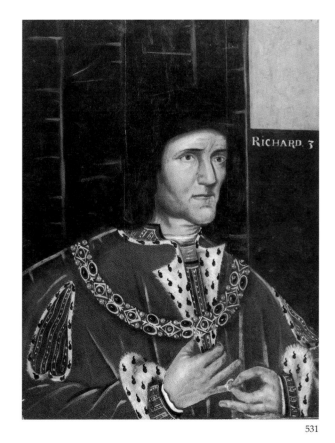

531

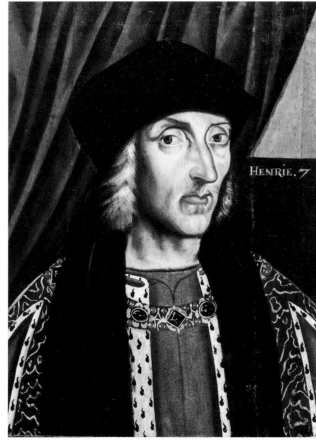

532

533

534

535

536

533 Henry VIII
Oak panel, 58.4 x 45.7 cm

Alleyn bequest, 1626.

534 Queen Anne Boleyn
Inscribed, centre left:
ANN. BOLEYN.
Oak panel, 56.8 x 42.2 cm

Alleyn bequest, 1626.

535 Edward VI
Oak panel, 57.2 x 45.1 cm

Alleyn bequest, 1626.

536 Queen Mary
Oak panel, 58.1 x 41.9 cm

Alleyn bequest, 1626.

537 Egyptian Sibyl

Inscribed, top:
SIBILLA ÆGIPTIA
Canvas, 61 x 44.4 cm

With DPG538–45 below, one of
nine surviving pictures from a
set of twelve Sibyls owned by
Edward Alleyn and acquired by
him from 'Mr Gibkyn' in 1620
in exchange for 'my 12 owld
Sybyles' and £2 (according to an
entry in his diary of 3 November).
The fact that some of the pictures
are on canvas and others on
panel, and the apparent
duplication of the Cumaen Sibyl,
suggest that the set was not
painted as such, but assembled
from Gibkyn's stock.

Alleyn bequest, 1626.

S. Foister in *Edward Alleyn*, pp.38–9,
52–4.

538 Samian Sibyl

Inscribed, top:
SIBILLA SAMIA[…]
Canvas, 58.7 x 44.1 cm

Alleyn bequest, 1626.

539 Cumaean Sibyl

Inscribed, top:
SIBILLA CVMANA
Oak panel, 57.2 x 40.9 cm

Alleyn bequest, 1626.

540 Cumaean Sibyl

Inscribed, top:
SIBILLA CVMEA
Canvas, 63.5 x 45.1 cm

Alleyn bequest, 1626.

537

538

539

540

541

542

543

544

541 Delphic Sibyl
Inscribed, top:
SIBILLA DELPHICA
Oak panel, 57.2 x 41 cm

Alleyn bequest, 1626.

542 European Sibyl
Inscribed, top:
SIBILLA EVROPEA
Oak panel, 57.2 x 41 cm

Alleyn bequest, 1626.

543 Hellespontic Sibyl
Inscribed, top:
SIBILLA HELESPONTICA
Oak panel, 57.2 x 42.4 cm

Alleyn bequest, 1626.

544 Persian Sibyl
Inscribed, top:
SIBILLA PERSICA
Oak panel, 57.2 x 42.3 cm

Alleyn bequest, 1626.

545 Tiburtine Sibyl

Inscribed, top: *SIBILLA TIBVRTINA*
Canvas, 57.2 x 42.5 cm

Alleyn bequest, 1626.

546 Piety

Inscribed, top: *PIETAS*
Oak panel, 152.3 x 61 cm

With DPG547 below, set into a Jacobean-style chimney piece in the master's library at Dulwich College. DPG546 and DPG547 are presumably survivals from the decoration of the old college. There is no evidence as to their origin, but it has been suggested that they may have been taken from 'ye queens owld barge', which Alleyn acquired in 1618.

Presumably Alleyn's College of God's gift.
S. Foister in *Edward Alleyn*, pp.37–8.

547 Liberality

Inscribed, top: *LIBERALITAS*
Oak panel, 152.3 x 61 cm

Presumably Alleyn's College of God's gift.

545

546, 547 (in situ)

569

569 Portrait of a Man

Canvas, 62.8 x 49.5 cm

Possibly a fragment of a larger portrait. The sitter was
formerly identified as the playwright Nathaniel Lee
(1649?–92); however, this would imply a date for DPG569
of c.1675, whereas the picture probably dates from the 1640s.
The fact that he rests his hand on a portrait bust suggests that
he could be an artist. M. Rogers (letters on file, 1997) draws
attention to portraits of possibly the same man in the Garrick
Club and the Clarke Library, University of Los Angeles.
Of these, the latter is recorded in a drawing by Vertue in
the British Museum, with an inscription in Vertue's hand
identifying the original as a self-portrait by Isaac Fuller (q.v.).

Fairfax Murray gift, 1911.

589

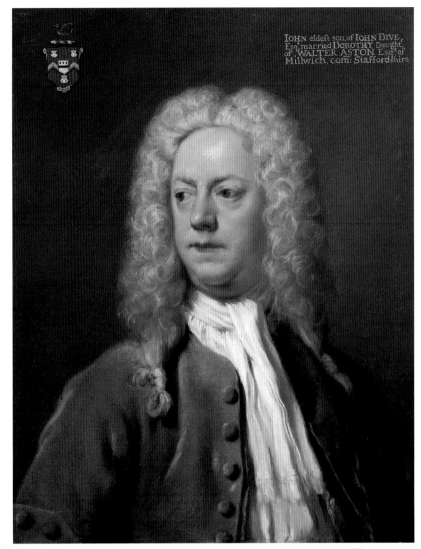

604

589 Portrait of a Man

Canvas, 76.2 x 63.5 cm

Entered the collection as Hoppner. Murray suggested that the style was closer to Raeburn. DPG589 is not attributable to either.

Fairfax Murray gift, 1911.

604 John Dive

Inscribed, top right: *JOHN eldest son of IOHN DIVE/ Esq:*[e], *married DOROTHY daught.*[r]/ *of WALTER ASTON, Esq:*[e]*, of/ Millwich, com: Staffordshire*

Canvas, 64.1 x 51.1 cm

John Dive (born *c.*1674): married Dorothy Aston, 1704. The coat-of-arms is Dive of Millwich charged with Aston. DPG604 seems to date from the late 1730s and the sitter is probably therefore in his early sixties. Although this is a portrait of some quality, its attribution remains problematic. Attributions have been suggested tentatively to Hans Hysing by B. Allen, and to Jonathan Richardson ('at his most sensitive') by E. Einberg (oral communications, 1997).

Fairfax Murray gift, 1917.

613

624

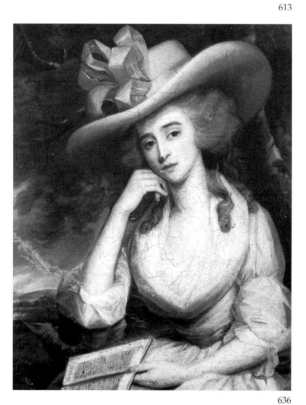

636

640

642

613 Portrait of a Woman
 Canvas, 127.6 x 101.6 cm

Previously catalogued as Highmore. Probably painted *c*.1700.

Bequest of Miss H. Margaret Spanton, 1934.

A.S. Lewis, *Joseph Highmore: 1692–1780*, diss. Harvard University, 1975, II, p.638, no.87 (as probably not Highmore).

624 River scene, Moonlight
 Canvas, 69.2 x 92.3 cm

Previously catalogued as After Van der Neer. The picture cannot be judged in its present condition, but seems more

likely to be by a British painter, possibly a member of the Pether family.

Bequest of Miss Gibbs, 1951.

636 Portrait of a Woman
 Inscribed, on the book: ... *JOURNAL*
 Canvas, 76.2 x 62.8 cm

Gift of Mr Smart, 1956.

640 Portrait of a Woman
 Mahogany panel, 22 x 17.8 cm

The verso is incised 'By Lawrence'.

Gift of Mr Smart, 1956.

642 Portrait of a Woman
 Canvas, 117 x 66 cm

Gift of Miss Gliddon, 1960.

37 A Man driving Cows
Inscribed, lower left: *A. Cuyp*
Canvas, 114.3 x 158.1 cm

Until 1880 attributed to Cuyp.

Bourgeois bequest, 1811.

37

153

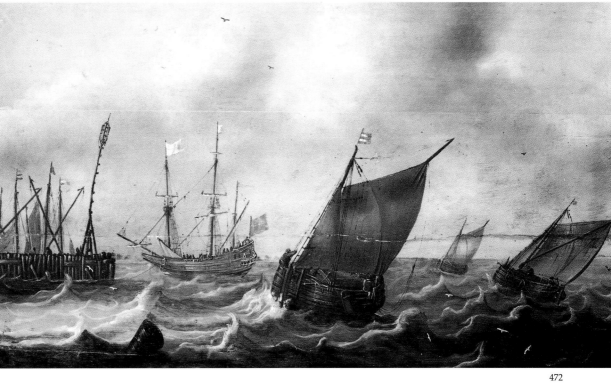

472

153 A Woman buying Game
Canvas, 46.6 x 36.8 cm

Until 1880 attributed to Gonzales Coques.

Bourgeois bequest, 1811.

472 A Light Breeze
Oak panel, 40.7 x 69.3 cm

DPG472 is close to the style of Justus de Verwer (*c*.1626–before 1688), as suggested by F. Meijer (oral communication, 1977), but seems too crude to be attributed even to his studio. The picture is said in earlier catalogues to be part of the Bourgeois bequest; it is, however, not identifiable in the 1813 inventory.

Traditionally Bourgeois bequest, 1811.

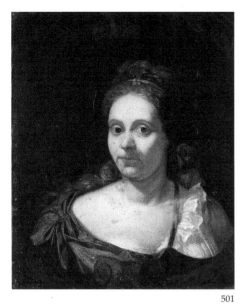

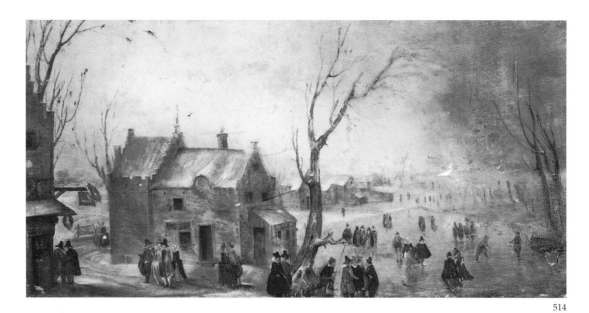

501

514

515

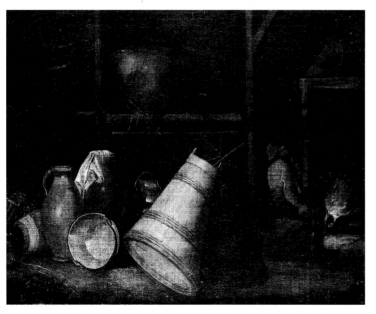

516

501 Head of a Woman
Canvas, 47.9 x 40.6 cm

R. Ekkart suggested a connection with the style of Juriaen Pool (1665/6–1745) and proposed a date in the first half of the 1690s (oral communication, 1997).

Dulwich College by 1890.

514 A Winter Scene on the Ice
Oak panel, 29.8 x 58.3 cm

The costume suggests a date of *c*.1615–17.

Cartwright bequest, 1686.

N. Kalinsky in *Mr Cartwright's Pictures*, no.56.

515 Interior
Canvas, 52 x 65.1 cm

With its pair, DPG516 below, attributable to the Rotterdam school.
J. Nieuwstraten has suggested a follower of Cornelis Saftleven (1607–81).

Cartwright bequest, 1686.

N. Kalinsky in *Mr Cartwright's Pictures*, no.57.

516 Interior
Canvas, 52.4 x 64.8 cm

See DPG515 above.

Cartwright bequest, 1686.

N. Kalinsky in *Mr Cartwright's Pictures*, no.58.

622 Scullery Maid
　　Oak panel, 55.8 x 78.4 cm

Formerly catalogued as Cornelis Mahu (1613–89).

Bequest of Miss Gibbs, 1951.

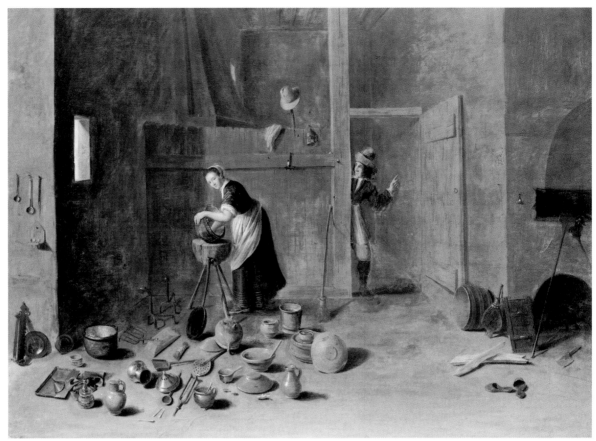

622

14

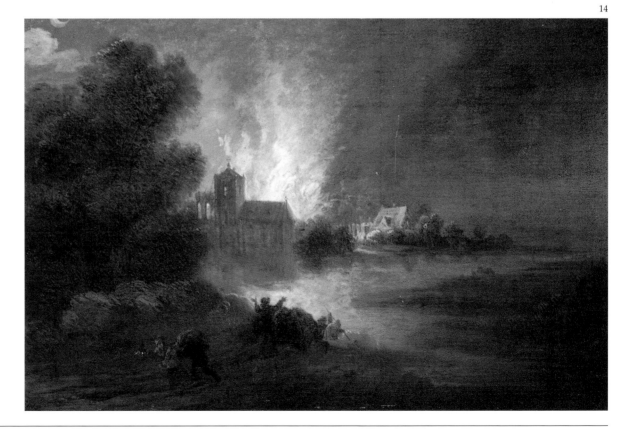

FLEMISH SCHOOL

14 A Village on Fire
　　Oak panel, 23.4 x 34.9 cm

Catalogued as David Teniers the younger until 1880, and then as David Teniers the elder.

Bourgeois bequest, 1811.

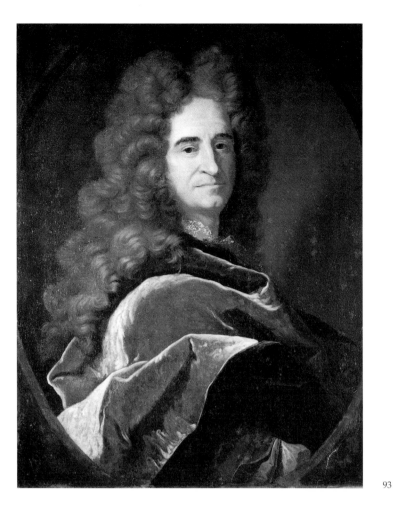

93

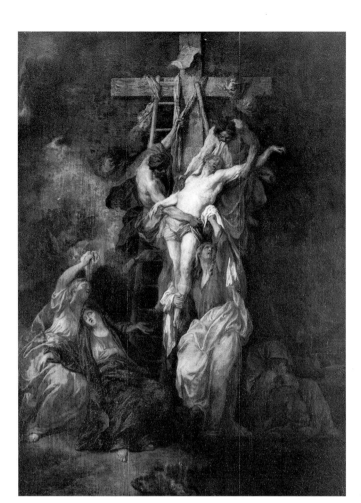

288

345

FRENCH SCHOOL

93 Portrait of a Man, called Racine
 Canvas, 80 x 63.5 cm

Previously catalogued as Studio of Rigaud. This is probably 'Rigaud's portrait of Racine', which James Boaden acquired from an émigré during the French Revolution and subsequently gave to Desenfans (*Memoirs of the Life of John Philip Kemble*, London, 1825, II, p.437).

Bourgeois bequest, 1811.

288 The Deposition
 Oak panel, 58.8 x 43.7 cm

Formerly catalogued as School of Van Dyck.

Bourgeois bequest, 1811.

345 Girl with a Magic Lantern
 Canvas on panel, 24.5 x 20.6 cm, including made-up strips
 of approximately 0.6 cm on each side

Until 1880 attributed to Chardin.

Bourgeois bequest, 1811.

397

404

397 Head of a Man
Oak panel, 42.3 x 33.7 cm

Described in the Cartwright inventory as 'a docturs head with a vuluit cap, a gray beard'. The costume suggests a date in the 1590s.

Cartwright bequest, 1686.

R.T. Jeffree in *Mr Cartwright's Pictures*, no.32 (as Flemish?).

404 Head of a Woman
Oak panel, 57.8 x 45.1 cm

Cartwright bequest, 1686.

R.T. Jeffree in *Mr Cartwright's Pictures*, no.40.

478 Abraham and the Angels
Canvas, 69 x 92.4 cm

Previously catalogued as After Poussin.

Bourgeois bequest, 1811.

478

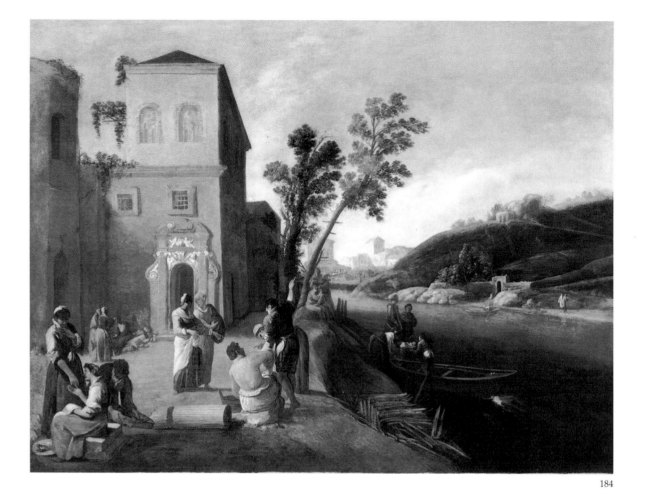

184

ITALIAN SCHOOL

184 Figures on the Bank of a River
Canvas, 110 x 147.6 cm

Attributed to Paul Bril (with figures
by Annibale Carracci) until 1880,
when catalogued by Richter as Italian
School.

Bourgeois bequest, 1811.

2

253

ITALIAN SCHOOL
(Bolognese)

2 Saint Cecilia
Canvas, 234.3 x 141.3 cm,
including additions of
approximately 45 cm at the top,
15 cm at the bottom and
8 cm on each side.

Much damaged. DPG2 was sent to
Desenfans by J.-B.-P. Le Brun as a
work by Annibale Carracci. The
additions were apparently made
by Bourgeois.

Bourgeois bequest, 1811.

253 Saint Francis
Canvas, 54.6 x 41 cm

Attributed to Annibale Carracci until
1880, when catalogued by Richter as
Italian School.

Bourgeois bequest, 1811.

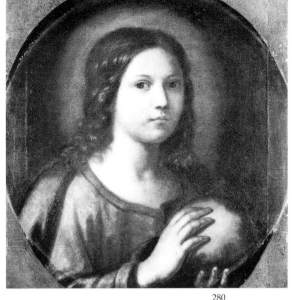

295　　　　　　　　　　　　　280　　　　　　　　　　　　　　　487

295　Artist Drawing
Canvas, 91.1 x 70.7 cm

Attributed to Salvator Rosa until 1880, when Richter gave the picture to the late-16th century Venetian school. The artist responsible for DPG295 seems, however, to have been familiar with the style of the Bolognese painter Giovanni Antonio Burrini (1656–1727).

Bourgeois bequest, 1811.

280　Salvator Mundi
Canvas, 50.8 x 48.6 cm (oval)

Bolognese or possibly Florentine.

Bourgeois bequest, 1811.

487　Woman and Child
Canvas on panel, in two pieces, 64.1 x 33.3 and 64.1 x 31.2 cm

A fragment – possibly, it has been thought, from a *Massacre of the Innocents*. Catalogued as English until 1980 and then as Unknown.

Traditionally Bourgeois bequest, 1811.

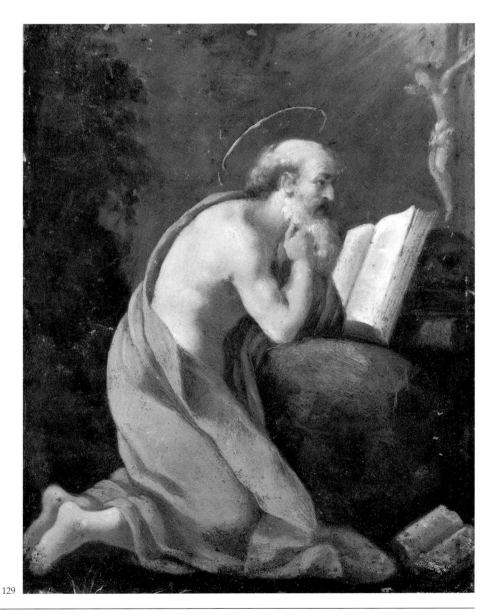

ITALIAN SCHOOL
(Emilian)

129　Saint Jerome in Penitence
Copper, 20.4 x 16.5 cm

Catalogued until 1880 as Guido Reni and thereafter as Italian School.

Bourgeois bequest, 1811(?).　　　　　　129

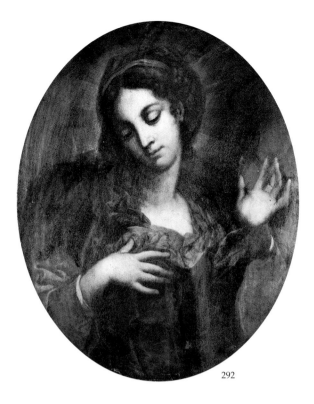

292

254

38

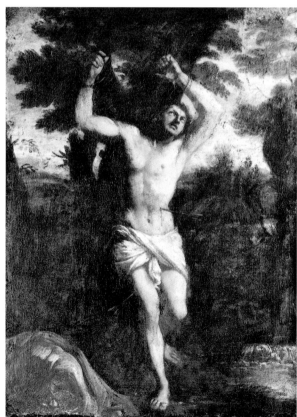

41

ITALIAN SCHOOL
(Florentine)

292 The Virgin Annunciate
Canvas, 74.6 x 61.6 cm (oval)

Formerly catalogued as a female saint (Veronica?) by Dolci. Probably originally one of a pair representing Gabriel and the Virgin Annunciate.

Bourgeois bequest, 1811.

ITALIAN SCHOOL
(North Italian)

254 Portrait of a Young Woman
Canvas, 56.3 x 49.9 cm

Catalogued since 1880 as Italian School. Richter suggested an attribution to the School of Sustermans.

Bourgeois bequest, 1811.

ITALIAN SCHOOL
(Roman)

38 Saint Lawrence
Canvas, 39.2 x 31.1 cm

Attributed to Pietro da Cortona until 1880, when catalogued by Richter as Italian School.

Bourgeois bequest, 1811.

G. Briganti, *Pietro da Cortona o della Pittura Barocca*, Florence, 1962, p.275.

41 Saint Sebastian
Canvas, 65.9 x 48 6 cm

Until 1880 given to Mola and then catalogued as Italian School.

Bourgeois bequest, 1811.

260 Venus gathering Apples
Canvas, 47.5 x 36.8 cm

The subject is perhaps Venus gathering the golden apples which she then used to aid Hippomenes in his race with Atalanta (Ovid, *Metamorphoses*, X). DPG260 was attributed to Domenichino until 1880, when it was catalogued by Richter as Italian School. The picture is recorded in the eighteenth century in the Breteuil collection (information on file from A. Brejon de Lavergnée).

Bourgeois bequest, 1811.

ITALIAN SCHOOL
(Umbrian)

256 Madonna and Child
Poplar panel, 63.5 x 43.5 cm

Bourgeois bequest, 1811.

ITALIAN SCHOOL
(Venetian)

21 Sleeping Cupid
Canvas, 20.8 x 22.1 cm

Attributed to Schedoni until 1880, when catalogued by Richter as Italian School. DPG21 is evidently a fragment – apparently, as noted by A. Laing, of a picture within a picture (the frame and its accompanying curtain visible at the right edge).

Bourgeois bequest, 1811.

84 Music Party
Poplar panel, 65.7 x 59.7 cm

Attributed to Giorgione until 1880, when catalogued by Richter as Venetian School. An attribution to Callisto Piazza was proposed by Berenson.

Bourgeois bequest, 1811.

B. Berenson, *Italian Pictures of the Renaissance, Central and North Italian Schools*, London, 1968, I, p.337.

260

256

21

84

250

NETHERLANDISH 16TH-CENTURY SCHOOL

250 The Crucifixion
Oak panel, 121.3 x 90.8 cm

The composition derives from a type established by Quentin Metsys (see particularly his *Crucifixion* in the National Gallery of Canada, Ottawa), but the picture does not seem to be the work of a close follower and probably dates from the late sixteenth century.

Bequest of Dr G. Webster, 1875.

SPANISH SCHOOL

13 Saint Anthony of Padua
Canvas, 39.7 x 30.5 cm

Saint Anthony of Padua is identifiable from his Franciscan habit and lilies, but the episode depicted remains obscure. DPG13 was attributed in the 1813 inventory to Velázquez, and was catalogued *c.*1866–74 as Dughet and from 1880 as Spanish School.

Bourgeois bequest, 1811.

62 Christ carrying his Cross
Canvas, 227.3 x 131.7 cm, including addition of *c.*37 cm at the top

The figures on the left may be Saint John the Baptist, the Virgin and the Magdalen. This seems to be the group which appears in a comparable composition by Valdés Leal in the Hispanic Society of America, New York. Conceivably they are the Daughters of Jerusalem who followed Christ on his way to Calvary, lamenting (Luke XXIII, 27–8). The subject was often treated in Spain, usually with Christ alone.

Bourgeois bequest, 1811.

13

62

185 Jacob and Rachel at the Well
Canvas, 93 x 149.2 cm

The subject is from Genesis XXIX, 11: bidden to choose a wife from among his cousins, the daughters of Laban, Jacob finds and falls in love with Rachel; his efforts to win her hand are temporarily frustrated (see Claude DPG205). E. Young associated DPG185 with the style of Pedro Orrente without suggesting a definite attribution (letter on file, 1977). E. Harris has suggested Francisco Collantes (letter on file, 1981).

Bourgeois bequest, 1811.

D. Angulo Iñiguez, *Murillo: Su vida, su arte, su ombra*, Madrid, 1981, no.612 (as Spanish School).

UNKNOWN

24 Christ as a Boy
Copper, 14.9 x 11.1 cm

Formerly catalogued as German. Possibly Spanish(?).

Bourgeois bequest, 1811.

329 Hawk and Sparrows
Canvas, 73.9 x 52.7 cm

Until 1880 attributed to Jan Weenix. Possibly British.

Bourgeois bequest, 1811.

185

24

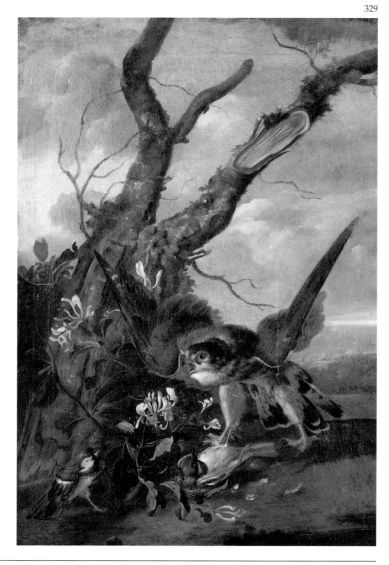

329

355

358

380

383

351 Dead Game
Canvas, 103.5 x 148.6 cm

Destroyed 1939/45. Identified in the 1914 catalogue with no.185 in the Cartwright inventory: 'a great pictur of fouls and a Rabett and a hare, a very long large pece'.

Cartwright bequest, 1686.

355 Still life
Oak panel, 37.5 x 29.5 cm

Identified by a label, verso, as no.207 in the Cartwright inventory (which occurs on one of the missing pages). Quite possibly British.

Cartwright bequest, 1686.

358 Bagpiper and Girl
Oak panel, 64.8 x 78.8 cm

The composition may derive from a Dutch print, such as that by Jacob Matham after Goltzius: *A Young Woman prefers a Lover her Own Age to the Riches of an Older Man*. The execution is crude and may well be British.

Cartwright bequest, 1686.

N. Kalinsky in *Mr Cartwright's Pictures*, no.52.

366 Elijah raising the Widow's Son
Canvas, 158.1 x 111.1 cm

Destroyed 1939/45.

Dulwich College by 1890.

380 Head of a Woman
Paper on canvas, 50.8 x 41.6 cm

Identified until 1987 with the *Head of a
Woman* on panel by the actor Richard
Burbage recorded in the Cartwright
inventory, but this seems groundless.
G. Ashton catalogued the picture
as North Italian.

Dulwich College by 1890.
G. Ashton in *Mr Cartwright's Pictures*, no.38.

383 An Old Man, called Josephus
Canvas, 45.4 x 36.5 cm

Dulwich College by 1890.

**394 Portrait of a Man,
called the Earl of Exeter**
Poplar or pine panel, 35.4 x 27.6 cm

Described in Cartwright's inventory
as 'ye Earle of Exitors head', but the
Earldom of Exeter was not created until
1605 and DPG394 is clearly earlier. The
verso bears a seal which appears to be
that of the Spoure family of Cornwall,
one of whom in the seventeenth
century married Maria Courtney, who
may have descended from Henry
Courtenay, Earl of Devon, who was
briefly (1525–39) Marquess of Exeter.

Cartwright bequest, 1686.
N. Kalinsky in *Mr Cartwright's Pictures*, no.1.

401 Saint Paul
Canvas, 52.7 x 42.5 cm

Possibly Flemish.

Cartwright bequest, 1686.
N. Kalinsky in *Mr Cartwright's Pictures*, no.30.

402 A Man Frowning
Paper on canvas, 48.3 x 34.9 cm

Dulwich College by 1890.

394

401

402

407

413

425

407 Soldier looking into a Jug
Canvas, 64.7 x 56.2 cm

Possibly Dutch, but could be a British imitation of the Dutch school.

Cartwright bequest, 1686.

N. Kalinsky in *Mr Cartwright's Pictures*, no.50.

413 Boy with a Candle and Girl with a Mousetrap
Canvas, 64.5 x 89.5 cm

Catalogued until 1987 as Italian, then as Dutch school.

Cartwright bequest, 1686.

N. Kalinsky in *Mr Cartwright's Pictures*, no.51.

425 Poultry
Canvas, 62.5 x 79 cm

Possibly British.

Cartwright bequest, 1686.

N. Kalinsky in *Mr Cartwright's Pictures*, no.74.

432

434

435

473

432 Christ carrying the Cross
 Canvas, 58.4 x 59.7 cm

The composition seems to derive from the *Christ carrying the Cross* by Titian or Giorgione in the Scuola di San Rocco, Venice (H.E. Wethey, *Titian*, London, 1969, I, no.22).

Cartwright bequest, 1686.

N. Kalinsky in *Mr Cartwright's Pictures*, no.45.

434 Ecce Homo
 Canvas, 96.8 x 78.2 cm

A crude derivation, probably from a late-sixteenth century North Italian prototype, possibly of English execution.

Cartwright bequest, 1686.

N. Kalinsky in *Mr Cartwright's Pictures*, no.46.

435 A Gypsy Encampment
 Canvas, 32.4 x 45.7 cm

Cartwright bequest, 1686.

N. Kalinsky in *Mr Cartwright's Pictures*, no.59.

473 Infant Saint John
 Inscribed on the banderole: *[EC]CE A[GNUS] DEI*
 Canvas, 61 x 81.5 cm

Described in the 1813 inventory as Murillo and catalogued in 1824 as Titian. Possibly the attempt of a British artist to evoke the style of Murillo.

Bourgeois bequest, 1811.

503

506

509

512

502 Portrait of a Clergyman
Canvas, 221 x 127 cm

Lost. Described in the 1914 catalogue as 'Artist unknown (early 18th Century)', the sitter apparently bearing 'considerable resemblance' to Dr Henry Sacheverell (1674–1724).

Dulwich College by 1890.

503 Noel Desenfans
Canvas, 47.3 x 38 cm

For the sitter, see Northcote DPG28. DPG503 was reproduced in (or may rather derive from) a mezzotint by 'I.T.' or 'J.T.' after a drawing by 'Gruin' or 'Gwin'. The bust is identified in the engraving as Fénélon, whose reputation Desenfans defended in 1777 against an attack by Lord Chesterfield. The mezzotint omits various features, including the lily, putto, fountain and arbour.

Assumed (since 1914) to come from the Bourgeois bequest, 1811.

506 The Holy Family
Canvas, 30.8 x 22.5 cm

Probably based on a Flemish prototype.

Cartwright bequest, 1686.

N. Kalinsky in *Mr Cartwright's Pictures*, no.42.

508 The Magdalen
Canvas, 128.3 x 142.2 cm

Lost. Described in the 1914 Dulwich catalogue as probably Flemish.

Dulwich College by 1890.

509 Winged Nude Figure
Oak panel, 44.2 x 57.5 cm

Cartwright bequest, 1686.
N. Kalinsky in *Mr Cartwright's Pictures*, no.48.

510 Flora and Cupid
Canvas, 104.8 x 121.9 cm

Destroyed 1939/45.

Dulwich College by 1890.

512 Jester
Paper on canvas, 48.6 x 34.9 cm

Dulwich College by 1890.

513

513 Allegory
Oak panel, 38.7 x 48.3 cm

Time is shown releasing a female figure, who presumably represents a city since she seems to have a mural crown as a headdress; at her feet are arms, on the right a wounded man, and in the right background a town in flames.

Cartwright bequest, 1686.

N. Kalinsky in *Mr Cartwright's Pictures*, no.54.

520 Fruit
Canvas, 73.7 x 63.5 cm

Lost. Identified in the 1914 catalogue with no.237 in the Cartwright inventory: 'a picture of fruits round in form of a sheeld'.

Cartwright bequest, 1686.

625 Bacchanal
Canvas, 126.5 x 150 cm

Formerly catalogued as After Jordaens.

Gift of Mrs H. Howard, 1952.

651 Woodland Landscape
Canvas, 133.6 x 143.1 cm

Bequest of Mr John Watts, 1940.

651

Appendix I: Changed Attributions

List of attributions changed since the 1980 catalogue and the exhibition *Mr Cartwright's Pictures*, Dulwich Picture Gallery, 1987–8

Follower of ALBANI	259	School of ALBANI		Circle of B. FRANCESCHINI	252	SACCHI
Studio of ALBANI	58	After ALBANI		Follower of GILLEMANS	350	FLEMISH
Studio of ALBANI	458	After ALBANI		Follower of GILLEMANS	406	FLEMISH
ANTOLÍNEZ	69	SPANISH (?)		Follower of GILLEMANS	433	FLEMISH
After BACCIARELLI	489	KUCHARSKI		After GIULIO ROMANO	602	After RAPHAEL
After BACCIARELLI	490	KUCHARSKI		Attributed to GOUBAU	20	Attributed to MIEL
BADALOCCHIO	265	After Annibale CARRACCI		Attributed to GRIGNION THE YOUNGER	595	GRIGNON
Follower of Fra BARTOLOMMEO	289	BUGIARDINI		After GUARINO	644	After STANZIONE
Attributed to BEALE	611	Attributed to John Baptist CLOSTERMAN		GUERCINO	237	GENNARI
Follower of BERCHEM	337	BERCHEM		Attributed to HANNEMAN	609	After HANNEMAN
BOEL	357	UNKNOWN		Attributed to HOARE	561	B. WILSON
BOEL	594	DUTCH(?)		Attributed to C. de HOOCH	23	BREENBERGH
BONAVIA	303	ITALIAN(?)		Attributed to C. de HOOCH	26	BREENBERGH
BONAVIA	305	ITALIAN(?)		Attributed to HOUBRAKEN	471	HOUBRAKEN
Attributed to BOTH	8	BOTH		HUDSON	596	Attributed to RAMSAY
Attributed to BOTH	10	BOTH		Imitator of J. van HUYSUM	139	J. van HUYSUM
Attributed to BOTH	12	BOTH		M. van HUYSUM	42	J. van HUYSUM
Ascribed to BOURGEOIS	488	BOURGEOIS(?)		M. van HUYSUM	61	J. van HUYSUM
Attributed to BREKELENKAM	50	BREKELENKAM		KESSEL	210	WIJNANTS
Ascribed to Agostino CARRACCI	255	Agostino CARRACCI		LANE	648	UNKNOWN
After Annibale CARRACCI	162	L.(?) CARRACCI		Attributed to LAWRENCE	474	LAWRENCE
Attributed to Annibale CARRACCI	286	ITALIAN(?)		Attributed to M. LE NAIN	180	School of LE NAIN
Attributed to Lodovico CARRACCI	269	Studio of L. CARRACCI		Attributed to LEFEBVRE	188	School of LEBRUN
Circle of Lodovico CARRACCI	232	Attributed to L. CARRACCI		LINGELBACH	55	School of LINGELBACH
CASTRO	518	Attributed to B. II PEETERS		Follower of LONGHI	307	LONGHI
Follower of CLAUDE	53	School of CLAUDE		Attributed to MAGNASCO	279	MAGNASCO
Imitator of CLAUDE	336	School of CLAUDE		MASTER OF THE BÉGUINS	332	G. I VAN HERP
Follower of COECKE VAN AELST	505	Circle of MABUSE		MASTER OF THE ANNUNCIATION		
CONCA	274	MARATTA		TO THE SHEPHERDS	558	FRACANZANO
Attributed to COSSIERS	605	LIEVENS		Follower of MOLA	32	MOLA
After CORTONA	121	CORTONA		Follower of MOLA	261	MOLA
CRADOCK	519	UNKNOWN		Studio of MONAMY	298	MONAMY
CRAYER	190	School of VAN DYCK		MONOGRAMMIST I.C.	410	?FLEMISH
Attributed to DE CRITZ	548	DE CRITZ		MOOR	116	SLINGELANDT
After CUYP	144	CUYP		MORRIS	551	UNKNOWN
After CUYP	469	UNKNOWN		After MURILLO	275	School of MURILLO
Imitator of CUYP	192	CUYP		Follower of MURILLO	206	School of MURILLO (?)
Manner of CUYP	245	CUYP		Follower of MURILLO	211	School of MURILLO
Manner of CUYP	315	After CUYP		Follower of MURILLO	276	School of MURILLO
After DUGHET	70	DUGHET		NYS	29	DUTCH
Follower of DUGHET	30	School of DUGHET		Attributed to ONOFRI	213	School of DUGHET
Follower of DUGHET	217	School of DUGHET		After A. van OSTADE	619	A. van OSTADE
Follower of DUGHET	479	After POUSSIN		OTTINO	287	TURCHI
Follower of DUGHET	480	After POUSSIN		POELENBURCH	338	BREENBERGH
Follower of DUJARDIN	48	School of DUJARDIN		Manner of POTTER	324	After POTTER
After VAN DYCK	381	Attributed to R. van LEEM		Manner of POTTER	343	DUTCH
After VAN DYCK	420	BRITISH		After POUSSIN	203	POUSSIN
Attributed to VAN DYCK	132	VAN DYCK		Follower of POUSSIN	101	After POUSSIN(?)
Manner of VAN DYCK	73	After VAN DYCK		Follower of POUSSIN	231	VENETIAN(?)
Manner of VAN DYCK	201	Studio of VAN DYCK		Manner of POUSSIN	482	After POUSSIN
ELLYS	441	BRITISH		Attributed to REMBRANDT	221	REMBRANDT
Manner of FLORIS	353	FLEMISH		Imitator of REMBRANDT	628	After REMBRANDT
FRAGONARD	74	GRIMOU		RENI	268	After RENI

	No.	
After RENI	204	Attributed to RENI
After RENI	284	School of RENI
Studio of REYNOLDS	104	REYNOLDS
Follower of RIBERA	233	Neapolitan follower of RIBERA
After RIGAUD	85	Studio of RIGAUD
Studio of RIGAUD	83	RIGAUD
J.H. ROOS	617	DUTCH(?)
Follower of ROSA	137	ROSA
Manner of ROSA	457	School of ROSA
RUBENS	148	Attributed to RUBENS
After RUBENS	403	SCHALKEN
Manner of RUBENS	1	After RUBENS
Manner of RUBENS	130	After RUBENS
Manner of RUBENS	450	After RUBENS
Follower of RUISDAEL	9	VERBOOM
Follower of RUISDAEL	349	After J. van RUISDAEL
RUYTEN	626	BELGIAN
Imitator of SCHALKEN	191	SCHALKEN
Studio of SCHEDONI	161	School of SCHEDONE
J.(?) SMART	634	PICKERSGILL
J.(?) SMART	638	UNKNOWN
John SMART	635	OWEN
John SMART	639	UNKNOWN
Follower of SPRANGER	455	FLEMISH
TENIERS	314	Attributed to D. TENIERS I or II
TENIERS	323	Attributed to D. TENIERS I or II
Imitator of TENIERS	35	Attributed to TENIERS
Imitator of TENIERS	299	Attributed to TENIERS
Studio of TENIERS	107	After TENIERS
Studio of TENIERS	109	After TENIERS
Studio of TENIERS	321	TENIERS
Studio of TENIERS	341	TENIERS
Attributed to J.E. THOMANN VON HAGELSTEIN	22	Circle of ELSHEIMER
Attributed to THOMAS	123	School of RUBENS
After TORRE	27	ITALIAN
After A. van de VELDE?	177	After A. van de VELDE
After W. van de VELDE	68	W. van de VELDE
After VERNET	623	VERNET
Follower of VERNET	610	VERNET
Studio of VERNET	300	School of VERNET
Studio of VERNET	306	VERNET
Follower of VERONESE	239	Studio of VERONESE
Manner of VERONESE	159	School of VERONESE
Manner of VERONESE	207	VENETIAN
After P. de VOS?	597	FLEMISH(?)
After WATTEAU	620	Imitator of PATER
WIJCK	247	MIEL
Attributed to WIJNANTS	633	HEUSCH
Imitator of WIJNANTS	616	After WYNANTS
Attributed to WOUWERMANS	193	WOUWERMANS
After WOUWERMANS	18	Imitator of WOUWERMANS
Follower of WOUWERMANS	34	Pieter WOUWERMAN
Follower of WOUWERMANS	36	Pieter WOUWERMAN
Attributed to ZUCCARELLI	452	ZUCCARELLI
Follower of ZUCCARELLI	119	ZUCCARELLI
BRITISH?	151	NETHERLANDISH (?GERMAN)
BRITISH?	200	After JOHNSON?
BRITISH	354	BRITISH, attributed to L. de HEERE
BRITISH	365	DUTCH
BRITISH	368	UNKNOWN
BRITISH	396	ANGLO-FLEMISH
BRITISH	421	UNKNOWN
BRITISH	427	UNKNOWN
BRITISH	496	C. STOPPELAER(?)
BRITISH	504	UNKNOWN
BRITISH	537	UNKNOWN
BRITISH	538	UNKNOWN
BRITISH	539	UNKNOWN
BRITISH	540	UNKNOWN
BRITISH	541	UNKNOWN
BRITISH	542	UNKNOWN
BRITISH	543	UNKNOWN
BRITISH	544	UNKNOWN
BRITISH	545	UNKNOWN
BRITISH	546	UNKNOWN
BRITISH	547	UNKNOWN
BRITISH	589	Attributed to HOPPNER
BRITISH	613	HIGHMORE
BRITISH	624	After VAN DER NEER
BRITISH	636	UNKNOWN
BRITISH	640	After LAWRENCE
BRITISH	642	UNKNOWN
DUTCH	501	UNKNOWN
DUTCH	622	MAHU
FRENCH	93	Studio of RIGAUD
FRENCH	397	?FLEMISH
FRENCH	404	FLEMISH
FRENCH	478	After POUSSIN
FRENCH?	288	School of VAN DYCK
ITALIAN (BOLOGNESE)	295	VENETIAN
ITALIAN (BOLOGNESE)	487	UNKNOWN
ITALIAN (EMILIAN)	129	ITALIAN
ITALIAN (ROMAN)	41	ITALIAN (MOLA?)
ITALIAN (FLORENTINE)	292	DOLCI
ITALIAN (NORTH ITALIAN)	254	ITALIAN
ITALIAN (ROMAN)	38	ITALIAN (P. da CORTONA?)
ITALIAN (ROMAN)	260	ITALIAN
ITALIAN (VENETIAN)	21	ITALIAN
ITALIAN (VENETIAN)	84	PIAZZA
NETHERLANDISH, mid-16th century	250	ANTWERP MASTER
SPANISH	62	MORALES
UNKNOWN	13	SPANISH
UNKNOWN	24	GERMAN(?)
UNKNOWN	329	DUTCH
UNKNOWN	380	NORTH ITALIAN
UNKNOWN	394	GERMAN or NORTH ITALIAN
UNKNOWN	401	FLEMISH
UNKNOWN	407	DUTCH
UNKNOWN	413	DUTCH
UNKNOWN	432	VENETIAN
UNKNOWN	503	FRENCH(?)
UNKNOWN	506	BRITISH
UNKNOWN	513	FLEMISH
UNKNOWN	625	After JORDAENS
UNKNOWN	651	FLEMISH

1626 (Alleyn Bequest)

After De Critz 384?
After I. Oliver 417?
British 368
British 369
British 370
British 392?
British 419
British 421
British 427
British 443
British 444
British 521
British 522
British 523
British 524
British 525
British 526
British 527
British 528
British 529
British 530
British 531
British 532
British 533
British 534
British 535
British 536
British 537
British 538
British 539
British 540
British 541
British 542
British 543
British 544
British 545
British 546
British 547

1686 (Cartwright Bequest)

After Barocci 409
After F. Bassano 386
After F. Bassano 398
After F. Bassano 412
After F. Bassano 422
Boel 357
Bol 360?
Castro 359
Castro 361
Castro 428
Castro 436
Castro 437
Castro 517
Castro 518
Colonia 371
Colonia 431
Attributed to Dobson 363
After Van Dyck 352
After Van Dyck 381
After Van Dyck 414
After Van Dyck 420
After Van Dyck 426
Manner of Floris 353

Fuller 379
Gheeraerts 389
Follower of Gillemans 350
Follower of Gillemans 406
Follower of Gillemans 433
Greenhill 374
Greenhill 387
Greenhill 393
Greenhill 399
Greenhill 416
Greenhill 418
Huysmans 362
After Lely 408
Monogrammist I.C. 410
After Spranger 511
Streeter 376
After Vrancx 356
Walton 429
After Wright 424
British 354
British 364
British 365
British 367
British 372
British 373
British 375
British 377
British 378
British 385
British 388
British 390
British 391
British 395
British 396
British 400
British 411
British 423
British 430
Dutch 514
Dutch 515
Dutch 516
French 397
French 404
Unknown 351
Unknown 355
Unknown 358
Unknown 394
Unknown 401
Unknown 407
Unknown 413
Unknown 425
Unknown 432
Unknown 434
Unknown 435
Unknown 506
Unknown 509
Unknown 513
Unknown 520

1724

Ellys 441

1778

Romney 440

1796

After Raphael 507

1811 (Bourgeois bequest)

Studio of Albani 58
Studio of Albani 458
Follower of Albani 259
After C. Allori 267
Antolínez 69
After Bacciarelli 489
After Bacciarelli 490
Badalocchio 265
Bakhuizen 327
School of Fra Bartolommeo 289
Beechey 111
Beechey 169
Berchem 88
Berchem 122
Berchem 157
Berchem 166
Berchem 196
Follower of Berchem 337
Bonavia 303
Bonavia 305
Borssom 133
Both 15
Both 208
Attributed to Both 8
Attributed to Both 10
Attributed to Both 12
Bourgeois 6
Bourgeois 100
Bourgeois 135
Bourgeois 149
Bourgeois 294
Bourgeois 301
Bourgeois 308
Bourgeois 310
Bourgeois 311
Bourgeois 325
Bourgeois 335
Bourgeois 342
Bourgeois 344
Bourgeois 459
Bourgeois 460
Bourgeois 461
Bourgeois 462
Bourgeois 463
Bourgeois 465?
Bourgeois 466?
Bourgeois 467
Ascribed to Bourgeois 488?
Attributed to Brekelenkam 50
Attributed to Brouwer 108
Manner of Cagnacci 160
Calraet 63
Calraet 65
Calraet 71
Calraet 181
Calraet 296
Camphuysen 64
Ascribed to Agostino Carracci 255
Attributed to Annibale Carracci 286

After Annibale Carracci 154
After Annibale Carracci 162
After Annibale Carracci 230
Attributed to Lodovico Carracci 269
Circle of Lodovico Carracci 232
Casanova 138
Cignani 257
Claude 205
Claude 309
Circle of Claude 174
After Claude 220
After Claude 312
Follower of Claude 53
Imitator of Claude 215
Imitator of Claude 336
Conca 274
After Correggio 246
After Correggio 468
After Cortona 121
After Cortona 226
Crayer 190
Cuyp 4
Cuyp 60
Cuyp 96
Cuyp 124
Cuyp 128
Cuyp 348
After Cuyp 144
After Cuyp 469
Imitator of Cuyp 192
Manner of Cuyp 245
Manner of Cuyp 315
Delen 470
Dolci 242
Domenichino 283 (sold)
Dou 56
G. Dubois 118
After Dughet 70
Follower of Dughet 30
Follower of Dughet 217
Follower of Dughet 479
Follower of Dughet 480
Dujardin 72
Dujardin 82
Follower of Dujardin 48
Dusart 39
Van Dyck 90
Van Dyck 127
Van Dyck 170
Van Dyck 173
Van Dyck 194
Attributed to Van Dyck 132
Studio of Van Dyck 81
Manner of Van Dyck 73
Manner of Van Dyck 201
Fragonard 74
Circle of B. Franceschini 252
M. Franceschini 313
Gainsborough 66
Gelder 126
Attributed to Goubau 20
Guercino 237
Guercino 282

Heyden 155
Hobbema 87
Hoet 176
Hoet 179
Attributed to C. de Hooch 23
Attributed to C. de Hooch 26
Horst 214
Attributed to Houbraken 471
J. van Huysum 120
Imitator of J. van Huysum 139
M. van Huysum 42
M. van Huysum 61
Jonson the elder 80
Jonson the elder 89
After Joos van Cleve 271
After Jordaens 293
Kessel 210
Lapp 330
Lauri 164
Le Brun 202
Le Brun 244
Attributed to M. Le Nain 180
Lingelbach 55
Lingelbach 326
Follower of Longhi 307
Louterbourg 297
Louterbourg 339
Attributed to Magnasco 279
Master of the Béguins 332
Mazo 277
Circle of Mola 75
Follower of Mola 32
Follower of Mola 261
Studio of Monamy 298
Moor 116
Moscher 16
Murillo 199
Murillo 222
Murillo 224
Murillo 281
After Murillo 187
After Murillo 272
After Murillo 275
Follower of Murillo 206
Follower of Murillo 211
Follower of Murillo 276
Neeffs 141
After Van der Neer 340?
Northcote 28
Northcote 172
Nys 29
Ommeganck 145
Attributed to Onofri 213
Opie 94
A. van Ostade 45
A. van Ostade 98
A. van Ostade 113
A. van Ostade 115
Ottino 287
Paggi 248
Piero di Cosimo 258
Poelenburch 25
Poelenburch 338
After Potter 334

Manner of Potter 324
Manner of Potter 343
Poussin 234
Poussin 236
Poussin 238
Poussin 240
Poussin 263
Poussin 481
After Poussin 203
After Poussin 225
After Poussin 227
After Poussin 229
After Poussin 477
Follower of Poussin 101
Follower of Poussin 231
Manner of Poussin 482
Pynacker 86
Pynacker 183
Raphael 241
Raphael 243
Rembrandt 99
Rembrandt 163
Attributed to Rembrandt 221
Reni 262
Reni 268
After Reni 204
After Reni 212
After Reni 284
Reynolds 102
Reynolds 318
Reynolds 333
Reynolds 483
Studio of Reynolds 104
Studio of Reynolds 223
Follower of Ribera 233
Ricci 134
Ricci 195
Studio of Rigaud 83
After Rigaud 85
Romeyn 3
Romeyn 5
Rosa 216
Follower of Rosa 137
Manner of Rosa 457
Rubens 19
Rubens 40
Rubens 40A
Rubens 43
Rubens 125
Rubens 131
Rubens 143
Rubens 148
Rubens 264
Rubens 285
Rubens 451
After Rubens 218
Follower of Rubens 165
Manner of Rubens 1
Manner of Rubens 130
Manner of Rubens 450
Ruisdael 105
Ruisdael 168
Follower of Ruisdael 9
Follower of Ruisdael 349

After Saenredam 59
H. Saftleven 44
After Del Sarto 228
After Del Sarto 251
Imitator of Schalken 191
Studio of Schedoni 161
D. Seghers 322
Snayers 347
Swanevelt 11
Swanevelt 136
Swanevelt 219
Teniers 31
Teniers 33
Teniers 49
Teniers 52
Teniers 54
Teniers 57
Teniers 76
Teniers 95
Teniers 106
Teniers 110
Teniers 112
Teniers 142
Teniers 146
Teniers 314
Teniers 323
Studio of Teniers 107
Studio of Teniers 109
Studio of Teniers 321
Studio of Teniers 341
Imitator of Teniers 35
Imitator of Teniers 299
Attributed to J.E. Thomann von
 Hagelstein 22
Attributed to Thomas 123
Tiepolo 158
Tiepolo 186
Tiepolo 189
Tiepolo 278
After Titian 198
After Titian 209
After Titian 266
After Titian 273
After Titian 484
After Torre 27?
Studio of Velázquez 249
After Velázquez 152
A. van de Velde 51
After A. van de Velde? 177
W. van de Velde 103
W. van de Velde 197
After W. van de Velde 68
Vernet 319
Vernet 328
Studio of Vernet 300
Studio of Vernet 306
Veronese 270
Follower of Veronese 239
Manner of Veronese 159
Manner of Veronese 207
Verwilt 485
Vos 290
Vries 7

Watteau 156
Circle of Watteau 167
J. Weenix 47
Werff 147
Wijck 247
Wijnants 114
Wijnants 117
Wilson 171
Woodburn 150
Wouwermans 67
Wouwermans 77
Wouwermans 78
Wouwermans 79
Wouwermans 91
Wouwermans 92
Wouwermans 97
Wouwermans 182
Attributed to Wouwermans 193
After Wouwermans 18
Follower of Wouwermans 34
Follower of Wouwermans 36
Zuccarelli 175
Zuccarelli 317
Attributed to Zuccarelli 452
Follower of Zuccarelli 119
British 151
British 200
British 486
Dutch 37
Dutch 153
Dutch 472?
Flemish 14
French 93
French 288
French 345
French 478
Italian 184
Italian (Bolognese) 2
Italian (Bolognese) 253
Italian (Bolognese) 280
Italian (Bolognese) 295
Italian (Bolognese) 487?
Italian (Emilian) 129?
Italian (Florentine) 292
Italian (North Italian) 254
Italian (Roman) 38
Italian (Roman) 41
Italian (Roman) 260
Italian (Umbrian) 256
Italian (Venetian) 21
Italian (Venetian) 84
Spanish 13
Spanish 62
Spanish 185
Unknown 24
Unknown 329
Unknown 473
Unknown 503

*c.*1830
After Rubens 403

1831
Gainsborough 316

1831/5 (Linley bequest)
Gainsborough 140
Gainsborough 302
Gainsborough 320
Gainsborough 331
Lawrence 178
Lawrence 475
Attributed to Lawrence 474
Lonsdale 456
A.J. Oliver 476

1836
Beechey 17
Reynolds 17A

1843
After Landseer 447

1845
Nuvolone 235

1846
Briggs 499

1852
Bellucci 46

1854
Attributed to Lefebvre 188
Briggs 291
Lane 449
Lane 500

1866
Bourgeois 464

1873
British 445

1875
Netherlandish 250

1883
Fisher 497
Wood 346

1889
Bourgeois 491

By 1890 (College pictures)
Follower of Coecke van Aelst
 505
Cradock 519
After Dolci 382
British 405
British 415
British 438
British 439
British 448
British 494

British 495
British 496
British 498
British 504
Dutch 501
Unknown 366
Unknown 380
Unknown 383
Unknown 402
Unknown 502
Unknown 508
Unknown 510
Unknown 512

1891
Denning 304

1892
Hodgkins 492
Hodgkins 493

1894
Hodgkins 446
Follower of Spranger 455

1897
Cope 442
Wood 453
Wood 454

1898
Attributed to De Critz 548

1901
After Angeli 550
Morris 549
Morris 551

1902
White 552

1903
Hastain 553

1911 (Fairfax Murray gift)
Beach 591
Beale 574
Bourdon 557
Dahl 575
Dahl 576
S. Du Bois 584
S. Du Bois 585
Gainsborough 588
Hanneman 572
Highmore 566
Attributed to Hoare 561
Hogarth 562
Hogarth 580
Honthorst 571
Hudson 578
Hudson 579
Hudson 596
Jervas 567

Jonson the younger 564
Kettle 582
Kettle 583
Kneller 570
Lely 555
Lely 559
Lely 560
Lely 563
Master of the Annunciation to
 the Shepherds 558
Muller 587
Nason 556
Riley 565
Riley 568
Romney 590
Sanders 577
Soest 573
Attributed to Soest 592
Vanderbank 581
West 586
Wilson 593
British 569
British 589

1912
Boel 594

1915
Canaletto 599
Attributed to Grignion 595
After P. de Vos? 597

1917
Canaletto 600
Attributed to Cossiers 605
After Giulio Romano 602
British 604
Reynolds 598
Russell 601

1917/18
Knapton 606
Soldi 603

1920
Horsley 607

1926
Storck 608

1930
After Reynolds 627

1934
Attributed to Beale 611
Attributed to Hanneman 609
British 613

1934
Murray 612
Follower of Vernet 610

1940
Unknown 651

1942
Wood 650

1946
Pronk 615
J.H. Roos 617
Studio of Teniers 614
Imitator of Wijnants 616

1951
Brakenburgh 621
M. Franceschini 629
Green 618
After A. van Ostade 619
After W. van de Vernet 623
After Watteau 620
British 624
Dutch 622

1952
Ruyten 626
Unknown 625

1953
Imitator of Rembrandt 628

1955
After Rubens 630

1956
Brodie 632
John Smart 635
John Smart 637
John Smart 639
J.(?) Smart 634
J.(?) Smart 638
British 636
British 640

1956
Ward 631

1957
Attributed to Wijnants 633

1960
Spanton 641
British 642

1961
Dürck 643
After Guarino 644

1990
Honthorst 652

1994
Dughet 656

Unknown
Lane 648

Appendix IV: Concordance

Inventories and early Catalogues. A list of Dulwich inventories and catalogues is included with the Abbreviations.

This table gives references to the following:

1. The Cartwright Inventory (undated and listed below under the date of the Cartwright bequest in 1686)

2. The 1813 catalogue by J. Britton. The numbering pre-dates removal of the collection from Charlotte Street to the Gallery.

3. One of the various undated early catalogues of the collection. The example used (Dulwich Picture Gallery library) probably dates from *c*.1824 and is referred to as such. The pictures seems to have been periodically renumbered at this period.

4. The 1880 catalogue. This reflects the numbering of the collection *c*.1866–1892.

5. The catalogue of the College pictures prepared by J.C.L. Sparkes and the Rev. A.J. Carver in 1890.

The pictures on display were renumbered in 1892 and the new numbering system was extended to the whole collection in 1914. Nos.548ff are post-1892 acquisitions and have no earlier references.

Some of the identifications proposed below are unavoidably conjectural.

DPG	1686	1813	1824	1880	1890
1		95	32	33	
2		38	339	334	
3		183	54	8	
4		64	68	9	
5		180	57	10	
6		43	37	88	
7		170	31	208	
8		260	192	30	
9		27	82	201	
10		176	184	199	
11		325	200	221	
12		259	101	41	
13		207	310	301	
14		131	86	56	
15		4	125	205	
16		126	66	178	
17				356	
17A		356			
18		289	39	53	
19		1	166	174	
20		330	77	21	
21		110	204	298	
22		329	311	297	
23		296	60	16	
24		267	277	288	
25		340	59	14	
26		294	87	15	
27		212	246		
28		346	343	338	
29		158	69	181	
30		366	245	212	
31		230	19	155	
32		320	210	195	
33		228	21	61	
34		316	8	64	
35		323	22	52	
36		317	78	63	
37		48	33	68	
38		212	258	164	
39		156	79	104	
40		247	165	78	
40A		247	165	78	
41		133	337	261	
42		157	328	29	
43		229	172	171	
44		182	75	101	
45		353	11	107	
46					365
47		250	136	147	
48		295	50	47	
49		241	9	84	
50		14	157	85	
51		13	173	72	
52		245	17	86	
53		318	189	264	
54		5	143	50	
55		347	202	90	
56		354	70	106	
57		173	27	100	
58		49	293	165	
59		187	52	94	
60		68	58	76	
61		155	330	39	
62		31	356	329	
63		78	43	5	
64		128	107	120	
65		70	73	114	
66		88	103	111	
67		322	76	93	
68		301	93	113	
69		141	276	224	
70		46	244	257	
71		73	74	156	
72		21	67	62	
73		297	198	167	
74		18	127	123	
75		83	272	284	
76		222	100	119	
77		306	115	125	
78		253	177	173	
79		305	47	126	
80		114	99	122	
81		215	106	124	
82		356	213	229	
83		41	109	98	
84		112	329	128	
85		87	111	2	
86		249	71	130	
87		268	153	131	
88		172	180	132	
89		345	122	134	
90		213	118	135	
91		254	114	136	
92		252	120	137	
93		42	110	118	
94		103	126	3	
95		224	123	139	
96		77	83	141	
97		232	108	144	
98		331	15	73	
99		171	55	189	
100		113	323	127	
101		211	256	142	
102		150	130	143	
103		324	137	166	
104		89	104	146	
105		257	145	154	
106		7	346	148	
107		335	85	71	
108		130	10	54	
109		334	63	69	
110		8	345	149	
112		300	169	116	
113		336	5	152	
114		242	6	12	
115		47	341	190	
116		266	280	151	
117		244	16	11	
118		191	168	157	
119		28	139	290	
120		251	102	140	
121		79	216	161	
122		125	164	160	
123		277	147	162	
124		76	18	163	
125		220	149	204	
126		302	144	179	
127		236	112	168	
128		71	3	169	
129		221	342	267	
130		109	174	172	
131		142	135	182	
132		352	158	175	
133		214	148	176	
134		84	215	177	
135		66	13	59	
136		188	249	273	
137		238	226	159	
138		185	268	28	
139		255	124	121	
140				358	

DPG	1686	1813	1824	1880	1890
141		178	178	79	
142		265	156	185	
143		299	91	187	
144		168	29	243	
145		179	80	66	
146		243	20	60	
147		239	352	191	
148		11	141	235	
149		45		371	
150		344	40	51	
151		315	223	353	
152		82	195	194	
153		192	30	237	
154		202	262	274	
155		240	160	196	
156		43	191	210	
157		227	186	200	
158		163	199	99	
159		100	275	203	
160		115			56
161		19	238	302	
162		357	320	311	
163		258	176	206	
164		186	35	223	
165		217	150	170	
166		231	190	209	
167		44	185	197	
168		246	151	241	
169		85	105	97	
170		99	163	214	
171		201	240	215	
172		91	117	183	
173		161	196	218	
174		349	252	219	
175		286	61	231	
176		184	36	42	
177		321	206	108	
178				359	
179		181	34	32	
180		199	134	158	
181		65	25	145	
182		226	119	228	
183		309	162	150	
184		304	183	314	
185		197	217	294	
186		292	253	236	
187		16	353	341	
188				363	
189		293	254	233	
190		140	154	234	
191		111	201	238	
192		72	48	239	
193		9	113	65	
194		343	88	242	
195		189	188	188	
196		360	46	17	
197		233	133	186	
198		86	228	323	
199		20	237	248	
200		123	121	213	
201		90	142	250	
202		288	271	252	
203		279	260	260	
204		154	232	280	
205		351	248	244	
206		298	332	330	
207		3	265	268	
208		167	92	36	
209		97	251	263	
210		271	159	278	
211		341	326	129	
212		263	255	259	
213		135	300	269	
214		58	152	272	
215		350	257	275	
216		124	236	271	
217		196	267	276	
218		6	161	207	
219			259	256	
220		365	246	270	
221		313	179	282	
222		35	324	283	
223		32	224	285	
224		34	322	286	
225		60	301	249	
226		147	290	318	
227		51	296	291	
228		149	233	326	
229		62	309	295	
230		218	350	335	
231		53	318	352	
232		219	348	265	
233		275	295	299	
234		56	287	300	
235				364	
236		61	304	305	
237		261	243	324	
238		57	313	315	
239		151	294	289	
240		63	291	310	
241		22	263	307	
242		177	49	337	
243		23	264	306	
244		285	234	319	
245		248	72	83	
246		24	349	255	
247		314	84	103	
248		282	282	247	
249		164	303	309	
250				381	
251		223	299	327	
252		96	269	346	
253		101	333	322	
254		120	94	67	
255		81	231	296	
256		338	288	287	
257		307	286	350	
258		364	335	133	
259		26	98	87	
260		165	312	226	
261		139	273	266	
262		40	331	331	
263		54	319	336	
264		136	197	240	
265		145	292	344	
266		108	214	40	
267		105	340	343	
268		42	344	339	
269		210	221	293	
270		33	354	333	
271		104	207	277	
272		12	338	262	
273		312	306	230	
274		159	239	342	
275		106	316	317	
276		205	315	312	
277		339	242	222	
278		290	274	58	
279		175	209	313	
280		235	351	328	
281		41	334	347	
282		208	357	348	
283		36	355	349	
284		237	336	332	
285		40	327	351	
286		102	325	225	
287		311	230	345	
288		169	203	26	
289		137	229	354	
290		107	194	355	
291					53
292		256	131	217	
293		144	96	37	
294		204	62	4	
295		98	270	193	
296		362	42	13	
297		272	89	55	
298		234	219	92	
299		355	155	46	
300		152	167		110
301		80	208	82	
302				361	
303		122	305	43	
304				383	
305		117	307	31	
306		148			111
307		162	51	27	
308		209	28	370	
309		283	266	320	
310		269	281	20	
311		264	278	24	
312		174	261	211	
313		67		375	
314		153	171	35	
315		69	65	184	
316				366	
317		118	220	232	
318		39	347	340	
319		30		49	
320			1	1	
321		200	24	18	
322		278	53	102	
323		146	170	34	
324		15	138	22	
325		194	81	38	
326		25	45	77	
327		327	90	75	
328		262	2	202	
329		160	140	19	
330		276	23	216	
331				362	
332		2	97	6	
333		127	193	138	
334		225	64	7	
335		326		23	
336		361	285	303	
337		358		198	
338		166	222	110	
339		206	128	89	
340		143	129	112	
341		203	41	44	
342		332	14	25	
343		333	4	70	
344		319	205	95	

DPG	1686	1813	1824	1880	1890
345		216	250	308	
346				382	
347		119	132	45	
348		75	26	192	
349		308	44	245	
350	85				127
351	185				122
352	99				81
353	176				96
354					62
355					125
356	28				99
357	67				123
358	175				95
359	225				113
360					112
361	224				118
362	72				67
363	100				18
364	180				16
365	179				17
366					77
367	165				15
368					23
369					25
370					22
371	83				108
372	181				14
373	121				20
374	117				65
375	174				4
376	228				109
377	156				66
378	77				19
379	110				69
380	103				68
381	118				13
382					85
383					58
384					6
385	167				50
386	69				105
387	116				33
388	120				34
389	97				63
390	148				52
391	109				49
392					10
393	234				29
394	101				2
395	105				48
396	96				3
397	107				61
398	80				107
399	78				32
400	168				30
401	104				57
402					93
403					97
404					74
405					64
406	87				128
407	71				91
408	123				87
409	145				80
410	91				59
411	169				31
412	70				104
413	172				92
414	94				8
415					74
416	68				12
417					7
418	95				27
419					24
420	56				26
421					21
422	79				106
423	166				51
424	76				11
425	75				121
426	93				9
427					60
428	227				115
429	122				124
430	108				5
431	82				78
432	111				83
433	86				126
434	164				84
435	124				103
436	216				116
437					119
438					43
439					46
440					39
441					37
442					
443					1
444					35
445				367	
446					
447					40
448					42
449					54
450		17	146	117	
451		134	218	227	
452		121	297	251	
453					
454					
455					
456					47
457		363	279	220	
458		274	235	80	
459		29	182	57	
460		270	95	74	
461		332	181	91	
462		337		96	
463		195	241	109	
464				368	
465				372	
466				373	
467		287		374	
468		129	227	281	
469		74	38	180	
470		193	247	258	
471		328	56	48	
472				378	
473		281	321	81	
474				357	
475				360	
476				369	
477		55	225	115	
478		52	289	253	
479		138	283	279	
480		198	284	292	
481		50	314	316	
482		59	302	325	
483		280	187	254	
484		10	308	304	
485		132	12	105	
486		116	298	321	
487				376	
488		273		377	
489		93		379	
490		94		380	
491					
492					
493					
494					28
495					36
496					38
497					41
498					44
499					45
500					55
501					71
502					72
503		348			73
504					75
505					76
506					79
507					82
508					86
509	163				88
510					89
511					90
512					94
513	130				98
514	125				100
515	26				101
516	27				102
517	219				114
518	213				117
519					120
520	237				129
521					130
522					131
523					132
524					133
525					134
526					135
527					136
528					137
529					138
530					139
531					140
532					141
533					142
534					143
535					144
536					145
537					146
538					147
539					148
540					149
541					150
542					151
543					152
544					153
545					154
546					155
547					156